Three Centuries of American Prints
from the National Gallery of Art

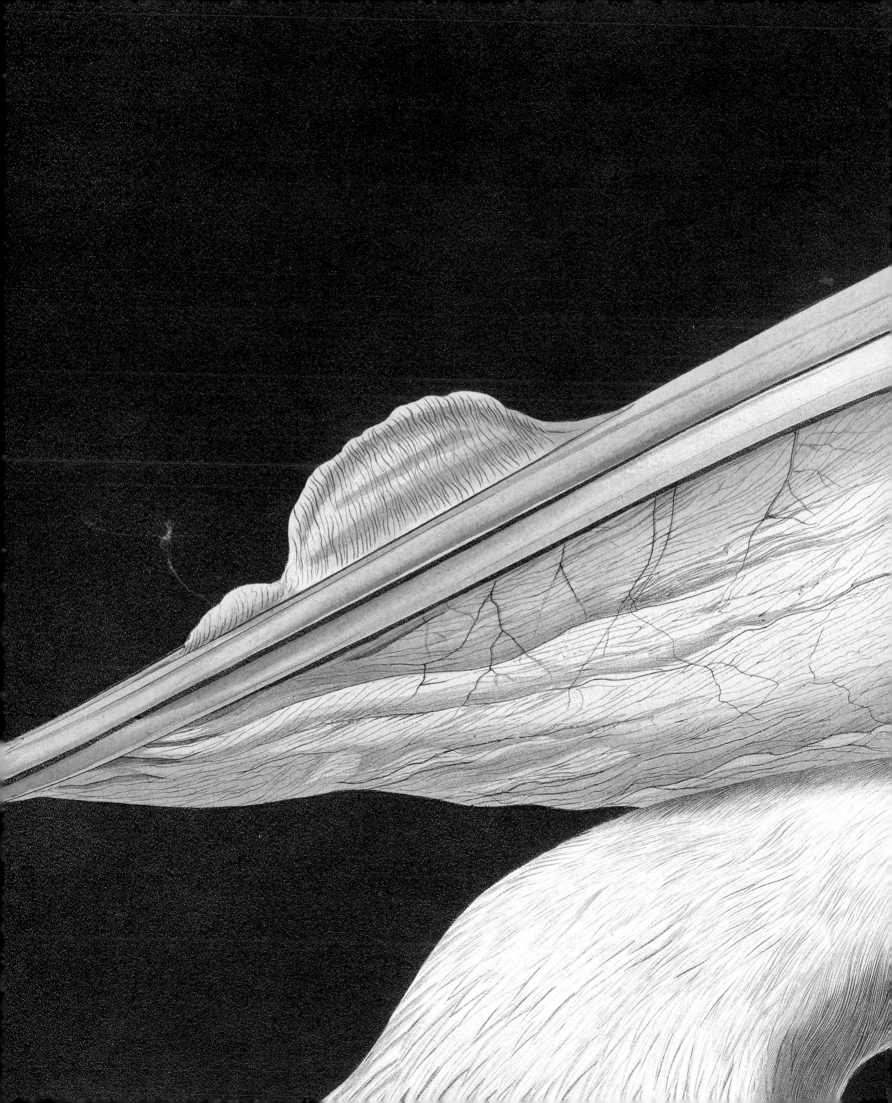

Judith Brodie
Amy Johnston
Michael J. Lewis

with
John Fagg
Adam Greenhalgh
Franklin Kelly
David M. Lubin
Leo G. Mazow
Alexander Nemerov
Jennifer Raab
Jennifer L. Roberts
Marc Simpson
Susan Tallman
Joyce Tsai
David C. Ward

National Gallery of Art
Washington

 Thames & Hudson

Three Centuries of American Prints

FROM THE NATIONAL
GALLERY OF ART

Contents

Colonial Era to the Civil War

Reconstruction to World War II

Post-World War II to the Present

Director's Foreword

THE NATIONAL GALLERY OF ART is known throughout the world for its great strength in European art — paintings, sculpture, drawings, and prints. From the beginning, however, the Gallery has also pursued the finest in American art. Especially in the past few decades the American collections have grown vastly in quality and scale. From 2000 until today, thanks to generous donors, the collection of American prints has almost doubled and now numbers some 22,500 works.

Celebrating that achievement and timed to coincide with the National Gallery's seventy-fifth anniversary, *Three Centuries of American Prints from the National Gallery of Art* reveals the breadth and excellence of the collection while showcasing its standouts: exquisite, rare impressions of Whistler's *Nocturne* (1879/1880), captivating prints by Mary Cassatt, a singularly stunning impression of John Marin's *Woolworth Building, No. 1* (1913), and Robert Rauschenberg's pioneering *Booster* (1967). The exhibition is bracketed by John Simon's *Four Indian Kings* (after 1710) — stately portraits of four Native American leaders who traveled to London to meet Queen Anne — and Kara Walker's *no world* (2010), which recalls the disastrous impact on native peoples of European settlement in the New World. Interestingly, both prints address the subject of transnational contact, a theme that runs through much of the history of American art.

Three Centuries of American Prints features works whose primary purpose is to provoke action, such as Paul Revere's call for moral outrage in *The Bloody Massacre* (1770) and Jenny Holzer's appeal to "Raise Boys and Girls the Same Way" in her *Truisms* (1977). Others lean more strongly toward visual concerns, such as Stuart Davis's striking black-and-white lithograph, *Barber Shop Chord* (1931), and Richard Diebenkorn's resplendent *Green* (1986). This duality between prints designed to exhort or teach and ones more weighted to artistic matters is evident throughout the exhibition and the history of American prints. In his groundbreaking essay for this catalog, Michael J. Lewis expresses it well when he writes of "the impulse to make an intrinsically beautiful object and the desire to convey an urgent message." There are urgent messages and beautiful objects aplenty in *Three Centuries of American Prints*, even some, as Lewis notes, that do both quite successfully.

The exhibition provides a vantage point from which to assess the rich terrain of American prints. This catalog does so in provocative new ways, drawing on the keen eyes and insightful points of view of emerging and established scholars who, with certain exceptions, are experts in American art or history more generally, not only in prints. By exploring the works for their aesthetic, historical, and cultural value, these essayists open the topic to a fresh range of interpretations. The result is a lively mix of voices and approaches, underscoring the opinion of Americanist art historian Jules Prown that there is "no single *right* methodology; it is the variety of approaches that makes and enriches our field."

Were it not for the generous support from hundreds of donors, the Gallery's collection of American prints would not exist. The names Lessing J. Rosenwald and Reba and Dave Williams appear frequently in the checklist of works in the exhibition, for these individuals contributed the

greatest number of American prints to the Gallery. In the contemporary field we are especially grateful to Kathan Brown, Gemini G.E.L., Mr. and Mrs. Robert Hauslohner, Ruth and Jacob Kainen, Roy and Dorothy Lichtenstein, Dorothy J. and Benjamin B. Smith, and the Woodward Foundation. We owe them and the innumerable supporters who have contributed to the collection these past seventy-five years our utmost gratitude.

An ambitious exhibition of this sort requires the attention of curators with knowledge and vision. Our appreciation goes to Judith Brodie, the Gallery's curator and head of the department of modern prints and drawings, and Amy Johnston, assistant curator of prints and drawings, whose combined expertise, enthusiasm, and thoughtful attention are evident in the exhibition galleries and on the pages of this catalog.

We are also deeply indebted to Altria Group, the Terra Foundation for American Art, and The Exhibition Circle of the National Gallery of Art for their vital support of *Three Centuries of American Prints*.

Earl A. Powell III

Acknowledgments

A HAPPY MILEPOST IN THE course of organizing an exhibition is the point at which we have the pleasure of thanking others. Our appreciation goes first to National Gallery of Art director Earl A. Powell III and deputy director and chief curator Franklin Kelly, who readily endorsed the exhibition. We are grateful also for the enthusiastic support and guidance of Andrew Robison, A. W. Mellon Senior Curator of Prints and Drawings, who since 1974 has worked to build the American collection of works on paper, especially in the area of American drawings. Ruth E. Fine, curator of modern prints and drawings at the National Gallery from 1980 to 2002 — and before that, curator of Lessing J. Rosenwald's collection — played a key role in the growth of the collection, particularly in the area of post-World War II American prints, and in establishing at the Gallery the print archives of Gemini G.E.L., Crown Point Press, Graphicstudio, and Jasper Johns.

D. Dodge Thompson, chief of exhibitions, and Jennifer Cipriano, exhibition officer, as well as Wendy Battaglino and Allison Keilman in the department of exhibitions, helped set the exhibition in motion and arranged for it to travel to institutions far and near. We extend our appreciation to them and to our colleagues at those institutions: Alena Volrabova, director of the collection of prints and drawings, National Gallery in Prague, and Bertha Cea Echenique, executive coordinator, Mandato Antiguo Colegio de San Ildefonso. For their help crafting the texts for the exhibition we are indebted to Susan Arensberg and especially Lynn Matheny, both in the department of exhibition programs.

Many talented people contributed to the exhibition's handsome design, foremost among them Mark Leithauser, chief of design, and Donna Kirk, senior architect. Their associates in the department of design — Gordon Anson, Nathan Peek, Elizabeth Parr, Deborah Kirkpatrick, Drew Watt, Barbara Keyes, Jeff Wilson, and Lisa Farrell — deserve much credit for their inventiveness and for putting complex plans into action.

This catalog bears the imprint of many knowledgeable scholars, above all Michael J. Lewis, who earned our sincere admiration for not only mastering new terrain and synthesizing three centuries of history, but also shaping that history into an engaging, insightful, and pioneering essay. We treasure his friendship. Our admiration for the twelve additional scholars who wrote for this catalog is equally sincere. Indeed, their essays give the catalog its lively flavor. We feel fortunate to have worked with such a distinguished group.

To the curators, fellows, and interns who wrote the artists' biographies for this catalog we express our deep gratitude: Mollie Berger, Mary Lee Corlett, Lauren Schell Dickens, Davida Fernandez-Barkan, Francesca Kaes, Carlotta Owens, Charles Ritchie, and John Tyson. Mollie Berger, who helped with the bibliography and a great deal more, and John Tyson, who brought the biographies to successful completion, deserve special recognition.

We praise the efforts of editor in chief Judy Metro and deputy publisher Chris Vogel, whose handsome design graces this catalog. Associate senior editor John Strand brought his sensitive reading and precise understanding

of language to the challenge of editing a broad range of writing styles. It has been a pleasure working with them and other devoted professionals in the publishing office, notably John Long, Sara Sanders-Buell, Katie Adkins, and Emily Francisco.

In the department of conservation we thank Kimberly Schenck, head of paper conservation, along with numerous accomplished conservators: Marian Dirda, Michelle Facini, Bethann Heinbaugh, Linda Owens, Judy Ozone, and Josefine Werthmann. We are grateful too for the indispensable contribution of preparators Laura Neal, Virginia Ritchie, and Stephen Muscarella, and the administrative support of Michelle Stein. We also thank Melissa Stegeman, associate registrar for exhibitions, and colleagues Theresa Beall and Holly Garner in the registrar's office, for their capable oversight of the movement and handling of the works of art. The works reproduced in this catalog were photographed by National Gallery photographers Ricardo Blanc, Dennis Doorly, Lee Ewing, Christina Moore, Greg Williams, and Tricia Zigmund, as well as by photographers Erica Abbey, Adam Davies, and Lea Ingold. We are indebted to them for their superb work, as well as to Alan Newman, chief of imaging and visual services; Lorene Emerson, head of photographic services; and Barbara Wood, permissions coordinator. We appreciate too the supportive contributions of John Gordy and Carolyn Campbell in our digital outreach department.

We are grateful for the resourcefulness of the development team of Christine Myers, Patricia Donovan, and Cristina del Sesto, and for the tireless efforts of those in the department of public relations and communications, especially Deborah Ziska and Anabeth Guthrie. Others deserve special recognition: Kathan Brown at Crown Point Press in San Francisco carefully reviewed and made improvements to the glossary and Margaret Morgan Grasselli, the Gallery's curator of old master drawings, was especially generous with her support.

Hundreds of public-spirited donors have contributed to the National Gallery's collection of American prints, the most prominent of whom are named in the director's foreword to this catalog. We echo his thanks to them and extend our special appreciation to Harry W. Havemeyer and Max N. Berry for lending works to the exhibition that are also generously promised to the National Gallery. Last but hardly least, our heartfelt thanks go to John Dunbar, Merv Richard, and Carolyn Stachowski for their critical input, exceptional patience, and warm encouragement.

Judith Brodie and Amy Johnston

American Prints, Their Makers, and Their Public MICHAEL J. LEWIS

She carved thee for her seal, and meant thereby,
Thou shouldst print more, not let that copy die.

SHAKESPEARE, SONNET 11

IT IS PLEASING TO LEARN that the author of the first book published in America was also the subject of the first American print.[1] The Reverend Richard Mather (1596–1669), the Puritan minister of Dorchester, Massachusetts, was depicted in a stately woodcut made shortly after his death (fig. 1). Six impressions of the print survive and it is striking: Mather belonged to the last generation of Puritan divines who cultivated beards, and he gazes at us from beneath his black velvet skullcap, solemn and serene. No earlier print has been discovered, making this the first known printed image made in America.

The print was evidently intended as the frontispiece for Mather's biography, *The Life and Death of That Reverend Man of God, Mr. Richard Mather*, published by his son Increase Mather in 1670 (earning the father yet another first: his is the first biography printed in America).[2] Strangely, the woodcut was made from two blocks, and the seam between them is just below Mather's beard. John Foster, the designer and printer of the woodcut, conceivably recut the face after having mangled it on the first attempt. But it has also been proposed that Foster intended from the start that the head could be removed and exchanged for another, so that he could print a whole series of portraits of Puritan ministers.[3] If so, prints in America were intended from the very beginning as commercial products, ingeniously exploiting every technical method for the mass reproduction of images.

That the subject of this first woodcut should be a Puritan minister is appropriate, for no other group of people did so much to form the culture in which the American print flourished. In part they did this simply by default, in the absence of that vast apparatus of institutions that in Europe were concerned with art: royal academies of painting and sculpture, a culture of aristocratic collecting and connoisseurship, state and church patronage of the arts. But they also held violently strong convictions about art that date to the very beginning of the Protestant Reformation. "Thou shalt make thee no graven image," it reads in the Geneva Bible that the Puritans carried with them (Deuteronomy 5:8). This was an injunction against the worship of idols, of course, and in Calvinist Europe it led to the fiercest iconoclasm. But if the plain meetinghouses of New England were parched of all paintings and statuary, they nonetheless instilled certain attitudes and doctrines that would be applied to art, and one of these was a distinctive literary sensibility.

Reverend Mather reminds us of the importance of the written word in Puritan New England. In his left hand he holds a book, and in his right a pair of reading glasses, suitable attributes for a minister who published constantly, in both Cambridge, Massachusetts, and (until the Restoration) London. Rates of literacy in the Puritan colonies were quite high, which is to be expected from a faith for which worship was essentially a literary experience, in effect a two-hour feat of literary deconstruction.[4] The Puritan sermon inevitably began with a short Biblical text that was dissected in a rigorous five-step sequence. First its grammar and literal sense were made clear, next its underlying doctrine, then the reasons for the validity of that doctrine. The fourth step was to extract from this doctrine a moral charge for the listener, after which the minister recapitulated the argument. (Jonathan Edwards's celebrated 1741 sermon, "Sinners in the Hands of An Angry God," is composed in just such a five-part structure.)

Those who heard these sermons, year in, year out, developed several unconscious habits of mind. One was

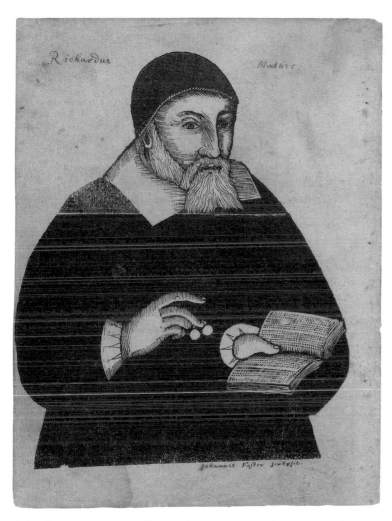

John Foster's woodcut of Rev. Richard Mather is America's earliest known print and it presents a mystery. Two separate blocks were used, one for the body and one for the head: did Foster muddle the head and insert a replacement, or did he intend to print a whole series of Puritan ministers, changing heads as needed?

the expectation that any work of art or literature could be distilled into a pithy moralizing injunction. Another was a preference for clear meaning over ambiguity (moral injunctions should not be vague). Finally, the assumption that a work of art was not an end in itself — to give sensual pleasure — but a means to an end, and that it should teach, enlighten, or correct.

It is easy to see that a highly literate culture, troubled by the Second Commandment, lacking great collections and having no tradition of connoisseurship, would not at once develop a rich culture of oil painting. But prints were a different matter. Their linear expression and clearly bounded forms were legible, which after all simply means readable. They did not present a sensuous display of color (and even if they were tinted with watercolor, they offered nothing like the unctuous tactile viscosity of oil painting). Finally, they were not private objects for private pleasure but rather public documents, much like books. John Foster, after all, made his woodcut of Reverend Mather in his role as a printer. And so the printed image emerged in the American colonies along with the printed book, both as species of literacy.

When the Puritan proscription against religious art eventually loosened and even a good Puritan like Paul Revere could make an engraving of the baptism of Jesus, the resulting images still retained the character of book illustrations — or rather, the illustration of a sermon. *Buried with Him by Baptism* depicts its subject in the most literal terms conceivable: John the Baptist holds Jesus in the river Jordan (conveniently labeled) and prepares to immerse him completely, while God provides signs by speaking and releasing the Holy Spirit in the form of a dove (pl. 7). Everything is laid out diagrammatically, and the engraving might have easily

been used as the basis of a sermon — or three sermons, since three different scriptural passages are cited in the print (Romans 6:4, Matthew 3:16, and Mark 9:7).

There were other British colonies in North America, but the Puritans of New England exercised an influence far in excess of their numbers. In need of an institution to train their ministers, the Puritans quickly founded Harvard (1636), which for more than half a century was the only university in the colonies. And in 1638 the first printing press in the colonies was established in Boston, which would remain a principal center of American publishing into the nineteenth century.

Supported by these Puritan attitudes and without serious competition from painting or sculpture, the print dominated the artistic life of the American colonies. Fashionable and affordable European mezzotints made their way to American shores; rudimentary engraving could be practiced by a variety of artisans, such as printers, silversmiths, gunsmiths, even mapmakers (in which role James McNeill Whistler learned to etch); finally, one did not need formal training to appreciate the plain and simple language of the print. But even after there were skilled painters in abundance, the print retained its central importance. In a mercantile society the place of courtly patronage of the arts is taken by commercial illustration, which offered an education as demanding and unforgiving as that of any academy; achievement was measured in financial success. Commercial illustrators might have little grooming in life drawing, classical allegory, or the pleasures of chiaroscuro and *sfumato*, but they learned the essential lessons of graphic art — how to give their forms lively outlines that caught the eye when seen from a distance or when reproduced at small scale, and even how to survive inept execution by a hack engraver. From Winslow Homer to Andy Warhol, an early stint in commercial graphic art was not an awkward detour in an artistic career but the very crucible.

In short, American art was shaped massively by the print and its culture, perhaps more than we realize, since our conception of high art is essentially European, with its hierarchy of genres dominated by that hallowed triad of architecture, painting, and sculpture. This hierarchy has gone more or less unquestioned by those who think about the history of American art and has led them to underappreciate the print. This catalog and the exhibition that accompanies it modestly seek to correct this and to propose that the print, far from being a minor art, is the archetypal form of American artistic expression.[5]

IT HAS NEVER BEEN SATISFACTORILY explained why an English printmaker of exceptional talent should leave cosmopolitan London in 1727 to set up shop in provincial Boston. The move by Peter Pelham seems so foolhardy that scholars have speculated he was fleeing something sordid. Pelham was a master of the mezzotint, that quintessentially baroque invention of the seventeenth century that captures painterly qualities in black and white. With mezzotint, a toothed metal instrument known as a rocker is used to create countless tiny pits in the surface of a copperplate; areas of the roughened surface are then smoothed using a burnishing tool. Depending on the plate's degree of roughness or burnished smoothness, when inked and printed, it yields tones ranging from pure white to velvety black. By liberating

the print from purely linear expression, the mezzotint achieved something analogous to the richness of oil paint. It was peculiarly suited for the making of spirited portraits, and it made the early eighteenth century a kind of golden age of the mezzotint (then called *mezzotinto*; the anglicized version of the word did not come into general use until the nineteenth century). Most of what American colonists knew of courtly English art (as well as of fashion in clothing, hair style, and gesture) they received secondhand through mezzotints of portraits from the reigning Peter Lely–Godfrey Kneller school.[6]

In London, Pelham was accustomed to making prints after paintings by other artists, but as there was as yet no competent painter in Boston, he was forced to produce his own paintings from which he subsequently made mezzotints. But he was a much better engraver than painter, and an uncertain colorist; his print of Rev. Cotton Mather is a consummate performance in mezzotint (pl. 5), far superior to his original oil painting on which it is based. None of Pelham's subsequent prints is quite as good, perhaps because he was removed from beneficial competition with equally talented artists.

Pelham was the stepfather of John Singleton Copley and gave him his first training in art. Copley made just one mezzotint, was unhappy with it, and never tried again. Still, he carried with him into his paintings the lessons of Pelham's prints and the conviction that every object must be a crisply bounded shape with sharp, distinct edges. When Copley first sent a painting to London for exhibition and was told by Benjamin West that it was "too liney" and showed too much "neatness in the lines," this was nothing more than an accurate description of an artist whose conception of an oil painting was essentially that of a glorified print.

Mezzotint is a laborious and demanding art, and Pelham would have no immediate successor until 1768 when Charles Willson Peale, who seemed to enjoy artistic challenges, revived the practice and found it a congenial way of disseminating his portraits of George Washington.[7] But for most of the eighteenth century there was simply no artist in the colonies capable of making a mezzotint or any other kind of engraving of superior quality. A dilettante might dabble at painting but there were no dilettante engravers. Prints that demanded either great delicacy of execution or substantial size could only be executed abroad. When Nicholas Scull, Pennsylvania's surveyor general, undertook to publish a seven-foot-long view of the Philadelphia waterfront in 1752, no engraver in the colony was up to the task. He had to send the drawing to Gerard Vandergucht, "one of the best Artists in London," who engraved separate copperplates to create the full image.[8]

In this dearth of trained professionals, let alone real masters such as Pelham, those who made engravings were typically craftsmen who knew how to work metal — silversmiths and goldsmiths (as was the case in the Renaissance), plus watchmakers and makers of mathematical instruments. Anyone who could engrave a fanciful rococo cartouche on a silver tankard surely could engrave a drawing onto a copperplate. Although artisans were happy to make an artistic print, it was incidental to their main business. Boston's most important pre-revolutionary engravers were silversmiths, Nathaniel Hurd and Paul Revere, while the finest engraver in Philadelphia was James Smither, a trained gunsmith whose

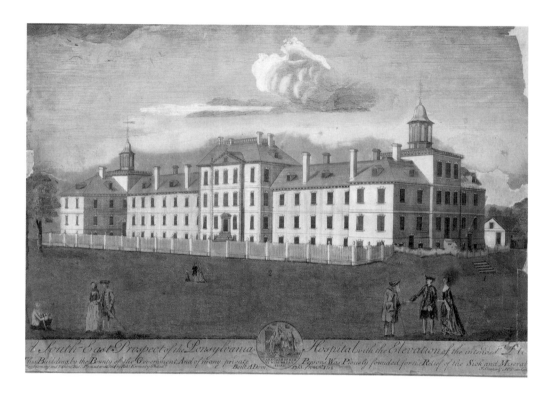

The engraving of the stately Pennsylvania Hospital, made by Henry Dawkins and John Steeper, was doubly useful: the completed east wing to the right showed donors what their gifts had accomplished; the attractive rendering of the unbuilt central and west wings encouraged them to give yet more.

specialties consisted of ornamenting "Guns and Pistols, both engraving and inlaying Silver."[9]

One of these all-purpose engravers was that amiable vagabond Henry Dawkins (d. 1786). He trained in London and in 1753 came to New York where he engraved for Anthony Lamb, a celebrated inventor of mathematical instruments.[10] Dawkins soon opened his own shop in Phila-delphia where he engraved "all sorts of maps, Shopkeepers bills, bills of parcels, coats of arms for gentlemen's books, coats of Arms, cyphers, and other devices on Plate likewise seals and mourning rings."[11] These were in the fashionable rococo mode, with swirling cartouches and shells, asym-metrically deployed, and copied from English pattern books. Dawkins did not mention artistic prints, which in any event

were a tiny part of his output. He stood closer to the world of the printer than that of the artist, and he either adorned useful objects or made items that were themselves useful, such as paper currency.

Nonetheless, Dawkins and John Steeper produced one of the exceptional images of the era, their *South-East Pros-pect of Pennsylvania Hospital* (1761). This was the institution made possible by Benjamin Franklin's brilliant suggestion that the Pennsylvania Assembly contribute two thousand pounds to match two thousand in private donations, thereby inventing the modern concept of matching funds. The print (fig. 2), made at the behest of the hospital, depicted its com-pleted east wing (to the right) as well as its unbuilt central and west wings. It was doubly useful, showing contributors

what they had already accomplished and enticing them to donate more. The sense of sculptural form was achieved by the vivid contrast between the cross-hatched elevations in shadow and the sunlit projecting pavilions.[12] Here was the first American engraving to depict realistically and in three dimensions a building yet to be constructed, and to show its appearance when completed. Regrettably, Dawkins never made another architectural rendering. He remains best known for his extravagant rococo bookplates.

Dawkins's artistic talents, to judge by the prints he designed himself, were modest. But one hardly need be a skilled artist to be a successful commercial engraver. One needed only to copy with absolute precision, which is why the occupational hazard of the engraver is the temptation to counterfeit. Engravers made the plates for printed paper money, as Revere did for Massachusetts; they also made the best counterfeiters. Dawkins was imprisoned in 1776 for counterfeiting paper money from Connecticut and Massachusetts. But he was too valuable to suffer the routine fate of counterfeiters — execution. Instead he was put to work engraving the official currency of the Continental congress. Likewise Smither, the engraver-gunsmith, went from printing paper money for Pennsylvania to forging Continental currency (although he would rationalize it as aiding the British war effort).[13]

Dawkins and Smither were hardly the only engravers with a cavalier attitude toward copying. In 1770 Paul Revere brashly purloined Peter Pelham's depiction of the Boston Massacre. The event was the sensation of the age and Pelham moved with red-hot speed, within days painting a study of the event. But Revere moved even faster. He inspected Pelham's painting, copied it, engraved it, and only

three weeks after the massacre was already selling prints of it. Pelham was caught by surprise, for he was still working on his own engraving. He could barely govern his rage:

> When I heard that you was cutting a plate of the late Murder I thought it impossible as I knew you were not capable of doing it unless you coppied it from mine.... But I find I was mistaken and after being at the great Trouble and Expense of making a design paying for paper, printing &c. find myself in the most ungenerous manner deprived...of any proposed Advantage...as truly as if you had plundered me on the highway. If you are insensible of the Dishonour you brought upon yourself by this Act, the World will not be so. However, I leave you to reflect upon and consider one of the most dishonorable Actions you could well be guilty of[14]

Pelham's cruelest remark — that Revere was utterly incapable of creating an image on his own — was probably true but it only offended Revere and made reconciliation impossible. When Revere issued a second state of the print, he did not generously add the words "Pelham *fecit*," as he should have, although he did change the time on the clock tower to 10:20, the actual time of the massacre.[15] Historical accuracy mattered more than copyright.

Here two worlds collided, for what is objectionable to the artist is natural for the commercial engraver. After all, the source book was as essential to their trade as the burin, which is why John Singleton Copley painted Revere (page 35) with his engraving instruments and Hurd (*Portrait of Nathaniel Hurd*) with those venerable pattern books, John Guillim's *Display of Heraldry* and Samuel Sympson's *A New Book of Cyphers*. The most successful engravers were those who knew which sources could be most lucratively plagiarized. For example, John Norman (c. 1748–1817), an

English "architect and engraver," made a cottage industry out of pirating English architectural books. In 1775 he faithfully copied each of the sixty copperplate engravings of Abraham Swan's *British Architect* (1745) and produced the first architectural book published in America. Norman worked briskly, copying the plates in reverse (the lazy way) and using a needle, like an etcher, rather than a burin.[16] Other unauthorized editions followed.[17]

Pelham and Revere were the first to recognize the great opportunity that the coming American Revolution would offer to printmakers, especially those nimble enough to depict contemporary events while public curiosity still ran high. The engraver Amos Doolittle was particularly deft. Just ten days after the battles of Lexington and Concord (April 19, 1775), he toured the battlefield along with the painter Ralph Earl and interviewed participants. Together the two men created a cycle of four prints showing the whole course of the battle, from the first skirmish at Lexington to the pitched battle at Concord and the English fighting retreat, which Doolittle rushed into print before the end of the year.[18] The high vantage point was awkward, and it reduced the soldiers to repetitious rows of red jackets and white trousers, but it permitted the public to envision the battle in topographic terms (pls. 9–12).

Doolittle's prints may have been hasty and crude but they were timely. This was not the case with John Trumbull (1756–1843), an infinitely superior artist who made the most exquisite of all images brought forth from the American Revolution. But Trumbull's prints did not appear until some twenty years after the events they depicted. He did not grasp as Doolittle had that when depicting current events, the trick is to be current.

In 1785 Trumbull "began to meditate seriously the subjects of national history, of events of the Revolution which have since been the great objects of my professional life."[19] He could not have been better qualified, for the whole thrust of his artistic education had prepared him for just this sort of project. He was the principal pupil of Benjamin West, who molded Trumbull in his own image, a painter of the grand manner whose highest calling was the painting of lofty subjects in a lofty style.[20] Moreover, he personally witnessed key events of the Revolution. Perhaps another artist could paint these scenes with more "elegance" but none could match him, as he boasted to Thomas Jefferson, in "truth and authenticity."[21]

It was West's brilliant suggestion to Trumbull that the only appropriate medium for such an enterprise was the print. Monumental canvases of the sort that West made required equally monumental buildings, and these the United States would not have for some time to come. Trumbull recalled in his memoirs that West advised him instead to "have the series engraved, by which means, not only would the knowledge of them, and of my [Trumbull's] talent, be more widely diffused, but also in small sums from many purchasers, I should probably receive a more adequate compensation for my labor, than I could hope from the mere sale of the paintings, even at munificent prices."[22] In other words, better to sell several hundred engravings at three guineas apiece than earn fifty guineas for the painting itself, which is what Charles Willson Peale received from Princeton University for his full-length portrait of George Washington.[23]

Trumbull eased himself into the project by paraphrasing in paint a work he knew well, West's celebrated *Death of General Wolfe*. Both his *Death of General Warren at the Battle*

of Bunker's Hill and his *Death of General Montgomery in the Attack of Quebec* centered on a valiant commander who, like General Wolfe, died at the climax of a battle. Trumbull did not attempt, as had Doolittle, to recreate the confused action of these battles in panoramic terms; instead his goal was to distill in intense and highly inspirational form their chief moral lesson, which in this case was virtuous self-sacrifice.

The paintings complete, it took Trumbull some time to find competent engravers. None in the United States were good enough and none in England were available; at last he found two on the Continent.[24] With those prints in the works, he was confident enough by 1790 to unveil his prospectus for a series of fourteen engravings that would show "the most important events of the American Revolution," from the Battle of Bunker Hill to the inauguration of President Washington. He stressed the literary dimension of the enterprise: "Historians will do justice to an æra so important; but to be read, the language in which they write, must be understood, the language of painting is universal and intelligible in all nations, and every age."[25] With these grand claims, he invited advance subscriptions for the first two prints, showing the deaths of Warren and Montgomery — at three guineas each, half now and half upon delivery.[26]

When no subscriber appeared for the first three days, Trumbull fell into "a fit of the Dumps."[27] Then orders slowly trickled in, eventually rising to nearly three hundred subscribers, all of whom he proudly named in his autobiography, beginning with George Washington, who bought four sets.[28] But his engravers lived in a Europe unsettled by the French Revolution and they were maddeningly slow. Years passed and Trumbull moved on to other things. Not until 1798 could he give his subscribers (those still living) their prints. The

time lag proved fatal. The project collapsed, although after a gap of twenty-five years one last engraving appeared, *The Declaration of Independence* (1823). Trumbull prudently assigned this one to an American engraver, Asher B. Durand (1796–1886). In the end, Trumbull had painted only eight of his fourteen-painting epic and engraved only three.[29]

From the outset, Trumbull's paintings were intended as a means to an end, an intermediate stage in the making of a print. He gave his figures spirited outlines that would carry well when translated to a linear medium. And he painted them just slightly larger than the twenty-by-thirty-inch prints that would follow, carefully gauging the amount of detail and visual anecdote to the moderate format. Conceived at this scale, they weaken when enlarged, and the monumental copies Trumbull painted in late life for the rotunda of the Capitol are flat and spiritless in comparison. The forty-eight individual portraits in his *The Declaration of Independence* are lively and distinctive in Durand's thirty-inch engraving (fig. 3), but swollen to fit the eighteen-foot version they simply look cartoonish.

Trumbull learned, as other printmakers would in their day, that aesthetic merit was no guarantee of the success of a print edition. Equally important were timing, a good sense of where the fickle public appetite was tending, and a feeling for the price structure. Trumbull's patriotic cycle came in too late and too expensive, the equivalent of about fifteen dollars at the time. But for less than twice that amount, one could acquire all twenty-eight plates of William Birch's *The City of Philadelphia…as it appeared in the year 1800.* Birch's suite aimed much lower than did Trumbull's ill-fated epic, offering only genre views and street scenes, and it was phenomenally successful.

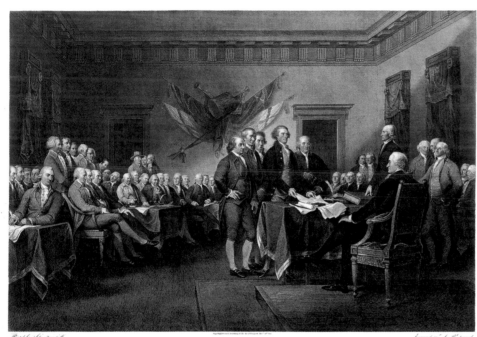

The DECLARATION of INDEPENDENCE of the UNITED STATES of AMERICA.
July 4 1776.

John Trumbull's grand plan to document the American Revolution in fourteen engravings was brilliantly conceived, but he did not take into account the slowness of his engravers. Public interest waned, and after a quarter-century pause, Trumbull ended the series with the third: his stately Declaration of Independence.

Before becoming a painter, William Birch (1755–1834) had been apprentice to a London goldsmith who taught him engraving. A few years after his 1794 arrival in Philadelphia, he conceived the idea of a suite of engravings that would showcase the city that was then the capital of the United States. Originally entitled "Philadelphia Dissected: Or, the Metropolis of America," it was to consist of thirty engraved plates showing "the principal buildings, with the prospective of the streets as connected with them, the most picturesque points of view &c. as calculated to give the idea of this Metropolis."[30] Able to engrave images after his own drawings, Birch could move more swiftly than Trumbull, although still not swiftly enough. By the time he completed the series in 1800, the national capital had just relocated to

Washington. Nonetheless, his combination of upbeat subject matter, happily composed scenes, and carefully considered prices (the plates could be purchased bound or in boards, hand-colored or plain) ensured its instant and perennial success. Over the ensuing decades Birch issued three revised editions, incessantly revising his plates to keep them current (fig. 4). He issued the last edition in 1828. Long after his death the plates continued to be reprinted.

Birch's success demonstrates the high quality of the engravers who arrived in the wake of the Revolution. Up until then, most of the émigré engravers were of the second tier. It would be unkind but truthful to say that when they sailed from England to America, the artistic quality of both places increased. Where most of them fell down

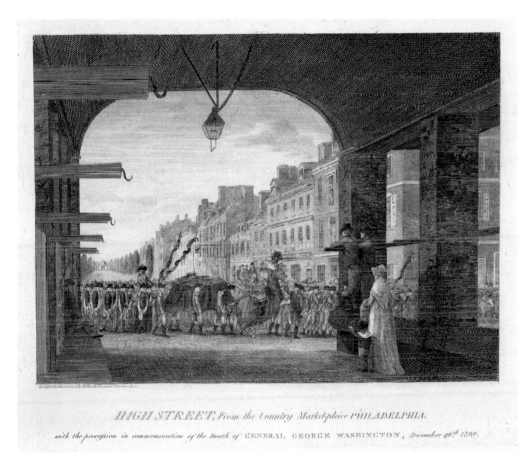

HIGH STREET, From the Country Market-place PHILADELPHIA.

with the procession in commemoration of the Death of GENERAL GEORGE WASHINGTON*, December 26th 1799.*

William Birch continually tinkered with his engravings of Philadelphia between 1800 and 1828, constantly changing the selection of subjects and even reworking the plates themselves to capitalize on current events. He first engraved his view of High Street before the death of George Washington and then immediately revised it to insert the funeral catafalque. That image contained a poignant mourner, weeping into his handkerchief. Birch must have found the figure jarring, because he removed him in subsequent editions. His ghostly image can still be faintly seen in the lower right.

was in the making of a strong portrait likeness, where the suggestive and subtle lines of the original would almost invariably thicken and harden into caricature. According to William Dunlap, a knowledgeable contemporary observer, this state of affairs persisted until 1797 when David Edwin (1776–1841) emerged, "the first good engraver of the human countenance, that appeared in this country."[31]

Besides being better trained, this new generation of printmakers were astute businessmen and, like Birch, were drawn into publishing ventures that made the most of their talents. John Hill, who arrived in 1816, helped create the

landscape counterpart to Birch's urban views. This was the *Picturesque Views of American Scenery* (1820–1821), a collaboration between Hill and the landscape painter Joshua Shaw. It is important as the first attempt to present the American landscape in its totality, but also as the first major American effort in aquatint. Hill recognized that landscape views required a softer technique than the hard-edged engraving that Birch used for his architectural views, and instead chose to work in aquatint, an invention of the late eighteenth century. A form of etching, aquatint involves coating areas of the copperplate with a finely powdered rosin

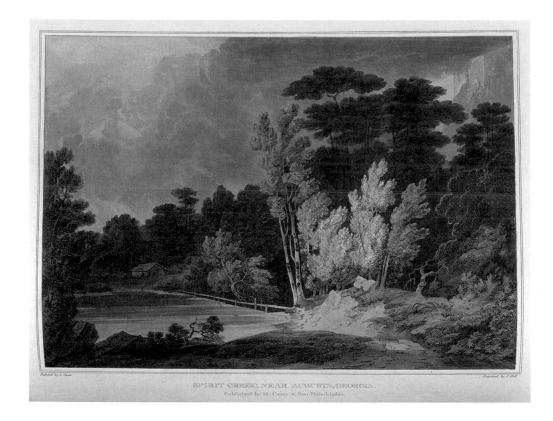

SPIRIT CREEK; NEAR AUGUSTA, GEORGIA.
Published by M. Carey & Son Philadelphia.

By the early nineteenth century engravers were coming to be viewed as creative artists in their own right and not merely as copyists. And so it was not the painter of this moody scene who received top billing, but the engraver who turned it into a print. This was John Hill, who found in aquatint the ideal medium for conveying the swiftly changing atmospherics described in the accompanying text: "Black and solemn clouds overhung the observer's head, rain had begun to fall in broad and heavy drops, the wind roared through the forest."

that, when submerged in an acid bath, leaves an etched pattern of tiny visible granules. Depending on the length of successive immersions, an aquatint can yield a delicately graded spectrum of half tones, like the mezzotint, but with a distinctive aqueous texture suggestive of watercolor. This softness and informality made it ideal for landscape art (fig. 5).

Hill repeated his success with the *Hudson River Portfolio* (1821–1825), producing an edition of twenty aquatints of the picturesque scenery of the Hudson Valley between New York City and Lake Luzerne (pl. 17), this time with the painter William Guy Wall.[32] It is customary to date the founding of the Hudson River School from Thomas Cole's

fateful sketching trip of 1826, but in fact there is little in his choice of subject matter, composition, or sensibility that was not already present in the *Hudson River Portfolio*. If its primacy is overlooked, it is only because one still tends to regard innovations in art as first occurring in the world of oil painting and then trickling down to printmaking. In this instance at least, it was the other way around.

THE ARDUOUS TECHNIQUE AND EXPENSE involved in the making of the mezzotint, aquatint, and copperplate engraving made them luxury objects affordable only to the prosperous few, but after about 1800 a new technique made possible

the production of much cheaper prints. This was the wood engraving. While it uses the same basic technique as the traditional woodcut, it produces work of emphatically different character. A woodcut is worked from the plank end of the board and the wood engraving from the end grain, but this makes all the difference. When making a traditional woodcut, one can easily experience the frustration of having slivers of wood break off as one variously works with or against the grain. But end-grain wood — especially the hardwoods used for wood engravings, such as boxwood and maple, or fruit trees such as cherry or pear — is uniformly dense, offering the same resistance in every direction. It can be worked with much the same tools as a copperplate engraving and is even more durable, able to generate thousands of prints without loss of quality. Finally, unlike a woodblock or copperplate, which must be printed individually and with care, a wood engraving can be run through a press along with type, permitting a close integration of image and text, making possible the production of cheap and fully illustrated books and magazines. In short order the versatile wood engraving became the principal means for disseminating visual information.

This information was attractive and accessible but not necessarily accurate. Like the Internet today, the sheer inexhaustible volume of visual information made it difficult to distinguish the wheat from the chaff. Somewhere between the two was the immense output of the historian John Frost (1800–1859) and his overworked illustrator, William Croome (1790–1860).[33] Frost was a Harvard-educated high school teacher in Philadelphia who published a conventional history of the United States in 1838 and then realized that

it could be turned into a lucrative commercial product if revised as an illustrated book. "Embellishing" it with some three hundred wood engravings by Croome, and issuing it in monthly installments that sold for twenty-five cents apiece, Frost became a national sensation with his *Pictorial History of the United States* (1843).

Having stumbled onto a goldmine, Frost mined it at an industrial pace. He followed up his history with *Book of the Indians of North America* (1849), *Great Cities of the World* (1854), *Daring and Heroic Deeds of American Women* (1860), and a great many other books whose only common thread was that they were bountifully bejeweled with Croome's wood engravings. Frost's most ambitious effort of all was the *Grand Illustrated Encyclopedia of Animated Nature* (1856), which was "embellished with thirteen hundred and fifty spirited illustrations." Spirited but not necessarily original; Croome and his assistants plagiarized freely from European publications and even their own work. An image like his Pocahontas (fig. 6) was liable to show up in the 1843 *Pictorial History*, show up again in Frost's *Book of the Colonies* (1849), and reappear in Frost's posthumous potboiler, *Frost's History of Indian Wars and Captivities* (1872).[34]

Croome's Pocahontas reveals his principal weakness as an artist: his inability to foresee and compensate for the degradation of an image as it passed through the process of wood engraving. What was an infinite range of finely graded ink lines in the original drawing was invariably translated in the engraving into a simplified register of either thick or thin lines. The imaginative commercial artist learns to anticipate this and make simpler and more economical drawings that convey their meaning clearly through bold outline, as

FIG. 6 William Croome, *Pocahontas rescuing Captain Smith,* 1843, wood engraving, in John Frost, *The Pictorial History of the United States of America,* vol. 1, Library of Congress, Toner Collection.

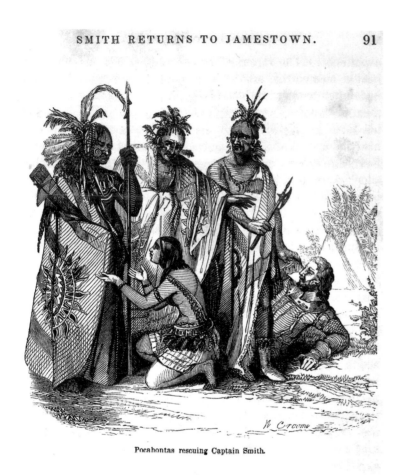

Pocahontas rescuing Captain Smith.

William Croome adapted his storytelling to the linear language of wood engraving. Here a few exaggerated gestures convey the famous story of Pocahontas interceding with Chief Powhatan to spare the life of Captain John Smith: the upraised tomahawk, the beseeching arms, and the commanding hand that stays the execution. More effective as storyteller than as historian, Croome felt no qualms about transposing the tipis of the Great Plains, center right, to tidewater Virginia.

Winslow Homer did from the beginning of his career; his *Sharp-Shooter* would be powerful even as a cutout stencil (pl. 34). But it may be that Croome's overcrowded compositions with their welter of operatic gestures, props, and details suited antebellum taste, inviting slow literal reading. He was certainly in constant demand.

The wood engraving changed magazine publishing just as it did book publishing. The first important American periodical to regularly include engravings, although these were copperplate engravings, was *The Portfolio*, which was founded in Philadelphia in 1801. Charmingly "Devoted to Useful Science, the Liberal Arts, Legitimate Criticism, and Polite Literature," it often showed Philadelphia buildings in the spirit of Birch's views (some were in fact by Birch or his son Thomas). By 1812 it was competing with the *Analectic Magazine*, which distinguished itself by making great use of prints, including the new medium of wood engraving. Because of its cheapness, wood engraving spread rapidly although it never completely supplanted the steel engraving and the mezzotint, which were essential when a look of elegance and softness was required, as when highlighting a new dress. By 1844 *Godey's Lady's Book* was promising its readers "a mezzotint in every number"; lithographs were shortly to follow.[35]

It was not only the cheapness of the wood engraving that commended itself but its speed. *Harper's Weekly*, the illustrated news magazine, was launched in 1857 to exploit the possibilities of large-format wood engravings. The leap in speed was stupendous. A Winslow Homer drawing from the Civil War front could be shipped by rail to New York and turned over to the magazine's art department. The drawing

was gridded and cut up, so that several engravers could work on separate blocks simultaneously. When finished, these blocks would be glued together, leaving those telltale white seams that are one of the allures of *Harper's Weekly* prints. With this breakneck system, a northern reader could look at relatively accurate scenes of a battle in Virginia just days after it happened. By the same token, Thomas Nast could read an item about the insomnia of Jefferson Davis, the imprisoned former president of the Confederacy, and immediately dash off an editorial cartoon that explained *Why He Cannot Sleep* in the most macabre manner imaginable (pl. 33). Here, in every respect except the speed of transmission, was modern photojournalism.

BY FAR THE MOST IMAGINATIVE response to the new popular culture of prints was that of the American Art-Union, which flourished from 1839 to 1851. Its goal was lofty: it was pledged to "diffusing among the people a pure and elevated taste for the arts." [36] Behind the boilerplate was an operation of extraordinary cleverness. Every year it would purchase between one hundred and two hundred paintings and watercolors from prominent American artists. Out of this large stock (142 paintings in 1846; 272 in 1847), those regarded as having the greatest crowd-pleasing potential would be chosen for engraving. The process was expensive, and hiring a first-class engraver could cost as much as two thousand dollars. But as the Art-Union grew it increased its number of commissions; by 1851 it could afford to publish six engravings. In exchange for a modest five-dollar fee, the subscriber would receive one or more of these engravings as well as a chance to win one of the original paintings, which were

raffled off at the end of the year (fig. 7). All this was to further its goal of encouraging the rise of a national school of art. The Art-Union's combination of high-minded idealism with the excitement of a lottery was irresistible; in its final year membership rose to more than 18,000.

America in the 1840s was roiled by every kind of strife imaginable — the worsening crisis over slavery, violent anti-Irish and anti-Catholic riots, war with Mexico — but one would not learn this from the Art-Union. Attempting to appeal to as broad an audience as possible, it studiously avoided all controversy. In December 1846, at the moment General Winfield Scott was planning his march on Mexico City, the Art-Union was raffling off a miscellany of Hudson River landscapes, religious platitudes, and any number of "fruit pieces." [37] Not until the war was safely won could it be enjoyed vicariously in the form of a congenial genre scene, Richard Caton Woodville's *Mexican News* (pl. 30). Given its chronic caution and insipid collection of paintings (though there were important exceptions), it is remarkable how well the Art-Union did when it came to choosing which paintings to engrave. During its brief tenure it issued a total of thirty-six engravings, and most of them were splendid. [38]

This was no small feat, considering the state of American printmaking. Few native-born engravers were as good as Asher B. Durand (who was no longer active, having renounced the grueling demands of the burin for landscape painting). To satisfy its lofty standards, the Art-Union invariably turned to foreign-trained engravers such as Charles Burt, Alfred Jones, John Sartain, and James Smillie, all born in England or Scotland. [39] Sartain was particularly good and had the knack for translating painted faces into

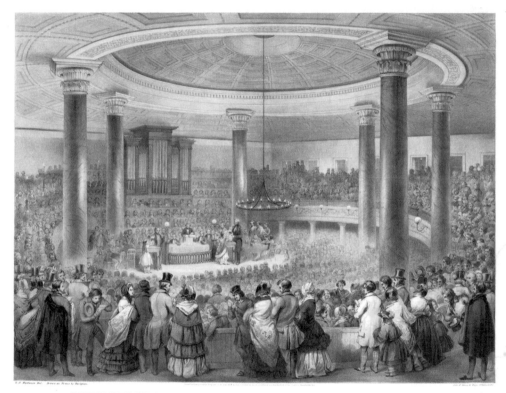

DISTRIBUTION OF THE AMERICAN ART-UNION PRIZES,

By combining moral uplift with the allure of the lottery, the Art-Union succeeded where John Trumbull failed. For only five dollars a year, subscribers received one or more first-rate engravings as well as the chance to win a painting. This lithograph is by Francis D'Avignon, who soon shifted to making lithographs from daguerreotypes — a sign of change in the art world that would bring an end to the Art-Union.

line without losing the likeness, often a stumbling block for engravers. The best of the lot was Smillie (1807–1885), the Scottish émigré whose delicately graded engraving of Thomas Cole's *Voyage of Life — Youth* was as exquisite as anything the Art-Union produced (fig. 8).

Apart from these happy exceptions, the general pattern of American printmaking in the 1840s was of a workman-like and uninspired competence. Hustling William Croome was more typical than the fastidious John Sartain. One can understand why William Sidney Mount might ship his *Power of Music* to Paris where it could be made into a

lithograph by a genuine artist, Alphonse-Léon Noël. Mount did this in 1848 although he might have waited. A year or two later, the American professional scene was transformed. What had once been a provincial branch of the British printing industry now became thoroughly professional and thoroughly German.

This was only natural, for Germany was the birthplace of lithography. The process was discovered in 1796 when the Bavarian composer and playwright Alois Senefelder (1771–1834) noticed how wet leaves left their impression on limestone. Bavaria happened to have the ideal stone for

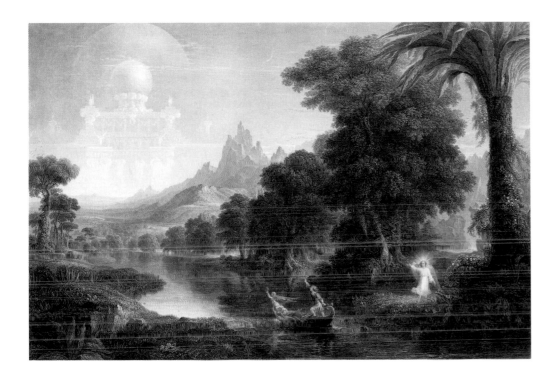

*The Art-Union issued some 19,000 engrav-
ings of Thomas Cole's dreamy* Voyage of
Life — Youth, *perhaps its most popular
print. But already the trustees of the organi-
zation were urging painters to look beyond
landscape painting to "other branches which
demand higher powers of mind and hand,"
such as "Historic Art."*

the purpose, the fine-grained Solnhofen limestone (famous
today for the beautiful delicacy of its fossils). Within a
year Senefelder had perfected the technique and devised a
lithographic press; in 1800 it was already being exploited
commercially.[40] A state-sponsored "lithographic institute"
was established in Munich in 1809 and quickly followed by
others in Vienna, Berlin, and Hamburg, which were typically
granted a monopoly for a certain period.

State sponsorship is agreeable so long as the state
keeps functioning. In 1848 a string of revolutions convulsed
the German states, and those dependent on state patron-
age — artists, architects, and engineers — were affected
severely. So began Germany's first great intellectual diaspora,
much of which poured into American cities. In short order,

Germans operated many of the most technically proficient
and enterprising lithographic firms: in New York, Julius
Bien, Louis Nagel, and Adam Weingärtner; in Philadelphia,
the brothers Max and Louis Rosenthal; in Chicago, Louis
Kurz, founder of the Chicago Lithographic Company.[41]

More than technical knowledge, these Germans
brought with them a distinct lithographic culture. Litho-
graphs in Germany were different from those in France,
where artists of the first rank such as Théodore Géricault
or Honoré Daumier used lithography for intensely personal
expression. Germany's state-sponsored institutes treated
the lithograph in practical terms as an instrument for the
mass reproduction of accurate facsimiles (the first com-
mercial lithographs were the sheet music to Mozart's piano

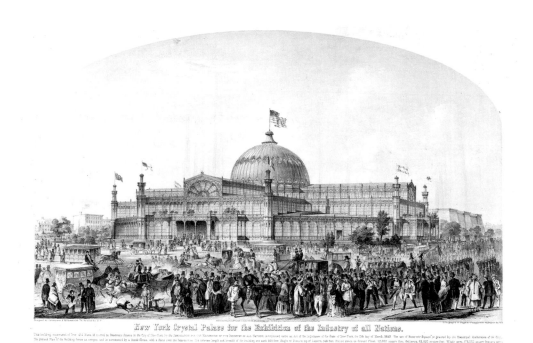

New York Crystal Palace for the Exhibition of the Industry of all Nations.

Lithography was the principal medium of visual communication in late antebellum America. Freed from the stiffness of the laborious wood engraving, its loose and lively crayon strokes seemed appropriate to a new modern age of the railroad, telegraph, and cast-iron architecture, as in this festive view of the New York Crystal Palace. Once again, the architects, building engineer, and lithographers were all German, as was the artist who drew the sprightly foreground figures: Carl Emil Doepler (1824–1905), who would design the costumes for Richard Wagner's Der Ring des Nibelungen.

concertos). In the United States, German lithographers were assiduous in finding new commercial markets for their trade. Julius Bien (1826–1909) is a good example. Having trained at the Städel Institute in Frankfurt, he emigrated to New York in 1849 and quickly realized that the settlement of the West was tailor-made for lithography, with its capacity for scientific accuracy and picturesque sensibility.[42] He turned out geological surveys, maps of the Western Territory, and an illustrated compendium of railroads and locomotives. Because of his expertise in chromolithography, he was chosen by John James Audubon's son in 1858 to produce the first full-size chromolithographed edition of Audubon's *The Birds of America*.[43]

The effects of the lithograph were not only commercial but aesthetic. The intaglio print — the engraving on copper or steel — was a linear medium ideal for expressing the

contours and outlines of things. It was thus perfect for an era of neoclassicism that valued clarity and perfection of form, whether in the human figure or a building. Yet the natural language of lithography was not the fine sharp line but the haziness and softness of a crayon, turned freely in the hand without the specialized skill required to wield the burin. It lent itself to picturesque expression, particularly if the tones could be inflected in the so-called tinted lithograph. Here was the great contribution of the cohort of trained Germans, who applied their technical ingenuity to the making of soft, luscious images. Anything that could manipulate the surface of the stone was done — it was scraped with a knife, abraded with a wire brush, wiped with soft chamois leather — and each yielded a different effect.[44] The glorious range of tones and tints was most evident in rich scenes of urban life, as in Nagel & Weingärtner's lithograph, *New York Crystal Palace*

Grand Lodge Room of the NEW MASONIC HALL, Chesnut Street Philadelphia.

The largest chromolithograph made in America, this interior view of Philadelphia's new Masonic Temple (1855) was also a triumph of German culture. Almost everyone involved was German: the artist who frescoed the interior, the draftsmen who made the drawing, and the lithographers who published it. It was a dream of a medieval throne room, part Walter Scott pageantry and part Nuremberg fantasy — elaborate oak canopies melting into intricate fan vaults; a frescoed ceiling in blue, purple, and pink; a veritable mob of carved figures, all lovingly captured in Max Rosenthal's twelve-color prodigy of a lithograph, which sold for three dollars.

for the Exhibition of the Industry of all Nations (fig. 9). The lithographers shrewdly decided that the most suitable way to convey the razor-sharp crispness of the new iron and glass architecture was to contrast it with its opposite, the soft rustling fabrics of finely dressed New York society below.

Had these German lithographers simply come on their own, they would have prospered, but it so happened that they arrived at a time when German artists and German ideas about art were pouring into America. Some of their most spectacular achievements came when they aligned themselves with likeminded German architects and illustrators with whom they shared common aesthetic goals. Such a collaboration was Max Rosenthal's luminous 1855 chromolithograph of the grand lodge of Philadelphia's Masonic Temple (fig. 10). The building's designer was Samuel Sloan, a capable architect but one who lacked the formal academic training for such a complicated perspective. Sloan enlisted a pair of academically trained German architects, Edward Collins and Charles Autenrieth, to create the rendering from which the lithograph would be made.[45] Printed from stones measuring twenty-two by twenty-five inches, it was marketed as the largest American chromolithograph up to

that time.[46] Its throbbing chromatic intensity and gorgeous density of detail can be taken as the zenith of high Victorian taste. Even today it is overwhelming, and it is not difficult to see why a counter-reaction soon set in.

ON FEBRUARY 23, 1867, THE art world was staggered when an impression of Rembrandt's etching *Christ Healing the Sick* sold at auction in London for £1,180.[47] Rembrandt's etchings had always been well regarded, but all at once they were prized as monumental achievements of world art, a sudden and seismic reevaluation. A welter of publications and catalogs fed the new public curiosity about Rembrandt and his prints, advancing the seventeenth-century Dutch master as "the great exemplar."[48] In fact, this was the start of an international Rembrandt revival that would have as its consequence the revitalization of the long slumbering art of etching.[49]

Much of the sudden craze for Rembrandt and etchings was a response to the exorbitant success of lithography. The practical advantages of printing from a lithographic stone had made it omnipresent on billboards, in parlors, and in popular journals. But what was at first delightful now turned cloying. The ease with which a crayon could be drawn on the stone now suggested a facile glibness while the ability to run off thousands of impressions from a single stone devalued the product. Above all, the ardor with which advertisers embraced lithography gradually tainted it with commercial associations. What had begun as a promising new form of artistic expression had declined into a trade, the crass tool of merchants rather than the sensitive instrument of artists. After the Civil War, chromolithography no longer attracted the attention of restless young artists, who are always sensitive to changing aesthetic tastes. Joseph Pennell, the

biographer, imitator, and close friend of Whistler, summed up this sudden change in sensibility: "[A]rtistic lithography was and had been long under a cloud. Commerce had appropriated and made a hateful thing of it and had given it a bad name."[50]

Etching and lithography were equally effortless — it is just as easy to cut through a wax resist with a needle as to draw with crayon on a stone — but etching is as unlike lithography as can be. The lithographic crayon tends to make smooth blurred lines that are useful when one wants a hazy image to shimmer pleasantly, as with Frances (Fanny) Palmer's moody *Midnight Race on the Mississippi* (pl. 31). Yet the lines of an etching are fine and delicate — as personal as a signature — and lend themselves to intimate expression. It is curious that a Whistler *Nocturne* (pl. 39) achieves the same visual unity as Palmer's steamboat race, for fog, mist, or moonlight tend always to unite a subject, but the one is an intensely private meditation and the other a boisterous public scene.

These were broad cultural changes, not limited to the world of prints. Late nineteenth-century taste was moving collectively from the didactic narrative to the suggestive mood piece, a broad cultural change not limited to the world of prints. Much as Henry James and Edith Wharton now made Mark Twain seem vulgar, so the ponderous storytelling of Croome, with his elaborate choreography of props and gestures, cloyed badly alongside the spare and reticent art of Whistler and Mary Cassatt. The contemporary English critic Philip Gilbert Hamerton summed up the power of the laconic, understated etching in a deft epigram: "Etching may be defined as the stenography of artistic thought."[51]

So prodigiously influential was Whistler that for the next half century his hushed reveries — stripped of narrative

content, innocent of moral lesson, often free even of tangible objects — set the standard for an artistic print. And not merely prints: the Secessionist photographers of the early twentieth century, such as Alfred Stieglitz and Edward Steichen, attempted to achieve on the photographic plate the same frail, gauzy effects that Whistler did with his etchings, taking them as the highest expression of the doctrine of art for art's sake. Not until the 1920s would they fall from favor, and for the same reason that they had galvanized the public in the 1870s — a sudden, convulsive shift in what the public felt to be modern and fashionable.

The decisive factor, of course, was World War I. The reserve and elusiveness of a Whistler etching made it the worst instrument imaginable for wartime propaganda, and even irritable Pennell reverted to the "hateful" lithograph when a sensational patriotic poster was required (fig. 11). But other, less obvious factors were at play. For much of its history, printmaking defined itself by its relationship to painting. It could try to imitate the qualities of an oil painting, as the velvety mezzotint did, or else do precisely what a painting could not — as in the calligraphic precision of Leonard Baskin's *The Hydrogen Man*, which makes perfect sense as a print (pl. 119). But over the course of the nineteenth century, the print began to orient itself with a relationship to the new art genre of photography. Bernarda Shahn's *Arkansas Sharecroppers* (pl. 98) would hardly have been possible without husband Ben Shahn's photographs of similar subjects. This is not surprising, given the similarities in format and character between photographs and prints (each can generate multiple copies from an original template and is printed on paper). What is surprising, though, is that a radically different genre such as the motion picture should affect the print, and that the influence should come from Germany.

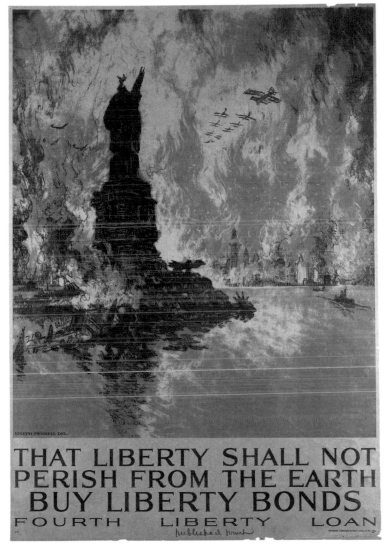

THAT LIBERTY SHALL NOT PERISH FROM THE EARTH BUY LIBERTY BONDS

FOURTH LIBERTY LOAN

Joseph Pennell, like his friend Whistler, preferred the subtlety and intimacy of the etching to the crass commercialism of the lithograph. But when a large audience had to be reached — and terrified — as in this World War I propaganda poster, Pennell knew that a lurid two-color lithograph was called for. The viewer needs a second glance to find where the Statue of Liberty's missing head has fallen.

The solitary figure in a boat has a long tradition in American genre art but Rockwell Kent used the peculiar properties of wood engraving to elevate it from the anecdotal to the symbolic. All incident and detail were purged, leaving only a nude figure under a jet-black sky, monumental in its bilateral symmetry and the way the mighty body fills the frame. The foreshortening is remarkable, as is the way the lines of the composition inexorably converge toward the vanishing point, just where the Drifter's clavicles meet at the base of his outstretched throat.

Strangely, the most vital innovation in printmaking during the 1920s, the German expressionist woodcut, scarcely touched the United States. In the wake of World War I, German printmakers brought about the revival of the long-moribund woodcut — and for precisely the opposite reasons that led Whistler to revive the etching: to carve in a difficult and resistant material was to make evident the signs of force and struggle, and to produce the harsh angular lines that conveyed anguish and feverish intensity. This agonized expression held little interest for American printmakers whose physical world had not been ravaged by war and who were more captivated by the quivering modernity of the Roaring Twenties, with its locomotives (pl. 83) and skyscrapers (pl. 73). When American printmakers worked in wood during the 1920s, they typically worked in a streamlined precisionist mode, even when drawing the human figure (fig. 12). This smooth, even, parallel hatching evoked the organized energy of the streamlined machine, as far from the Gothic ecstasy of German expressionism as can be imagined.

If American artists paid little attention to German expressionist printmaking, it was a different story with German cinema. In one of those odd paradoxes of history, the invention of the cinema made the woodcut seem modern again. The easiest woodcut to make is one where the lines are printed white on a mostly black ground, so that each individual line needs only to be scored into the plank, as opposed to working away the wood to either side of the line when one wants to print it black. This art of white lines on a mostly black background recalled expressionist cinema, with its atmospheric shadows punctuated by harsh slivers of light.

As it happened, two classics of German cinema, F. W. Murnau's *Faust* and Fritz Lang's *Metropolis*, debuted while

FIG. 13 Page from
Lynd Ward's *Gods' Man,
A Novel in Woodcuts,*
1929, bound volume
with wood engravings,
National Gallery of Art,
Gift of Jacob Kainen.

the young artist Lynd Ward (1905–1985) was studying printing and book design at the Kunsthochschule in Leipzig. Ward seems to have seen them both, for his subsequent *Gods' Man: A Novel in Woodcuts* (1929) is like nothing so much as the storyboard for a silent film transposed into a sequence of 139 prints.[52] Its visual language is that of expressionist cinema: sharply angular figures engaged in violence, rapturous scenes of exalted light, chiseled cityscapes, and leering distorted faces (fig. 13). Ward adopted the linear rhythm of a film sequence to a series of prints, for which reason he is regarded as a pioneer of the graphic novel.

Whistler's aesthetic etchings had one other legacy: he banished the didactic agenda of the antebellum American print. Instead of trying to tell a story or impart a moral lesson, the etching of the aesthetic movement that he advanced had no other goal than to give visual pleasure. As different as were the prints of an Ashcan School artist like John Sloan (pl. 59), who drew with the unsentimental eye of a journalist, or Cassatt, who found beauty in the simple rhythms of plane and interval (pl. 54), they had in common this same freedom from narrative or moralizing content. This was the mark of the modern print, and this the Great Depression swept away.

The great event in American art after 1929 is the massive revival of instrumental art — art that exists to achieve, persuade, or teach. Prints happen to do this very well, and the specific social consequences of the Depression — breadlines, demonstrations, idle factories, vain art deco skyscrapers with apple peddlers at their base — were all suited for the compact symbolic language of printmaking. A Graphic Arts Division was created under the Federal Art Project in 1935 to provide relief for unemployed printmakers and put them to work making prints for schools, libraries, and government

Gods' Man, Lynd Ward's wordless 1929 novel, links the world of German expressionist cinema to the graphic novels of today. With his 139 dark and menacing wood engravings, Ward tells the story of a poor artist who receives a magic paintbrush from a masked stranger, which brings him success, then madness and death. The story is a retelling of Faust, *which was the subject of the classic F. W. Murnau film that debuted while Ward was studying in Germany.*

FIG. 14 Claire Mahl
Moore, *Modern Times*,
1940, lithograph,
National Gallery of Art,
Reba and Dave Williams
Collection, Gift of Reba
and Dave Williams.

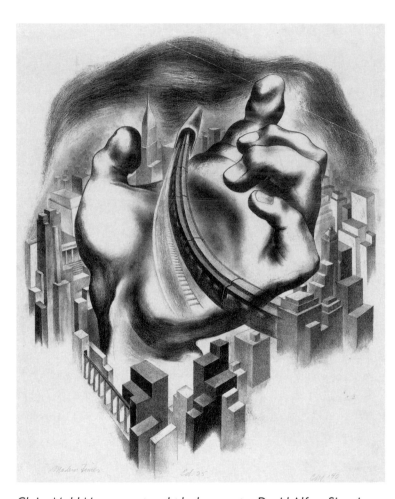

Claire Mahl Moore was taught by her mentor David Alfaro Siqueiros, the Mexican muralist, to mix art and radical politics. Her lithographs for the WPA *are filled with class consciousness, such as* Modern Times, *her vision of a mighty hand rising from the capitalist American city to bring the benefits of socialism.* WPA *lithographs were typically issued in an edition of 25 prints, after which the stone was resurfaced and reused.*

buildings. Most influential was the New York division, which established a workshop with presses to spare artists the cost of having their engravings or lithographs professionally printed. An ingenious procedure was developed:

> The artist submits a design and, after it has been approved, goes on to prepare the plate or block or stone. When completed, it is taken to the workshop and an edition of 25 prints is made, after which no more prints are pulled. In the case of lithographs, the stones are re-surfaced and used over and over again Plates and blocks, after the edition is printed, are often given to schools for use in art classes, so that students can see how graphic arts media are employed.[53]

By 1937 the Graphic Arts Division had 238 printmakers on its payroll, 88 in New York alone, enough to mount a prestigious exhibition called *Prints for the People*. Much of their work was historical and educational, but there was also much political art in the form of posters. Here the influence of the communist-leaning Mexican muralists was particularly strong among the Works Progress Administration (WPA) printmakers, some of whom studied with them, such as Claire Mahl Moore (1910–1988), a pupil of David Alfaro Siqueiros (fig. 14). Here was an insistence that the duty of a print was to do good, as sincere and pious as the platitudes of the Art-Union a century earlier.

BY NOW IT SHOULD BE plain that certain patterns in American printmaking recur across the centuries. One of the most enduring is the perennial role played by commercial illustration as the proving ground for young artists. An artist who in early life undergoes the grinding discipline of making commercial prints retains its lessons throughout his life. Winslow Homer, who learned his trade in the drudgery of J. H. Bufford's lithographic sweatshop in Boston, blossomed into a superbly imaginative painter and watercolorist, but he preserved the printmaker's gift for vivid silhouettes. This explains why he could turn such splendid oil paintings as *Eight Bells* or *The Life Line* into etchings with virtually no loss of visual interest (pls. 45, 46).

The same is true with his successors, the journalist-painters of the Ashcan School. They were the product of a brief interval after 1883 when Joseph Pulitzer purchased the *New York World* and transformed it into a "picture paper," using photolithography to make precise images of artists' sketches; three years later it had the largest circulation of any newspaper in the world.[54] At first, photolithography could only depict "subjects in line," and not until the early twentieth century was it possible to print photographic halftones cheaply.[55] But in the intervening two decades, every substantial newspaper had a stable of sketch artists. No longer were they contributing drawings that were to be approximated on the woodblock, as Homer's were; now they were creating works of personal expression in which every nuance of line thickness, weight, and value was meaningful. This daily bout of racing from street to street — from fire to courthouse to train wreck to police station — taught them to draw vividly and economically. John Sloan may have taken night classes at the Pennsylvania Academy of the Fine Arts and paid tribute to his teacher Thomas Anshutz (pl. 62), but his real education came in the decade he spent as a sketch artist for the illustrated dailies of Philadelphia.

We think of this as the quaint world that modern art swept away but the pattern persists to our own day. Andy

Warhol, like Homer, spent a decade as a commercial illustrator before remaking himself as a fine artist. And as with Homer, the lessons of his graphic career remained with him to the end, not only his ready use of the techniques of commercial illustration (such as screenprinting) but its billboard-like intensity of expression (pl. 123). In fact the whole visual ethos of pop art was that of commercial illustration, and even those who did not hone their craft in the world of advertising, such as Roy Lichtenstein, nonetheless embraced its attention-getting brashness, commercial subject matter, and labor-saving printing processes, most famously in Lichtenstein's use of its Ben-Day dots (pl. 121). Perhaps no artist in recent times was more thoroughly immersed in the world of commercial art than Barbara Kruger (born 1945), who spent her formative years working as a designer and photographic editor for a number of Condé Nast publications, including *Mademoiselle* and *House and Garden* (and whose work still appears on the op-ed pages of the *New York Times*). If the goal of her billboard-like epigrams is political criticism, her means are fundamentally those of a graphic designer who learns to bring together image and caption in an arresting and resonant way (fig. 15).

While the role of commercial art is a durable constant, other patterns have repeated themselves again and again, returning only to be discredited and drop from sight, definitively — until they are so forgotten that they again have the frisson of novelty when they reappear. The didactic printmaking of Depression-era America was banished by the apolitical formalism of abstract expression and Jackson Pollock (pls. 112, 113) only to come thundering back in the 1980s with the serious (though humorous) agenda art of the sort represented by the Guerrilla Girls (pl. 134). The broadly

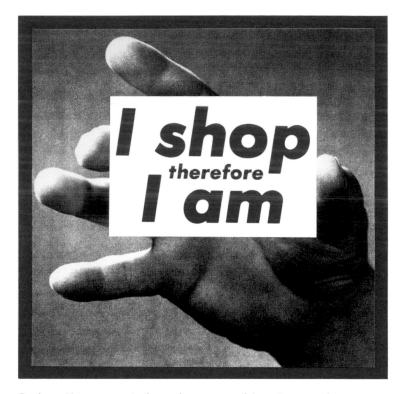

Barbara Kruger recapitulates the pattern of American art that runs from Winslow Homer to Andy Warhol: early training in graphic art and commercial illustration before success as an independent artist.

drawn stereotypes of George Caleb Bingham's genre scenes for the Art-Union — inebriated voters, hustling candidates, sanctimonious officials (pl. 28) — are not all that different in type (or shape) from those of Mabel Dwight's *Queer Fish* (pl. 86). In each case, easily recognizable types gave the soothing sense that the world was stable, comprehensible, and endlessly comical, a message that is always reassuring to a society troubled by looming dangers.

A generation ago, at a time of often strident political art, the last thing one would have expected was a recurrence of ineffably delicate printmaking in the vein of Whistler. An age in which visual information is transmitted on computer monitors is not likely to be kind to an art based on infinitesimal gradations of tone, optical phenomena which are at the threshold of what the eye can see, as fleeting as the barely perceptible blush in the human face. One might expect a vibrant and garish art, intense in contrast, high in decibel level, and easily consumable, like pop art. And yet the most recent object in this exhibition, Kara Walker's *no world* from her series *An Unpeopled Land in Uncharted Waters,* shows as subtle and complete a mastery of the art of printing as anything Whistler did (pl. 144). One cannot grasp its full effect in print or on a screen; it can be fully experienced only in person. There is a gorgeous density to the aquatint, changing subtly in value with the spit biting, that is offset by the frail web of drypoint lines in the ship's rigging. And contrasting with both is the loose painterliness of the white cloud at upper right, a brilliant application of sugar lift. All this in a work of chilling political content that hints at a slave ship, death on the high seas, and the despoiling of a continent.

Walker's *no world* brings together two tendencies that have been at loggerheads throughout the history of the American print — the impulse to make an intrinsically beautiful object and the desire to convey an urgent message. They are at loggerheads because of their different means and ends; objects please because of their abstract qualities of form, texture, and color; messages carry when they are loud and vivid. It is surprising to see these conflicting impulses so fruitfully united in a single print. At the same time, it is gratifying to learn that the vitality of the sturdy American print has by no means played itself out.

1 The book was *The Whole Booke of Psalmes Faithfully Translated into English Metre* (Cambridge, MA, 1640). A minority of scholars believes that John Cotton wrote the foreword. See B. R. Burg, *Richard Mather* (Boston, 1982); Gillett Griffin, *John Foster's Woodcut of Richard Mather* (Lunenberg, VT, 1959).

2 Increase Mather, *The Life and Death of that Reverend Man of God, Mr. Richard Mather* (Cambridge, MA, 1670).

3 Elisabeth L. Roark, *Artists of Colonial America* (Westport, CT, 2003), 25.

4 For the nature of the Puritan sermon and the exceptional rate of literacy in New England, see David Hackett Fischer, *Albion's Seed: Four British Folkways in America* (New York, 1989), 117–125, 130–134.

5 Three invaluable sources for the history of American prints are Una Johnson, *American Prints and Printmakers* (Garden City, NJ, 1980); James Watrous, *A Century of American Printmaking* (Madison, WI, 1984); Wendy Shadwell, *American Printmaking, the First 150 Years* (Washington, DC, 1969).

6 Sir Peter Lely (1618–1680) and Sir Godfrey Kneller (1646–1723) were England's leading court portrait painters of the era.

7 Peale was studying in London with Benjamin West when he executed his first mezzotint, *Worthy of Liberty, Mr. Pitt scorns to invade the Liberties of other People,* c. 1768.

8 A total of five hundred impressions were printed and shipped back to the colonies. See "The Curious and Beautiful Prospect of the City and Harbour of Philadelphia," *Pennsylvania Gazette* (Nov. 8, 1753): 5.

9 Hurd made an unusually fine engraving of the Old State House in Boston in 1751; see Abbott Lowell Cummings, "A Recently Discovered Engraving of the Old State House in Boston," in *Boston Prints and Printmakers, 1670–1775* (Boston, 1973), 174–184. For Smither, see Morrison H. Heckscher and Leslie Greene Bowman, *American Rococo, 1750–1775: Elegance in Ornament* (New Haven, 1992), 39, 54; David McNeely Stauffer, *American Engravers upon Copper and Steel,* pt. 1 (New York, 1907), 254–256.

10 Silvio A. Bedini, *At the Sign of the Compass and Quadrant: The Life and Times of Anthony Lamb* (Philadelphia, 1984).

11 Heckscher 1992, 39; "Henry Dawkins," in *Philadelphia: Three Centuries of American Art,* ed. Darrel Sewell (Philadelphia, 1976), 77.

12 The preliminary drawing was made by the Philadelphia painter John Winter and an otherwise unknown artist named Montgomery. As of October 1761, the print was "now engraving, and may be expected within two Weeks." "A Prospective View of the Pennsylvania Hospital," *Pennsylvania Gazette* (Oct. 29, 1761): 4; *Made in America, Printmaking 1760–1860,* ed. Stefanie A. Munsing (Philadelphia, 1973), 1–2. Dawkins's print competed with that of the painter James Claypoole, which is almost identical in perspective but shows a variant of the hospital's central block.

13 Kenneth Scott, *Counterfeiting in Colonial America* (Philadelphia, 2000), 255–256.

14 Letter, Henry Pelham to Paul Revere, March 29, 1770, quoted in Roark 2003, 138. It was not, technically speaking, Pelham's print that Revere copied but a lost painting (by Pelham?) of the scene. Revere made his engraving of the painting before Pelham's own print appeared, making it look as if Pelham were the imitator.

15 The only known impression of the first state is in the Chicago Historical Society.

16 "Proposals for Printing by Subscription," *Pennsylvania Packet* (December 5, 1774): 1; Kenneth Hafertepe, "*The Country Builder's Assistant*: Text and Context," *American Architects and Their Books before 1848,* ed. Kenneth Hafertepe and James F. O'Gorman (Amherst, 2001), 141; Heckscher 1992, 6.

17 *The Town and Country Builder's Assistant* (1786) was cobbled together out of plates from Swan and the *Practical House Carpenter* (1795).

18 Donald C. O'Brien, *Amos Doolittle: Engraver of the New Republic* (New Castle, DE, 2008), 3–5. Ralph Earl's participation has been thrown into question; see Ian M. G. Quimby, "The Doolittle Engravings of the Battle of Lexington and Concord," *Winterthur Portfolio* 4 (1968): 83–108.

19 John Trumbull, *Autobiography, Reminiscences and Letters of John Trumbull* (New Haven and London, 1841), 30.

20 Jules David Prown, "Trumbull as History Painter," in *Art as Evidence: Writings on Art and Material Culture* (New Haven, 2001), 159–187.

21 Letter, John Trumbull to Thomas Jefferson, June 11, 1789; Trumbull 1841, 158.

22 Trumbull 1841, 31.

23 Sean Wilentz, "Nassau Hall, Princeton, New Jersey," in *American Places: Encounters with History,* ed. William E. Leuchtenburg (New York, 2000), 317–318.

24 *The Death of General Montgomery* was engraved by Johann Frederick Clemens of Copenhagen (1749–1841) and *The Death of General Warren* by Johann Gotthard von Müller of Stuttgart (1747–1841). Antonio di Poggi made drawings after the paintings and served as publisher.

25 "Proposals by John Trumbull," *Pennsylvania Packet* (May 7, 1790), 4, col. 4, as corrected in Trumbull 1841, 340.

26 "Proposals by John Trumbull," *Pennsylvania Packet* (May 7, 1790).

27 Hugh Howard, *The Painter's Chair: George Washington and the Making of American Art* (New York, 2009), 134.

28 The architect Charles Bulfinch bought one set and John Adams two; Washington's four were the most by anyone. Trumbull 1841, 341–345. It is not clear how long it took Trumbull to reach 300 subscriptions. Dunlap reports that he reached "nearly three hundred subscribers." William Dunlap, *History of the Rise and Progress of the Arts of Design in the United States,* vol. 1 (New York, 1834), 46.

29 Trumbull does not seem to have painted the Treaty with France, Battle of Eutaw Springs, Treaty of Peace, Evacuation of New York, Arch at Trenton, or the Inauguration of Washington.

30 *Federal Gazette* (January 29, 1799); quoted in Sewell 1976, 182; Emily T. Cooperman and Lea Carson Sherk,

William Birch: Picturing the American Scene (Philadelphia, 2010).

31 Dunlap 1834, v. 2, 66.

32 The first print of the suite, *View from Fishkill*, was evidently drawn by Hill alone.

33 Gregory M. Pfitzer, *Popular History and the Literary Marketplace, 1840–1920* (Amherst, 2008), 47–54.

34 Gregory M. Pfitzer, *Picturing the Past: Illustrated Histories and the American Imagination, 1840–1900* (Washington, DC, 2002), 30.

35 Cynthia Lee Patterson, *Art for the Middle Classes: America's Illustrated Magazines of the 1840s* (Jackson, MS, 2010), 142.

36 "Annual Meeting of the American Art-Union," *New York Evening Post* (December 19, 1846): 2, col. 4.

37 *New York Evening Post* (December 19, 1846): 2, col. 4.

38 The Art-Union had its stable of favorite artists. For genre it preferred William Sidney Mount, George Caleb Bingham, and the sentimental Francis William Edmonds; for landscape it preferred Asher B. Durand and Thomas Cole.

39 Charles Burt (c. 1823–1892) and Alfred Jones (1819–1900) both came as young men and completed their training in the United States. John Sartain (1808–1897) had learned to make mezzotints in London before emigrating to Philadelphia in 1830. See John Sartain, *The Reminiscences of a Very Old Man, 1808–1897* (New York, 1899).

40 Wilhelm Weber, *Aloys Senefelder, Erfinder der Lithographie* (Frankfurt am Main, 1981).

41 Kurz (1833–1921) emigrated from Salzburg in 1848; he is best known for his luridly colored chromolithographs of the Civil War that he issued during the 1880s under the name Kurz and Allison.

42 Benjamin F. Peixotto, "Julius Bien," *The Menorah* VIII, no. 6 (June 1890): 285–295.

43 *The Birds of America, from Original Drawings by John James Audubon* (New York, 1858–1860). This edition, referred to by collectors as the Bien Edition, was interrupted by the Civil War and only 15 of an intended 45 parts were issued.

44 By far the best account is in Erika Piola, ed., *Philadelphia on Stone: Commercial Lithography in Philadelphia, 1828–1878* (State College, PA, 2012), 57–61; also see Nicholas B. Wainwright, *Philadelphia in the Romantic Age of Lithography: An Illustrated History of Early Lithography in Philadelphia* (Philadelphia, 1958).

45 [Stefanie A. Munsing], "Max Rosenthal," In Sewell 1976, 348–350.

46 "Rosenthal, Max," in James Grant Wilson and John Fiske, eds., *Appleton's Cyclopaedia of American Biography*, vol. 5 (New York, 1898), 326; "The Craft in Philadelphia," *Masonic Review* 14, no. 4 (January, 1856): 240–245; "A Beautiful Picture," *Masonic Review* 14, no. 4 (January, 1856): 256.

47 "Prints, Pictures, and Prices," *Harper's New Monthly Magazine* 35, no. 205 (November, 1867): 798.

48 "Rembrandt's Etchings," *The Art-Journal* (August 1, 1867): 193.

49 The French revival was equally strong; see Alison McQueen, *The*

Rise of the Cult of Rembrandt: Reinventing an Old Master in Nineteenth-Century France (Amsterdam, 2003).

50 Elizabeth Robins Pennell, *The Art of Whistler* (New York, 1928), 127–128.

51 Philip Gilbert Hamerton, "The Philosophy of Etching," *Philadelphia Evening Telegraph* (May 26, 1869): 7.

52 Ironically, the images are actually wood engravings, but Ward seems to have preferred the deliberate archaism of the term woodcut.

53 "Prints for the People," *Brooklyn Daily Eagle* (Jan. 3, 1957): 8C. The article lists the leading New York printmakers of the Graphic Arts Division: Arnold Blanch, Albert Webb, George Constant, Hubert Davis, Adolf Dehn, Gyula Zilzer, Fritz Eichenberg, Emil Ganso, Yasuo Kuniyoshi, Nat Lowell, Don Freeman, Mabel Dwight, Clara Mahl [Moore], Nan Lurie, Mathilde de Cordoba, Kyra Markham, Elizabeth Olds, Fred Becker, and Irwin Hoffman.

54 Christopher H. Sterling, ed., *Encyclopedia of Journalism*, vol. 3 (Thousand Oaks, CA: 2009), 1,362; Bennard Perlman, *Painters of the Ashcan School: The Immortal Eight* (Dover, DE, 1988), 52.

55 W. T. Wilkinson, *Photo-Engraving, Photo-Etching, and Photo-Lithography in Line and Half Tone*, 3rd ed. (New York, 1888), xvi.

Colonial Era to the Civil War

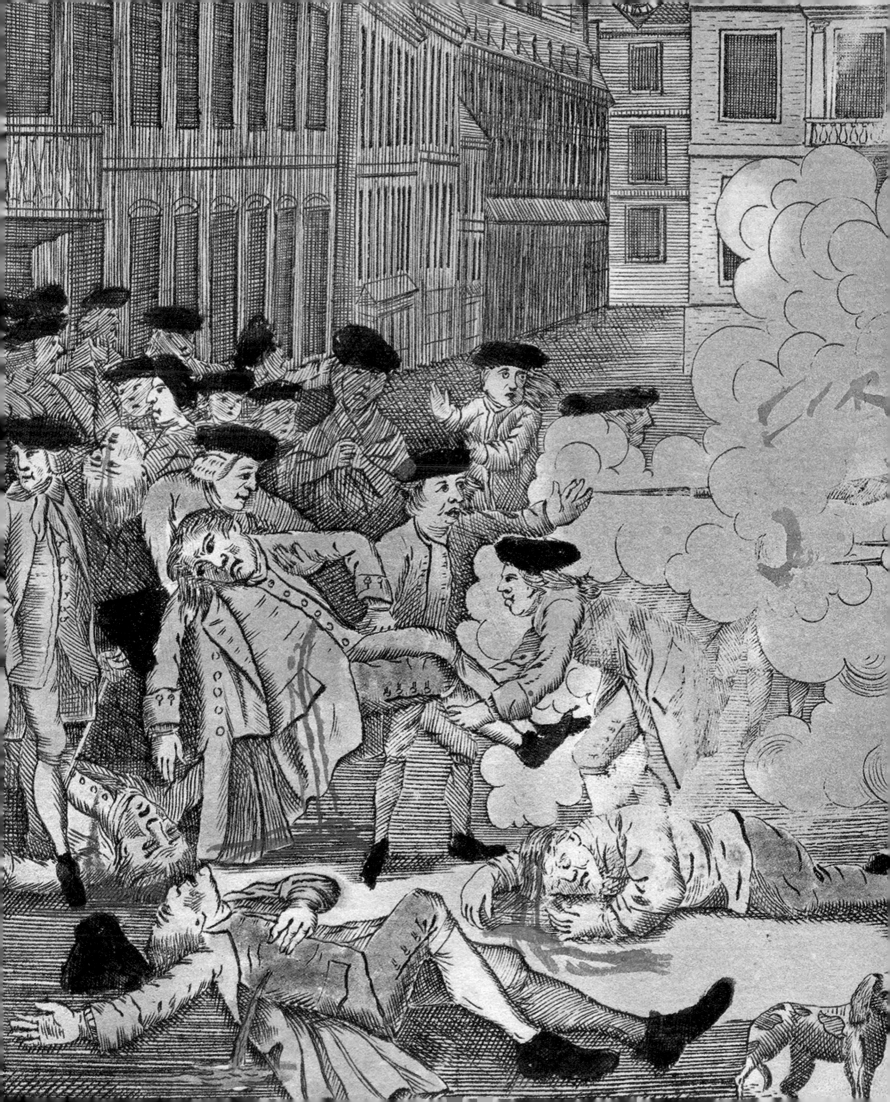

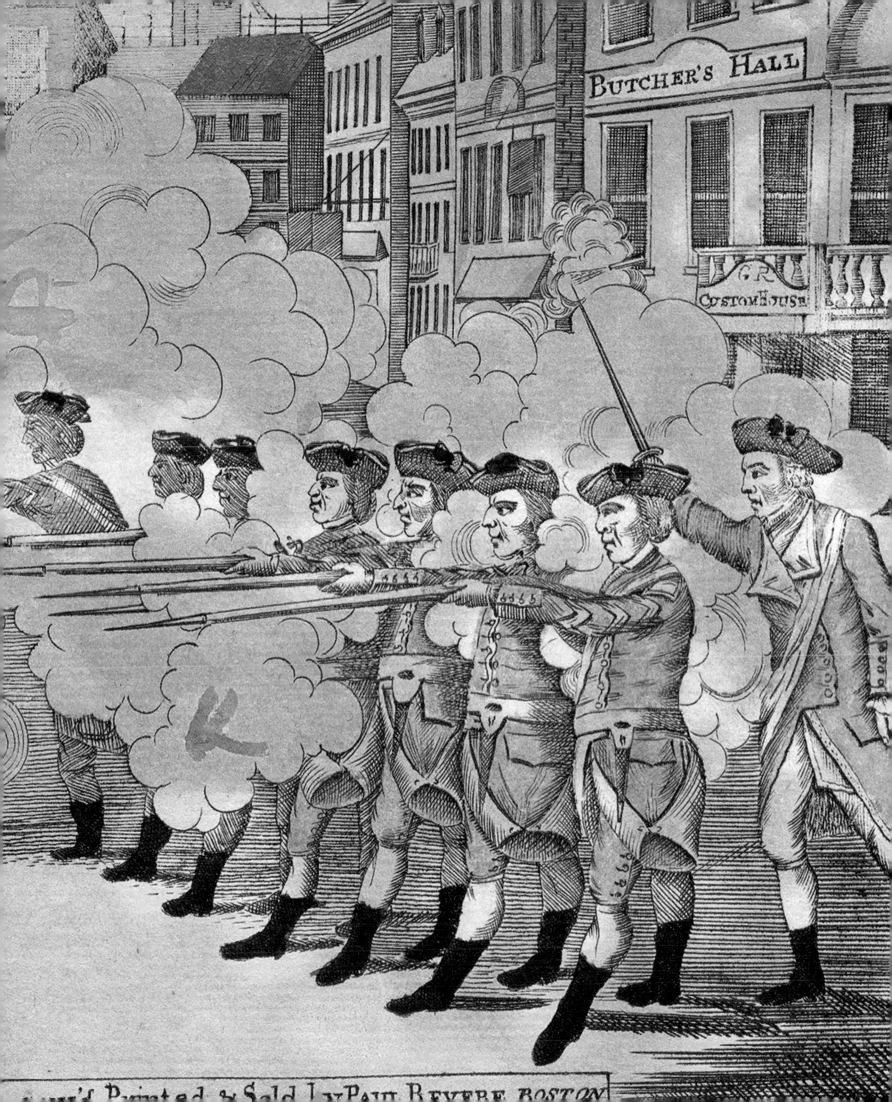

Paul Revere's Caffeine: *The Bloody Massacre* ALEXANDER NEMEROV

STIMULATING IS A GOOD WORD for Paul Revere's engraving, *The Bloody Massacre* (pl. 8). Propaganda may be an even better one. The killing of five Bostonians by the 29th Regiment of British militia under the command of Captain Preston gave American patriots an excellent rallying cry. The event, which took place on March 5, 1770, when a crowd of snowball-throwing citizens confronted Preston and his men, could not have served a better dish of British cruelty and depravity.[1] So said the patriots, among them Samuel Adams and Revere, who identifies himself in a rectangular inset at the feet of the British soldiers as having engraved, printed, and sold the hand-colored print that he titled *The Bloody Massacre*.[2]

Blood it has got, spouting in gouts from the waistcoats of the innocents, pooling on the ground from fatal head wounds. But this blood we could also call stimulating. This is an action picture, yes — it offers plenty of excitement — but more especially it is equivalent to a strong cup of coffee, a steeply brewed mug of tea, a bracing elixir, something that leaves a strong taste in the mouth and a heady feeling in the brain — in short, a stimulant.

Coffeehouse culture was one of the hallmarks of the eighteenth-century public sphere in England — think of Addison and Steele back in the early days of the century — and in colonial Boston and New York there were equivalents. One of Revere's patriotic broadsides announcing an act of sabotage against British troops in Boston in 1774 was printed in New York "near the coffee house."[3] In Boston, John Singleton Copley's painting of Revere, most decidedly not a coffeehouse picture, shows him nonetheless in a most vivacious state of mind (fig. 1). Holding a teapot he will soon engrave, envisioning an inscription, Revere rests the teapot shape of his head partly on the spigot of his thumb. The alertness of his mind — the wide-eyed gaze, the gleaming forehead, the crisp shivers of his rustling sleeves — comes across in nearly every detail of Copley's superbly animated picture. The man Revere is in a reverie but not dreamy. He is awake and alert, strongly dosed in the moment of his creative realization. *The Bloody Massacre*, scripted in the wire of his burins, made by his bright mind, is a caffeinated call to righteous outrage.

Boston thrived in imports and exports, spices, rum, slaves, sugar, coffee, tea. The sign reading "G[eorgius] R[ex] Custom House," just below the Butcher's Hall sign, indicates this flow of goods. Down at the wharves not far from King Street, packages from the Indies and Europe dropped on the docks like the bodies before the English guns. The heavy thud of these exotics gave off a corresponding lightness in the heads of their consumers. Bright ideas and strong opinions, galvanized quickly to the foaming point in a brief summit of intoxicated alertness and conviction — this was the stuff of Revere's moment when he made *The Bloody Massacre*.

The smoke issuing from the British soldiers' muskets is like the aromatic steam coming from a strong brew. If Leonardo's *sfumato* is a kind of visual incense — a soft smoke that permeates the look of the picture, perhaps to approximate the actual incense that used to waft before it — then the smoke of the soldiers' Brown Bess muskets is itself a kind of religious steam. Incense, incensed, the citizens of Boston will be mad.

The long caption in verse is no less a broadside than the image itself. The top line of the center column — *If scalding drops from Rage from Anguish Wrung* — puts a fine temperature on what we see. Emotions come to a boiling point. The

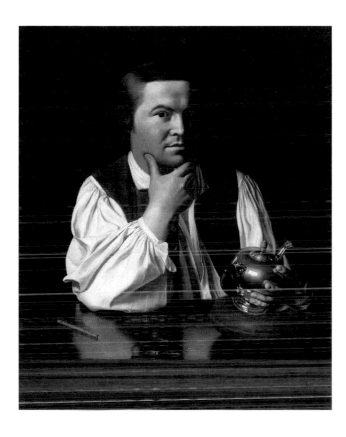

"scalding drops" are not hard to find in the Boston coffee-houses, the public places where prints like this would have been sold, displayed, and discussed.

Discussed, yes, because Revere, who stole the picture's design from Copley's half-brother, Henry Pelham,[4] gives his viewers plenty to notice as they scour the scene. For example, the gun firing from a second-floor window of the custom-house behind the British troops (one has to look closely for this detail). Who was the shooter? What dire conspiracy did it suggest? Or the pugnacious propaganda of the sign, "Butcher's Hall." The forward lean of Preston leaves no doubt about his assertive culpability. The soldier at the far end of the line jabbing his bayonet at the colonials is another telling

bit of barbarism to debate in the jittery-digit talk this print was designed to promote.

And the ramshackle victims are only at first an indistinguishable group of citizens. One declaims in outrage; another bravely turns his back to the gunfire, helping to carry off the wounded. The dead man on his back, right arm extended, invites us to start reading the poem directly below him, which extends in horizontal design like his own body. He is the ditty of his own demise, rhymed in couplets like a drinking song. Above, in a rhyme of his right hand, a crescent moon bobs in the sky. Peaceable moonlight and chimney smoke are the zodiac of the innocents, made to bear their calamities. We, imbibing what we see, are stimulated to action.

It is all a moral outrage, like the William Hogarth (1697–1764) prints that lurk in Revere's (and Pelham's) conception of the scene. Among the many engravings rifled through, pored over, in the book and print stalls of the colonial city there must have been some of Hogarth's. *Cruelty in Perfection*, the third plate of Hogarth's *The Four Stages of Cruelty*, shows the capture of ne'er-do-well Tom Nero after he has murdered his mistress, who lies dead at his feet (fig. 2). Her throat cut, her wrist chopped, she gestures from beyond the grave — her voice the mute outcry of her wounds — to indicate the culprit to which her very toes accusingly point. Nero has no chance amid the mob angered to violence by the ruthlessness of his crimes. Beneath a crescent moon something like the one hovering over Boston's King Street, they shed the lantern light on an innocent person's death, exposing also the mercenary purpose of the slaughter (the jewels, the household goods) as the mob prepares to show no mercy. Hogarth's coffeehouse prints — his engravings such

as this one that helped create a public in eighteenth-century England — become a template for another group of people across the ocean brought to their own boiling point.

The feeling is giddy; it is about lightness. The contrast with another famous print of the 1770s, John Hall's engraving after Benjamin West's painting, *William Penn's Treaty with the Indians, When He Founded the Province of Pennsylvania in North America 1681* (pl. 6), shows how. The Lenni Lenape tribe pauses in grave comportment, struck into suitably Roman attitudes by the dignity of the great occasion. Forgetting the question of war and peace, of right or wrong motives, Hall's engraving — and West's painting before it — is *pictorially* a tableau of heavy dignity. Penn's portly demeanor, there at the center, strikes the right note for the weightiness of the proceedings. It is as though the figures strive, even by the addition of several pounds of fat and muscle, to anchor the event in stentorian permanence. Defying the lightness and transportability of a print, they impart heavyweight dignity even to the leaves on the trees and the clouds that float thickly in the skies.

Hall's fantasy, the opposite of Revere's, is of a print remaining in one location. He imagines a print assuming the power and dignity of occupying a single spot, taking pride of place in a dwelling or other notable location. The same is true in other weighty prints of the period, such as Edward Savage's engraving after Robert Edge Pine's *Congress Voting Independence* (pl. 14). And yet a print's very purpose was its lightweight capacity to be disseminated, broadcast. Portability, as Jennifer Roberts notes,[5] was a prerequisite, a built-in factor for Copley and other artists (Revere included) when they made such pictures.

The lightness of Revere's print suggests a purpose very different from Hall's. It is made to be borne on the winds, carried by the latest shouts. The thinness of the lines is always so striking in any viewing of it. The delicate, toy-like British soldiers are almost buoyant in the way they are drawn. The lifting smoke of their light lines sets a signal tone for the picture overall. The rising lines of the architecture on either side, the upward-pointing triangle of blank space at the soldiers' feet, the ascendant smoke, the lifted sword of Preston, and especially the two elevated spindles of steeple and meetinghouse tower at upper center, there where the

smoke floats and the moon suspends — all of these drive the picture up, as if it were convinced that to be most effective it should be lightweight, spread to the winds, a kind of radio.

That is why the phalanx of fallen patriots at lower left seems to weigh next to nothing. As a group, they read as going up rather than down — their composite energy more elevated than grounded. The larger dead man on his back, looking up, assumes greater importance than the smaller dead man on his stomach. The two are a kind of pendulum by which Revere emphasizes the upward-looking man more than the downward-looking one, as if outrage should best look to the heavens. The stirring ballad of outrage is itself something like the sky — a rousing declaration made to raise the roof.

That dead man, last, evokes Revere himself. Hand to his heart, his head thrown back in a swoon, he is aligned with Revere's autograph running along that same ground. The little dog is the only thing between. Together the heart-afflicted dead man and Revere make a couplet like the rhymes below. The dog separates artist and sufferer, announcing their rhymed likeness and unlikeness to one another ("deplore" and "Gore," "Wrung" and "Tongue"). The picture and the poem are an outpouring of grief-stricken emotion, the extravagant faint of the maker. He too suffers unto death to transcribe the scene. And like the dead man at lower left, he is a part of but also cut off from the rest of the mourners, he and the dog occupying a separate plane from the rest of the colonials. The artist is intoxicated by tragedy, driven to spread the word so that others, breathing the smoke of his slogans, can inhale the deep and steady draft of a singular potent moment, *The Bloody Massacre*.

1 For the rich historical record of the massacre, see Hiller B. Zobel, *The Boston Massacre* (New York, 1970); Neil York, *The Boston Massacre: A History with Documents* (New York and London, 2010); Richard Archer, *As If an Enemy's Country: The British Occupation of Boston and the Origins of Revolution* (New York, 2010); and Russell Bourne, *Cradle of Violence: How Boston's Waterfront Mobs Ignited the American Revolution* (Hoboken, NJ, 2006).

2 The prints could be bought without color or, for an additional eight pence, with color. See E. McSherry Fowble, *Two Centuries of Prints in America, 1680–1880* (Charlottesville, VA, 1987), 449

3 "To the publick. New-York, October 5, 1774 : By Mr. Rivere [*sic*], who left Boston on Friday last…we have certain intelligence that the carpenters and masons who had inadvertently undertaken to erect barracks for the soldiers in that town…unanimously broke up…" (New York: Printed by John Holt, near the coffee house, 1774).

4 See for example Zobel 1970, 211. Henry Pelham engraved his own version of the event and titled it *The Fruits of Arbitrary Power, or the Bloody Massacre*. He lent a copy to Revere, who copied it, produced a nearly identical engraving, and began selling it a week before Pelham circulated his own. Pelham wrote but may never have sent a letter to Revere, accusing him of acting dishonorably.

5 Jennifer L. Roberts, *Transporting Visions: The Movement of Images in Early America* (Berkeley, 2014).

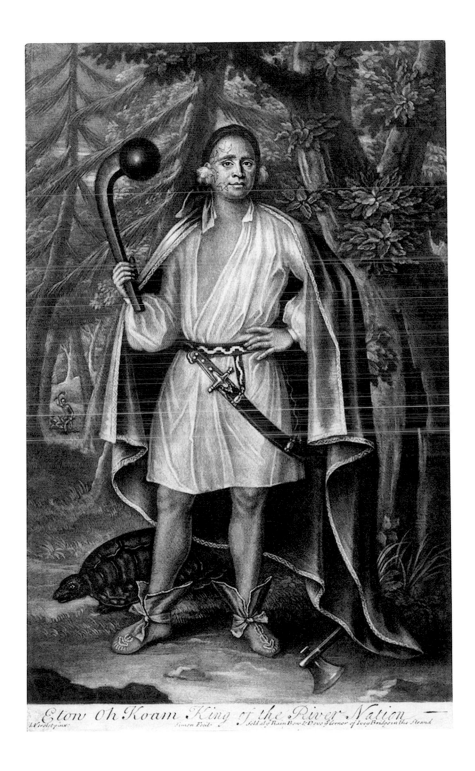

Etow Oh Koam King of the River Nation

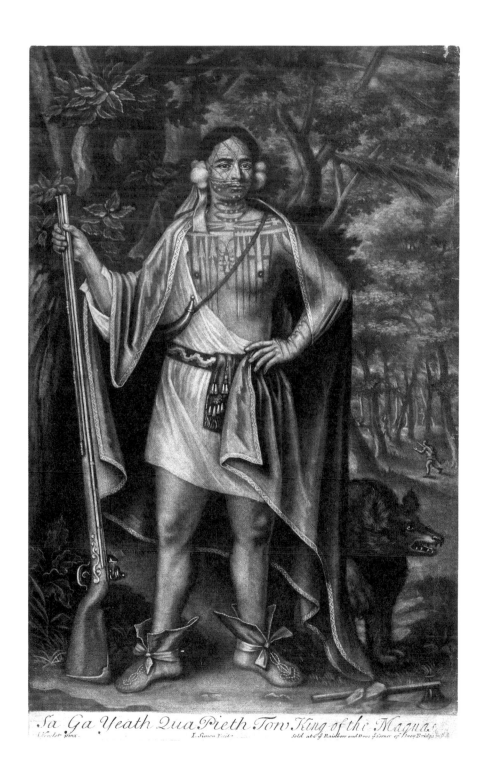

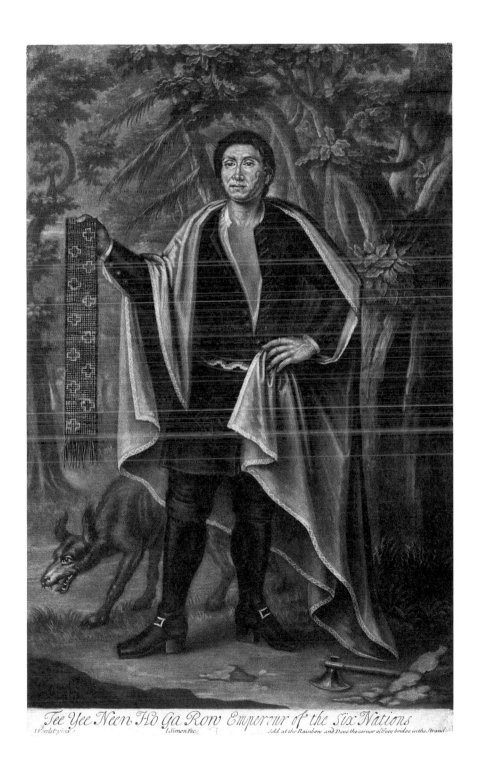

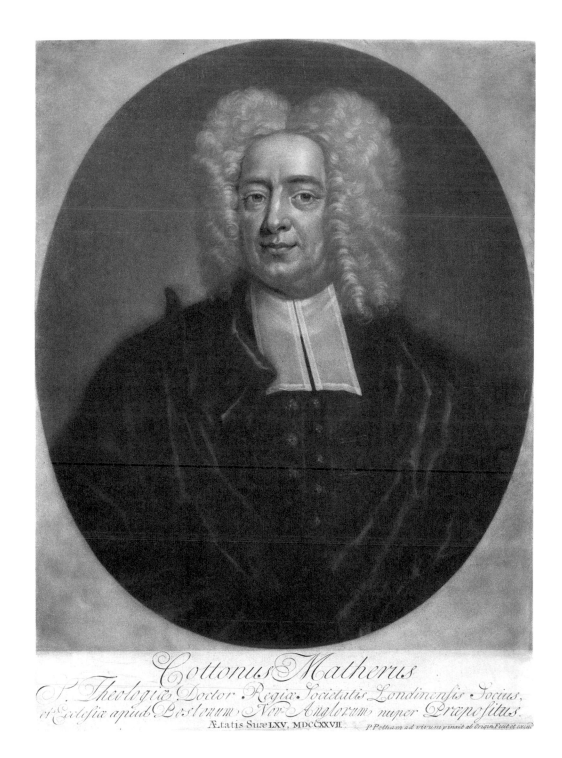

Cottonus Matherus
S. Theologiæ Doctor Regiæ Societatis Londinensis Socius,
et Ecclesiæ apud Bostonum, Nov-Anglorum nuper Præpositus.
Ætatis Suæ LXV. MDCCXXVII. *P Pelham ad vivum pinxit ab Origin Fecit et excud.*

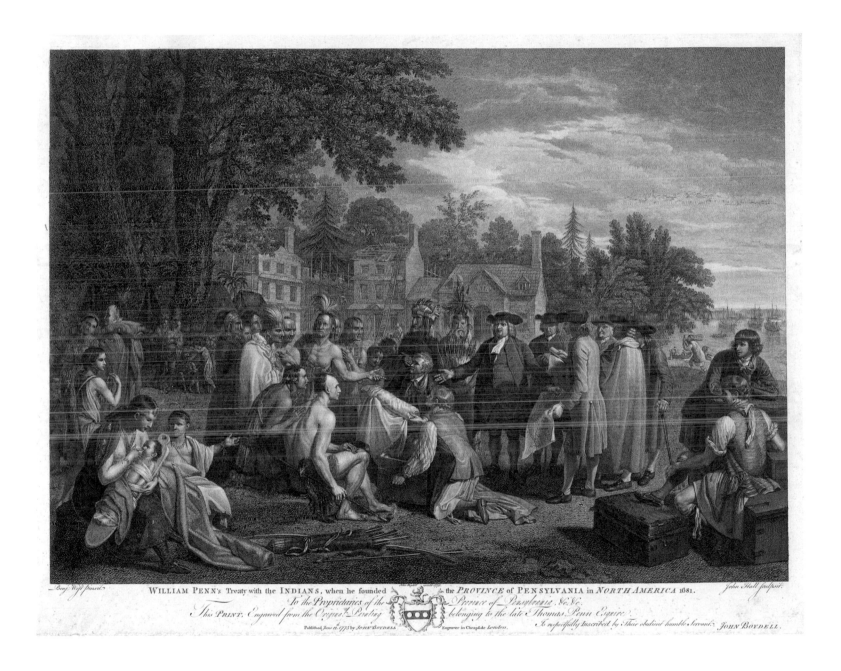

WILLIAM PENN's Treaty with the INDIANS, when he founded the PROVINCE of PENSYLVANIA in NORTH AMERICA 1681.

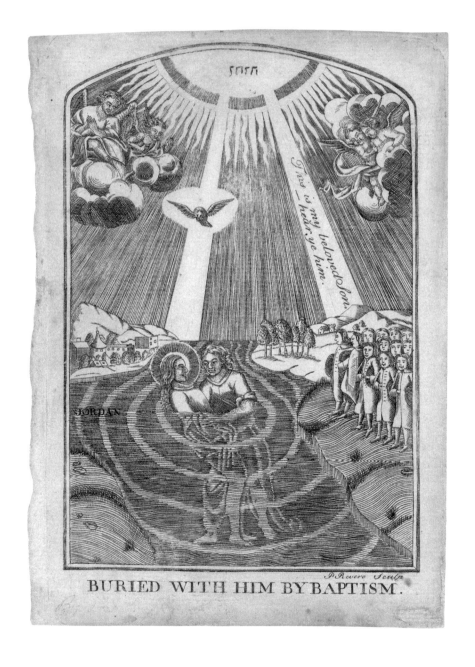

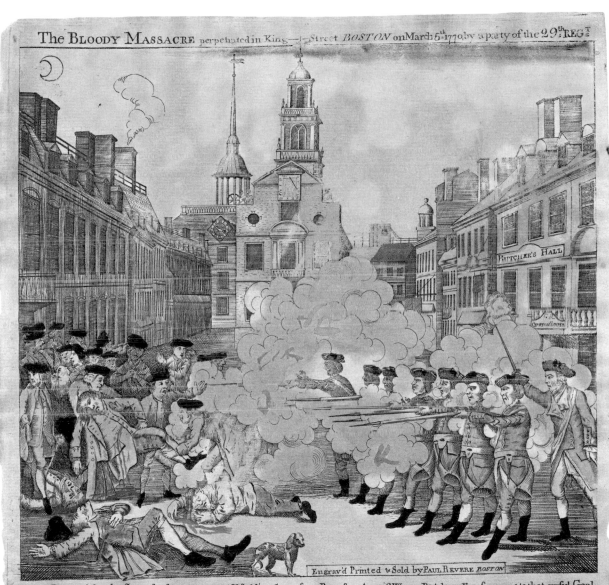

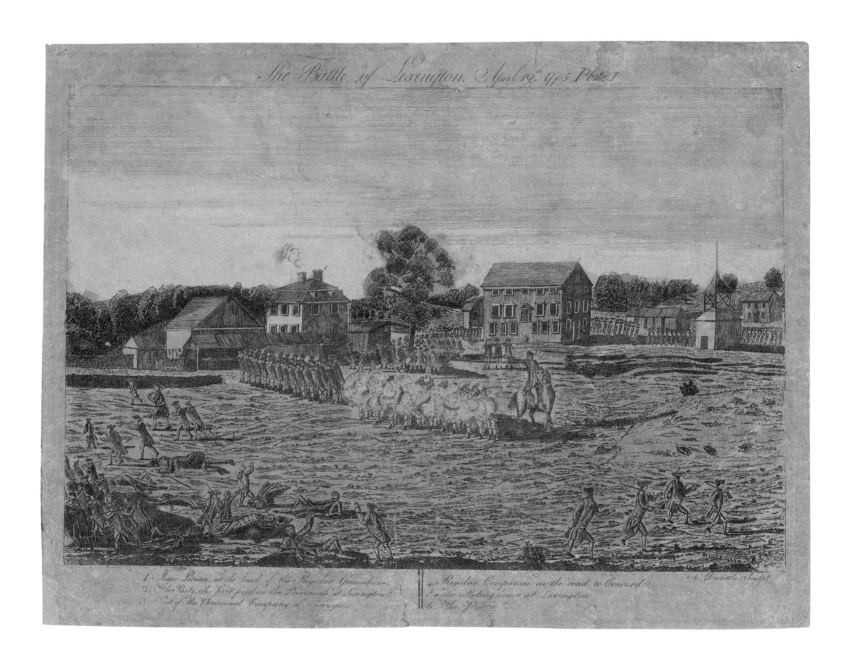

10 Amos Doolittle after Ralph Earl, *Plate II: A View of the Town of Concord,* 1775, hand-colored engraving

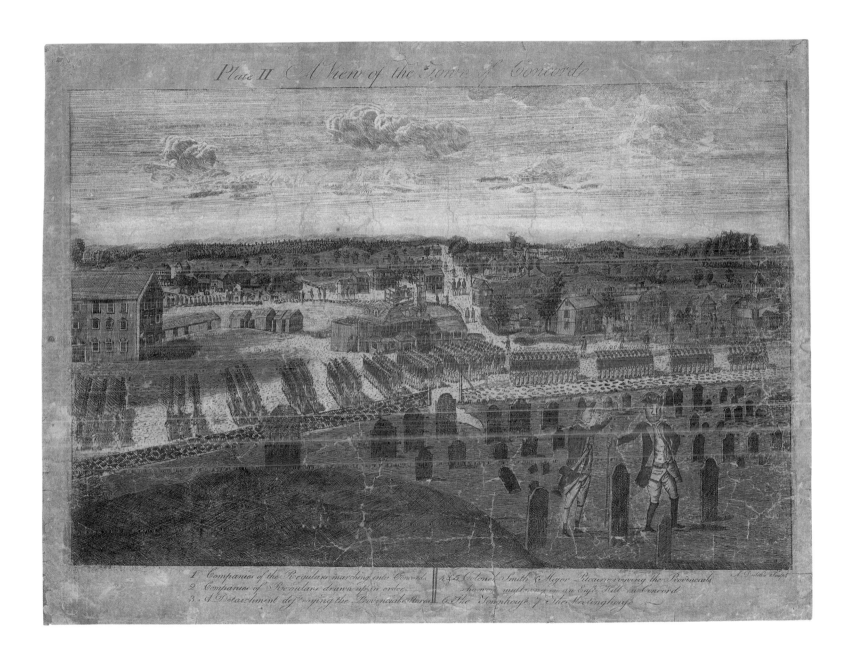

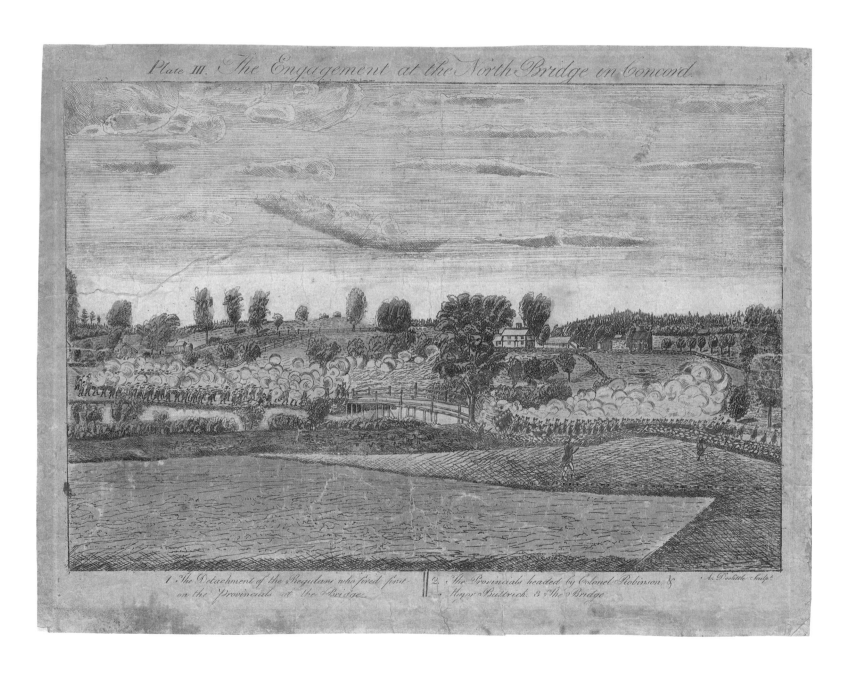

48

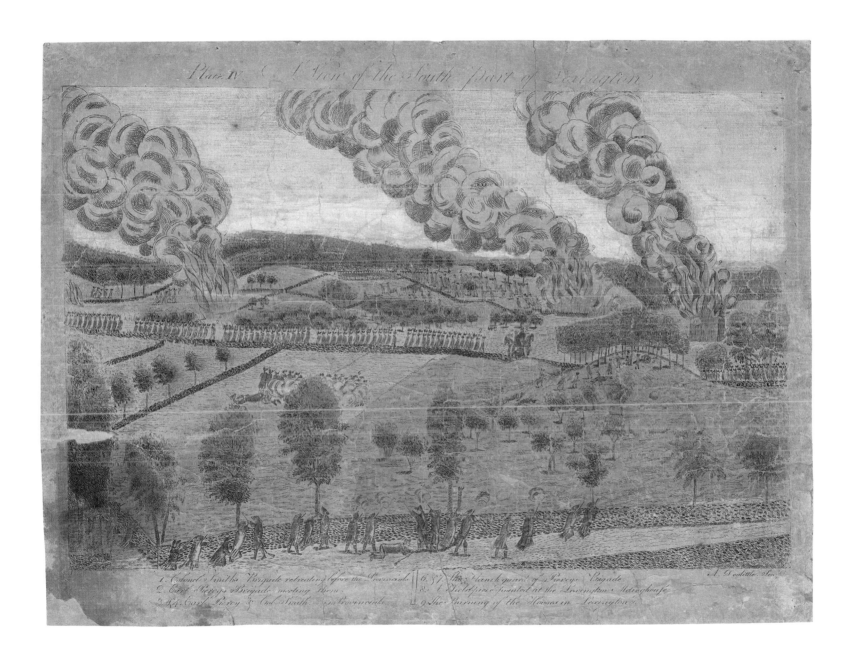

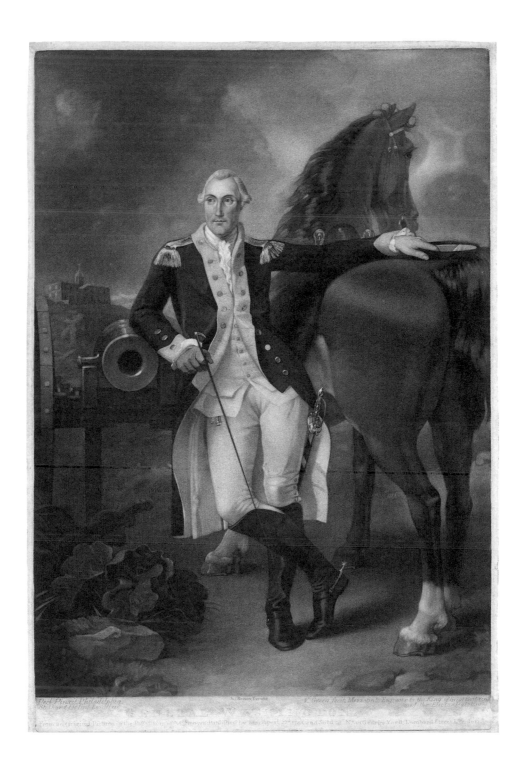

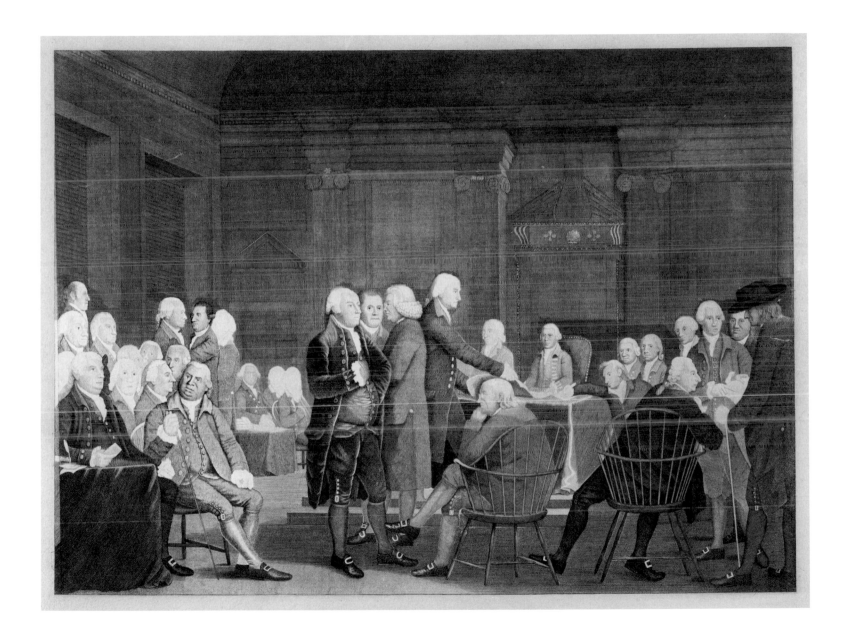

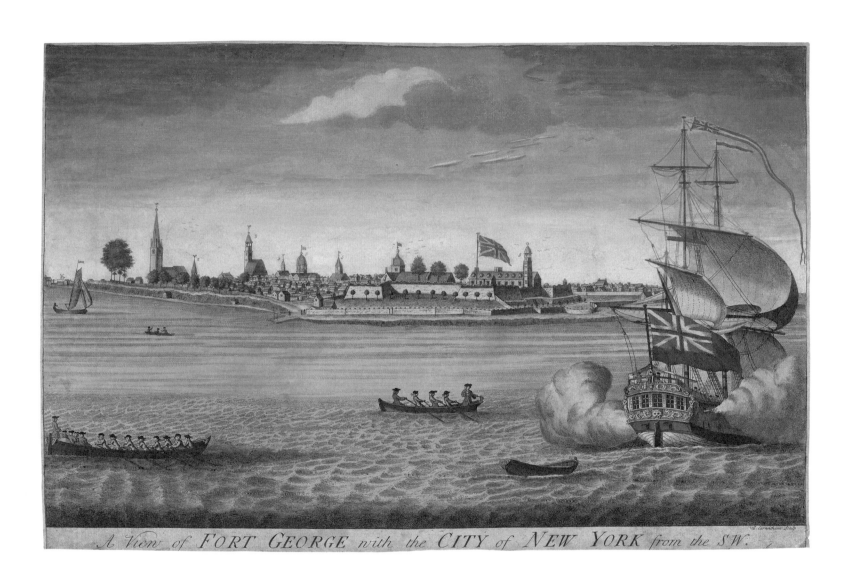

A View of FORT GEORGE with the CITY of NEW YORK from the SW.

16 Charles Balthazar Julien Févret de Saint-Mémin, *Saint-Mémin Album,* 1796–1810, unbound volume of fifty-eight pages containing 833 engravings mounted on paper and annotated in ink (apparently under Saint-Mémin's direction)

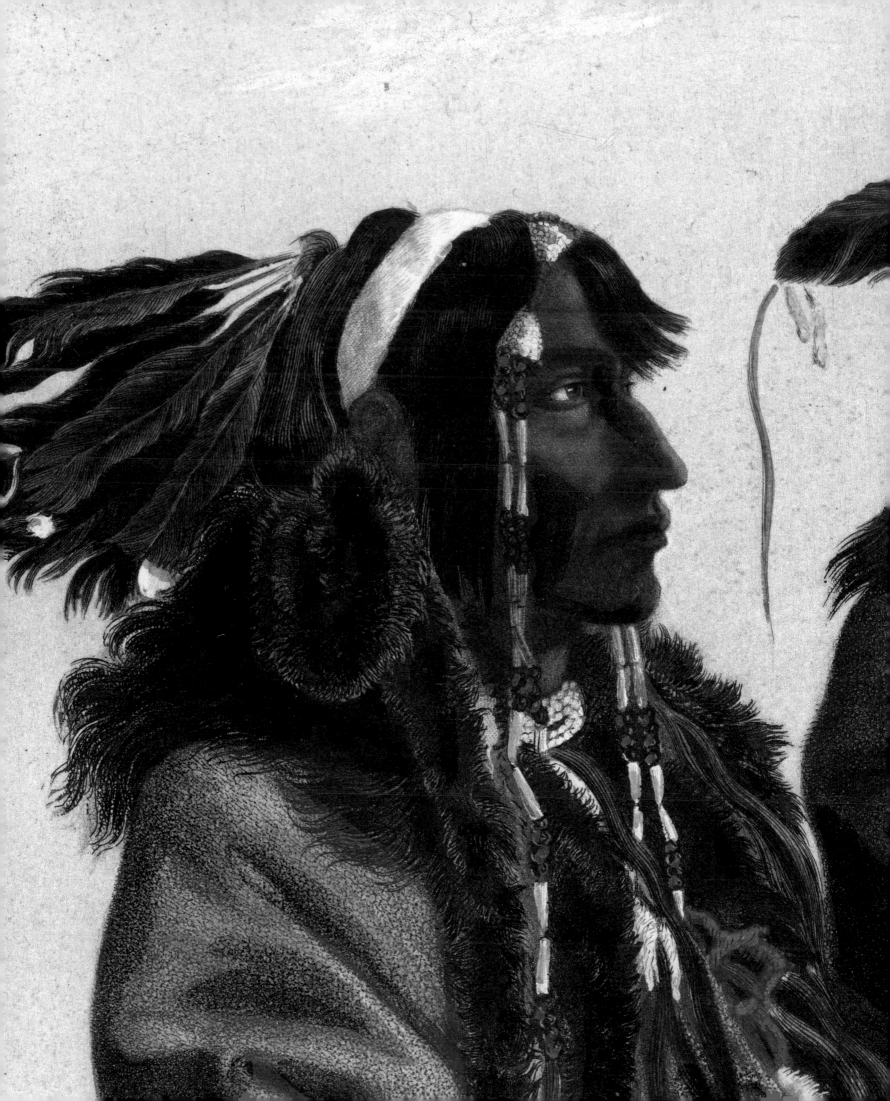

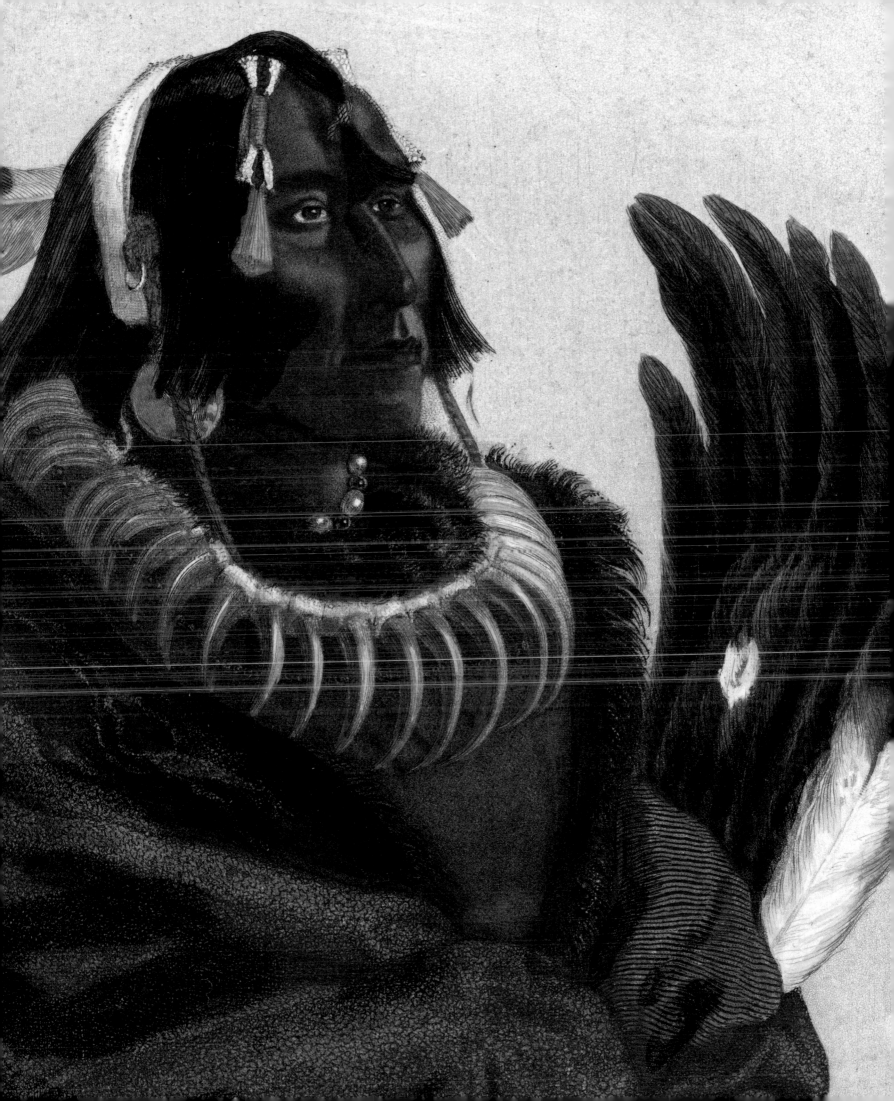

The One Who Makes Pictures JENNIFER RAAB

A VIEW OF WEST POINT. The wild turkey. A Native American man known as Cornplanter. Two young Mandan warriors. What do these images that encompass such different genres — landscape, natural history, portraiture — have in common? The works of John Hill, William Lizars and John James Audubon, Charles Bird King, and Karl Bodmer were all published as part of larger projects, from the double elephant-sized folio that endeavored to represent the avian species of a continent (*The Birds of America*) to the illustrations for a sweeping history of the indigenous peoples of that continent (*History of the Indian Tribes of North America*). The prints in this section are all sites of contact and transformation as well. Charles Bird King's *Ne-Sou-A Quoit, A Fox Chief* (pl. 27) features a souvenir of diplomatic contact between the United States government and Indian nations — a peace medal with the bust of President Andrew Jackson — which transforms this Native American chief from an armed adversary to the subject of a ceremonial portrait, one of many lithographs of Indian dignitaries based on oil paintings originally displayed in a gallery at the War Department in Washington, DC. William James Bennett's *View of the Natural Bridge, Virginia* (pl. 22) offers a wilderness made pastoral, where strolling couples domesticate this imposing geological phenomenon while the inclusion of a contemplative hunter — seated on a foreground boulder, gun casually propped up, sleeping dog at his feet, head tilted back as if in awe — speaks of Jeffersonian ideals, a society based on rural virtues. Straining to fit his *American Flamingo* (pl. 21) at life size onto the largest available sheet of paper, John James Audubon manipulated the posture of the bird, its neck elegantly but oddly bent beneath its body. At the top of the page, diagrams of specific features appear (bill, mandible, tongue, and foot), recasting the illusionistic space of the sky into a flat ground for scientific taxonomy.

Karl Bodmer's *Síh-Chidä and Máhchsi-Karéhde*, engraved by Johann Hürlimann, presents a different sense of contact and transformation (pl. 25). Images of Native Americans are usually read in terms of exoticizing otherness, ethnographic conventions, and colonial violence. Following the work of Elizabeth Hutchinson, I want instead to think about the agency of the two young men portrayed in this image and their "self-fashioning" through dress, ornament, and posture.[1] Shaped by complex negotiations between artist and subjects, *Síh-Chidä and Máhchsi-Karéhde* raises surprising questions about masculinity, performance, and portraiture.

Prince Alexander Philipp Maximilian of Wied-Neuwied, mentored by the eminent polymath Alexander von Humboldt and a respected naturalist in his own right, needed an artist to accompany him to North America. His choice was Karl Bodmer, a young Swiss watercolorist who was a skilled landscape painter but possessed no training in natural history. The two set sail for Boston Harbor in the summer of 1832 and soon headed west, meeting the explorer William Clark that winter in St. Louis, where they saw paintings by George Catlin, who had spent four weeks with the Mandan tribe the previous year.[2] Navigating with reproductions of maps from the Lewis and Clark expedition, the fifty-year-old Maximilian and the twenty-five-year-old Bodmer traveled farther north to present-day Montana. For five bitterly cold months, from November 1833 until April 1834, they lived at Fort Clark on the Missouri River, in the territory where

the Mandan had long made their home and that historically had served as the center for trade between Indian tribes.[3] In this place where Europeans "grafted themselves onto an indigenous trading system," the prince and his artist met and befriended Native American warriors and chiefs.[4] During those long winter months, Bodmer created two watercolors of Síh-Chidä ("Yellow Feather") and Máhchsi-Karéhde ("Flying War Eagle"), the men who would later appear together in his hand-colored print, produced to accompany Maximilian's account of the voyage, *Travels in the Interior of North America*.[5]

Vivid, detailed ornamentation marks the clothing and bodies of these two men. Máhchsi-Karéhde, pictured on the right, clutches an eagle feather fan and wears several pieces of jewelry, some delicate and barely visible, such as a white-and-blue beaded choker that appears opalescent in the print, or the abalone shell earring that glitters like gold, while others spectacularly draw the attention, as with the rare and valuable bear-claw necklace that seems to grip his torso. Both men are wrapped in buffalo-skin robes that feature wide, beaded bands punctuated by geometric rosettes. Such beadwork signifies a preference for a newer material and decorative process — glass beads had been introduced by European traders, and blue and white beads were particularly favored — as opposed to the indigenous tradition of porcupine quillwork.[6] Thus trade and the adaptation of new goods is quite literally manifested in the garments that are pictured here. The man on the left, Síh-Chidä, wears long strings of shells and beads in his hair while sinuous lengths of red cloth lined with otter fur are attached to the heels of his moccasins. These trail behind him like obedient serpents,

signs of exploits on the battlefield, as with the wolves' tails that adorn his comrade's shoes.

Certainly many of the designs and materials represented in this print have symbolic importance within Mandan culture. Yet iconography alone does not suffice to understand this image; to merely "decode" it is to assume that the picture functions as an ethnographic text, each element possessing a fixed cultural meaning. As John Ewers points out following the observations of Prince Maximilian, dress and embellishment "were matters of personal more than tribal preference."[7] In *Síh-Chidä and Máhchsi-Karéhde*, such subjectivity is both expressed by the sitters and represented by the artist. The garments and objects are also explicitly gendered, presenting masculinity as visually constructed through ornament. In his journal, Maximilian described the men of the Mandan and neighboring Hidatsa tribes:

> We now witnessed…the most handsome, powerful men we had seen, in the most attractive, highly imaginative costumes!…these energetic men, laughing, with their ivory teeth, give free rein to their feelings….They had beautifully ornamented and bedecked themselves in their finest, and they had not failed to achieve their ultimate purpose: we could not stop admiring them.[8]

But ornamentation is, in European cultures, so often gendered feminine, and the Mandan preference for being "bedecked" would appear to violate those norms. "It is remarkable that the men are far more vain than the women," Maximilian later wrote in *Travels in the Interior of North America*. "The Indian dandy is constantly consulting his mirror," which was often worn around the neck, set in a wooden

frame.[9] Síh-Chidä, the prince noted, "primped a long time in front of his small mirror."[10] Maximilian's travel diary and subsequent narrative reveal a discomfort with a perceived paradox: powerful and magnetic warriors who favor lavishly embellished clothing.

Yet in Bodmer's hands, the ornamentation seems rigorous and careful, not the stuff of mere vanity, as if to question the assumption that decoration must be indicative of femininity. The bodies are entirely concealed by buffalo-skin robes, the hands gripping the edges of the material. Neither man carries a mirror. Each detail is meticulously drawn — the irregularities of the small beads beneath the bear-claw necklace, the uneven lengths of the leather tassels emerging from the rosettes, the velvety sweep of eagle feathers, the way the wolf's tail is just barely attached to the moccasin, fixing the feet ever so slightly to the ground.

The pages of Maximilian's journal are filled with references to Síh-Chidä and Máhchsi-Karéhde; they were, along with a few other prominent Mandans, the men whom Maximilian and Bodmer became closest to during the sojourn at Fort Clark. The young warriors visit constantly and often spend the night; they provide invaluable insight into the daily lives and rituals of the Mandan people; they are among Bodmer's most frequently drawn subjects. What formed was, in a sense, an unexpected but closely knit homosocial community, and one can imagine that the bonds were especially tight between Bodmer and the two Native Americans portrayed in his print, who were all in their early twenties. The artist was given a Mandan name, Káwa-Kapúska, "the one who makes pictures," or "painter."[11] At one point Síh-Chidä requested that Bodmer paint a bird directly on his shield, a particularly personal and powerful act. Shield designs embodied the spiritual encounters that men had on "vision quests," during which they would isolate themselves from their tribe, fast, and remain awake in order to make contact with the nonhuman realm.[12] To allow Bodmer to paint his war shield — the very object that would protect him physically and spiritually in battle — conveyed the deep trust that the warrior had in the artist.[13] Here was a collaborative visual process, combining Síh-Chidä's spiritual vision with Bodmer's artistic one.

Soon Síh-Chidä too began to paint. Requesting paper, pencils, and watercolor from Bodmer, the Mandan tribesman began to make his own images with these new tools. He had sat for Bodmer many times; he had watched him paint; he had been given a copy of his portrait. Now he followed Bodmer's method of first making a precise pencil drawing and then adding watercolors, creating pictures of others and at least two portraits of himself on horseback, shield in hand, arrows flying around him, one image rimmed with guns and spears (fig. 1).[14] Bodmer and Maximilian both sat for him, the prince admitting that the Native American man "cannot be denied some talent."[15] One day Síh-Chidä drew Bodmer's full figure and, according to Maximilian, "took the picture along, perhaps as protection [against Bodmer's] portrait" of him.[16] Síh-Chidä thus appropriated his portraitist's medium to create his own images of the European men as well as images of himself, executed in a style that hybridizes the flat pictographic forms of traditional Plains Indian drawing with the modeled bodies and specific facial features that he had observed in Bodmer's work.[17]

The print of Síh-Chidä and Máhchsi-Karéhde, produced years after these encounters, retains some traces of these intimacies: the closely observed details, the resistance

to equating ornament with femininity as Maximilian does in his texts, the decision to place the two men together to create a double full-length portrait. Their bodies turn in the same direction, toward the right of the composition, leading our eye past the rocky formation that extends behind them and into the distance where a strange construction — two wooden poles crossed at the top — breaks the horizon line. This appears to be a shrine, where a dead body had most likely been placed on a scaffold to decompose before the bones were buried. The skulls would often be placed in a circle and offerings made to protect the site (fig. 2).[18] Maximilian and Bodmer saw many during their travels, but sometimes they could not determine their meaning, creating vague, fanciful names for the structures, such as "Magic Pile," two words that exist in uncomfortable tension, as if to admit an unbridgeable distance between the material world and the realm of dreams and visions.[19] In the print, the shrine marks the landscape as an unfamiliar, even unknowable space. Yet it also visually recalls the men in the foreground: the two poles as two bodies, intersecting in the distance, a memory of a past life.

1 Elizabeth Hutchinson, "From Pantheon to Indian Gallery: Art and Sovereignty on the Early Nineteenth-Century Cultural Frontier," *Journal of American Studies* 47, no. 2 (May 2013): 325, 336. I am indebted to Hutchinson's revelatory approach, which focuses on the works of Charles Bird King. For a recent study investigating the ways in which Native Americans more often determined "the form and content of inter-cultural relations" than did their "would-be" European colonizers, see Kathleen DuVal, *The Native Ground: Indians and Colonists in the Heart of the Continent* (Philadelphia, 2006).

2 Joseph C. Porter, "The Eyes of Strangers: 'Fact' and Art on the Ethnographic Frontier, 1832–34," in W. Raymond Wood, Joseph C. Porter, and David C. Hunt, *Karl Bodmer's Studio Art: The Newberry Library Bodmer Collection* (Urbana, IL, 2002), 41.

3 W. Raymond Wood and Robert M. Lindholm, *Karl Bodmer's America Revisited: Landscape Views Across Time* (Norman, OK, 2013), 7.

4 Porter 2002, 67.

5 The text was first published in Germany in two volumes between 1839 and 1841, during which time Bodmer's eighty-one engravings were issued separately. *Travels* was then published in English as a single volume in 1843.

6 John C. Ewers, "An Appreciation of Karl Bodmer's Pictures of Indians," in Ewers et al., *Views of a Vanishing Frontier* (Omaha, NE, 1984), 74.

7 Ewers 1984, 72.

8 *The North American Journals of Prince Maximilian of Wied, Volume 3: September 1833–August 1834*, ed. Stephen S. Witte and Marsha V. Gallagher, trans. Dieter Karch (Norman, OK, 2012), 207.

9 Maximilian, Prince of Wied, *Travels in the Interior of North America*, trans. H. Evans Lloyd (London, 1843), 338. David C. Hunt and Marsha V. Gallagher, *Karl Bodmer's America* (Omaha, NE, 1904), 302. The term "dandy" also appears in the journals of Lewis and Clark.

10 *Journals* 2012, 94.

11 *Journals* 2012, 239; Hunt and Gallagher 1984, 75.

12 Janet Catherine Berlo and Ruth B. Phillips, *Native North American Art*, 2nd ed. (Oxford, 2015), 31.

13 Robert J. Moore, *Native Americans: A Portrait; The Art and Travels of Charles Bird King, George Catlin, and Karl Bodmer* (New York, 1997), 225.

14 Ewers 1984, 82, 91; Hunt and Gallagher 1984, 358–359.

15 *Journals* 2012, 59. Unfortunately these images have not been located.

16 *Journals* 2012, 110.

17 Ewers 1984, 82, 84.

18 Hunt and Gallagher 1984, 292–294; Moore 1997, 266.

19 Hunt and Gallagher 1984, 292; Hartwig Isernhagen, "Bodmer–Wied–America: A Journey of Exploration," in *Karl Bodmer: A Swiss Artist in America, 1809–1893; Karl Bodmer: Ein Schweizer Künstler in Amerika, 1809–1893* (Nordamerika Native Museum, Zürich, 2009), 34.

17 John Hill after William Guy Wall, *View from Fishkill Looking to West Point,* 1821–1825, from *The Hudson River Portfolio*, hand-colored aquatint and engraving

VIEW FROM FISHKILL, LOOKING TO WEST POINT.

(N.º 15) of the Hudson River Port Folio

Published by Henry I. Megarey New York

18 John Hill after William Guy Wall, *New York from Weehawk,* 1823, hand-colored aquatint and etching

NEW YORK FROM WEEHAWK.

To Thomas Dixon Esq.t this Plate is respectfully Inscribed by his Obliged Serv.t Will.m & G. Wall.

Printed and Publish.d by Will.m G. Wall. New York 1823.

William Home Lizars after John James Audubon, *Great American Cock Male (Wild Turkey)*, 1827, from *The Birds of America*, hand-colored etching

Robert Havell Jr. after John James Audubon, *American Flamingo,* 1838, from *The Birds of America,* hand-colored etching, aquatint, and engraving

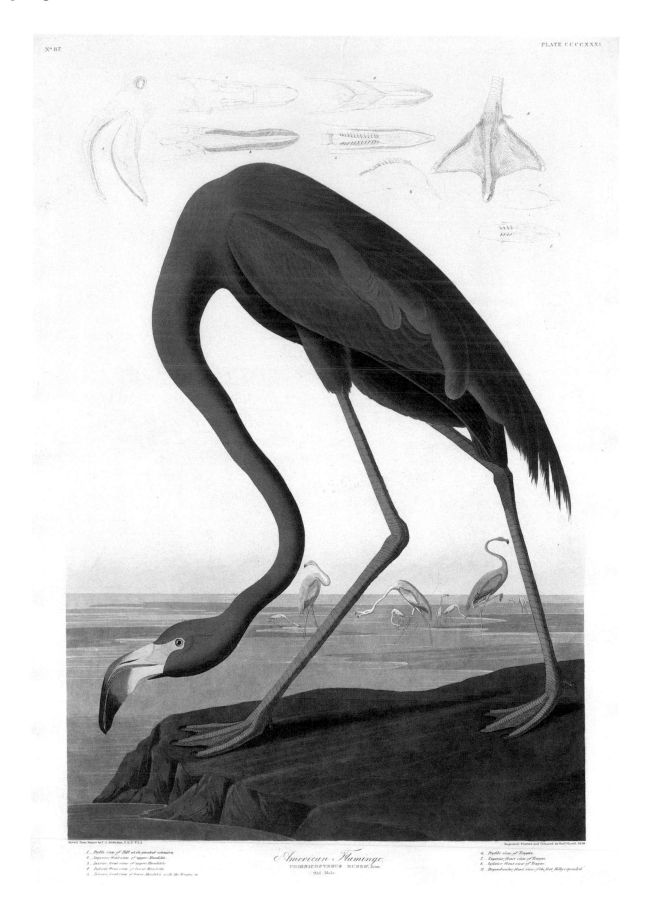

View of the NATURAL BRIDGE, Virginia

Published by Lewis P. Clover, New York.

23 William James Bennett after George Cooke, *City of Charleston S. Carolina looking across Cooper's River,* 1838, hand-colored aquatint and engraving

BOSTON,

From City Point near Sea Street.

Published by Henry I. Megarey New York.

26 After F. Bartoli (misattributed to Charles Bird King), *Ki-On-Twog-Ky or Cornplanter,* 1837, from *History of the Indian Tribes of North America,* hand-colored lithograph

KI-ON-TWOG-KY

or Cornplant

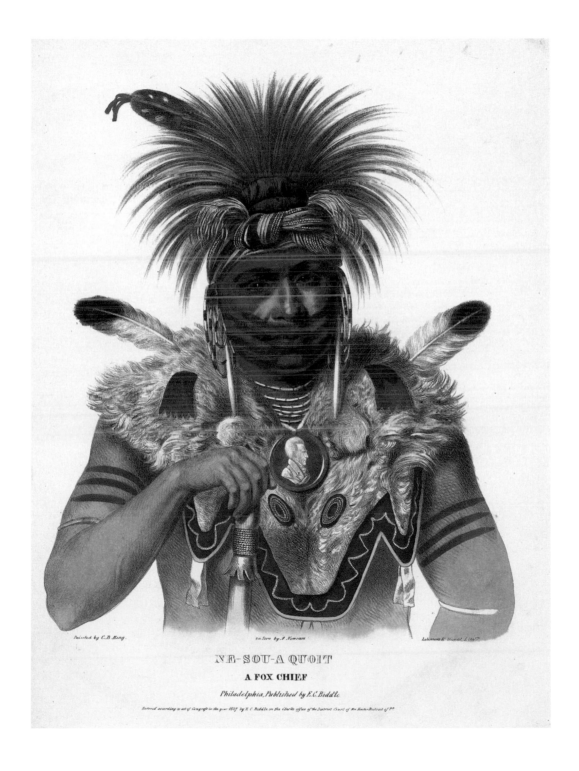

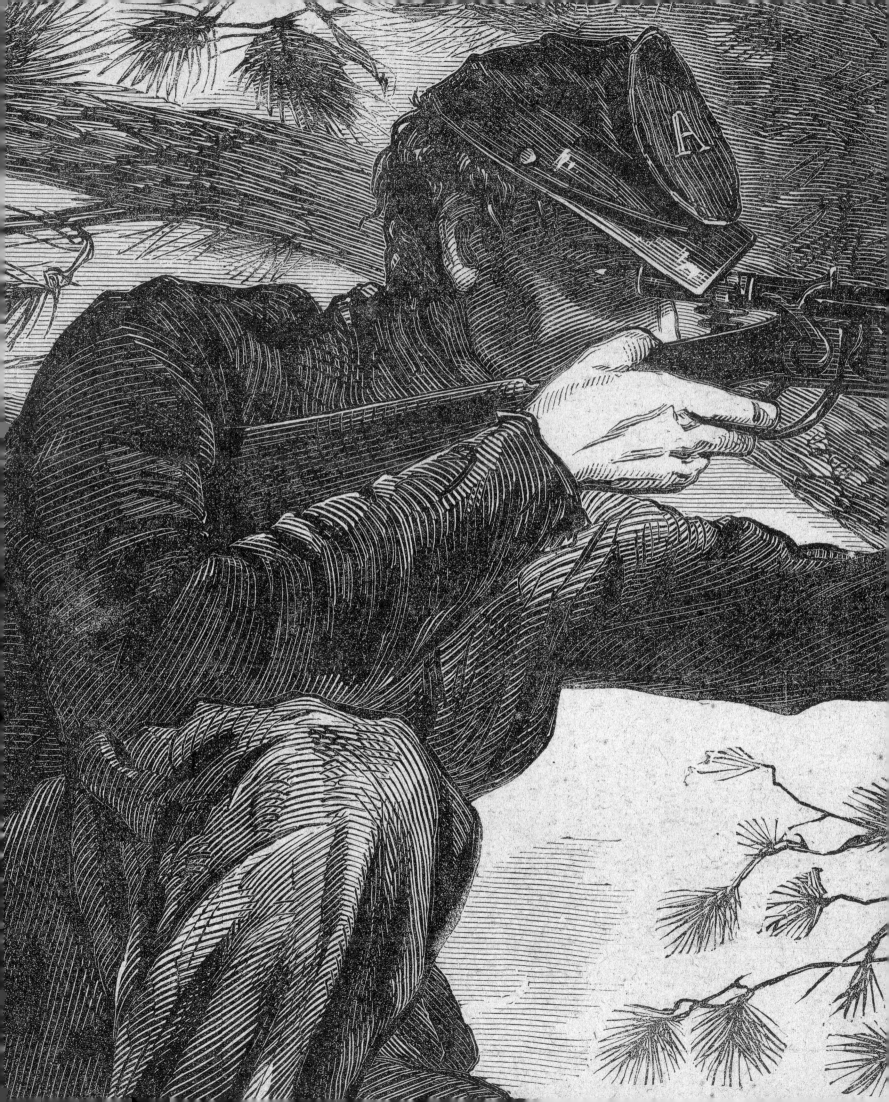

"And the War Came…" Rupture and Contradiction in Mid-Nineteenth-Century Visual Culture DAVID C. WARD

ULYSSES S. GRANT FIRST TRAVELED by railroad in 1839, a seventeen-year-old aspiring soldier on his way to West Point. The speed of the train, he later reflected, "seemed like annihilating space." Annihilation would prove to be the watchword for the convulsive period in American history in which Grant played a leading role: the approximately 700,000 killed in action in the Civil War and the physical damage inflicted on the bodies of Americans north and south — the wounded, the diseased, the shell-shocked. The war was the great accelerator in the making of modern America, transforming everything from the transportation network and industrial processes to the way that Americans thought and wrote about themselves and their culture. Grant's own *Memoirs* (1885), hailed by critics for its clear, descriptive, nonemotive prose, was a harbinger of twentieth-century modernism. Grant's editor Mark Twain went further. Signaling the new sensibility in *The Adventures of Huckleberry Finn*, Twain presents the ghostly, haunted wreckage of the steamboat *Walter Scott*, named for the undisputed leader of the nineteenth-century romantic novel. If romance lived on in tales that people read in order to take refuge from the world, it no longer existed in the world itself. The railroad and industrial warfare had seen to that.

Yet the changes in American society proceeded unevenly and in contradiction as Americans struggled to adapt to new imperatives whose goals or outcomes were frequently unclear. Moreover, the South, both ante- and postbellum, remained the great exception to the modernizing tendencies occurring in the nation as a whole. The steamboat is a case study in these contradictions, representing both the past and present. While it transformed travel on America's rivers, it was only an interim step in the transportation revolution. Twain didn't just signal the end of the *Walter Scott* as a literary exemplar, he also wrecked the actual steamboat. Frances Palmer took a very different approach. This neglected woman artist, working for New York–based Currier & Ives, masked the powerful mechanism of the steamboat beneath the ornate decorative construction of their decks and superstructure, suggesting a genteel luxury belied by the smokestacks belching flames. Luxurious floating hotels, the steamboats also were instruments of masculine and corporate aggression, the pilots racing for sport or to make ever-faster passages. In *A Midnight Race on the Mississippi*, the noise and dynamic motion of steamboats at full throttle are undercut by the benign, pastoral moonlit setting of the riverscape (pl. 31). The machine is subsumed into the garden, the threat of a boiler explosion or a wreck washed away by the placidity of the river's surface.

In Palmer's *"Wooding Up" on the Mississippi*, the steamboat at rest becomes an effective representative of a society in flux (pl. 32). The print illustrates the racial division of society with whites above, enjoying the view and socializing at their leisure, while African Americans work furiously to fuel up the boat. The two white supervisors superfluously point the workers to their tasks. The controlled burn of the boat's engines — the paddle wheels are turning, holding the boat against the river bank — contrasts with the wild flames of the bonfire that lights and heats the laborers. In the midst of riverine pastoralism and the managed chaos of the "wooding up," the steamboat *Princess* seems to be on fire: its smokestacks shoot flames and sparks like a fuse and the interior of the boat glows red as if it is about to blow up. Produced during the war and dated 1863, Palmer's image is of an antebellum America about to explode.

The sense of an impending crisis runs throughout the 1850s as the antagonism between North and South deepened, and the question of slavery increasingly colored all aspects of public and private life. As Lincoln and others prophesized, a "house divided against itself cannot stand." Politics was one of the main organizing principles of antebellum American society, and party loyalty determined everything from one's opinion on issues to one's choice of friends. Because politics, from rallies to voting, was a public affair, it was visual fodder for genre artists. Genre scenes were usually played for poignancy or comic effect, and politics provided plenty of opportunity to poke gentle fun at the manners and mores of the American public. Despite its title, *Politics in an Oyster-House* is actually a meditation on aging as the aggressive younger man lectures his tired, slightly fuddled older companion (pl. 29). Nonetheless, growing uneasiness about the sectional crisis was starting to thread its way into otherwise typical depictions of familiar American "types." In *Mexican News* locals congregate around the newspaper reader at the American Hotel (pl. 30). The men run the gamut in age and aspect from the gape-mouthed trio reading the newspaper to the two codgers sitting to the right. Since men alone could vote, the only woman in the print looks on at all the hubbub from the adjoining window. The African American man and girl, like the African Americans in *"Wooding Up,"* are pictured below the white people; the girl is dressed raggedly and the liquor jug partly hidden by the man's straw hat hints at his dissolution. Politically, victory in the war with Mexico caused a crisis over slavery that only ended with the Civil War. The acquisition of so much new land destabilized the careful balance of slave and free states established by the Missouri Compromise (1820). And the

system of two national parties, Whigs and Democrats, was about to be destroyed by sectionalism.

The County Election by John Sartain after a painting by George Caleb Bingham presents a visual typography of the American polity (pl. 28). Largely white and male — there are no women and only one African American pictured (pouring drinks to the left) — it is a tableau of American democracy in action. The blue banner ("The Will of the People the Supreme Law") establishes sovereignty while the sign in the background identifies the Union Hotel, reaffirming analogies between the polity and a house. The well-dressed, slightly obsequious election managers and politicians greet the crowd on the porch, handing out prepared sample ballots. The artist has great sport in showing how alcohol lubricated the machinery of democracy. The discordant note in all this bonhomie is the small figure on horseback in the middle distance. With his outflung arm and hat, he is the only man in a hurry amid the stasis of "business as usual," a Paul Revere raising the alarm. By 1852 civil war was not yet a certainty, but following the Mexican War, the crisis of the Union was at hand.

"And the War came…" Lincoln used a depersonalized construction in his Second Inaugural Address (1865) — as if the Civil War was not a product of history and politics — to clear the slate for his program of reunion and reconstruction. But when civil war did break out in 1861, the material impact of the fighting came as an unfamiliar and harsh reality. The industrial infrastructure of warfare, especially the rapidly evolving technology of weaponry, transportation, and communications, combined with the unpreparedness on the human side in everything from tactics to medical care, resulted in a storm of lethality on the battlefield. The

FIG. 1 Timothy H. O'Sullivan, *Field Where General Reynolds Fell, Gettysburg,* 1863, albumen print, National Gallery of Art, Gift of Mary and Dan Solomon and Patrons' Permanent Fund.

FIELD WHERE GENERAL REYNOLDS FELL, GETTYSBURG.

telescopic sight, the victim remained unknowing until the bullet's impact. Death was random and arbitrary, inflicted by an anonymous rifleman out of sight and earshot. You never knew what hit you. At the battle of Spotsylvania, Union General John Sedgwick was rallying his troops, crying "Come on, men, they couldn't hit an elephant at this distance!" Immediately a bullet fired from long range killed him. Snipers have always been loathed by regular troops because they violate the convention of an open fight. Homer was signaling that war was no longer chivalric but a dirty business. The sniper is a cheat. But the sniper is also a harbinger of modernity: life is capricious, uncertain, unplotted, and nervous — death from above, out of a clear blue sky, a constant threat.

What did all this annihilation, the breakup of the Union, and the resulting war settle? Reconstruction and reunion shook out in ways that no one anticipated or intended, especially for the victorious North. Thomas Nast's nightmare vision of Jefferson Davis in *Why He Cannot Sleep* settles scores: the traitors of the slavocracy will be punished physically and psychically (pl. 33). Nast's savage caricature pictures the allegorical figure of Liberty indicting Davis, pointing not just to the casualties of war but to the gallows from which the president of the Confederacy will presumably soon hang for war crimes. The necrophilic skeleton in bed with Davis points accusingly at the bullet hole in his skull. Davis clutches the bedclothes, trembling at his fate. But Nast's cathartic image (cathartic at least for the North) is contradicted by a historical irony: there is no evidence that Davis ever had any trouble sleeping, even after his two years in prison. Very few of the Confederacy's leaders, military or civilian, were punished. Davis was never tried for treason or anything else; he was just held as a prisoner. Divisive legal

inadequacy of medical care multiplied the mortality rate dreadfully (fig. 1). Battles were almost always won by the side that took the defensive, restricting its opponent's ability to maneuver through concentrated fire from protected positions. When a Union officer described the decimation of an attack across open ground at Antietam as the "landscape turned red," he was not speaking metaphorically.

Winslow Homer's *The Army of the Potomac — A Sharp-Shooter on Picket Duty* reasserts the focus on the individual waging war (pl. 34). But by making his subject a sniper, Homer also indicated the anonymity and capriciousness of death on the battlefield. Between two opposed ranks of troops firing high-powered ordnance, it was impossible to know who hit whom with any single shot. While the sniper "knew" his victim, lining him up in the crosshairs of his

and moral issues that would have been raised by a trial were thus avoided. Indeed, Davis prospered and wrote a lengthy, dull, and self-justificatory history, *The Rise and Fall of the Confederate Government* (1881), that re-argued the right of the South to secede, as if the war had never happened.

The South, by the end of Reconstruction (1877), had won the peace after losing the war. Segregation replaced slavery as a system of racial control and the South reconstituted itself as a premodern appendage to the modernizing North. With its cultural nostalgia for "moonlight and magnolias," the myth of the Lost Cause — the claim that the South's superior civilization was defeated by the greater population and soulless materialism of the North — refloated the *Walter Scott* as a reactionary counterpoint to American modernism. Politically and socially, above all racially, the consequences were significant. Lincoln in his first inaugural address pointed to the unifying "mystic chords of memory" that bound North and South to the patriot graves of the Revolution. There could be no such unifying symbol in Civil War graveyards. The cemeteries and shrines would be separate and unequal, conveying different meanings to profoundly different audiences. Despite Nast's call for a fierce and cleansing retributive justice, the causes and consequences — including the human costs — of the house divided would be elided, displaced, and sublimated, influencing our history, including our art history, in ways that are unexpected and frequently confounding as we chart America's evolution toward modernity.

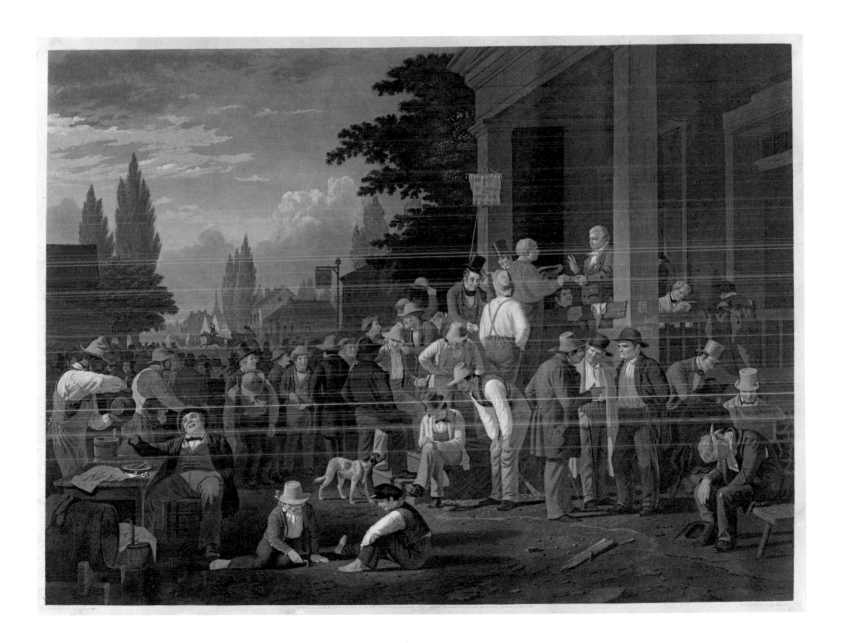

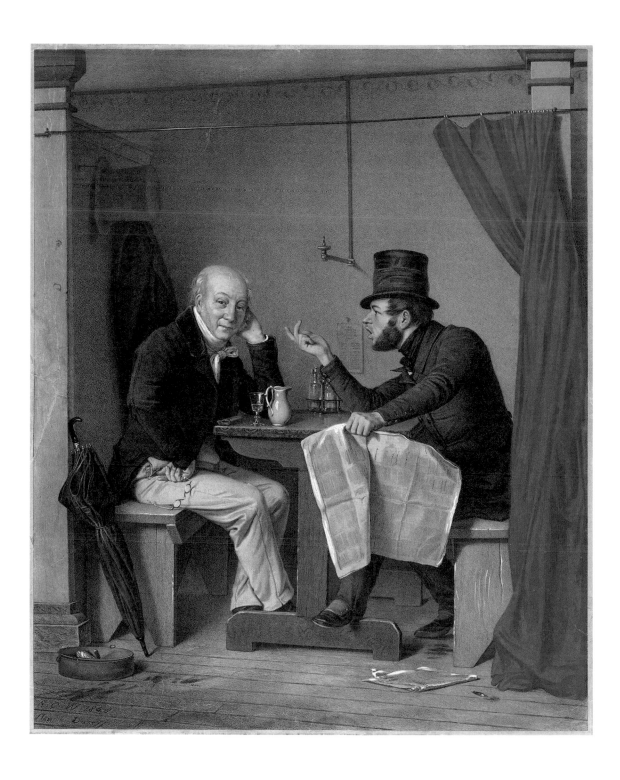

Frances Flora Palmer, *A Midnight Race on the Mississippi*, 1860, color lithograph with hand-coloring

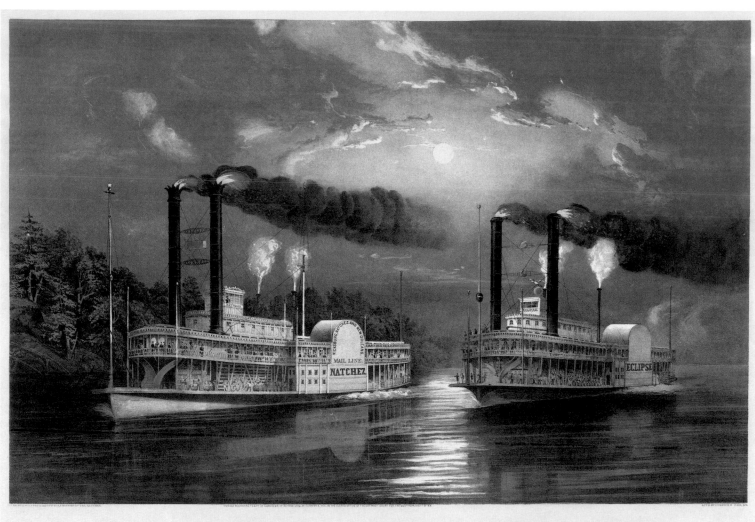

A MIDNIGHT RACE ON THE MISSISSIPPI.

"WOODING UP" ON THE MISSISSIPPI.

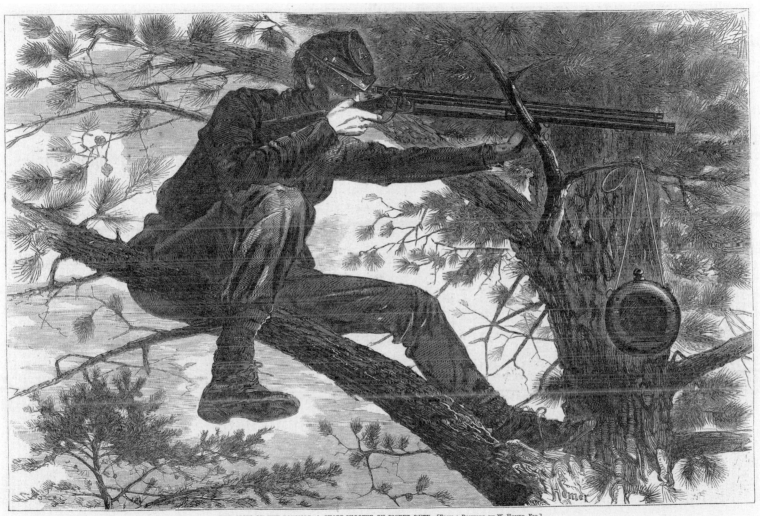

THE ARMY OF THE POTOMAC—A SHARP-SHOOTER ON PICKET DUTY.—[From a Painting by W. Homer, Esq.]

Reconstruction to World War II

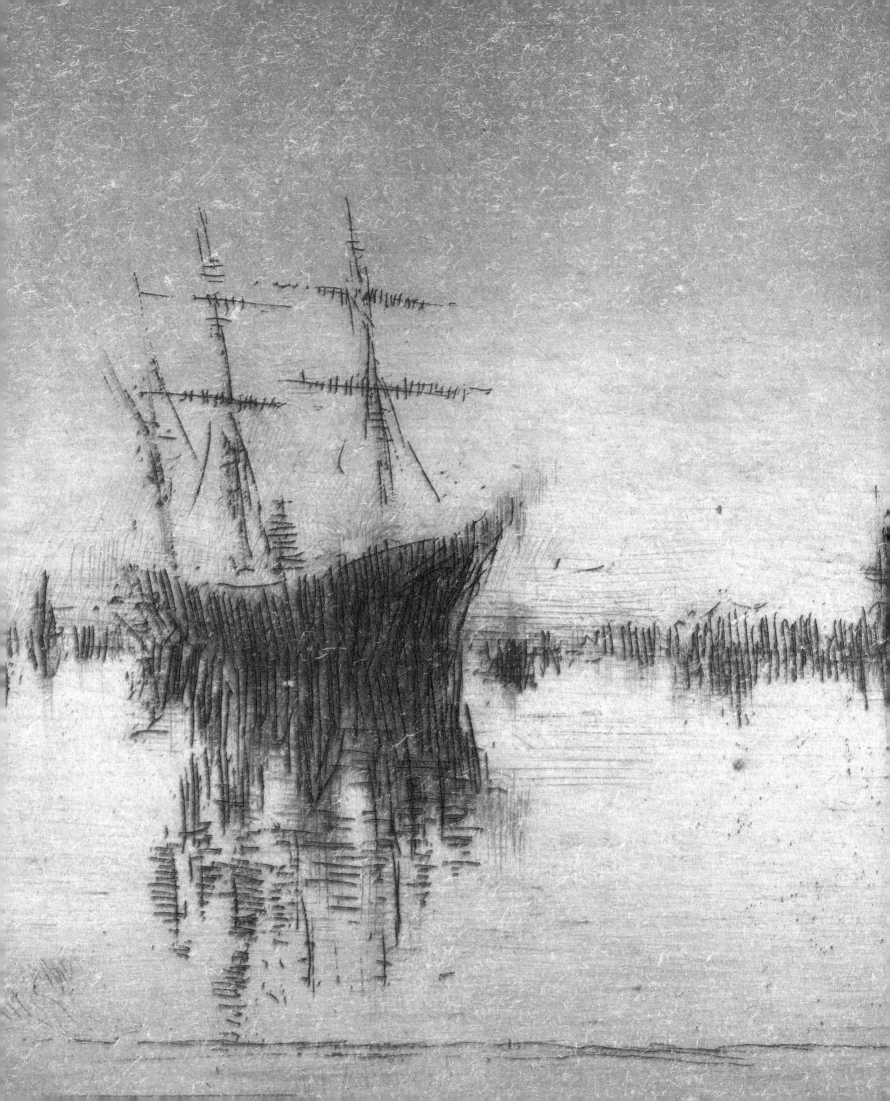

At Home Abroad in the Later Nineteenth Century MARC SIMPSON

PERSPICACIOUS ART CRITICS OF THE later nineteenth century took note of three interrelated trends to distinguish their art culture from that of the pre-Civil War era: a rising cosmopolitanism; a growing interest in artists' autographic technique; and the elevation of printmaking, watercolor, pastel, and other so-called minor media.[1] A small sampling of their texts illustrates the point: "Half our young American artists go to Paris…; the other half go to Munich….Our picture exhibitions have of late years been tilting matches for these contestants," wrote Earl Shinn in 1879, characterizing with only slight hyperbole American artists' urge for study abroad and its impact on the native scene.[2] Sylvester Koehler, summarizing the Paris/Munich divide from the vantage point of 1886, remarked that in one thing, however, the two camps "were of accord, and it was this, that the technical side of art, the *métier*, was their principal care."[3] Writing of previously underappreciated art forms, Mariana Griswold Van Rensselaer in 1884 proclaimed, "Great as has been our advance in oil painting within recent years, I think our most notable evidence of progress lies in the fact that these minor branches are no longer either unfamiliar or despised."[4] The nation's embrace of the etching revival — a movement initiated in France and England in the 1850s — exemplified these tendencies, given the European origins and the previously undervalued status of its focus and, most decisively, the fact that etching was, as Van Rensselaer declared, "the only graphic process by which an artist can *improvise* — can put his own thoughts — directly, and with such ease that his most fleeting vision can be fixed and the least idiosyncrasy of his handling be preserved — upon a plate from which many duplicates may be printed."[5] Six

of this section's seven prints tie in diverse ways to priorities of the American etching revival.

The prints of George Loring Brown, preceding Van Rensselaer's comments by decades, nonetheless aspired to the aura of Europe, the dignity of the etching medium, and the individuality of hand that she lauded as coming to fruition only later in American art. Brown traveled to Europe first in 1832, staying for two years, and then again in 1840. This time he remained, primarily in Rome, until 1859. During these two decades Brown, the "most celebrated of American landscape painters living abroad," perfected a mode of painting so reminiscent of his great seventeenth-century French predecessor that critics praised him as the "American Claude."[6] Catering to a burgeoning tourist trade, in 1853 and 1854 Brown made nine prints showing Rome's storied countryside.[7] In 1860, the year after his return to the United States, he published them as a set, *Etchings of the Campagna, Rome*.[8]

For our purposes, it is striking that as late as 1885 exponents of the etching revival republished prints pulled from several of Brown's three-decades-old plates, including the National Gallery of Art scene.[9] American critics of the era noted their relative antiquity, one attributing to *A View near Rome* (pl. 35) "a certain quaint old manner — a scragginess, which recalls the pre-Raphaelite period."[10] "They lack the freedom and spontaneity which we at present look for in works of the needle," wrote another. He went on:

I do not, however, criticise Mr. Brown's work. A painter's etching, such as we understand it to-day, was out of the question at the time these plates were done, and as every artist is a child of his

time, we must judge him as such. Looked at under these limitations, the etchings in question will reveal much to us in which we can take genuine pleasure....[A]nd in the later and most elaborate of them, as in the *View near Rome*...there is a delicacy and perfection of workmanship which is in itself admirable.[11]

A decade later, writing of "original or painter's etching" — as prints of the etching revival were commonly characterized — yet another author valued Brown's works as among America's "oldest examples."[12]

Nocturne by James McNeill Whistler, to the contrary, when it was seen in London in 1880 (and the next year in New York and Philadelphia), exemplified the very newest and freest of painterly etchings (pls. 38, 39). Whistler, after an abruptly truncated West Point Military Academy education and short-term service as an etcher in the United States Coast and Geodetic Survey, had left the country in 1855 to study painting in Paris; he never returned.[13] In spite of his youth, by the early 1860s he was counted among the most avant-garde artists of either Paris or London and was at home in both cities. His work and his articulate advocacy of "art for art's sake" — reinforced by the era's celebrity culture that fed on his appearance, manner, and wit — ensured that he would be at once the most famous and infamous of American artists. A principal example of his courting of notoriety was a libel suit against the English writer John Ruskin who had accused Whistler of "cockney impudence" for "flinging a pot of paint in the public's face" with his *Nocturne in Black and Gold: The Falling Rocket* (1875). Although Whistler won the trial, the associated costs bankrupted him and prompted a fourteen-month-long sojourn in Venice, where,

on commission from London's Fine Art Society, he made a set of twelve etchings.[14] *Nocturne*, now considered among his more important prints, was then the most controversial of the group.[15] Critics complained that it "can hardly be called, as it stands, an etching; the bones as it were of the picture have been etched, which bones consist of some shipping and distant objects, and then over the whole of the plate ink has apparently been smeared."[16] The writer's ire is directed at *Nocturne*'s plate tone — ink left on the plate and purposefully manipulated so as to augment the scene's atmosphere — which plays so prominent a role in its effect, in contrast to the relatively few etched lines that define the middle-ground shipping and the distant isle of San Giorgio Maggiore.[17] Whereas Brown's Campagna prints were likely inked and printed by a professional without the artist necessarily being present, the success of each Venetian sheet depended on Whistler's wiping of the plate, with the potential to present, as in the two examples here, radically different lighting: crepuscule as opposed to near-impenetrable darkness. The sixty or so impressions that Whistler pulled are not, thus, equivalent to one another; each, individually precious, calls up a different response from the viewer. Whistler augmented the singularity of every print by using various old papers and different tonalities of ink. The fact that one impression of *Nocturne* can differ dramatically from the next, denying the mechanical, reproductive element of printmaking, epitomizes the definition-breaking character of the era.

The contrast between the complex linearity of Whistler's early etching *Rotherhithe* (pl. 36), with its London dockside types, and the feathery suggestiveness of the drypoint

portrait of Florence Leyland (pl. 37), daughter of his most important English patron, reveals the extreme range of effects that he sought in his prints. Yet rarely, if ever, did he experiment with techniques to the degree that was typical of the work of Mary Cassatt. *The Visitor* (pl. 40), with its combination of etching, softground etching, aquatint, and drypoint, reveals the complex experimentation that she undertook in the very earliest years of her printmaking, evidently inspired by the work of such impressionist colleagues as Edgar Degas.[18] This and the other five intaglio prints of this section are radical, precedent-setting achievements of their day.

The seventh print in this section — *Study of a Seated Man* by John Singer Sargent — is a lithograph, a planographic rather than intaglio form of printmaking, and thus stands apart from its cohort (pl. 41). Sargent drew his lithographic designs on specially prepared paper that was used to transfer his drawing onto a lithographic stone; relatively few impressions of each were printed.[19] *Study of a Seated Man*, the best known of them, demonstrates both his mastery of anatomy and his typically atypical point of view, yet in general calls attention to Sargent's skill as a draftsman rather than printmaker. In spite of this, so compelling is it that in 1912 Frank Weitenkampf chose *Study of a Seated Man* as the frontispiece to his landmark *American Graphic Art*.

The careers of Whistler, Cassatt, and Sargent reflect the three trends of cosmopolitanism, emphasis on technique, and the elevation of minor media to varying degrees. The three artists trained and spent their maturity in Europe (Sargent, born in Italy, first visited the United States when he was twenty). All three likewise developed distinct individual styles that shaped the art world of their time. Only Whistler and Cassatt, however, devoted significant energy to expanding printmaking's technical and emotive potential; Sargent's turns to the so-called minor arts were fleeting or, in the case of watercolor, well after the medium's more general acceptance. Together, nonetheless, the three epitomize the high achievement of advanced American art at the turn of the century. If only he had somehow included Cassatt in his summation of the era, Kenyon Cox's 1905 encomium of the two men would illustrate the status of these expatriates to perfection: "Since the death of Whistler, Mr. Sargent holds, by all odds, the highest and most conspicuous position before the world of any artist whom we can claim as in some sort an American — indeed, he is to-day one of the most famous artists of any country."[20]

1 For a convenient overview, see the introductions and writings collected in Sarah Burns and John Davis, *American Art to 1900: A Documentary History* (Berkeley, 2009), 643–939. In addition, J. M. Mancini has analyzed contributing components of the broader art culture in *Pre-Modernism: Art-World Change and American Culture from the Civil War to the Armory Show* (Princeton, 2005).

2 Edward Strahan [Earl Shinn], "The National Academy of Design," *Art Amateur* 1, no. 2 (July 1879): 27.

3 S. R. Koehler, *American Art* (New York, 1886); quoted in Burns and Davis, *American Art to 1900* (Berkeley, CA, 2009), 860.

4 M. G. Van Rensselaer, "American Painters in Pastel," *Century Magazine* 29 (December 1884): 204–205.

5 Mariana Griswold Van Rensselaer, "American Etchers," *Century Magazine* 25 (February 1883): 485. See also Elizabeth Helsinger et al., *The "Writing" of Modern Life: The Etching Revival in France, Britain, and the U.S., 1850–1940* (Chicago, 2008).

6 Edgar P. Richardson, *Painting in America: The Story of 450 Years* (New York, 1956), 170; and "Malden's Artist Recluse," *New York Times*, June 7, 1885. Thomas W. Leavitt is Brown's most thorough modern biographer, with a Harvard dissertation (1957) and his *George Loring Brown: Landscapes of Europe and America, 1834–1880* (Burlington, VT, 1973).

7 An account book (Museum of Fine Arts, Boston, Library) records the sale of at least two of these, including *A View near Rome*, in batches of forty, to retailers (Thomas P. Bruhn, *The American Print: Originality and Experimentation 1790–1890* [Storrs, CT, 1993], 62–63).

8 S. R. Koehler, "The Works of the American Etchers: XXVI — George Loring Brown," *American Art Review* 2, pt. 2 (1881): 192.

9 *A View near Rome* accompanied S. R. Koehler's "The Works of American Etchers: XXVI" in the *American Art Review* (1881) and in his *American Etchings: A Collection of Twenty Original Etchings* (Boston, 1885).

10 "Works on Art: The American Art Review for September," *New York Times*, October 16, 1881.

11 Koehler, "The Works of American Etchers: XXVI," 192.

12 "American Prints in Boston," *The Collector* 4, no. 16 (July 1, 1893): 252.

13 His one later Atlantic crossing took him to and from Chile in 1866.

14 In the event, in Venice he also etched another forty-nine plates, drew roughly one hundred pastels, and created several significant paintings — all of which recouped both his finances and his reputation.

15 Margaret F. MacDonald et al., *James McNeill Whistler: The Etchings, a Catalogue Raisonné* (University of Glasgow, 2012). http://etchings.arts.gla.ac.uk/catalogue/search/cn_display/?rs=222&display=Search (accessed February 15, 2015).

16 "Mr. Whistler's Etchings," *British Architect* 14 (December 10, 1880): 247.

17 Even among eight of the nine known states of the plate, the changes to the etched or drypoint lines matter relatively little; the exception is the fifth state, documented by a single example now in the collection of the Freer Gallery of Art. The two impressions in this exhibition are from the sixth state and the ninth and final state.

18 Nancy Mowll Mathews and Barbara Stern Shapiro, *Mary Cassatt: The Color Prints* (Williamstown, MA, 1989).

19 Albert Belleroche, "The Lithographs of Sargent," *Print Collector's Quarterly* 13, no. 1 (February 1926): 30–45. Campbell Dodgson's catalogue closing the essay lists six designs, most printed in fewer than ten impressions; only two designs, he writes, including the present one, had "any considerable edition," by which he seems to mean around twenty-five.

20 Kenyon Cox, "Sargent," in *Old Masters and New* (New York, 1905), 255.

37 James McNeill Whistler, *Florence Leyland,* c. 1873, drypoint on Japanese paper

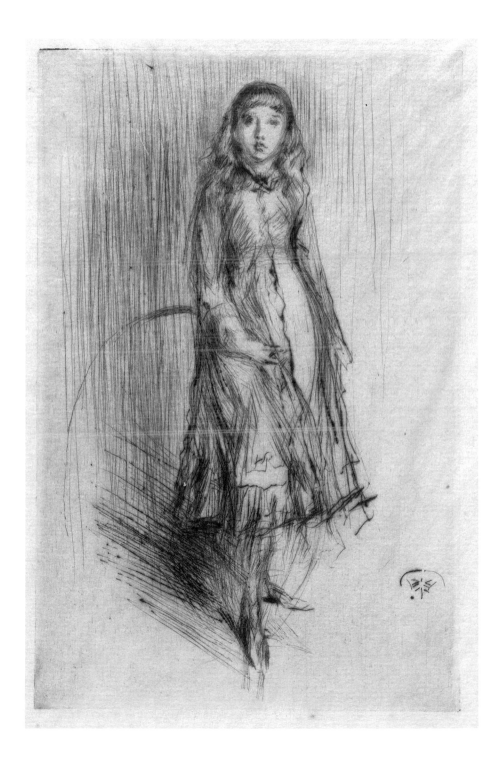

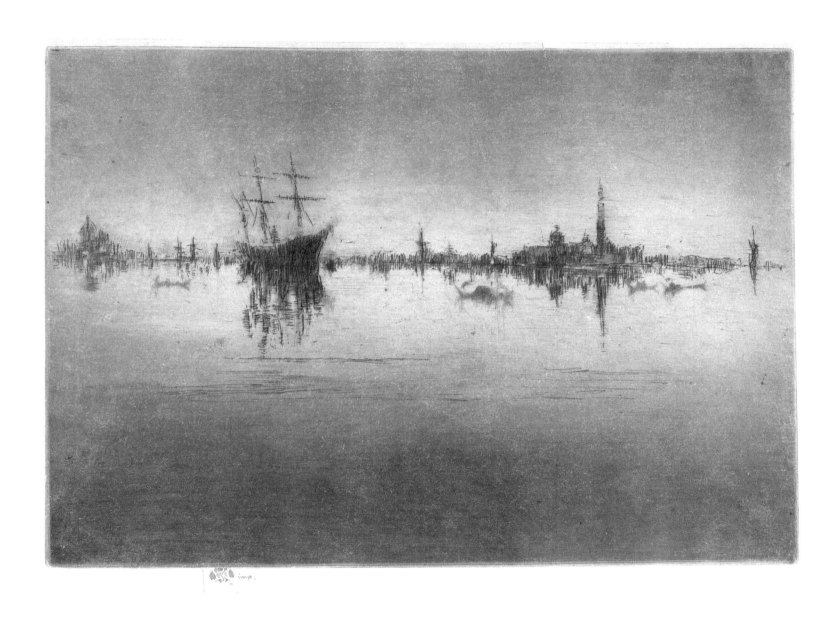

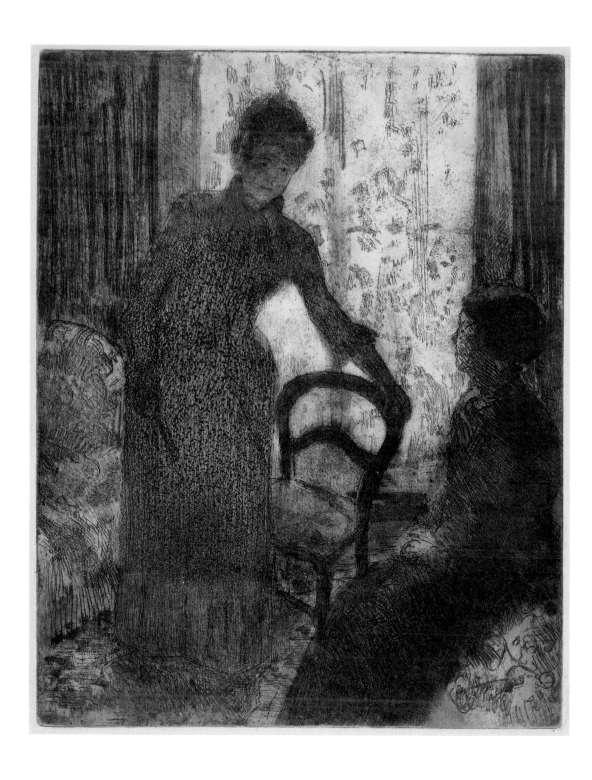

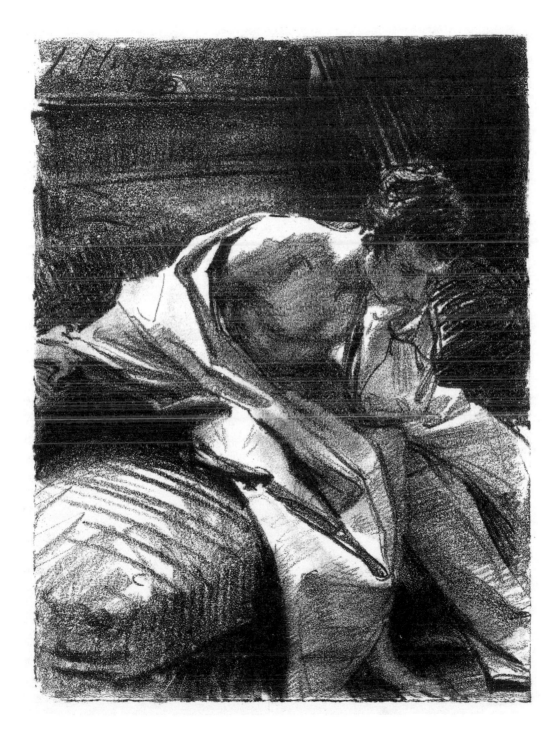

Lines Defining Land and Sea FRANKLIN KELLY

IN 1862 SCOTTISH ENGRAVER William Forrest completed a large print reproducing one of the most famous paintings of the day, *The Heart of the Andes* (1859) (fig. 1) by the American Frederic Edwin Church.[1] Measuring some six by ten feet, Church's massive canvas was a detailed depiction of a vast area of South American scenery, ranging from a tropical lowland jungle to the snow-capped peaks of mighty mountains. Church presented a wealth of visual information in the painting, using a precise and detailed style to depict the facts of the natural world with a high degree of realism. Viewers who saw the picture on its multicity tours in America and England were amazed and enchanted, and many signed subscription lists to purchase a copy of the engraving once it was available. Remarkably, Forrest managed to achieve a comparable synthesis of close detail and sweeping distance in the much smaller print, creating an accurate transcription that could be reproduced multiple times and purchased at an affordable price (pl. 42). Although reproductive prints such as this could not convey the sheer size and coloristic impact of original paintings, they were significant factors in bringing landscape imagery to a wide audience in America.

Church, along with Thomas Cole, Asher B. Durand, John F. Kensett, and other members of what became known as the Hudson River School (the Hudson River and its environs were a favorite, although not exclusive, subject) made images of American lands and seas the country's most important and popular genre of painting during much of the nineteenth century. The landscapes and seascapes of these artists ranged from quietly introspective and intimate images of forest interiors to sweeping epic vistas such as *The Heart of the Andes*, and from calm coastal views to scenes of storm-tossed oceans. In seeking picturesque and dramatic scenery, Hudson River School artists traveled widely throughout North America and to distant locales in the tropics of Central and South America, and even to the arctic environs of the far north. The works they created were received by American viewers as emblems of the unique character of New World scenery, optimistic visions of the promise held by those great spaces.

Several Hudson River School painters, including Durand and Kensett, were trained in printmaking, engraving in particular. However, landscape or seascape prints that stood as independent works in their own right were rare during the years before the Civil War. There were, to be sure, many reproductive prints made of Hudson River School paintings, ranging from small engravings published in popular magazines to ambitious works such as Forrest's *The Heart of the Andes*. Following the war, some artists did translate their painted visions of American landscapes and seascapes into prints that were fully independent works of art. Among them were two artists loosely affiliated with the Hudson River School, Thomas Moran and William Bradford. Both took up etching, which previously in nineteenth-century America had been most often used for reproductive images of artworks. The revival of interest in etching in France and England in the middle of the century similarly inspired artists in America. In 1877 a group including Moran, his wife Mary Nimmo Moran, Childe Hassam, and Joseph Pennell formed the New York Etching Club. Their goal was to create and promote etchings that went beyond the reproduction of paintings and could be deemed works of high art in their own right.

Thomas Moran began his career painting landscapes in the vicinity of Philadelphia but achieved greatest fame

FIG. 1 Frederic Edwin
Church, *The Heart of
the Andes*, 1859, oil on
canvas, Metropolitan
Museum of Art, New
York, Bequest of Marga-
ret E. Dows, (09.95).

for his views of the American west. Initially celebrated for his large paintings of the Grand Canyon and the valley of the Yellowstone (many of which provided the basis for widely circulated, inexpensive chromolithographs), Moran also ventured into other areas in search of inspiration. One of those places, the Mountain of the Holy Cross, in the Territory of Colorado, became the subject of works in all of Moran's preferred media: watercolor, oil paint, and etching. Among his depictions of the site are a large oil painting of 1875, an 1888 etching (pl. 51), and a watercolor of 1890; none of these images is a strict reproduction of the other.[2] In the etching Moran followed the general composition of his oil painting but made numerous variations in the details of the foreground and the middle distance. He gave the group of trees at center right more prominence, creating a striking contrast of dark forms against the snow and clouds in the

distance. He skillfully used the white of the paper to create the most energized areas of the print. In the sky, long sweeping lines define the shapes of surging clouds, creating volume out of areas of nearly blank paper. A contrasting movement is established by the stream as it falls over rocks; here the artist used more jagged lines to animate areas of the surface and create the sense of foaming, churning water. Moran was deeply influenced by the English artist J.M.W. Turner, and his fluent handling of sky and water in *Mountain of the Holy Cross* is evidence of how well he had learned the lessons of that master's art.[3]

Marine painter William Bradford was best known in his own time (as he is today) for paintings, drawings, and photographs depicting scenes of the far north. He made only a few prints, and among the grandest and most accomplished is the etching *Among the Ice Floes* (pl. 52). It is closely related

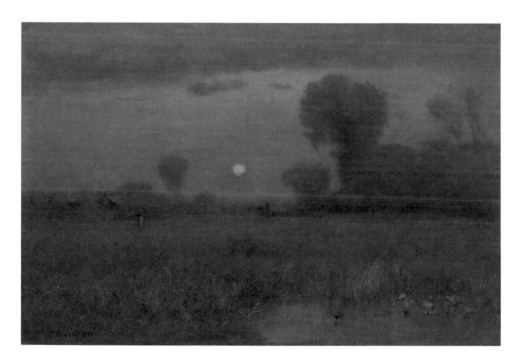

to two works also from 1890 titled *Arctic Explorers Cutting a Channel*: an oil painting and a charcoal drawing on canvas.[4] Bradford's etchings, it has been observed, "possess the same spacious luminosity of his best finished drawings… [he] was able to create shimmering textures [and] a full range of light and dark tonalities."[5] In *Among the Ice Floes* Bradford left large areas of the sheet blank for the white of the ice and icebergs, creating a strong visual contrast with the dark mass of the ships at the center of the composition. The dark and light areas stand out sharply against the dull, leaden sky, which Bradford achieved by using short, curving lines grouped thickly at the horizon and gradually thinning in the higher areas.

Moran's and Bradford's etchings are evidence of the survival of Hudson River School imagery and aesthetics in postbellum America. However, tastes had begun to move

away from such grandiloquent and dramatic depictions of land and sea and the cultural insularity they implied. This was manifest in the kinds of artistic productions that now rose to the fore. Works in which figures assumed more prominent roles — as in Winslow Homer's 1866 painting *Prisoners from the Front* — were now the subject of critical and popular acclaim. Admiration also grew for art that reflected greater awareness of contemporary European art, French and German in particular. New modes of depicting the natural world, seen especially in the works of French Barbizon artists such as Camille Corot and Théodore Rousseau, favored less emphasis on intricate detail and literal description and more reliance on unifying tonal effects and suggestiveness. The works of George Inness, especially the softly drawn and atmospheric landscapes he produced in the 1880s and early 1890s (fig. 2), epitomized a new, modern

FIG. 3 Winslow Homer, *The Life Line*, 1884, oil on canvas, Philadelphia Museum of Art, The George W. Elkins Collection.

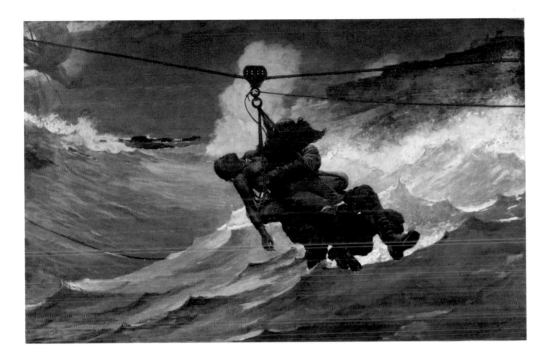

aesthetic that would be embraced by other artists, American printmakers not the least.

Winslow Homer's knowledge of printmaking dates to his earliest days as a professional artist. Beginning in the 1850s and continuing until the early 1870s, Homer provided images that were translated into wood engravings for popular publications such as *Harper's Weekly*. He experimented with etching early in his career, but it was only in the 1880s that he seriously began to explore the medium. Following a sojourn from 1881 to 1883 in Cullercoats on the coast of England's North Sea, Homer settled in Prout's Neck, Maine. There he commenced — beginning with *The Life Line* and concluding with *Eight Bells* — a series of powerful seascapes that brought a new level of drama and profundity to his art. After completing his painting *The Life Line* in 1884 (fig. 3), Homer made an etching of the subject, repeating the basic

format of the oil, but focusing visual interest on the central figures by making them larger in the overall composition.

In 1886 following his completion of the painting *Eight Bells*, Homer returned to etching. In the print *Eight Bells* (pl. 45) he echoed what he had done in his earlier etching of *The Life Line*, again increasing emphasis on the figures, making them larger and eliminating some of the ship's rigging. During 1887–1889 Homer completed several other etchings based on his American and English marines; the largest of these was *Saved* (pl. 46). Here he returned to the subject of *The Life Line*, but he now completely reimagined it to create a wholly new work of art. The positions of the man and woman are reversed from the earlier painting and print so that they now move from right to left as the rope from shore is hauled in. As has been observed, "the figures seem to battle the weight and the wind with even greater difficulty, pushing

as well against the usual Western tendency to read a composition form left to right."[6] The angry sea is distilled into one mighty wave breaking against the rocky shore, its white foam represented by a large area of uninked paper. The overall effect is powerfully dramatic, making *Saved* "wilder and more frightening than the first two images."[7] For Homer's biographer Lloyd Goodrich, *Saved* was "no mere repetition of an early picture; it is a new creation — one of his most complete works in any medium."[8]

In contrast to Homer's grandly scaled and dramatic etchings, works by other printmakers of the time, including Mary Nimmo Moran, Albion Bicknell, Charles A. Walker, and Elbridge Kingsley, were smaller in scale, quieter and more restrained in effect. Mary Nimmo Moran's 1883 etching *Tween the Gloamin' and the Mirk When the Kye Come Hame* depicts a humble scene in the environs of her Long Island home (p. 43). The time of day is between dusk ("gloaming") and dark ("mirk"). Moran's deeply shadowed landscape beneath a dark, lowering sky is evocative of Rembrandt's prints, which were touchstones for her and other Americans during the etching revival. Mary Moran's preferred technique, which combined starting a plate out-of-doors while studying a scene directly and finishing it in the studio, differed from that of her husband, who executed his etchings completely in the studio.

Techniques besides etching were explored by artists influenced by the restrained, tonal style made popular by Inness. Boston artists Albion Bicknell and Charles A. Walker created monotypes, drawing in ink on plates that were pressed directly on paper, creating unique works.[9] Bicknell began his career as a painter. During time spent studying in Paris he came to know and admire contemporary French painting, including the landscapes of Barbizon artists. Although moderately successful as a painter, Bicknell achieved greatest recognition for his etchings and monotypes. Examples of the latter, including *A Sun-dappled Meadow by a River* (pl. 50), demonstrate the delicacy of his technique, which included wiping and blotting to thin the ink on a plate to varying degrees. As one of his contemporaries observed, "each print is individual and impossible to be duplicated as an oil painting. The softness of depth and brilliancy of this work defies all attempt at translation into words."[10] In comparison, landscape monotypes by Walker, such as *Evening on a River with a Boatman* (pl. 49), although portraying similar scenery, are generally more animated in effect. Walker created brittle lines by scratching the inked plate with the edge of a knife; then, once the print was made, he scratched again to expose the white of the paper itself.

The wood engraver Elbridge Kingsley made reproductive prints of the works of other artists, including Inness whom he knew well, and landscape images of his own meant to stand as independent works. For the latter, Kingsley preferred to work out-of-doors. He built a "camping car," a wagon-like conveyance that allowed him to make preparatory sketches and take photographs of landscapes, and sometimes make engravings directly from nature on wood blocks.[11] Kingsley's aesthetic, as in *New England Elms* (pl. 47), combined seemingly incompatible elements — a high level of detail with an overall tonal unity recalling the paintings of Inness. He described his method as being "faithful to the great masses and values, simplifying the form as much as possible . . . a matter of simple feeling and nerve-power held up to their best level till the work was completed."[12]

The landscapes and seascapes in this group, except Forrest's *The Heart of the Andes*, were created between 1883 and 1891. The variety and diversity they display — in technique,

interpretive approach to their subjects, and in actual appearance — testify to how richly fertile the artistic environment for printmaking had become in late nineteenth-century America. In these years the artistic status and independence of printmaking steadily grew, and that growth would continue in the coming new century.

1 See Gerald L. Carr, "American Art in Great Britain: The National Gallery Watercolor of *The Heart of the Andes*," *Studies in the History of Art* 12 (1982): 81–100.

2 See Joni L. Kinsey, "Sacred and Profane: Thomas Moran's *Mountain of the Holy Cross*," *Gateway Heritage* 11 (1990): 4–23.

3 Moran's etching includes a small image — known as a "remarque" — of a deer at the bottom left. Originally remarques were little sketches or scribbles made in the margins so that the artist could test the plate in trial printing; these would have been removed before pulling the final prints. During the etching revival such remarques became popular and artists often included them as part of the finished print.

4 See Richard C. Kugler, *William Bradford: Sailing Ships and Arctic Seas* (New Bedford Whaling Museum, New Bedford, MA, 2003), 41.

5 *William Bradford, Artist of the Arctic* (DeCordova Museum and New Bedford Whaling Museum, Lincoln, MA, and New Bedford, MA, 1968); reprinted in John Wilmerding, *American Views: Essays on American Art* (Princeton, 1991), 118.

6 Kathleen A. Foster, *Shipwreck! Winslow Homer and* The Life Line (Philadelphia Museum of Art, 2012), 76.

7 Foster, 76.

8 *The Graphic Art of Winslow Homer* (Washington, DC, 1968), 17.

9 See Joann Moser, *Singular Impressions: The Monotype in America* (National Museum of American Art, Washington, DC, 1970), 22–27.

10 From an article in *The Malden City Press*, November 12, 1881; quoted in Wayne Craven, "Albion Harris Bicknell, 1837–1915," *Antiques* 106 (1974): 446.

11 See *Catalogue of the Works of Elbridge Kingsley, Compiled & Arranged for Mount Holyoke College* (1901), http://babel.hathitrust.org/cgi/pt?id=chi.80803494;view=1up;seq=1 (accessed 27 August 2015).

12 Elbridge Kingsley, "Wood-Engraving Direct from Nature," *The Century* 25 (1882): 49.

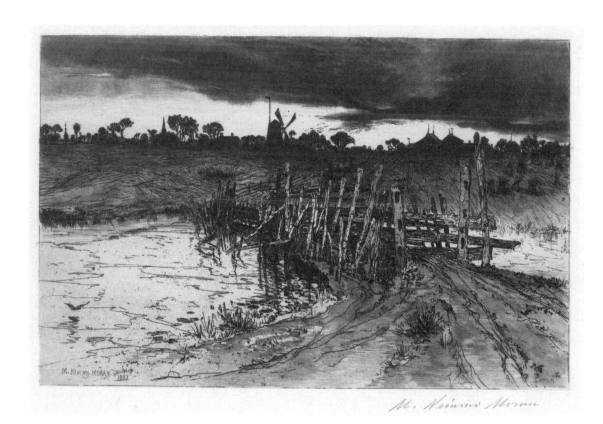

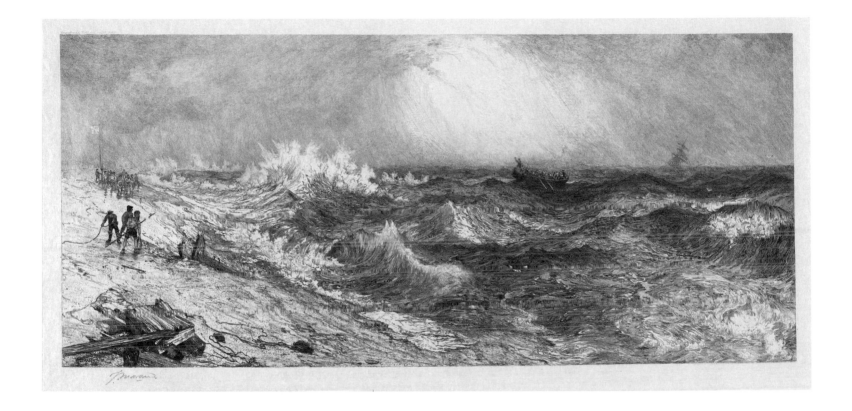

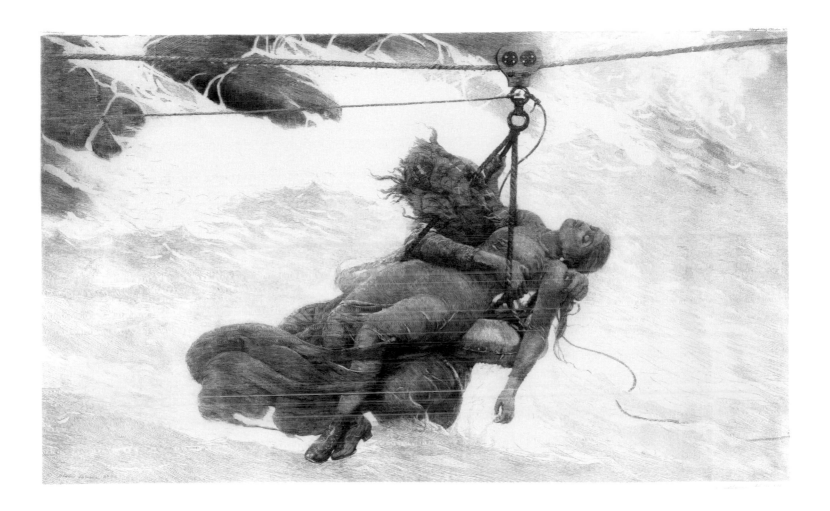

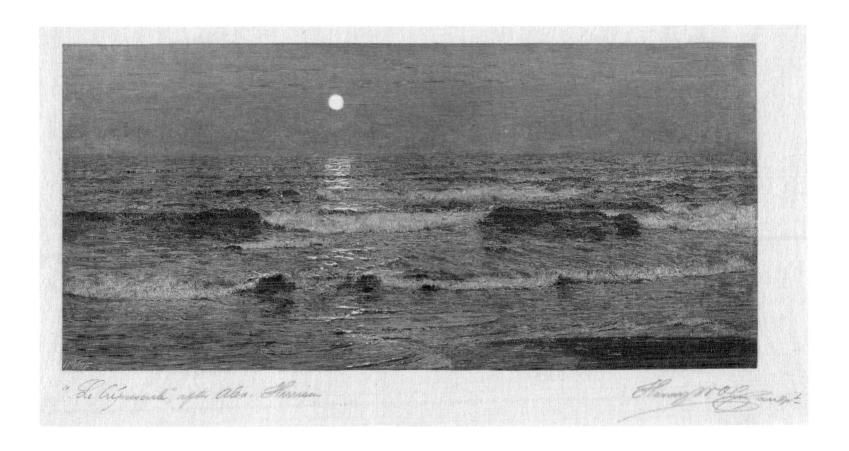

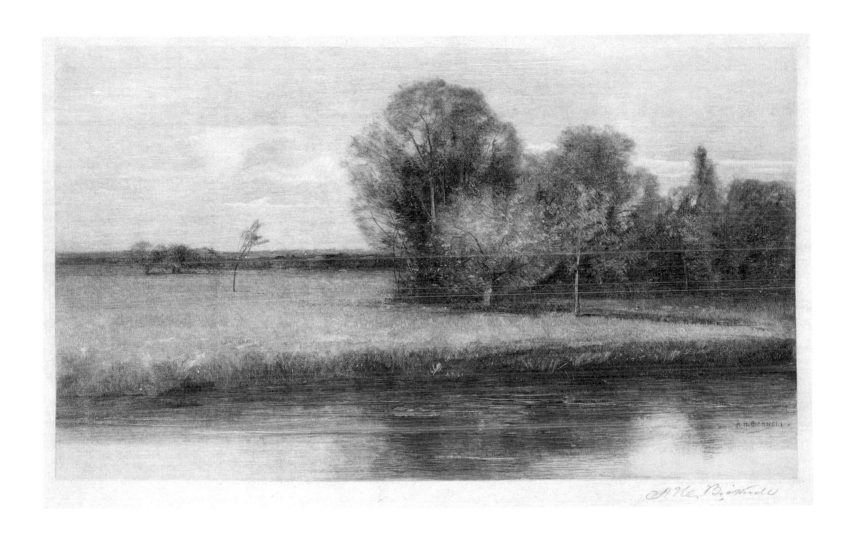

51 Thomas Moran, *Mountain of the Holy Cross, Colorado*, 1888, etching, roulette, and aquatint

Marking Distinction JOHN FAGG

THE CURVE OF A BARE BACK and the mass of a glimpsed thigh. Mary Cassatt's *Woman Bathing* (pl. 54) and John Sloan's *Turning Out the Light* (pl. 59) describe female bodies in striking and strikingly different ways that work within and against a visual culture flooded with images of women. Late nineteenth-century advances in photomechanical technology brought concomitant increases in the range and circulation of illustrated magazines, which created competition for fine art through high-quality reproductions and commissioned illustrations. Specialized magazines, such as *L'art de la mode* and the *Ladies' Home Journal,* as well as general interest publications proliferated idealized and conventionalized representations, making "the girl on the magazine cover" the "first mass-media stereotype."[1] All of the prints in this section, including Maurice Prendergast's *Six Ladies in Elegant Dress* and *Central Park,* register this phenomenon (pls. 57, 58). Cassatt and Sloan did not radically break from such imagery, but their subtle shifts and defamiliarizations do produce alternative representations of women.

While Sloan as a jobbing illustrator was immersed in popular culture, Cassatt's wealth and position in Paris art circles kept her at some distance from it; when she said "I hated conventional art," she meant salon painting.[2] But Cassatt understood the series of drypoint and aquatint prints that she made in 1891, which includes *Woman Bathing* and *The Letter* (pl. 53), as a step toward a wider audience:

> I love to do the colored prints, and I hope the Durand-Ruel's [gallery] will put mine on the market at reasonable prices, for nothing, I believe, will inspire a taste for art more than the possibility of having it in the home. I should like to feel that amateurs in America could have an example of my work, a print or an etching for a few dollars. That is what they do in France.[3]

The proximity of their enterprise — creating and reproducing multiple images of women — to that of mass-market illustration heightened the need for distinction in Cassatt's and Sloan's printmaking.

The woman's exposed back in Cassatt's print is at once part of a body intimately seen and an element in a complex play between volume and flatness. As critic Félix Fénéon noted when Cassatt first exhibited these works, the color prints are "compositions without shadow, modeling, or values." Shapes of uniform and patterned color are placed in harmonious, unsettling, and abstract relation to one another and to the picture plane. But in his 1913 book on Cassatt, Achille Segard admired the way that she conjured a back that "is traced with a single stroke and yet is round and firm. It turns as naturally as do the soft backs of young women."[4] If Cassatt's woman thus offers the pleasure of female flesh to a gazing male, she also withholds it. With her face turned away, she presents herself not to the viewer but to her mirror, to the water in her basin, and to herself. In the compositional elements described by Fénéon, and in the way the finished works acknowledge the paper's fleeting contact with the inked plate, Cassatt's color prints display their difference in kind from the tactility of "soft backs."

"I like line work that is talking about *things,*" declared Sloan in a late-career reflection on his printmaking. In a similar vein he explained, "Realization comes through a feeling of the bulk and weight of the thing, the bruises you would get if you stumbled over it in the dark."[5] Sloan's thigh — the right thigh of a woman who turns purposefully toward the

man lying in front of her, his hands behind his head — is indeed a weighty thing. It presses down, indenting the bed and rumpling the sheets, anticipating the energetic physicality that will follow. From the woman's left side, where the glow of the soon-to-be extinguished lamp illuminates flesh and gown, to her right, which is cast in deep shade by dense hatching lines and emphatic strokes, Sloan creates striking chiaroscuro. This scene, like three others in his set of ten *New York City Life* prints (1905–1906) to which *Turning Out the Light* belongs, was glimpsed or imagined while looking out from his studio at neighbouring tenements and carries the voyeuristic frisson of spied intimacy. However, the woman presents herself not to the viewer, as in the manner of the girl on the magazine cover, but to her lover: his invited presence and her reciprocal gaze create a moment of positive objectification.[6] The narrative turn of the etching is from light to darkness, from the pleasure of seeing and being seen to the haptic experience of bodies in the dark, to which artist and viewer have no access.

Cassatt's and Sloan's treatment of bodies created obstacles to the ways in which mass-market art conventionalized women. The reproduction and imitation of fine art in illustrated periodicals produced complex dynamics of competition. Artists developed sophisticated techniques of narrative, composition, and facture — such as those associated with impressionist painting — to mark the sphere of fine art and differentiate their original works from reproductions. Late nineteenth-century fine-art printmakers invented "limited editions" and, as art historian Tom Gretton explains, adopted "newly marginalized technologies, first intaglio and then lithography, as their own, and made a virtue of the fact that these technologies were hopelessly slow and artisanal."[7]

Cassatt described her process to the art connoisseur and dealer Samuel P. Avery: "The printing is a great work; sometimes we worked all day (eight hours) both, as hard as we could work & only printed eight or ten proofs in the day."[8] When making the *New York City Life* series Sloan "liked to work at night when there would be no interruptions, and would often work until four or five in the morning."[9] The imprecisions of the color printing, the variance between pulls, and the presence of the artist's hand distinguish Cassatt's printmaking from photomechanical technologies. Sloan's autographic etching — the way his textured mesh of lines and hatchings becomes a distinctive signature across the series — set his work apart from the emerging house styles of commercial illustration. These signs of labored production encourage a reciprocal slow looking at odds with the quick flick of the magazine page.

Influences beyond the transatlantic world also contribute to the analogous strategies of differentiation and contrasting approaches to materiality in Cassatt's and Sloan's prints. Cassatt, like the other impressionists, was long fascinated by *japonisme* and took particular inspiration from a vast exhibition at the École de Beaux-Arts in 1890. Her series of color prints were, by her own admission, an attempt to imitate Japanese methods, though she explained: "Of course I abandoned that somewhat after the first plate, and tried more for atmosphere."[10] Ukiyo-e prints, the art of the floating world, inform the viewpoint and coloration as well as the sense of flatness and ephemerality in *Woman Bathing* and *The Letter*. Art historian Anne Higgonet argues that ukiyo-e revealed the conventionalized nature of Western vision: "Once Cassatt and [Berthe] Morisot had seen the female body through foreign eyes, they could begin to see it differently

themselves."[11] *Woman Bathing* and Cassatt's related print *The Coiffure* (pl. 55) acknowledge the rounded, tactile body fetishized, as in Segard's commentary, in Western art, but place it in an unfamiliar "atmosphere."

Soon after Cassatt made her prints, Sloan, then a young illustrator in Philadelphia, contributed to the transatlantic poster craze pioneered by Henri de Toulouse-Lautrec, Aubrey Beardsley, and Will Bradley that transferred the formal qualities of ukiyo-e to advertising and magazine art (fig. 1). Looking back on this phase of his career, Sloan observed, "Even in [my] Poster period, my work differs from Beardsley in being closer to the earth and less 'stylized Japanese.'"[12] Sloan did not distance himself from Japanese influences so much as their Western stylization: according to a 1912 diary entry, an exhibition of Katsushika Hokusai's drawings inspired him to visit "[New York] Public Library to see more Japanese work C[olor] prints. Very interesting lot. One, a mother suckling her child under a netting shield very beautiful and unusual."[13] Among the things that must have struck Sloan as unusual in Kitagawa Utamaro's *Mosquito Net for a Baby* (fig. 2) is its frank, earthy acknowledgment of the female body as something other than a locus of male desire.

Sloan's commitment to bodily frankness — to representing the body as a thing of weight and matter — led him to satirize the surrounding genteel culture, most pointedly in what he termed his "distortions," the humorous reworking of magazine illustrations.[14] Sloan "distorted" Sarah S. Stilwell's "stylized Japanese" *Saturday Evening Post* cover of a woman in a kimono playing a biwa (fig. 3). He drew in high-heeled boots that call out Stilwell's work as Western image-making dressed in the accoutrements of *japonisme*, and added naked

breasts peculiarly interwoven with the musical instrument, revealing the sexualized body coyly hinted at in the original. That Stilwell's cover echoes Cassatt's *The Banjo Lesson* (pl. 56), from the second group of color prints made later in the 1890s and at further remove from the defamiliarizing influence of ukiyo-e, suggests Cassatt's proximity to the conventionalized representation of bourgeois female leisure and the degree to which she relied on a complex iconography of motherhood to differentiate her work from it.[15]

The serial nature of mass-market magazines — their weekly and monthly repetition with slight variation of narratives, images, and ideas — was central to their appeal to consumers, who found pleasure and comfort in familiar features, and to publishers, advertisers, and other stakeholders, who harnessed this conventionalizing power to establish and reinforce patterns of thought and behavior.[16] The efforts that Cassatt and Sloan made to exhibit and sell their prints as complete sets were no doubt attempts to maximize value, but also suggest an investment in the capacity of the series over the individual work to create alternative structures of meaning. Cassatt's set depicts two women in different phases of the daily round of privileged Parisian life. Sloan's series takes in a broader sweep of New York society, but several prints focus on the moments in a tenement day that precede *Turning Out the Light*, including *The Women's Page*, which shows one woman at rest amid daytime chores, and *Man, Wife and Child*, where another woman is whirled in an exuberant dance by her returning husband. Perhaps later the same day *Roofs, Summer Night* follows the tenement dwellers up and out of the oppressive heat of their apartments to sleep (and cast furtive glances at one another) amid the wash hanging upon the improvised clotheslines.

Cassatt and Sloan do not so much reject mass-market visual culture as create counter-serials within it. Men figure in Cassatt's color prints to the extent they are the assumed reason for women's self-presentation in scenes of bathing and dress-fitting and the source of the wealth conspicuously consumed with nannies, lavish dresses, and afternoon tea parties. But the dominant thematic concern of her prints, underscored by their aesthetic coherence and self-sufficiency, is a markedly female sphere of companionship, motherly care, and attention to self. Sloan's tenement milieu of unkempt but nicely furnished rooms and frank but monogamous, heteronormative sexuality is one of familial domesticity roughened a little around the edges. That he pitched these etchings for photomechanical reproduction in *Collier's* magazine suggests their proximity to the mass-market magazines' aesthetic conventions and bourgeois values; that they were rejected marks their distinction from that world.

1 Carolyn L. Kitch, *The Girl on the Magazine Cover: The Origins of Visual Stereotypes in American Mass Media* (Chapel Hill, 2001), 192; see also Lisa Tiersten, *Marianne in the Market: Envisioning Consumer Society in Fin-de-Siècle France* (Berkeley, 2001), 133–141.

2 Quoted in Nancy Mowll Mathews, *Mary Cassatt: A Life* (New Haven, 1994), 342n.

3 Quoted from an unpublished chapter of Louisine Havemeyer's memoir in Nancy Mowll Mathews and Barbara Stern Shapiro, *Mary Cassatt: The Color Prints* (New York, 1989), 39.

4 Quoted in Mathews and Shapiro 1989, 39.

5 John Sloan, "Autobiographic Notes on Etching" in Peter Morse, *John Sloan's Prints* (New Haven, 1969), 387; John Sloan, *Gist of Art* (New York, 1939), 45

6 Martha C. Nussbaum, "Objectification," *Philosophy and Public Affairs* 24, no. 4 (1995): 249–291.

7 Tom Gretton, "Difference and Competition: The Imitation and Reproduction of Fine Art in a Nineteenth-Century Illustrated Weekly News Magazine," *Oxford Art Journal* 23, no. 2 (2000): 159.

8 Nancy Mowll Matthews, ed., *Mary Cassatt and Her Circle: Selected Letters* (New York, 1984), 221.

9 John Sloan 1969, 384.

10 Quoted in Frederick A. Sweet, *Miss Mary Cassatt: Impressionist from Pennsylvania* (Norman, OK, 1967), 121. On Cassatt and ukiyo-e see Colta Feller Ives, *The Great Wave: The Influence of Japanese Woodcuts on French Prints* (New York, 1974), 45–53.

11 Anne Higgonet, *Berthe Morisot's Images of Women* (Cambridge, MA, 1992), 192.

12 John Sloan "Major Influences" (n.d.), Whitney Museum of American Art, Frances Mulhall Achilles Library, Artists Files, John Sloan (1871–1951), Miscellaneous. On Sloan's poster period see also Michael Lobel, *John Sloan: Drawing on Illustration* (New Haven, 2014), 20–22.

13 *John Sloan's Diaries (1906–13)*, April 3, 1912. Transcribed and annotated by Judith O'Toole and based on originals in the Delaware Art Museum's John Sloan Manuscript Collection, Helen Farr Sloan Library & Archives.

14 For further discussion of Sloan's distortions, see John Fagg, "Chamber Pots and Gibson Girls: Clutter and Matter in John Sloan's Graphic Art," *American Art* 29, no. 3, 28–57.

15 On Cassatt in relation to late nineteenth-century visual representations of childhood and maternal care, see Anne Higgonet, *Pictures of Innocence: The History and Crisis of Ideal Childhood* (London, 1998), 57–58.

16 On magazine structure and hegemony, see Richard Ohmann, *Selling Culture: Magazines, Markets, and Class at the Turn of the Century* (London, 1996).

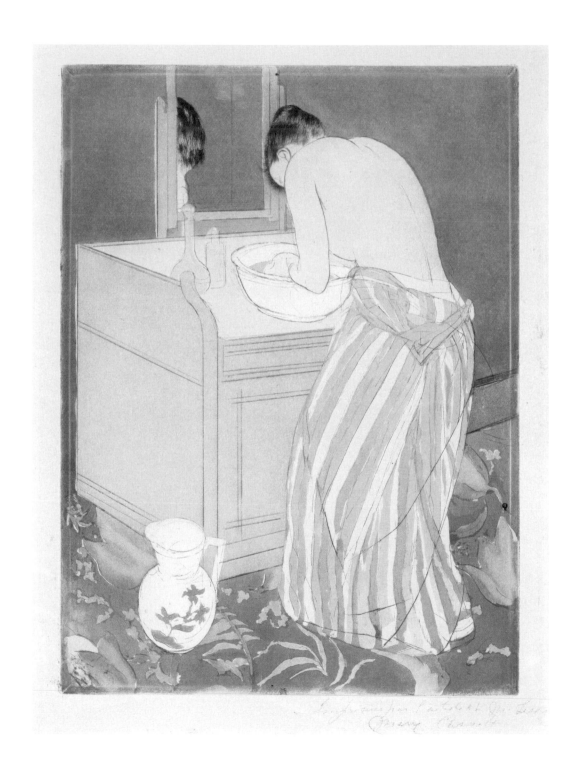

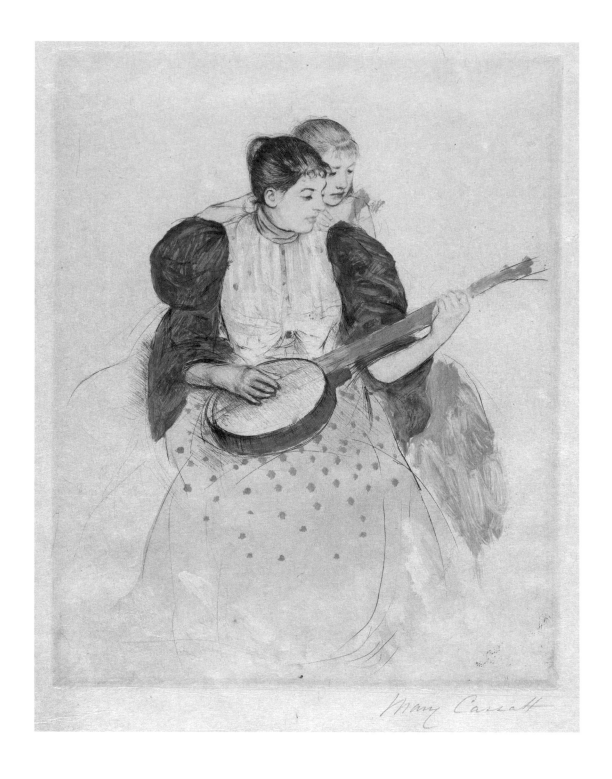

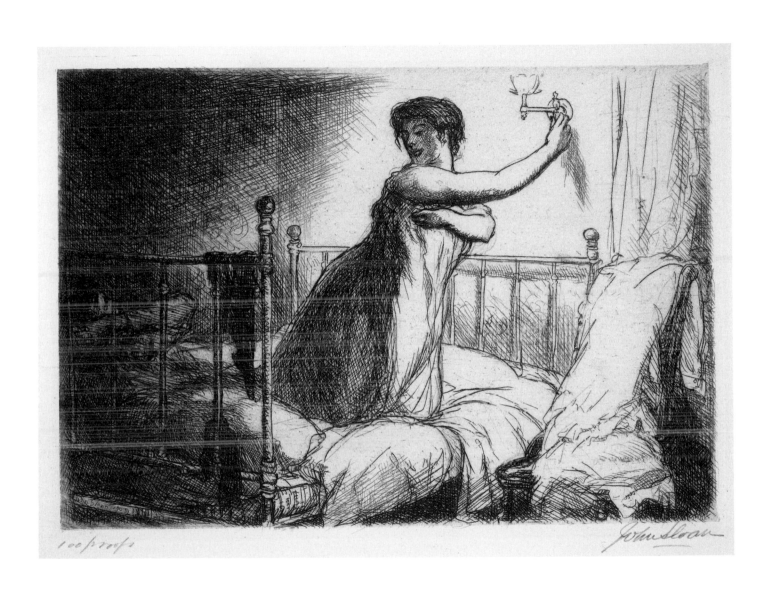

100 proofs

John Sloan

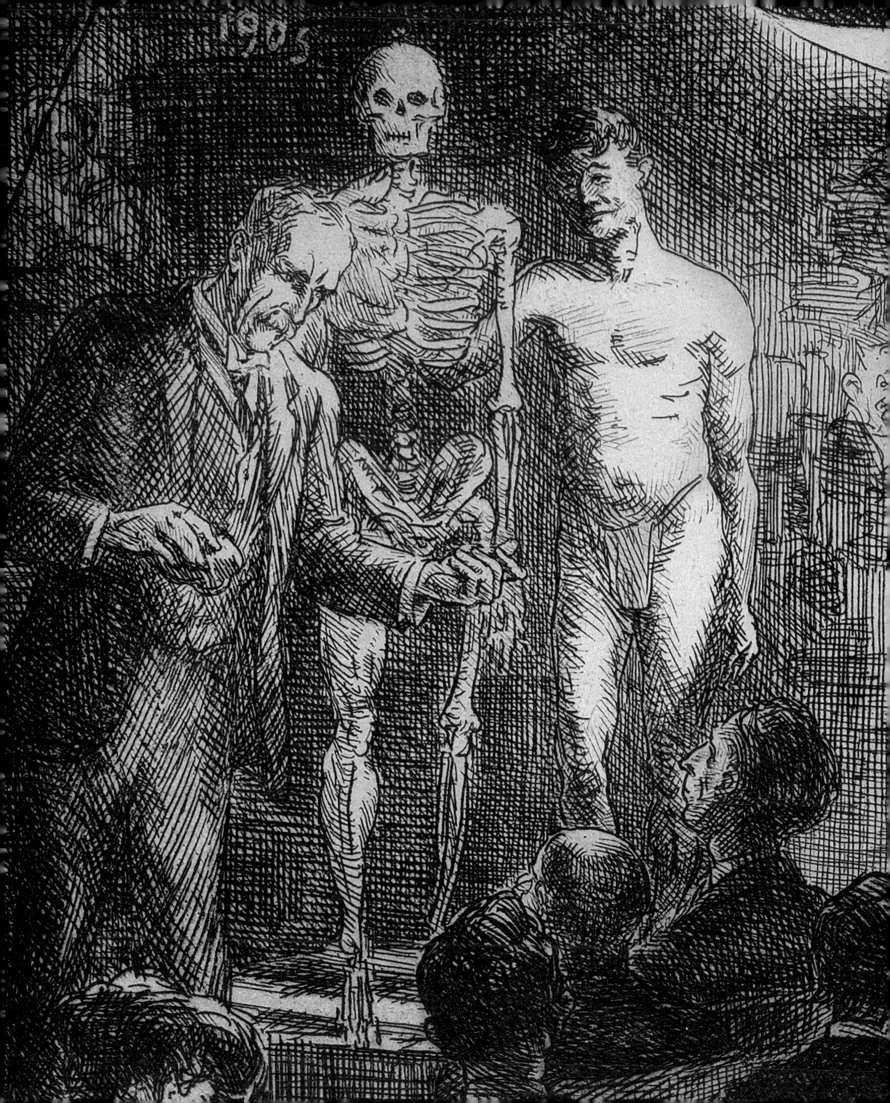

Building Bodies, Body Buildings: New York City around 1900 ADAM GREENHALGH

IN JOHN SLOAN'S 1912 ETCHING *Anshutz on Anatomy*, the respected art instructor Thomas Anshutz holds in his right hand a lump of clay (pl. 62). In his left hand he squeezes a fistful of the stuff, making it warm and pliable. Anshutz models muscles — he has formed from clay the musculature of the leg, chest, arm, and shoulder on the skeleton behind him. The model in the loincloth stands by to demonstrate anatomical function.[1] As Anshutz warms the clay, he inflames the imaginations of his rapt students, including some responsible for key prints in this section: Sloan is the bespectacled man standing, far right; George Bellows is the tall man near him.[2]

Sloan's print is an image of transfiguration — turning dirt into art. Sloan, Bellows, and the other realists commonly referred to as Ashcan artists explored the city's earthy vitality, producing images of "life in the raw."[3] They spelunked the urban netherworld, finding art-worthy subjects in the lowliest of places, including seedy riverside docks, saloons that hosted prizefights, and off-limits establishments like McSorley's Old Ale House, a male-only Bowery saloon where men could be found "maturely reflecting in purely male ways and solemnly discoursing, untroubled by skirts or domesticity"[4] (pl. 63). Expressing the dynamic energies of the city, the prints in this section testify to the pleasures and anxieties provoked by the shadowy crevices and the skyscraping peaks of the metropolis by drawing on period metaphors of transfiguration (like Anshutz with his fistful of clay) to represent the city's swelling population and erupting skyline.

Between 1890 and 1920, the period demarcated by the prints in this section, New York City's population increased nearly fourfold from 1.5 million to 5.6 million.[5] People streamed into the nation's most populous city from rural areas and from abroad. The bull's-eye of an illuminated sign at the heart of Charles Mielatz's *A Rainy Night, Madison Square* dubs Manhattan "The Center of the United States" (pl. 60). New York's status as the nation's financial, commercial, and labor-force hub was reflected in the skyline's increasing verticality as insurance companies, banks, real estate speculators, and commercial enterprises demonstrated their wealth by erecting ever-taller buildings. The cluster of shadowy buildings in Mielatz's print occupies the trapezoid of land bounded by 5th Avenue, 23rd Street, and Broadway. Those buildings would be razed and replaced within the decade by the iconic early skyscraper, the Flatiron Building.[6]

In 1907, the year before Joseph Pennell made *Hail America* with its tenebrous and rather menacing Statue of Liberty towering above Manhattan's crepuscular skyline (pl. 61), Ellis Island processed over one million immigrants. By 1910 over forty percent of the city's population was foreign-born. Beneath the Brooklyn Bridge, the location depicted in George Bellows's 1916 print *Splinter Beach*, was the kind of seamy location, thick with pollution, where hordes of immigrant children played and where "many artists gathered material for pictures."[7]

In Bellows's print, a tightknit cluster of nude and semiclad boys engage in a range of shenanigans — arguing, jostling, diving, lounging, etc. — on a splintery dock at the edge of the East River (pl. 68). The subject relates to a group of paintings of immigrant youths that Bellows produced during the first decade of the century and derives specifically from a pair of closely related drawings dating from 1912 and

1913. The artist characterized the boys in *Splinter Beach* as "bathing urchins."[8] He subtitled the related 1912 *Splinter Beach* drawing *Wharf Rats*,[9] a slang term for criminal ne'er-do-wells who frequented the East River docks. By using this epithet for juvenile delinquents, Bellows drew on an established discursive practice that linked immigrants with dirty animals. In her popular 1899 exposé of New York City, Helen Campbell described a group of "kids" (a period term denoting young hooligans with predilections for mischief and petty crime) like those in *Splinter Beach* as "a swarm of cockroaches."[10]

Although *Splinter Beach* is an amusing and light-hearted scene of harmless youthful frolic, for Bellows's audience the cluster of grimy, writhing limbs and tangled, naked bodies would have evoked insects, vermin, and germs. Recent developments in bacteriology, coupled with the rising popularity of eugenic and evolutionary theories, facilitated the social construction of foreigners as dangerous, diseased, and contagious.[11] Popular imagery triangulated immigration, contagion, and swimming. In *The Fool Pied Piper* (fig. 1), a cartoon published in the satirical magazine *Puck* in 1909, Europe celebrates as Uncle Sam lures rat-human hybrids with ethnicized faces into the ocean toward the Statue of Liberty, a cringing cousin to Pennell's looming gatekeeper. Labeled "criminal," "murderer," "degenerate," and worse, the swimming rats carry the threat of defective genes, degenerate morals, and political unrest. Bellows's *Splinter Beach* "wharf rats" would have carried similarly contagious connotations. Bathing in municipal swimming pools and open-water floating baths was endorsed as a healthy and hygienic form of exercise, a way of quite literally cleaning

and controlling dirty lower-class bodies. But Bellows's swimming hole, populated with smoke-belching tugboats and compressed beneath the Brooklyn Bridge's blackened undercarriage, is far from salubrious.

The ethnic neighborhoods of New York's foreign-born working classes were described as pigsties, rookeries, dens, burrows, lairs, hives, and warrens. The photographer Jacob Riis condemned New York's tenement neighborhoods as "hot-beds of epidemics" and "nurseries of pauperism and crime."[12] Around 1900 the city itself was compared, as one historian has put it, to "a grubby, often odorous body."[13] The author Stephen Crane provided one of the more distasteful bodily metaphors for the city's tenement neighborhoods in his 1893 novel, *Maggie: A Girl of the Streets*, when he likened the "dark region" and "the dozen gruesome doorways" of the slum's "careening building[s]" to a giant mother that "gave up loads of babies to the street and gutter."[14]

This unpleasant obstetric image resonates with Bellows's lithograph: his young wharf rats, nesting beneath

the Brooklyn Bridge's protective maternal span, might be siblings to Crane's slum-gutter infants. Amusingly, Bellows explicitly rhymes the limbs of one of his boys — the naked boy slumped at lower right with splayed legs, fully exposed genitals, and a particularly rodent-like face — with the Gothic arches of the pier that support the bridge's deck, formally linking anatomy and architecture, body and building.

Like swimming, boxing was lauded at the turn of the twentieth century by advocates, including Theodore Roosevelt, as a beneficial, vigorous, and masculine activity that would make men out of enervated Americans. *A Stag at Sharkey's*, which depicts an illicit, members-only prizefight, fashions boxers as both atavistic brutes and pure force (pl. 69). The lithograph reworks a painting of the same title that Bellows made in 1909 when prizefighting was illegal in New York. Illicit bouts were held in members-only venues such as the Sharkey Athletic Club, located at 65th Street and Broadway. Bellows made the lithograph in 1917 when, after a period of legality, prizefighting was once again prohibited in New York.

The "pleasure" derived from prizefighting was summed up in a 1910 newspaper report that connected the "primitive combat" of the boxers with the vicarious devolution of the spectators.[15] Bellows blurs the distinction between the bloodlust of combatants and spectators by eliminating the ropes that would ordinarily separate the former, "filled with demonic energy,"[16] from the latter, "a sodden set of brute 'mugs.'"[17]

Bellows's antagonists engage in a dynamic, mechanical dance of thrust and counterthrust. Each body appears to exert a force equal and opposite to the force of the other, like a diagram of Newton's third law of motion. The hardened, smoothly polished, and precisely balanced anatomies call to mind gleaming pistons, crankshafts, and flywheels.

Bellows was not alone in twinning bodies and machines. The author William Dean Howells compared the famous two-cylinder Corliss steam engine that impressed audiences at the 1876 Centennial Exposition in Philadelphia to "an athlete of steel and iron."[18] An illustration of the 45-foot tall machine in *Harper's Weekly*, in which an engrossed audience surrounds the massive, pyramidal, double-pumping dual mechanism, is strikingly similar to *A Stag at Sharkey's* (fig. 2). Jack London, in his 1909 short story "A Piece of Steak," describes an aging pugilist as a worn out steam engine and his youthful opponent as "a mechanism of steel and springs balanced on a hair trigger…slipping and leaping like a flying shuttle in a machine loom."[19] And a 1910 article, "Punches Which Would Run Factories," calculated that blows traded in an upcoming heavyweight match would generate a whopping 11,700 horsepower.[20]

By configuring boxers in terms of mechanistic forces, Bellows echoes the discourse of thermodynamics, a branch of physics that around 1900 provided the framework for a popular social, historical, and biological model.[21] *A Stag at Sharkey's* jibes with historian Henry Adams's interpretation that "man is a thermodynamic mechanism."[22] Proponents of a thermodynamic worldview concluded pessimistically that the world was a closed system "unceasingly wearing itself out" and heading inevitably toward entropy.[23] *A Stag at Sharkey's* reads as a metaphor for the degradation of matter and the ceaseless expenditure of energy in a grim endgame.

In a seemingly more optimistic vein, John Marin described New York City as "alive; buildings, people, all are alive; and the more they move me the more I feel them to

FIG. 2 After Theodore Russell Davis, *Our Centennial—President Grant and Dom Pedro Starting the Corliss Engine*, wood engraving, published in *Harper's Weekly*, May 27, 1876, Yale University Art Gallery.

OUR CENTENNIAL—PRESIDENT GRANT AND DOM PEDRO STARTING THE CORLISS ENGINE.—FROM A SKETCH BY THEO. R. DAVIS.—[SEE PAGE 422.]

be alive."[24] He continued, "I see great forces at work; great movements;…the warring of the great and the small."[25] Marin wrote these statements for an exhibition at Alfred Stieglitz's 291 gallery that included a group of fourteen New York City watercolors to which *Woolworth Building, No. 1*, *Woolworth Building (The Dance)* (pls. 66, 67), and *Brooklyn Bridge No. 6 (Swaying)* (pl. 65) closely relate.

Hung together, Marin's watercolors of the Woolworth Building, the world's tallest from 1913 to 1930, described a progression from figuration to abstraction as the building "grows more and more assertive [and] begins to swerve and bend…until at the last…shows but a series of swirls."[26] There is a similar progressive serial relationship between Marin's etchings. *Woolworth Building, No. 1* depicts the "warring, pushing, pulling forces" that the artist sensed in the city's skyline.[27] In *Woolworth Building (The Dance)*, the counterthrusts of tower, trees, smaller buildings, and pedestrians are exaggerated, made more dramatic. The Woolworth Building appears to cleave from its foundations, blasting off in an explosive patchwork of curlicues, squiggles, and contrails.

While many viewers appreciated the "resistless exultation" of Marin's series, others saw catastrophe, calamity, and chaos.[28] "Extreme," "awry," and "disconcerting," Marin's "topsy-turvy"[29] tower was likened to "wreckage after an explosion"[30] and "a cyclone of color."[31] One reviewer felt compelled to clarify that Marin's Woolworth watercolors "are not a series depicting an earthquake,"[32] while another half-jokingly hypothesized that "some inebriated giant had gone swinging down Broadway putting buildings out of plumb."[33] Marin's watercolor Woolworth Building was "bulging out ready to fall down," and his Brooklyn Bridge

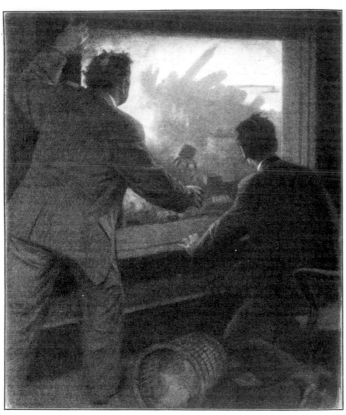

"LOOK, MY BOY, LOOK! THE LOWER FAULT HAS BROKEN!"

looked as though it was "struck by a ninety-eight mile [per hour] gale."[34] Such comments apply equally well to his etchings of the same subjects, in which the Woolworth tower dances and the Brooklyn Bridge sways.

By 1913 New York City's skyscrapers had been wrecked numerous times by natural, manmade, and supernatural disasters, albeit only in popular literature.[35] In Thomas Vivian's and Grena Bennett's 1909 story "The Tilting Island," a seismic catastrophe causes the "huge mass of skyscrapers with their cyclopean walls, their glistening summits...to quiver and rock and slide and topple"[36] (fig. 3). It is hardly surprising that New Yorkers, exposed to stories and illustrations teaching them to envision skyscrapers falling like dominoes (as in the picture window in "The Tilting Island" illustration), would see worrisome messages in Marin's prints and watercolors.

The cause given for the quake in "The Tilting Island" was the recent construction boom in lower Manhattan, "that mountain range of masonry with its towering peaks of copper and its titantic [*sic*] ribs of steel."[37] Such stories reveal anxieties about skyscrapers' structural soundness. They also reconfigure buildings as natural forces, the equivalents of hurricanes and tornadoes.[38] Even as they express the awe-inspiring power, energy, and commercial dynamism of the city, Marin's cataclysmic skyscrapers and bridges also provoked uncertainty. The explosive capitalist construction frenzy of the early twentieth century, embodied by skyscrapers like the Woolworth Building, caused fear of imminent collapse. What goes up, be it building or boxer, must eventually come down.

1 Peter Morse, *John Sloan's Prints, A Catalogue Raisonné of the Etchings, Lithographs, and Posters* (New Haven, 1969), 180. Sloan's print is based on a memory of six guest lectures on anatomy that Anshutz, a professor at the Pennsylvania Academy of the Fine Arts, delivered at the New York School of Art in 1905 at the invitation of his former student, Robert Henri. The date, along with "NYSA," appears in the print, floating like a thought bubble near the skeleton's cranium.

2 The profile portrait dead center annotated "GB" is a sketch of Bellows made on the wall of this studio by an unknown classmate. Morse 1969, 180.

3 Sadakichi Hartmann, "Studio Talk," *International Studio* 30 (December 1906): 183.

4 H. Hapgood, "McSorley's Saloon," *Harper's Weekly* (25 October 1913): 15; quoted in Mariea Caudill Dennison, "John Sloan's Saloon Etchings," *Print Quarterly* 22, no. 3 (September 2005): 306.

5 U.S. Bureau of the Census, *Census of Population*, 1890, 1900, 1910, 1920. See also Kenneth T. Jackson, ed., *The Encyclopedia of New York City* (New Haven, 1995), 920–923.

6 "Work of an American Etcher," *New York Times*, July 6, 1919, magazine section, p. 12.

7 Bellows, quoted in Robert Conway, *The Powerful Hand of George Bellows, Drawings from the Boston Public Library* (Washington, DC, and Boston, 2006), 46.

8 Conway 2006, 46.

9 Bellows, Record Book A, p. 132, no. 161; quoted in Jane Myer and Linda Ayres, *George Bellows, The Artist and His Lithographs, 1916–1924* (Fort Worth, 1988), 34.

10 Helen Campbell, Thomas W. Knox, and Thomas Byrnes, *Darkness and Daylight; or, Lights and Shadows of New York Life* (Hartford, 1899), 153.

11 Alan Kraut, *Silent Travelers: Germs, Genes, and the "Immigrant Menace"* (New York, 1994).

12 Jacob A. Riis, *How the Other Half Lives: Studies Among the Tenements of New York* (New York, 1890), 3.

13 Peter Conrad, *The Art of the City: Views and Versions of New York* (Oxford, 1984), 92.

14 Stephen Crane, "Maggie: A Girl of the Streets" (1893), in Joseph Katz, ed., *The Portable Stephen Crane* (New York, 1969), 7.

15 "Why All Mankind Is Interested in a Great Prize Fight," *New York American*, 3 April 1910, magazine section, 6; quoted in Marianne Doezema, *George Bellows and Urban America* (New Haven, 1992), 108.

16 Unidentified newspaper clipping in George Bellows curatorial files, National Gallery of Art, Washington, DC.

17 "Academy Exhibition — Second Notice," *New York Sun*, 23 December 1907, 4; quoted in Doezema 1992, 67. The critic is referring to *Club Night* (1907, National Gallery of Art, Washington), which was originally titled *A Stag at Sharkey's*.

18 William Dean Howells, "A Sennight of the Centennial," *Atlantic Monthly* 38 (July 1876): 96.

19 Jack London, "A Piece of Steak," originally published in the *Saturday Evening Post*, November 20, 1909; in Donald Pizer, ed., *To Build a Fire and Other Stories by Jack London* (New York, 1986), 258, 259.

20 "Punches Which Would Run Factories," *New York American*, 3 April 1910, magazine section, 6.

21 On literature's relationship to thermodynamics, see Mark Seltzer, *Bodies and Machines* (New York, 1992). See also Paul Staiti, "Winslow Homer and the Drama of Thermodynamics," *American Art* 15, no. 1 (Spring, 2001): 10–33.

22 Henry Adams, *The Degradation of the Democratic Dogma* (New York, 1920), 231.

23 Adams 1920, 255.

24 Marin, untitled statement, In An *Exhibition of Water-Colors — New York, Berkshire and Adirondack Series — and Oils by John Marin, of New York*, Gallery of the Photo-Secession, reprinted in *Camera Work* 42–43 (April–July, 1913): 18.

25 Marin in *Camera Work* 42–43, 18.

26 Samuel Swift, review in the *New York Sun*, in *Camera Work* 42–43, 23.

27 Marin in *Camera Work* 42–43, 18.

28 Charles H. Caffin, review in *New York American* in *Camera Work* 42–43, 42.

29 Boswell, review in *New York Herald* in *Camera Work* 42–43, 25.

30 W.B. McCormick, review in *New York Press* in *Camera Work* 42–43, 24.

31 J. Edgar Chamberlin, review in *New York Mail* in *Camera Work* 42–43, 23.

32 Boswell in *Camera Work* 42–43, 25.

33 McCormick in *Camera Work* 42–43, 24.

34 McCormick in *Camera Work* 42–43, 25.

35 Nick Yablon, *Untimely Ruins: An Archaeology of American Urban Modernity, 1819–1919* (Chicago, 2009), 243–288.

36 Thomas J. Vivian and Grena J. Bennett, "The Tilting Island," *Everybody's Magazine* 21 (September 1909): 389.

37 Vivian and Bennett, *Everybody's Magazine* 21, 388.

38 Yablon 2009, 266.

60 Charles Mielatz, *A Rainy Night, Madison Square*, 1890, etching, aquatint, and roulette on Japanese paper

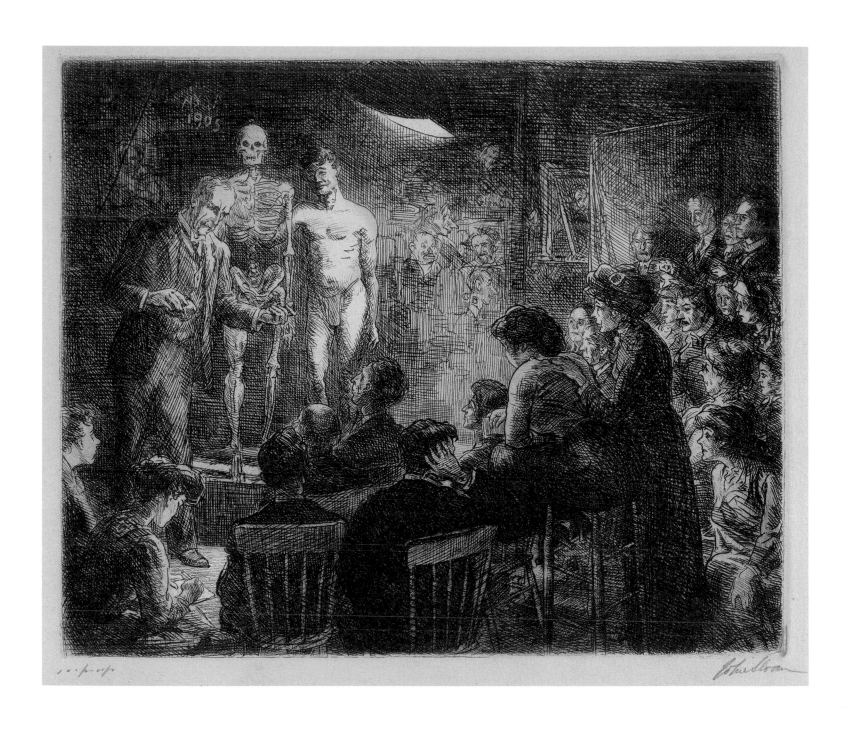

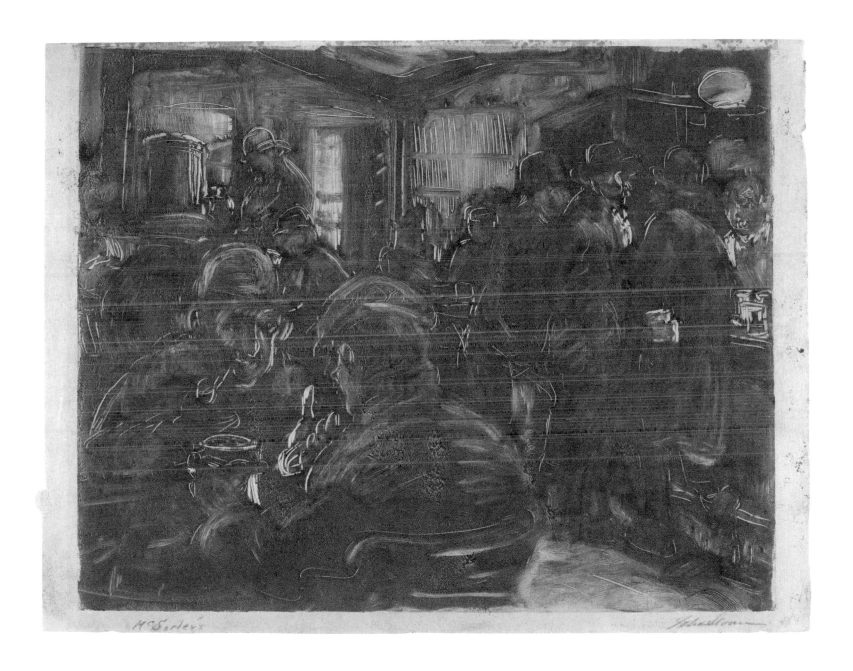

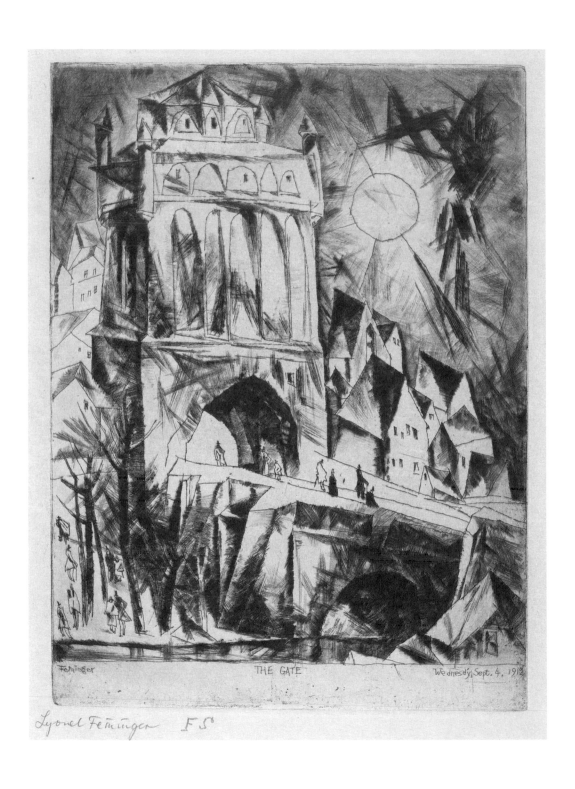

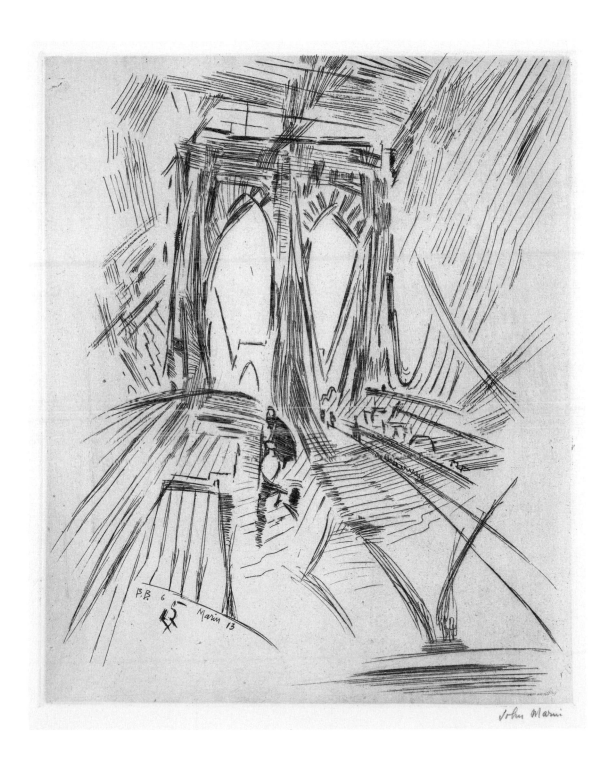

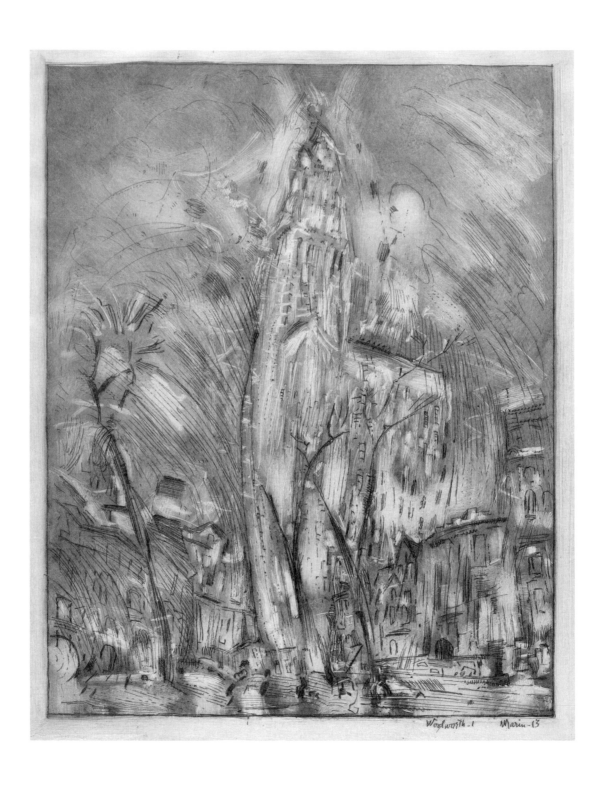

First Proof Splinter Beach Geo Bellows

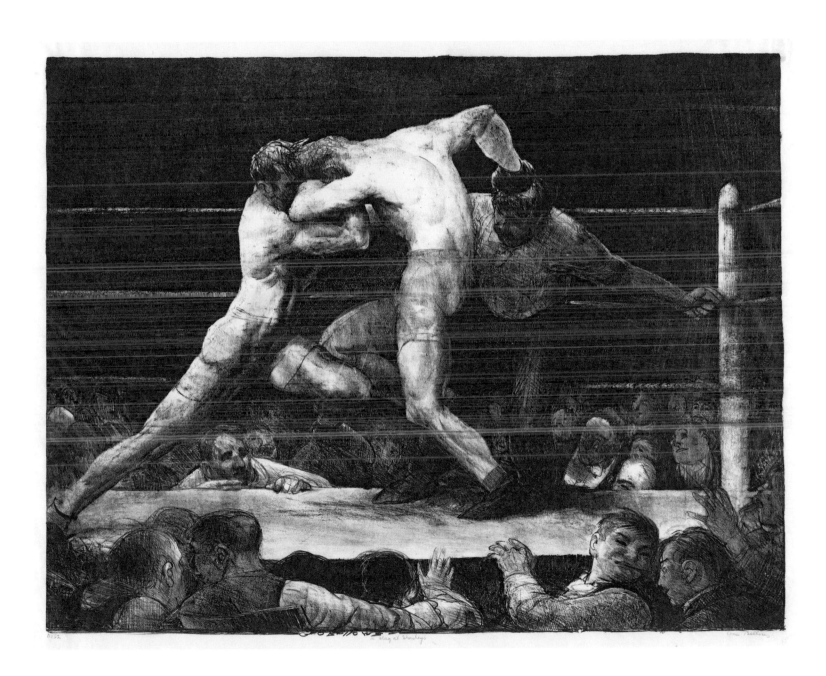

69 George Bellows, *A Stag at Sharkey's*, 1917, lithograph

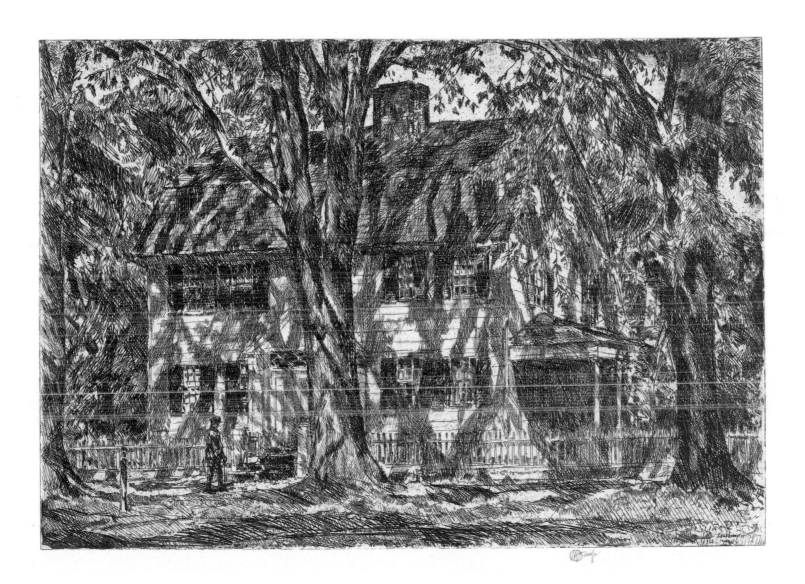

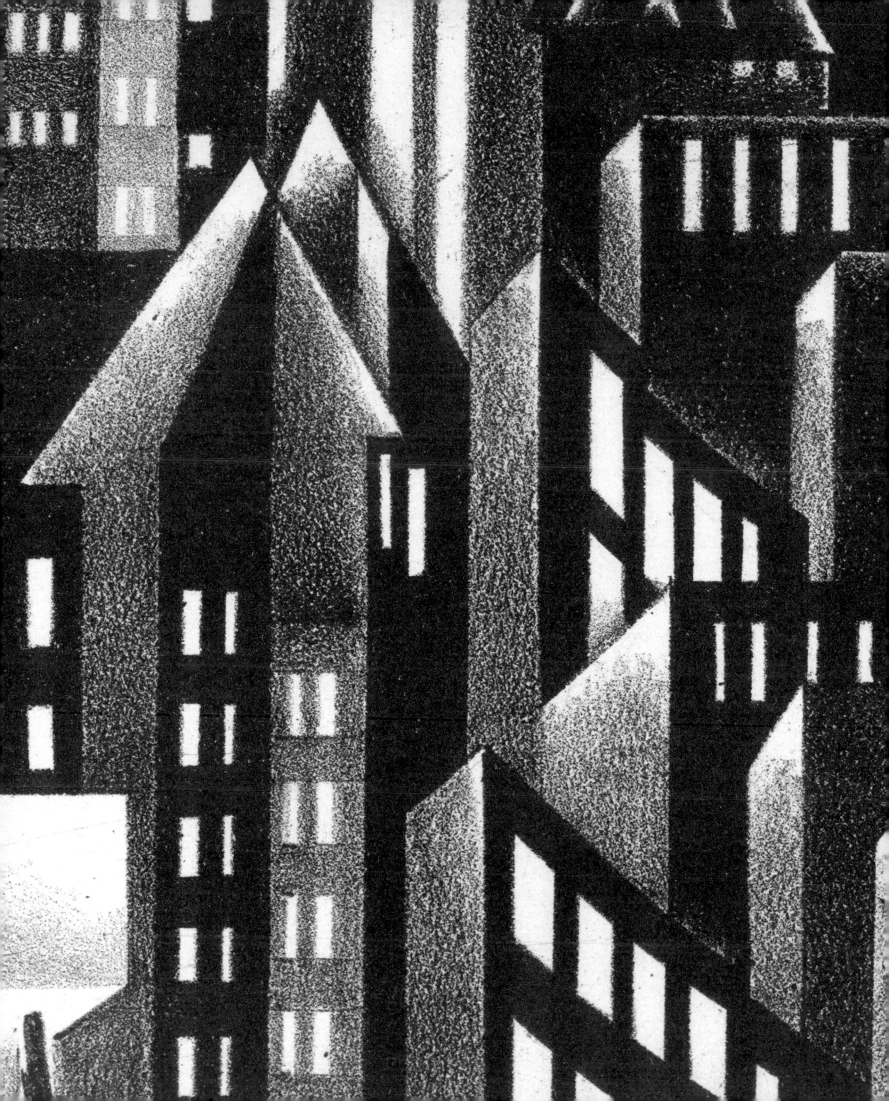

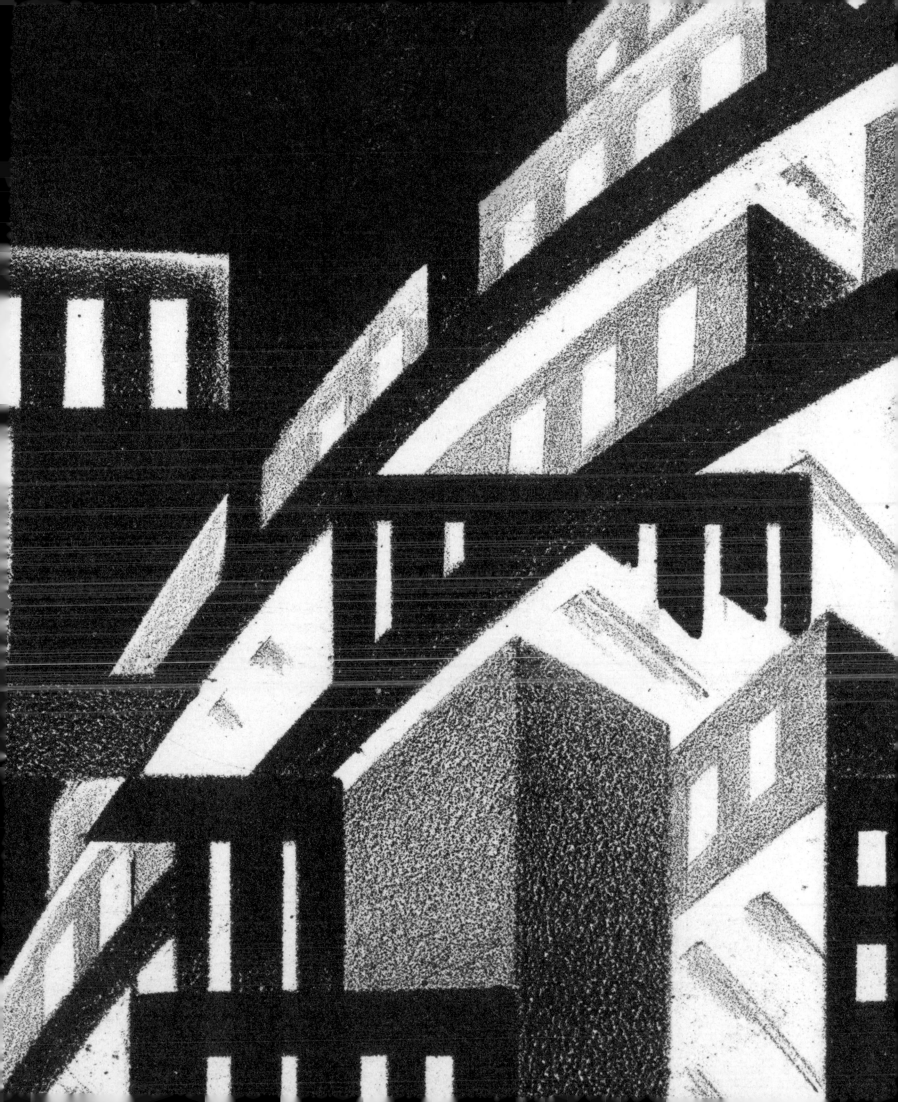

American Mosaic: Modern American Prints JOYCE TSAI

AS A LEADING MEMBER OF THE Ashcan School of American art, John Sloan is known as an artist who specialized in astute observations of city life. His abstract print *Mosaic*, therefore, appears hardly representative of his oeuvre (pl. 71). But the picture is not entirely abstract. Text fragments drawn from the biblical prohibition of graven images from Exodus 20:4 appear throughout the collage-like picture. Upon closer inspection, we find parted lips, fleshy fingers, and hidden at the lower right corner, an eye peering back at the viewer, bulging as if in horror or in rage.

Mosaic, Sloan remarked, was made in belated response to the Armory Show of 1913. The exhibition introduced America to the newest developments in European art — wild fauves, cold cubists, fevered expressionists, frenetic futurists, and many others. It proved sensational. That year Sloan published his response in the pages of the socialist magazine *The Masses*, to which he often contributed. The caption reads "A slight attack of third dimentia brought on by excessive study of the much-talked of cubist pictures in the International Exhibition of New York." Sloan's cartoon was one of many in the popular press that lampooned the ultra-moderns' drive to subject the body to willful abstraction (fig. 1). Seen in conjunction with that earlier cartoon, *Mosaic* might be read as Sloan's tongue-in-cheek commentary on how fervently the European vanguard renounced the conventions of figural representation, as if in obedience to Mosaic Law.[1]

The Armory Show and the controversy it provoked brought into view a particular American distrust of modern art, a perspective that *Mosaic* might appear at first to confirm. Yet Sloan was not hostile to the new art. In fact he belonged to a generation of artists that actively sought to free American art from the propriety of the dusty academy.

The Armory Show was mounted precisely to upset those sensibilities and Sloan himself participated in the exhibition. He delighted in what he perceived as a "bomb under conventions."[2] For Sloan and others, the disruption of conventions in the aesthetic realm might have ramifications in other domains as well. Viewed in this light, *Mosaic* hardly constitutes pure rejection. The print negotiated Sloan's attraction to and antipathy toward the abstraction and avant-garde strategies he encountered and speaks to what he identifies as the radical power of vanguard art.

Over the course of the twenties, Americans would shed their sense of cultural inferiority as Europeans came to view them not as the cultural rearguard but as exemplars of modernity. In the wake of World War I that laid waste so much of the Continent but left the United States unscathed and prosperous, Europeans grew ever more fascinated with American factories, skyscrapers, and automobiles. Louis Lozowick, who was born in the Ukraine and emigrated to America in 1906, traveled to Europe in 1920 to continue his studies in art. He discovered amid the cubists and futurists in Paris, dadaists and expressionists in Berlin, and constructivists in Moscow a mania for all things American. In a highly acclaimed series of paintings and prints, Lozowick presented his European audience with skylines of major American cities, executed in a vernacular that grew out of his encounter with German expressionism and Italian futurism. Made in Berlin, his lithograph *New York* compresses the sheer verticality of the Manhattan skyline into a dynamic, if not claustrophobic enclosure, like a backdrop for German expressionist cinema (pl. 75).

Lozowick left this expressionist mode behind but brought back to the States a faith in the capacity of art to modernize the viewer and society, a belief fostered by

Drawn by John Sloan.

his engagement with international constructivism and friendships with artists such as El Lissitzky and László Moholy-Nagy. His lithograph *Subway Construction* features a massive open trench alongside tenement buildings hung with lines of laundry (pl. 77). Neat, evenly spaced support beams visually link the structure underway with the elevated trains that already run above. This deeply optimistic image associates the construction of a subway not with disruption but with the ordered transformation of this working-class area.

For some African Americans, the metropolis promised not only economic opportunity but also refuge from the violence of lynch mobs in the rural south. James Lesesne Wells's woodcut *Looking Upward* speaks to the hope attached to the cities of the north, the skyscrapers rising up as if free from the strictures of old values and the burdens of the past (pl. 74). The central figure is dressed in the service uniform of a hotel or rail porter, the stripe of pants and flash of lapel suggested with two clean cuts. Upon a platter he balances a few buildings, as if holding the city's promise of a viable future in his hand. After all, it was in such service industries that African Americans would establish an economic and political foothold in the North during this period. Executed using the graphic shorthand of expressionism, the vanguard style of the print conveys its cosmopolitan outlook.

The optimism palpable in Lozowick's and Wells's prints that celebrate the grandeur of American technical and architectural achievements would give way to a period of anxiety in the thirties. The industrial productivity for which America was renowned took on a menacing cast in the hands of Carl Hoeckner, a German-born artist active in Chicago. His print *Cold Steel* was made in 1934, twenty years after the start of World War I (pl. 80). Shirtless factory workers

in a highly compressed space line up to produce for the war effort. They stand behind Allied soldiers whose gnarled faces peer from beneath their Brodie helmets, their bodies separated by the sharp blades of the bayonets and the heavy barrels of the machine guns. The picture is an indictment of war and production that sap the vitality of soldier and worker alike, transforming their bodies into sinewy husks, aged as if ghosts of the recent past or, seen now in retrospect, as menacing premonition of Germany's rearmament under Hitler.

Hoeckner, a member of the radical John Reed Club dedicated to inciting social and political change, was hardly alone in his sense of foreboding. In a speech delivered in 1936, American social historian Lewis Mumford remarked that in addition to the dire catastrophe of the Great Depression there loomed "the threat of war. We have seen…that depression and repression go hand in hand. When the economic situation gets so bad that people's minds must be moved from their own desperate plight, there is nothing so effective as to give them something else to think about, namely, a war." And war was already afoot in Europe, launched by fascists who sought to "exterminat[e] every other type of personality and every kind of social and political group."[3] To counter these threats, a call for collective action was produced and signed by more than three hundred artists. Mumford's speech was delivered at the organization's first meeting that February.

In a decade marked by isolationism and a sense of American nativism, the American Artists' Congress (AAC) was decidedly inclusive. Among its members were American and foreign-born artists, African, Asian, and Hispanic Americans. Realists and modernists, easel painters and propagandists, card-carrying communists and liberal progressives worked together for a time in common cause. The AAC organized exhibitions and publications, lobbied to secure a permanent federal arts project and to protect artists' rights, while also intervening on matters of domestic and international affairs, from anti-lynching laws to the Spanish Civil War. AAC members felt that without changing the economic conditions for artistic production, the artist would never truly be able to achieve free expression through his or her work. As a result, the democratic character of society would be lost and capitulation to tyranny and fascism would become a real possibility.

With the exceptions of Sloan and Wells, all of the artists featured in this section were involved with the AAC as members and signers of the organization's calls. Several also served in leadership capacities. Stuart Davis, known for his upbeat and decidedly American take on cubism exemplified by prints such as *Barber Shop Chord* (pl. 78), served as the national secretary of the congress. Max Weber, whose early cubist- and expressionist-inflected work like *Prayer* (pl. 72) helped establish his reputation as one of America's first modern artists, became its national chairman. Lozowick was a founding member. Given the range of styles and even subject matter pursued by individual members, it is clear that the AAC was created not to advance a particular aesthetic agenda, be it social realism or radical abstraction, but instead sought to establish conditions that would allow a free, critical, engaged art to flourish in tandem with contemporary life.[4]

The AAC had a few remarkably influential years between its founding in 1936 and 1939, when its membership peaked at nine hundred. But its links to the Communist Party eroded its influence in the wake of the Moscow Trials and

the signing of the Molotov-Ribbentrop Pact in 1939. These events discredited communism in America and created a rift between critics of the Soviet Union and its remaining loyal supporters. Many, including several founding members of the AAC, would resign by 1940. Others including Jolán Gross-Bettelheim maintained their participation in the AAC despite its continued support of Stalin. Gross-Bettelheim's work during these years reveals the depth of her commitment to the Soviet Union. Her print *Imperialism* from around 1944 shows workers and soldiers borne as if along conveyer belts with gas-masked civilians streaming toward the viewer. The workers are fed into the maw of a factory, producing soldiers who would be sacrificed meaninglessly on the battlefield (fig. 2). Her title betrays her adherence to the shift in communist policy. Instead of attacking Hitler with whom Stalin was now aligned through a non-aggression pact, Western imperialism was cast as the true enemy of peace in this print.

Once the United States joined the war in 1941, however, the sense of community and shared artistic purpose initially fostered by the AAC would return. Gross-Bettelheim submitted *Home Front* (pl. 81) to the exhibition *Americans in the War*, a print competition that opened simultaneously at several venues nationally.[5] Instead of condemning capitalist complicity, Gross-Bettelheim promoted domestic industrial productivity as a necessary contribution to American victory. Along with working men marching proudly to their shift, women rivet engines, and bombshells are lined up, ready for deployment.

Gross-Bettelheim was born in Hungary, trained in Paris, Vienna, and Berlin, and came to the United States in 1925. She was Jewish and a committed communist. But

during World War II she made New York City her home and created her art in service to the home front.[6] The *Americans in the War* exhibition, as in AAC shows in years past, showcased a broad range of approaches and featured the work of radicals and progressives, regionalists and modernists, foreign- and native-born Americans alike. *Americans in the War* was hardly the high-art affair that the Armory Show was three decades prior. Yet even in this exhibition, mounted as an exercise in patriotism during a time of crisis, there emerged a distinctly American mosaic. American art between the world wars proved remarkably expansive, responsive, and inclusive.

1 Michael Lobel, *John Sloan: Drawing on Illustration* (New Haven, 2014), 162.

2 Lobel 2014, 159.

3 Lewis Mumford, "Opening Address" (1936) in *Artists Against War and Fascism: Papers of the First American Artists' Congress,* ed. Matthew Baigell and Julia Williams (New Brunswick, NJ, 1985), 63.

4 Max Weber, "The Artist, His Audience, and Outlook," in Baigell and Williams 1985, 128.

5 Ellen G. Landau, *Artists for Victory* (Library of Congress, Washington, DC, 1983), 3, 42.

6 Lóránd Hegyi, "Introduction to the Exhibition of Jolán Gross-Bettelheim," in *Gross-Bettelheim Jolán, Retrospektív Kiállítása* (Budapest, 1988), n.p.

MOSAIC

John Sloan 1917

Delmonico Building Charles Sheeler.

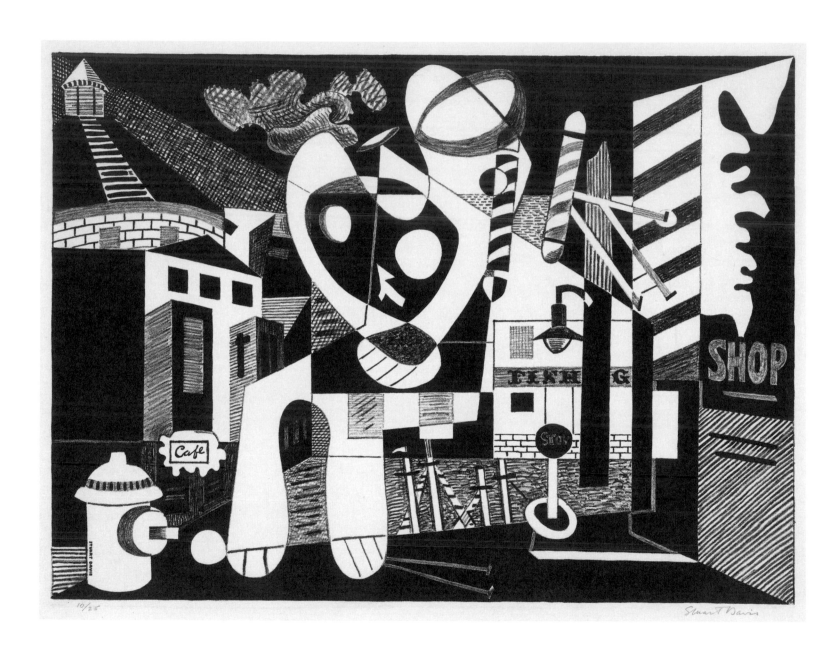

Cold Steel #29 Carl Hoeckner

"Just Looking": Prints, 1925–1940 DAVID M. LUBIN

IN ONE WAY OR ANOTHER most of the prints in this section display people engaged in optical activities such as gazing, looking, looking away, inspecting, and scrutinizing. These activities parallel those of the print connoisseur but also of the casual viewer who is transfixed by a print while strolling through an art exhibition or flipping through the pages of a catalog, present instance included.

Peggy Bacon's *Frenzied Effort*, for example, comically portrays art students, both male and female, studying a nude model in a life class (pl. 84). Or so we might think; on closer inspection, it turns out they aren't gazing at the model but rather at the rendition of her that each of them earnestly struggles to make. Reginald Marsh's *Eltinge Follies* shows men in suits looking variously attentive or bored as a statuesque nude parades her wares; the trumpet-playing putti affixed to the balcony appear livelier than either the spectators or the spectacle (pl. 91). Members of a very different audience are captivated by the onscreen masked villain in Mabel Dwight's *Stick 'Em Up*, while in Dwight's *Queer Fish*, spectators at an aquarium stare at large fish who stare back at them (pls. 85, 86). Railroad workers inspect a stationary locomotive in a train yard in Edward Hopper's *The Locomotive* (pl. 83); workmen repairing a city street at night concentrate their attention on an unseen blowtorch flame in Martin Lewis's *Arc Welders at Night* (pl. 89). In Marsh's *Tattoo-Shave-Haircut*, denizens of a crowded underground urban setting either attend to or ignore the passing parade of which they are a part (pl. 90).

In Isabel Bishop's *Noon Hour*, two young women on a lunch break inspect each other's faces as they engage in conversation; they are not shown looking at others, but we can assume that others are looking at them (pl. 87). In this and many similar studies, Bishop took what might be called a sociological view of working-class females interacting with one another during their moments of leisure in Union Square, where the artist maintained a studio. Drawing her protagonists in a loose, flowing style inspired by the seventeenth-century Flemish master Peter Paul Rubens, thus lending them romantic stature, she regarded these women, who belonged to a social class other than her own, with intimacy and respect but also abiding fascination, as if they were rare birds.

Lewis's *Stoops in Snow* shows city-dwellers trudging through a snowstorm, their heads lowered protectively, their gazes focused on the treacherous path before them as they literally watch their step (pl. 88). Lewis has filled the print with slashing snow that streaks across the paper surface. Sooty markings show where pedestrians have already trod, but their footprints are fragile and fleeting, soon to be erased by the accumulating whiteness. Snow here equals the absence of ink; in a sense, the snow we see is devouring the print, making it a self-consuming artifact. *Stoops in Snow* is indeed a bravura piece, dazzling the viewer with its technical finesse, but it is also philosophically provocative. By 1930 snow had long appeared in realist and naturalist fiction as an ominous force of nature, capable of snuffing out lives or otherwise disrupting human well-being; think, for example, of Stephen Crane's "The Blue Hotel" (1898), Theodore Dreiser's *Sister Carrie* (1900), Jack London's *Call of the Wild* (1903), Edith Wharton's *Ethan Frome* (1911), and from across the Atlantic, James Joyce's "The Dead" (1914). In *Stoops in Snow*, the accumulating whiteness poses no such threat. Instead it is simply a beautiful annoyance, disruptive but not destructive, a backdrop against which we observe

the quiet determination of the faceless, forward-thrusting figures who are themselves "stooped" in the snow.

Lewis achieves something of the opposite effect with *Arc Welders at Night*. Here night rather than snow, which is to say ink rather than the absence of ink, predominates. The only uninked portions of the picture are the small globules of white attached to lampposts in the distance and the shards of incandescence emitted from the unseen blowtorch, so intense against the darkness of the workers' forms that they wear masks to shield themselves from its glare. If *Stoops in Snow* depicts an ordinary urban setting magically transformed by a silent outburst of nature, *Arc Welders at Night* converts a mundane street corner into a mystical environment as rendered by a modern day Georges de La Tour.

In some ways the opposite of Martin Lewis's futurist magic realism is Reginald Marsh's Rabelaisian realism, crammed with detail. The seemingly infinite range of cross-hatched markings in *Tattoo-Shave-Haircut* is in keeping with the print's presentation of the metropolis as a nearly impenetrable forest of signs, not only verbal, as represented by the declamatory words in English (and Chinese) flung at the viewer, but also architectural (the iron trusses and cross-rails of the densely populated space) and social (as indicated by the plethora of faces, expressions, costumes, and body types). The title of the piece derives from the commercial offerings for men typically found in the underworld setting of a big-city subway or train station, but it also wittily refers to the artist's need to edit ("cut") and crop ("shave") his composition and, through inking and rolling, "tattoo" it to paper.

Hopper's print *The Locomotive* also depicts a proletarian, masculine world associated with trains, but without Marsh's comic self-reflexivity. Trains and tracks were a recurring motif in naturalist fiction, such as Frank Norris's *The Octopus* (1900) and Émile Zola's earlier, internationally influential novel *La Bête humaine* (1890), which Jean Renoir memorably filmed in 1938. In this body of work, trains on tracks symbolize inexorable fate, a destiny that, once set in motion, cannot be derailed. In Hopper's etching, the almost anthropomorphic engine overshadows the two conductors who engage in conversation while giving it a casual once-over. The scene Hopper provides is relatively innocuous, lacking in the alienation and implied violence found in similarly themed works by him such as his famous painting *House by the Railroad* (1925), in which train tracks in the foreground sever a dilapidated Victorian mansion from its surroundings, or in his print *American Landscape* (1920). But even here in this etching the relaxed pose of the inspectors is belied by the looming tunnel — a sign of the existential unknown — against which both men and machine are implicitly pitted.

Hopper is by far the best-known artist grouped in this section of the exhibition, and it is difficult in looking at some of the other prints on view not to be reminded of certain of his iconic images. Thus Lewis's *Arc Welders at Night*, with its illuminated storefront window in the background of the nocturnal urban setting, calls to mind Hopper's *Nighthawks* (1942), even though the print predates the famous painting by a good five years. Mabel Dwight's 1928 lithograph *Stick 'Em Up* reminds us of Hopper's 1939 *New York Movie* (fig. 1), although Dwight comically emphasizes audience reaction whereas Hopper focuses instead on isolation and estrangement (the solitary usher, a young working-class female, resembles one of Isabel Bishop's characteristic protagonists,

but unlike Bishop, Hopper does not provide her with the solace of friendship). Marsh's *Eltinge Follies* from 1940 satirizes the male prerogative to gaze unabashedly at a sex worker/entertainer, while Hopper's equivalent painting of a burlesque scene, *Girlie Show* (fig. 2), painted in 1941, eliminates the male spectators and concentrates on the single figure of an Amazonian chorus girl, the epitome of sexual self-assurance, modeled for the artist by his wife, Jo Nivison Hopper, to whom he had been married for seventeen years.

Both *Eltinge Follies*, which refers to a popular burlesque theater in Times Square that was sometimes raided by the police for public indecency, and *Girlie Show* address questions of male desire to look and female desire to be looked at (to invoke John Berger's well-known formulation from the early 1970s, which, to be sure, is complicated by the fact that the theater was named for Julian Eltinge, the most celebrated female impersonator of the early twentieth

century). The Hollywood director Dorothy Arzner, working with the New York novelist and short-story writer Tess Slesinger, contributed her thoughts on the dichotomous relationship between sexual looking and being looked at in her 1940 film *Dance, Girl, Dance*. Maureen O'Hara stars as a serious ballet dancer who takes a job in a burlesque house to make ends meet. When she attempts to perform ballet in front of the audience, the paying customers hoot and shriek for her to get down to business and remove her clothes. Incensed by their rude behavior she turns a steely eye on them and remonstrates:

> Go ahead and stare. I'm not ashamed. Go on, laugh, get your
> money's worth. Nobody's going to hurt you. I know you want me
> to tear my clothes off so's you can look your fifty cents' worth.
> Fifty cents for the privilege of staring at a girl the way your wives
> won't let you. What do you suppose we think of you up here, with

your silly smirks your mothers would be ashamed of?…We'd laugh right back at the lot of you, only we're paid to let you sit there and roll your eyes and make your screamingly clever remarks. What's it for? So you can go home when the show's over and strut before your wives and sweethearts and play at being the stronger sex for a minute? I'm sure they see through you just like we do.

For all its invective against male preening by means of sexualized spectatorship and trash-talking the performers, Arzner's *Dance, Girl, Dance* is comic rather than tragic, in the sense of accepting the highs and lows of the human condition, including the disparities of the sexes, instead of bitterly lamenting them. In that regard, the burlesque scene in Arzner's film has more in common with Marsh's satiric *Eltinge Follies* than it does with the sexual role-playing in Hopper's interpersonal marital fantasy scene *Girlie Show*. Peggy Bacon's 1925 drypoint *Frenzied Effort* also satirizes "naked" looking, only this time the female nude who is the object of the gaze is not a strutting chorus girl with high heels, G-string, and headdress but rather a bored young woman, not far removed from the world of Isabel Bishop's female working-class protagonists, who subjects herself with a scowl to the bourgeois gaze of about twenty middle-aged art "students." They, in deft contrast to the model, are clad head-to-toe in dresses, suits, sensible shoes, neckties, and ruffled collars.

Let us end by looking again at Mabel Dwight's comic portrayal of interspecies looking, *Queer Fish*. The lithograph dates from 1936, the same year that in a thriller called *Sabotage* the British master of suspense Alfred Hitchcock depicted a secret encounter between two would-be terrorists in the darkness of the aquarium in the London Zoo.

Hitchcock plays the setting for its creepiness and implied menace; the conspirators are as sinister-looking as the tortoises that swim past them while they hatch their plot. *Queer Fish* redoes Hitchcock in the name of comedy.

The four adults looking at the "queer" fish behind the glass resemble the two aquatic creatures in manifold ways, from the rotund form of the spectator on the right who stands aghast when his doppelgänger swims unnervingly close to the safety glass that separates them, to the dapper gentleman at the left who leans to the side in a soigné *contrapposto* that echoes the streamlined curves of the stingray. A third spectator, leaning forward, reveals a pleat in the back of his suit coat that mirrors the mouth of the fat, bug-eyed grouper, and the woman beside him, who also leans forward, supporting her weight with a foot on the railing, pushes back at the viewer a wide rear end that echoes the fish's rotundity. As we look at them as they look at the fish, we realize that we too are objects of spectacle, living within our own narrow, brightly illuminated display cases, "queer fish" in the broader scheme of things.

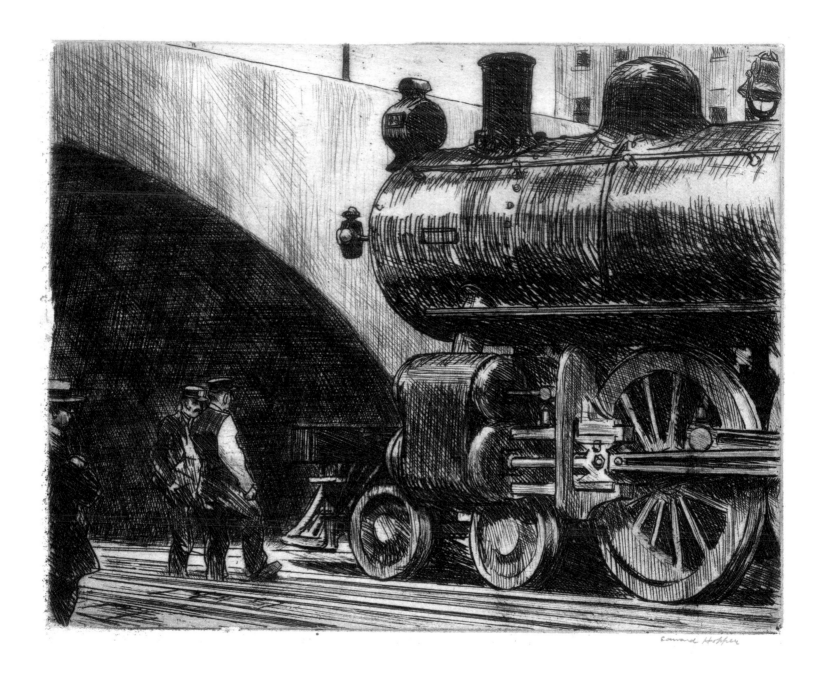

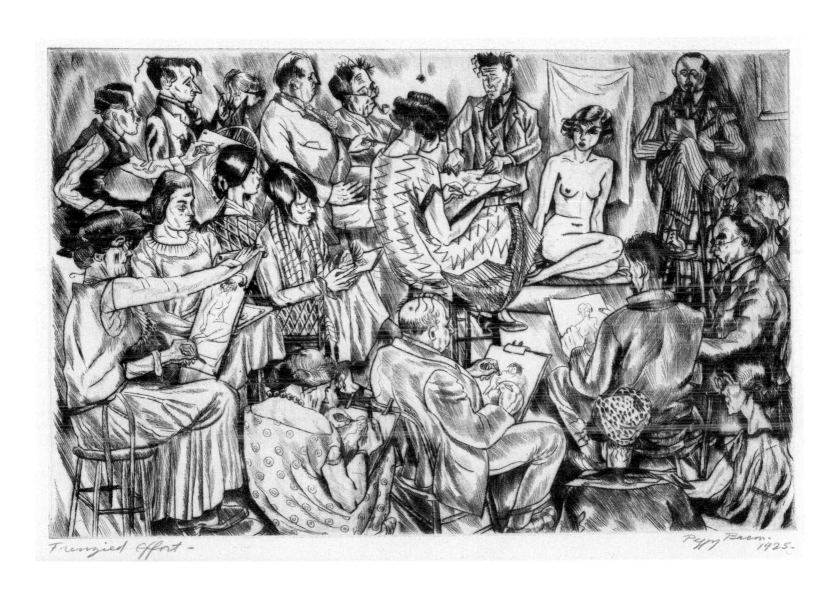

Frenzied Effort —

Peggy Bacon.
1925.

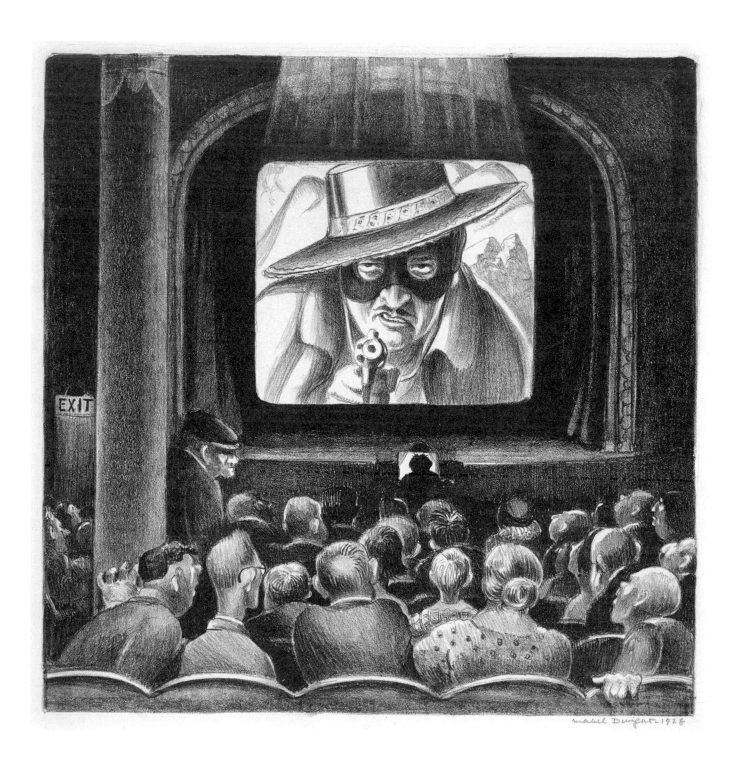

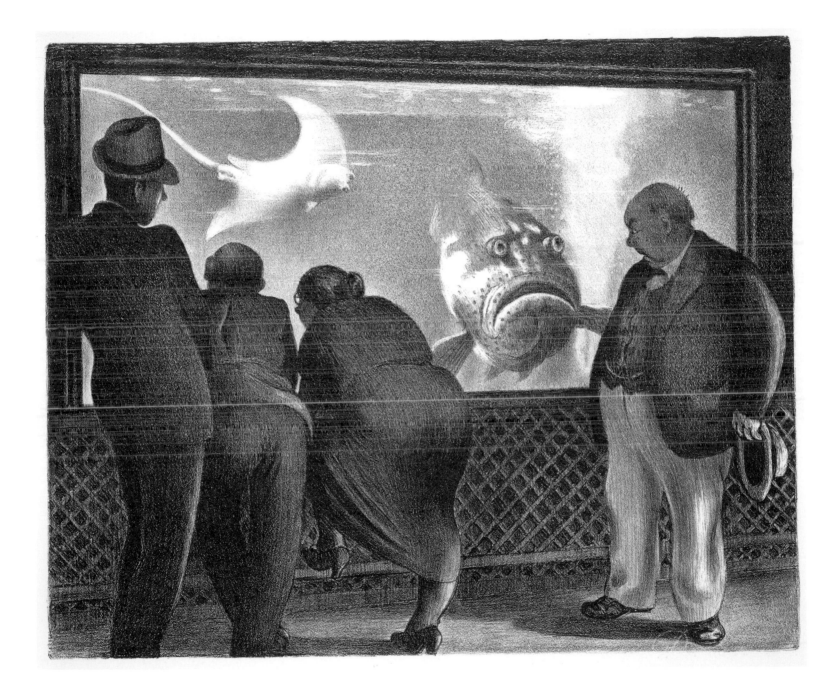

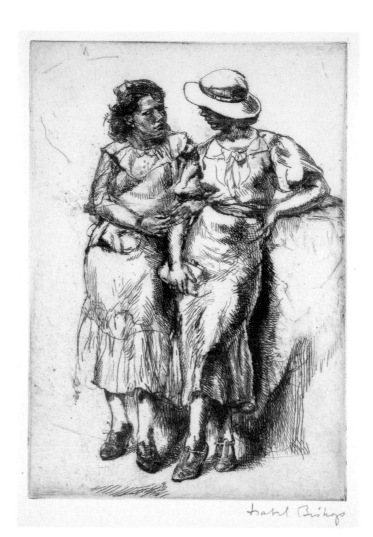

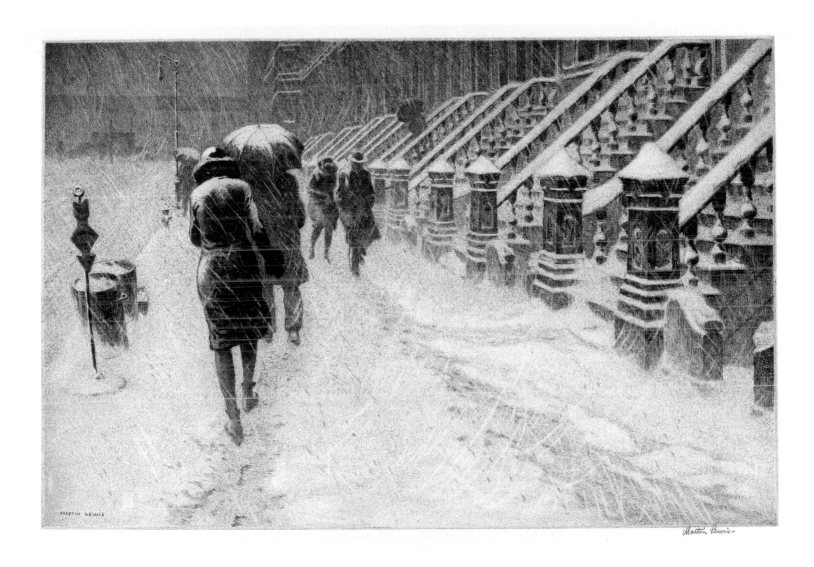

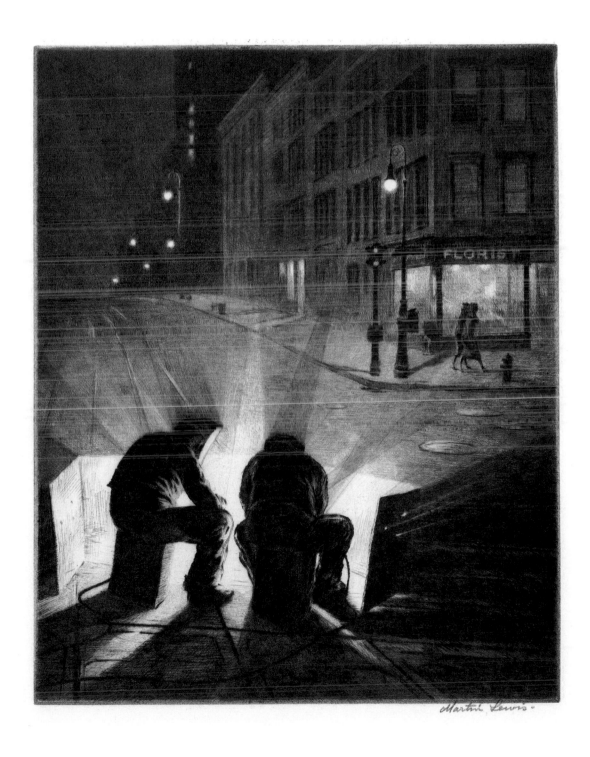

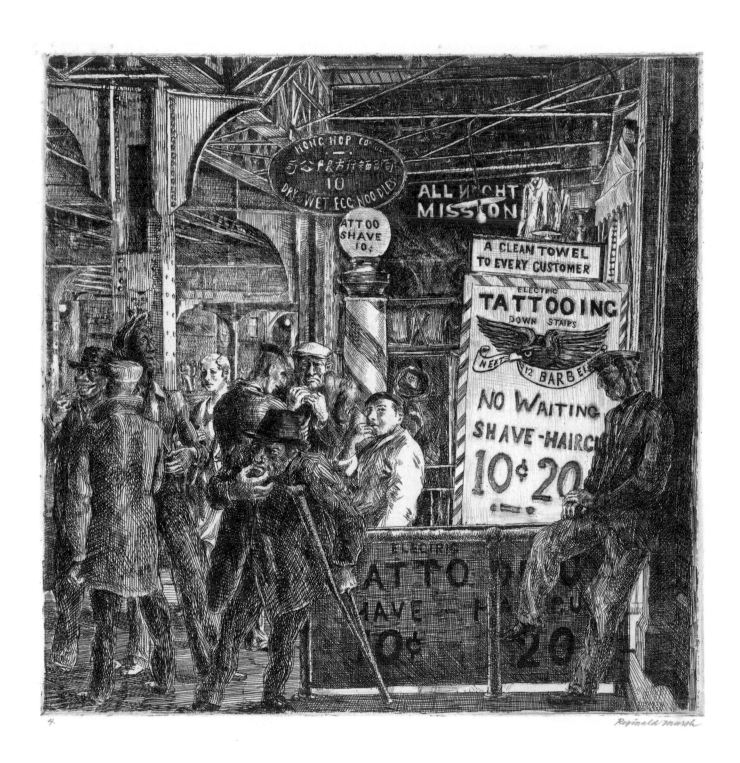

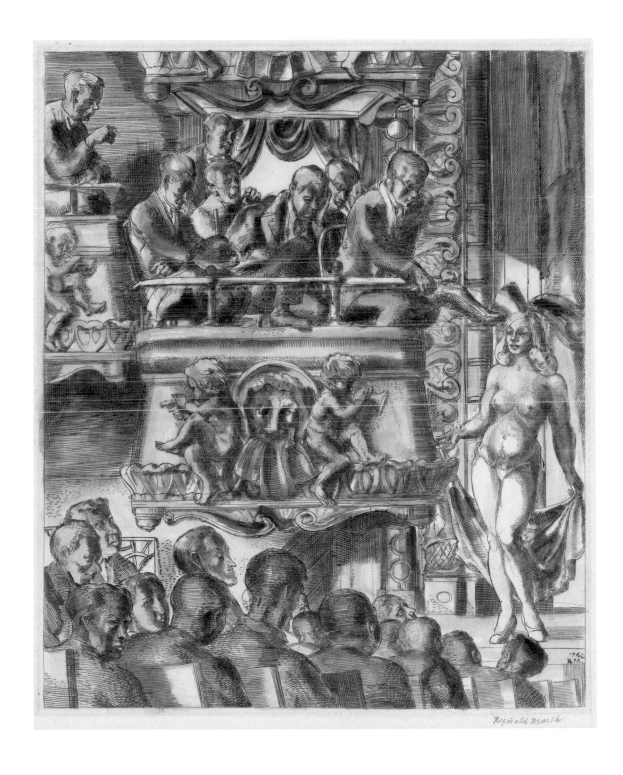

Mobility and Connectedness LEO G. MAZOW

MOBILITY IS A CENTRAL THEME in the history and continuing narrative of American life and culture. Several prints in this section portray the subject: the automobile in Thomas Hart Benton's *Departure of the Joads* and the railroad tracks in Edward Hopper's *American Landscape* (pls. 103, 102). Eugene Morley's *Jersey Landscape* shows a viaduct and a petroleum storage tank, while Elizabeth Catlett's linocut of Harriet Tubman and Robert Gwathmey's *The Hitchhiker* represent individuals traveling by foot, or trying to do so. (pls. 100, 97, 99).

Insofar as these works show means of transportation, of getting from one point to another, they also address what we might call connectedness. In yet another sense of the term, American artists sought to reach — to connect with — audiences beyond those at museums and gallery exhibitions through inexpensive, widely circulated prints. Connectedness was of concern to the so-called Mexican muralists as well, who relied on printmaking to relay their often politically charged messages to audiences scattered throughout Mexico and the United States. Indeed, a correlation exists between the circulation of prints and the mobility and interconnectedness of peoples, their memories, and their identities.

Commentators in the Depression years wrote optimistically of the promise of technology and infrastructure to connect people and information, suggesting that social linkage itself might be at the core of a modern American identity.[1] Yet as several prints suggest, the promise of connectedness could be illusory, even perilous in Tubman's case. No train moves along the tracks in Hopper's etching and the rails become an obstacle not just for the cows lumbering across

them but also for those seeking an unobstructed view of the house in the middle ground.

Catlett made her linocut of the famed abolitionist Tubman in 1953 on the brink of the civil rights movement. Catlett was one of several artists to preserve Tubman's memory and promote a public understanding of her heroic efforts. While Charles White and Jacob Lawrence did so in murals, considerably more artists turned to works on paper, including affordable and widely disseminated prints.[2] Depicting Tubman holding her walking staff and pointing onward, Catlett emphasizes the movement of African Americans escaping to the north. But the journey of the print itself — its circulation — was also of primary importance.

Catlett produced the linocut of Tubman under the aegis of the Taller de Gráfica Popular (The People's Print Workshop), a printmaker's collective in Mexico City renowned for its support of progressive political movements. The Taller distributed prints both in Mexico and the United States, and with its ties to the communist Partido Popular (People's Party), attracted left-leaning artists of various nationalities, including White, Margaret Burroughs, and Jean Charlot.[3] Many of the Taller artists were of the same opinion as Charlot — that "the power of the graphic arts lies in reproduction, multiplication" and its accessibility to its "potential users."[4]

Prints of the period not only referenced technologies that support social and geographic connectedness, but precisely because prints are widely disseminated multiples they also functioned *as* such technologies. Thanks to the Federal Art Project and other New Deal art programs, the innovative sales methods of publishers and dealers, and businesses that sold art by subscription, printmaking and print distribution

were able to advance connectedness, creating networks of people and places. Charlot sought to preserve the identity of Mexicans and the memory of what he called "pre-Hispanic things." He regularly depicted tortilla makers, who evoke the native and mestizo peasantry, resourcefully subsisting on tortillas because wheat bread was largely unavailable to them (pl. 95).[5] Charlot's lithograph creates a connection not only to this indigenous people's past but also between the various recipients of the print. For Charlot, printmaking was also an antidote to the elitism and pretense he perceived in contemporary modernist painting.

American Artists Group (AAG), founded during the Great Depression to provide financial relief to artists, published Charlot's *Tortilla Maker* as part of an ambitious art-appreciation campaign based on the sale of affordable prints, artists' monographs, and limited-edition Christmas cards. Proposing that the prints constituted "the first major step in democratizing art," AAG sold them at affordable prices — $2.75 per print, at first — in an effort to "remove the barricade around art" and gain access to a wide audience, far broader than previously achieved by contemporary artists and galleries.[6] Established in 1934, the same year AAG began operations, a different enterprise, Associated American Artists (AAA), devised an even more ambitious program: selling lithographs, etchings, and engravings for $5.00 per print through mail order and eventually in department stores. AAA connected artists to collectors across the country, often from the very locales depicted in the prints, effectively bringing regionalism to the regions. Its roster of artists was extensive and included the regionalists Benton, John Steuart Curry, and Grant Wood. Benton stated that AAA marketed "not something for the few but for all." For Benton and others, AAA's print distribution efforts offered a democratic sensibility that matched the identifiably American and vernacular subject matter of the works themselves.[7]

Among the many agreements brokered by AAA was a 1940 series of lithographs by Benton commissioned by Twentieth Century Fox to promote its film adaptation of John Steinbeck's *The Grapes of Wrath*. The artist produced five portraits plus an image of the Joads' departure from Oklahoma; reproductions of the lithographs could be found in trade and popular periodicals, and even on a billboard.[8] In this way AAA brought a scene from the movie — the departure of the Joads — to audiences across the nation. Actual connectedness or movement across the land was a different matter altogether. The overloaded, broken-down automobile in Benton's lithograph points to the paradoxes and difficulties of mobility during the years of the Depression.

The ironies and contradictions of modern travel are also the subject of Robert Gwathmey's *The Hitchhiker*. In the foreground a man holds out his thumb in hopes of catching a ride, while in the middle ground another man, seated on his suitcase, suggests the odds are not in his favor. The laterally cropped, zigzagging billboards indicate rhythmic motion and spatial continuity, a sort of open-endedness out of step with the stationary figures. These men in turn evoke a life of difficulty far removed from what the artist called the "Pepsodent smile" of the "handsome girls" depicted on the billboards.[9] A telephone pole appears in an earlier painted version of *The Hitchhiker* by Gwathmey but the pole is absent in the screenprint; thus Gwathmey further reduced the possibility for communication and social connectedness.[10]

Bernarda Bryson Shahn's lithograph *Arkansas Share-croppers* is from her series *The Vanishing American Frontier* (1935–1936) (pl. 98), a project funded by the Resettlement Administration (RA), a New Deal agency. In addition to publicizing the plight of migrants and sharecroppers, the RA sought to relocate farmers to agriculturally productive land — even though, as Shahn's series title suggests, such land had all but vanished.[11] Shahn's print contests the staying power of a time-honored American idea — a limitless frontier — that of course was rendered obsolete with the Depression. The desperate- and dejected-looking man and woman appear without hope, and there is no evidence — no car, road, or telephone line — of a means to escape their bleak situation. The advertisement for medicine, "666 Malaria Chills Fever," posted on the shack to the left, suggests infirmity and only underscores the individuals' plight within a foreboding landscape. The sign announces the inescapable presence of dysentery, typhus, and malaria.

Ideas about connectedness similarly inform Charles White's prints in subtle yet trenchant ways. A stylized portrayal of two faces with eyes looking upward as if longingly, *We Have Been Believers* (pl. 96) alludes to a poem of the same name (1942) by the twentieth-century African American writer Margaret Walker. Walker compares the "black gods of an old land" with the "white gods of a new land" and concludes that African Americans remain "believers feeding greedy grinning gods." She wrote: "We have been believers, silent and stolid and stubborn and strong," which resonates with the somber and self-possessed expressions of the couple depicted in White's lithograph.[12]

Diego Rivera, David Alfaro Siqueiros, and José Clemente Orozco are best known for registering political dissent in monumental murals in high-traffic, public locales such as universities, museums, and corporate and government buildings. They increasingly realized, however, that prints were a viable alternative, able to reach a wide audience. Siqueiros used his prints to proclaim indigenous themes and connect with politically subjugated Mexicans. After being incarcerated for government protest in 1930 and subsequently exiled from Mexico City, he created a group of prints titled *Siqueiros: 13 Grabados* (13 woodcuts) (1930) that calls attention to many of the challenges faced by the impoverished citizens of Mexico. Even in less politically motivated prints such as *Reclining Nude* and *Black Woman*, Siqueiros still invoked his own brand of *indigenismo* by way of stylized Mexican features and by rejecting the prescribed style of art that he learned during his European training (pls. 92, 93).[13]

The Mexican muralists lacked an entrepreneurial model like AAA through which to circulate their prints. But they discovered an ally in Carl Zigrosser, whose Weyhe Gallery in New York not only published many of their prints, including Rivera's *Viva Zapata*, but also made them available to an American audience (pl. 94).[14] Rivera's lithograph is one of several prints by artists wanting to honor the slain revolutionary and reformer, and it is by far the best known (Siqueiros too made a lithograph of Zapata), contributing to the effort to keep alive the memory that Zapata's enemies sought to expunge.[15] Based on a detail of Rivera's *Conquest and Revolution* (1929–1931) adorning the walls of the Palace of Cortés in Cuernevaca, Mexico, *Viva Zapata* joins additional works by the Mexican muralists and other artists who sought to connect people politically and culturally through prints. A similar connecting impulse is found in politically

charged works by American artists such as Catlett, Shahn, and White, and in prints by nonactivist artists such as Hopper. The mobility of prints made it possible for art and ideas to travel widely, creating a social linkage and connecting people to their history, and thus their identities.

1 See Charles A. and William Beard, *The American Leviathan* (New York, 1930).

2 Andrea D. Barnwell, "Sojourner Truth or Harriet Tubman? Charles White's Depiction of an American Heroine," in Barnwell, *The Walter O. Evans Collection of American Art* (Seattle, 1999), 59.

3 Dawn Adès, "The Mexican Printmaking Tradition c. 1900–1930," in Adès and Alison McClean, *Revolution on Paper: Mexican Prints 1910–1960* (Austin, 2009), 7.

4 Quoted in Peter Morse, *Jean Charlot's Prints: A Catalogue Raisonné* (Honolulu, 1976), vii.

5 Jeffrey M. Pilcher, *Planet Taco: A Global History of Mexican Food* (New York, 2012), 22.

6 Murdock Pemberton, *Object: Every American an Art Patron* (New York, 1945), n.p.

7 Thomas Hart Benton, *An Artist in America*, 3rd ed. (Columbia, MO, 1968), 280. On AAA, see Erika Doss, "Catering to Consumerism: Associated American Artists and the Marketing of Modern Art," *Winterthur Portfolio* 26, nos. 2–3 (1991): 143–167.

8 Margaret C. Conrads, "The *Grapes of Wrath* in Pictures," in *American Epics: Thomas Hart Benton and Hollywood*, ed. Austen Barron Bailly (Salem, MA, 2015), 68–69.

9 Gwathmey quoted in Reba Williams, "The Prints of Robert Gwathmey," in Linda Tyler and Barry Walker, eds., *Hot off the Press: Prints and Politics* (Albuquerque, 1994), 34.

10 Williams 1994, 43.

11 *The Vanishing American Frontier: Bernarda Bryson Shahn and Her Historical Lithographs for the Resettlement Administration of FDR* (New York, 1995). Thanks to Diana Linden for sharing information about Shahn's RA work.

12 Margaret Walker, "We Have Been Believers," in Walker, *For My People* (New Haven, 1942), 122.

13 John Ittman, "David Alfaro Siqueiros," in *Mexico and Modern Printmaking: A Revolution in the Graphic Arts, 1920 to 1950*, ed. John Ittman (Philadelphia Museum of Art, 2006), 158–171.

14 Reba White Williams, "The Weyhe Gallery between the Wars, 1919–1940" (PhD dissertation, The City University of New York, 1996), 123–150.

15 Adès 2009, 19.

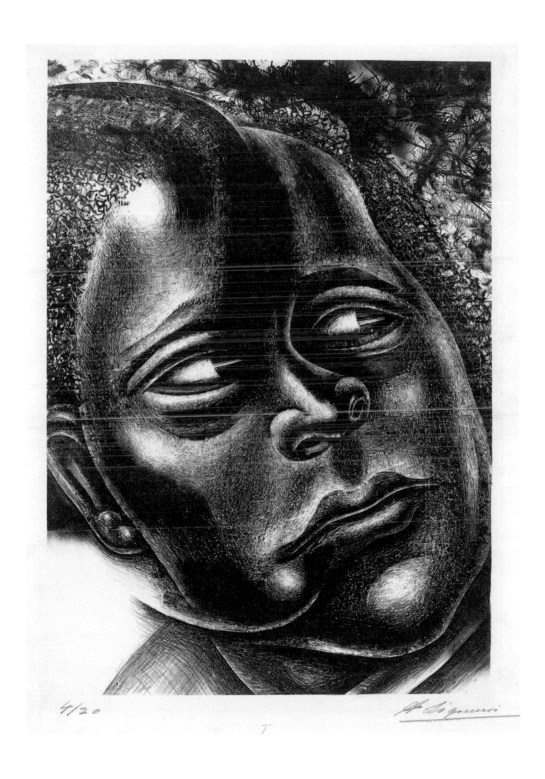

4/20

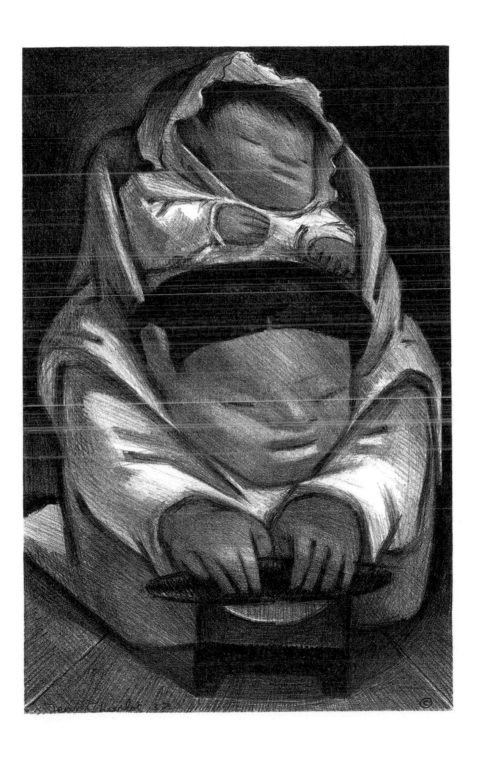

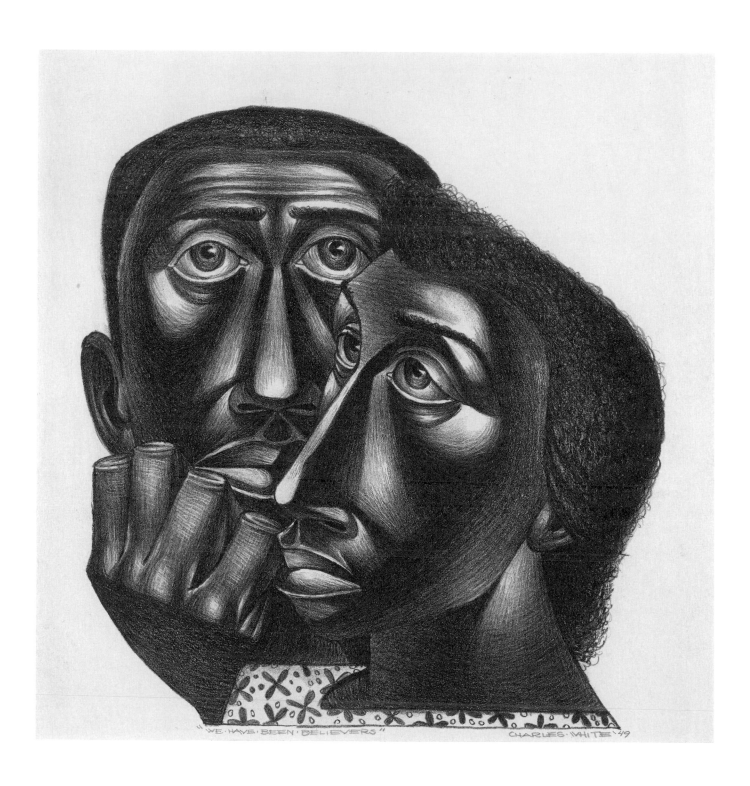

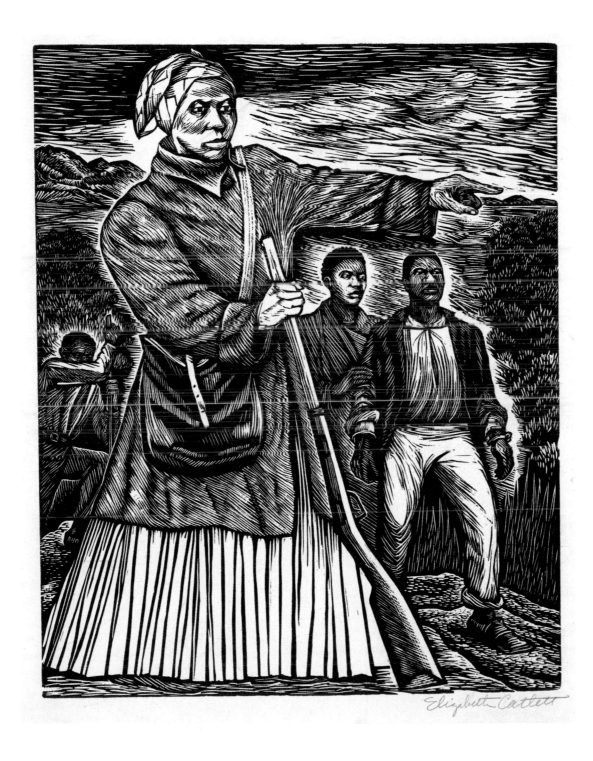

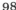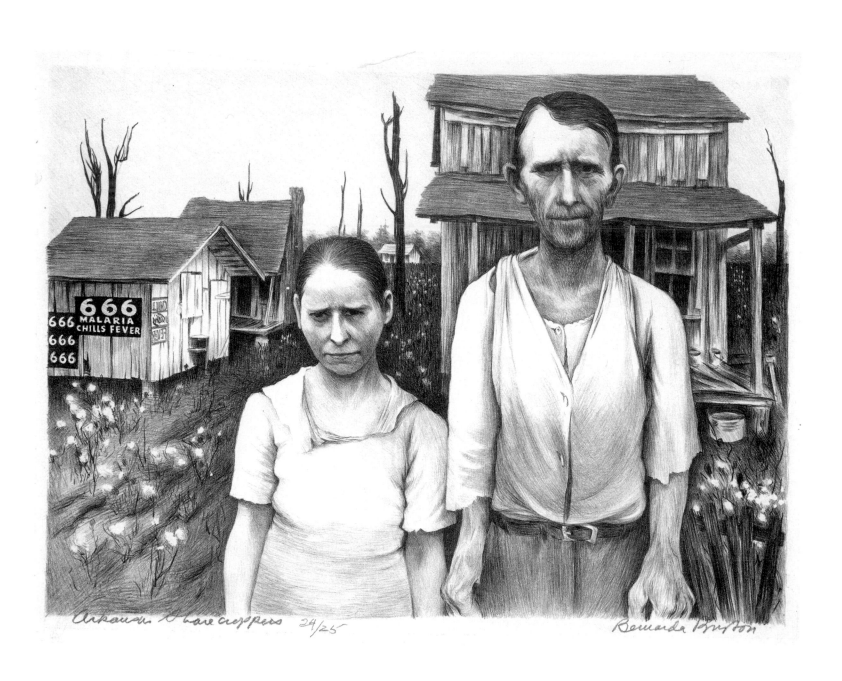

98 Bernarda Bryson Shahn, *Arkansas Sharecroppers*, 1935–1936, lithograph

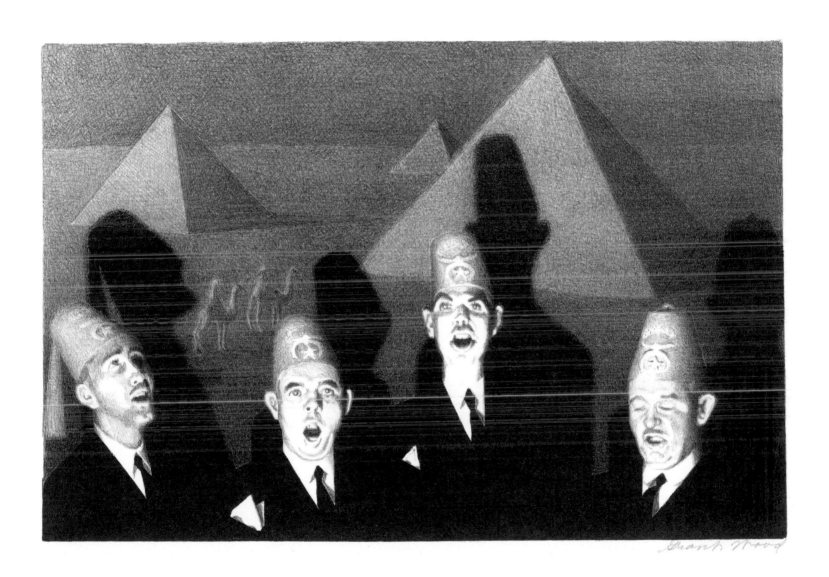

Post-World War II to the Present

Picturing Depth in Mid-Twentieth-Century America AMY JOHNSTON

FOR CLEMENT GREENBERG, POSTWAR America's most influential art critic, modern painting began with the appreciation of the flat picture plane: "the stressing of the ineluctable flatness of the surface [was] more fundamental than anything else to the processes by which pictorial art criticized and defined itself under Modernism. For flatness alone was unique and exclusive to pictorial art."[1] During the 1950s, in part through Greenberg's influence, this became a defining characteristic of American art. Two-dimensional artwork of the period — whether executed in a hard-edged or abstract-expressionist manner, whether multicolored or monochromatic — tends to lack a coherent system of pictorial depth. And when techniques for conveying depth are used, they are often fragmented and undermined.

To find clues to a work's meaning, the painter Ad Reinhardt exhorted us to look "not only at what [artists] do but at what they refuse to do."[2] David Smith, for example, dispensed with linear perspective, shading, and contour lines in his *A Letter* (pl. 114). Instead Smith brushed calligraphic marks across the page in a style reminiscent of Zen calligraphy. The expressive glyphs are evenly spaced across the picture plane, none of them overlapping and hinting at depth. The title of the work invites the viewer to attempt decryption — to read the letter — and find a narrative. The flat surface is alive with feathers, faces, swimmers (fish?), and birds that move, interact, and look, but they remain distant and undecipherable. The viewer is left roving the surface, kept at a perceptual and intellectual distance. Ultimately the work turns back to the viewer and is about our relationship to the surface, our *desire* to decrypt the text.

Neuroscientists and psychologists have demonstrated that humans are wired to read three-dimensionality from very subtle cues.[3] Our minds want to make sense of the flat images that proliferate in our everyday world. Cognitive scientists David Melcher and Patrick Cavanaugh write that "it is difficult to image modern life without this ability to overcome the lack of three-dimensionality in pictures. A world without tolerance to flatness would contain no paintings, posters, televisions, or cinema, but would instead be filled with statues of people and sculptures of scenes, in place of pictures and photographs."[4]

In his sculpture, Smith often capitalized on the formal quality of flat letters stripped of linguistic meaning, in much the same way that he did in *A Letter*, where textual forms are loosely imitated but impossible to decode, having no actual tie to known language. In a 1964 interview, he said, "The knowledge, the perception, of vision is so far greater than any statements using words, that nothing an artist can do passes beyond the vision of the beholder…Do you know [in James Joyce's *Finnegans Wake*] the little red hen that scratched up a letter? Well, I'm always scratching up letters…It's a kind of opening, like when I first saw Cubism or Constructivism or De Stijl or any of the things I saw that I didn't know about. I love things I see and don't know about."[5]

The composition of Jackson Pollock's untitled engraving from 1944/1945 resembles a baroque scene of hell (pl. 112). An undulating pattern of light and dark covers the surface, creating overlapping, twisting organic forms. The dynamic mesh of shapes and shading leaves no calm space for the eye to rest. Even the lighthearted doodles that peer out of the web hold the eye only momentarily: backward and upside-down letters and numbers, eyes and arrows, a curling snake, and a fork (or paintbrush?). Pollock employs an astounding range of lines: short and long, curved and straight, fuzzy,

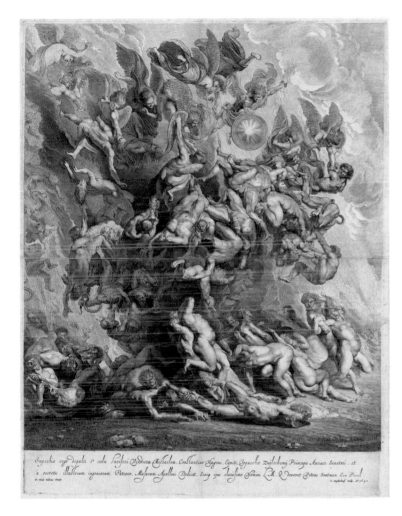

FIG. 1 Jonas Suyderhoff after Peter Paul Rubens, *Fall of the Damned*, 1642, engraving, National Gallery of Art, Gift of Ruth Cole Kainen.

fine and textured, soft and strong. Closely repeated parallel lines and dots create dark areas of shading with few sharp edges or hard contour lines. Long sweeping diagonals across the composition pull the space together. Compare Jonas Suyderhoff's *Fall of the Damned* (1642) (fig. 1) in which writhing bodies fall in an ambiguous, claustrophobic space. A dense pattern of chiaroscuro evokes the chaos of the scene. Pollock's mesh of marks and forms, though almost entirely abstract, creates a similar roiling surface. Without a horizon

line or linear perspective, the patterns of light and dark in both works are pushed to the surface. For Suyderhoff this effect was employed to confront the viewer with a religious message about the consequences of sin. For Pollock the intention is not so clear. Absent meaningful shapes or signs, the composition consists mainly of marks that do not convey meaning. It may be that Pollock's intention was to emphasize these marks and thereby suggest contemplation of how they were made, a parallel to his explorations in painting at the time.

Without cues such as directional light or clear spatial relationships, an image can seem ungrounded or limitless, evoking a sense of space that is not of material reality, even otherworldly. Sylvia Wald achieved such ethereal effects in the rather unlikely, or at least unexpected, medium of screenprinting, a process associated with the mechanical finish of commercial production. Countering the inherent flatness of screenprinting, Wald developed expressive abstract effects, evident in her print from 1950, *Between Dimensions* (pl. 111). She built up delicate layers of color based on her observations of nature. Transparent veils of blue, red, and green intermix, making it unclear what areas move forward or recede from the picture plane. This ambiguous effect is further enhanced by areas of paint reticulation that protrude from the surface, created by pressing large amounts of ink through the screen with a squeegee. When the screen was removed, the ink lifted in partially controlled patterns of ridges. Without clear spatial cues the image oscillates between a sense of flatness and depth, or as the title of the work indicates, between two and three dimensions.

Despite its title, *Figures in Landscape*, Dorothy Dehner's figures are less strictly representational than one

might imagine, and the print imparts little indication of landscape (pl. 115). The composition features configurations of delicate black lines and geometric shapes floating in a modulated grayish-white background. Three humanoid figures stand in somewhat balletic poses at left, right, and center. Just left of center are rows of rectangles and lines that resemble electric transformers and power lines. While the image does not meet traditional expectations of a landscape, Dehner plays with pictorial cues to create some sense of depth. There are at least three short horizon lines, and two curving lines at bottom, the latter possibly signifying water. The spatial relationships in the background are confusing. However, the placement and relative size of the top two horizon lines — higher in the composition and smaller — suggest that they are indeed in the background, distant from the foreground figures. Dehner employed overlapping angled lines and shading to give the figures three-dimensionality, carefully hand-wiping the plate's black ink so that each figure is surrounded by hazy gray shadows and stark areas of white as if illuminated by spotlights. The image gives the impression of figures standing in a self-contained, shallow space.

Having primarily made paintings and drawings in her early career, Dehner became attuned to issues of three-dimensionality in the mid-1950s. She took up sculpture at the age of fifty-four and it dominated her artistic interests for the rest of her life. Her early sculptures were gangly, twisting towers of accumulated biomorphic forms much like the figures here, or flat schematic systems not dissimilar to the background elements. Dehner's first solo exhibition of sculpture took place in 1957 at Willard Gallery in New York City just one year after she made *Figures in Landscape,* and it

is easy to imagine that she had in her mind's eye the glowing white walls of an art gallery when she made this print.

In *Tlaloc*, Josef Albers uses two visual tricks to play with the representation of depth (pl. 106). A geometric shape composed of straight white lines creates the illusion of a cuboid figure. Two shapes appear to overlay one another but when the line is carefully followed it is revealed as a single continuous loop. Albers made many such abstract geometric configurations in the 1930s and 1940s that explored elliptical and shifting forms. In *Tlaloc* this ambiguity is further complicated by the grainy texture achieved by inking and printing from a block of wood. At first glance the viewer may recognize the pattern of wood grain. However, the curved lines can also be interpreted as expanding circles rippling on the surface of water, an interpretation that is hinted at in the title, the name of an Aztec water god. Albers leaves it to the viewer to decide the depth of the image. Does a white geometric form hover above a pool of water or are these simply flat white lines carved in a plank of wood?

Leonard Baskin's *The Hydrogen Man*, is the most obviously figural work in the group and arguably presents the most coherent sense of pictorial depth in the form of a life-size man standing against an empty background (pl. 119). Even Baskin, whose work was unfailingly figurative and who had little appetite for abstraction, maintained a tenuous sense of depth in his works. Meandering contour lines, skillfully carved into the surface of a plank of wood, trace the interior and exterior surfaces of the body. Yet somehow the lines, and the space they inhabit, have gone awry, as though unseen forces twist and bend perceptual reality. The figure stands upright on strong legs reminiscent of a Greek kouros

but his body shows signs of severe decay — a missing (or atrophied) limb, a severely distorted hip, sunken eyes, and missing teeth. Baskin titled the work after Castle Bravo, the code name given to the United States government's first test of a hydrogen bomb on March 1, 1954, at Bikini Atoll in the Marshall Islands. At fifteen megatons, the blast was a thousand times the magnitude of the nuclear weapons dropped on Japan in World War II. It essentially vaporized the island, rendering the site unfit for habitation and exposing residents of neighboring islands to dangerously high levels of radiation. Indeed the figure's wildly curving spine, the hardened masklike face, and spiky skin convincingly portray the fear of a world on the brink of nuclear destruction.

Why the consistent suppression of spatial coordinates and other cues indicating depth? Why did artists seek such ambiguity? After two world wars and with the new threat of nuclear annihilation, the future indeed seemed ambiguous. By attempting to reflect that uncertainty, they were simply, and rather straightforwardly, mirroring the condition of their own time.

1 Clement Greenberg, "Modernist Painting" in *Clement Greenberg: The Collected Essays and Criticism*, vol. 4, ed. John O'Brian (Chicago, 1993), 87.

2 Ad Reinhardt, "Abstract Art Refuses," first published in the catalog accompanying the exhibition *Contemporary American Painting*, University of Illinois, 1952; reprinted in *Art-as-Art: The Selected Writings of Ad Reinhardt* (New York, 1975), 50.

3 See the chapters on three-dimensional processing in Margaret Livingstone, *Vision and Art, the Biology of Seeing* (New York, 2002), 100–163.

4 David Melcher and Patrick Cavanagh, "Pictorial Cues in Art and in Visual Perception," in *Art and the Senses*, ed. Francesca Bacci and David Melcher (Oxford, 2011), 360–361.

5 Interview with David Smith by Thomas B. Hess, June 1964. First published in the catalogue of the Marlborough-Gerson Gallery exhibition, October 1964, reprinted in *David Smith, Sculpture and Drawings*, ed. Jörn Merkert (Munich, 1986), 163–167.

123/200 SWHayter

Plate 7 L. Bourgeois

"BETWEEN DIMENSIONS"

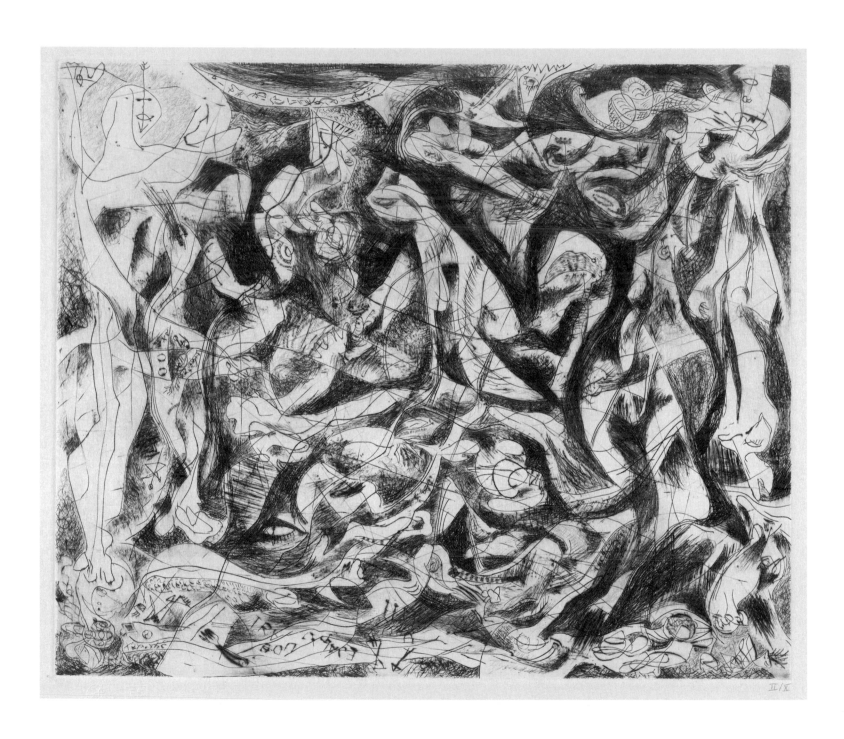

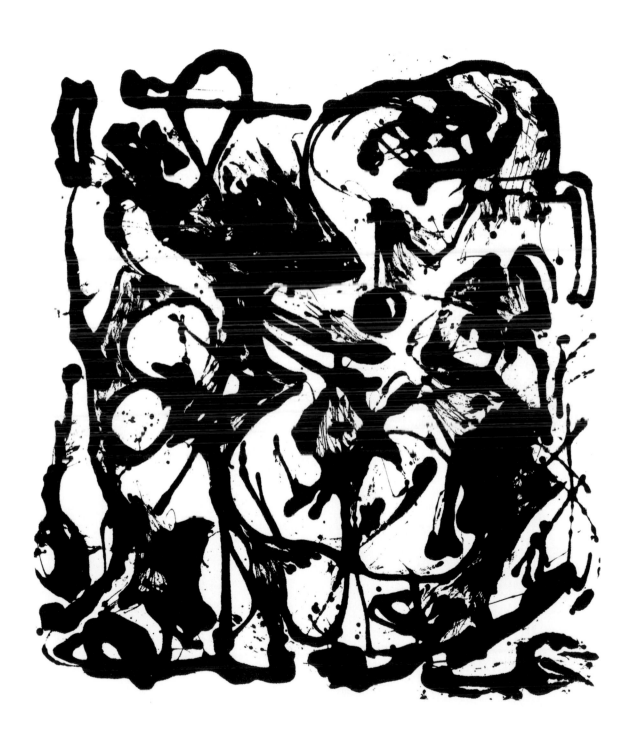

Figures in Landscape 7/40 Dorothy Dehner '56

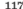 **117** Louise Nevelson, *Magic Garden,* 1953/1955, hand-colored etching, engraving, aquatint, and softground etching

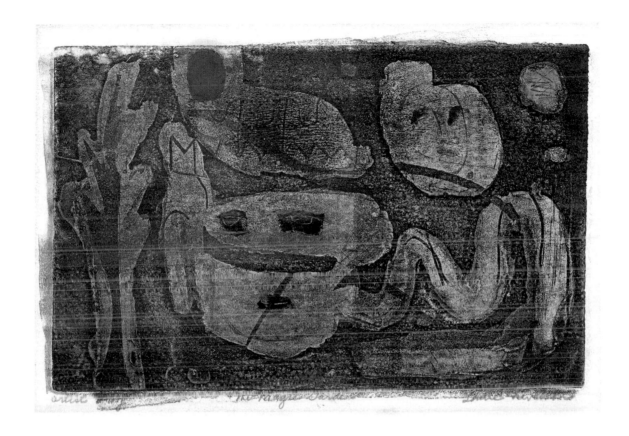

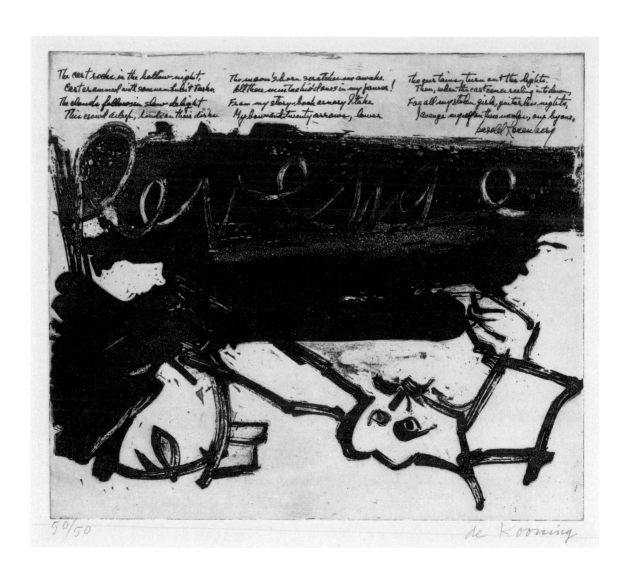

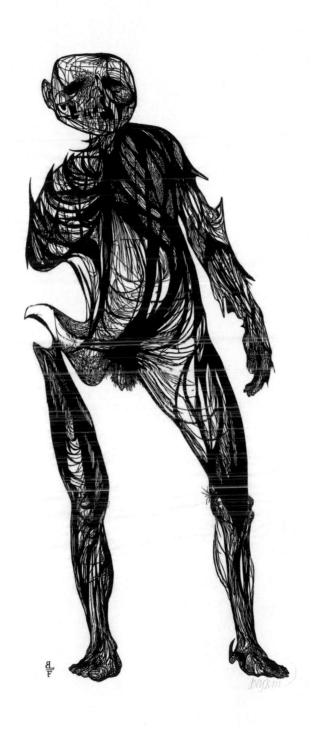

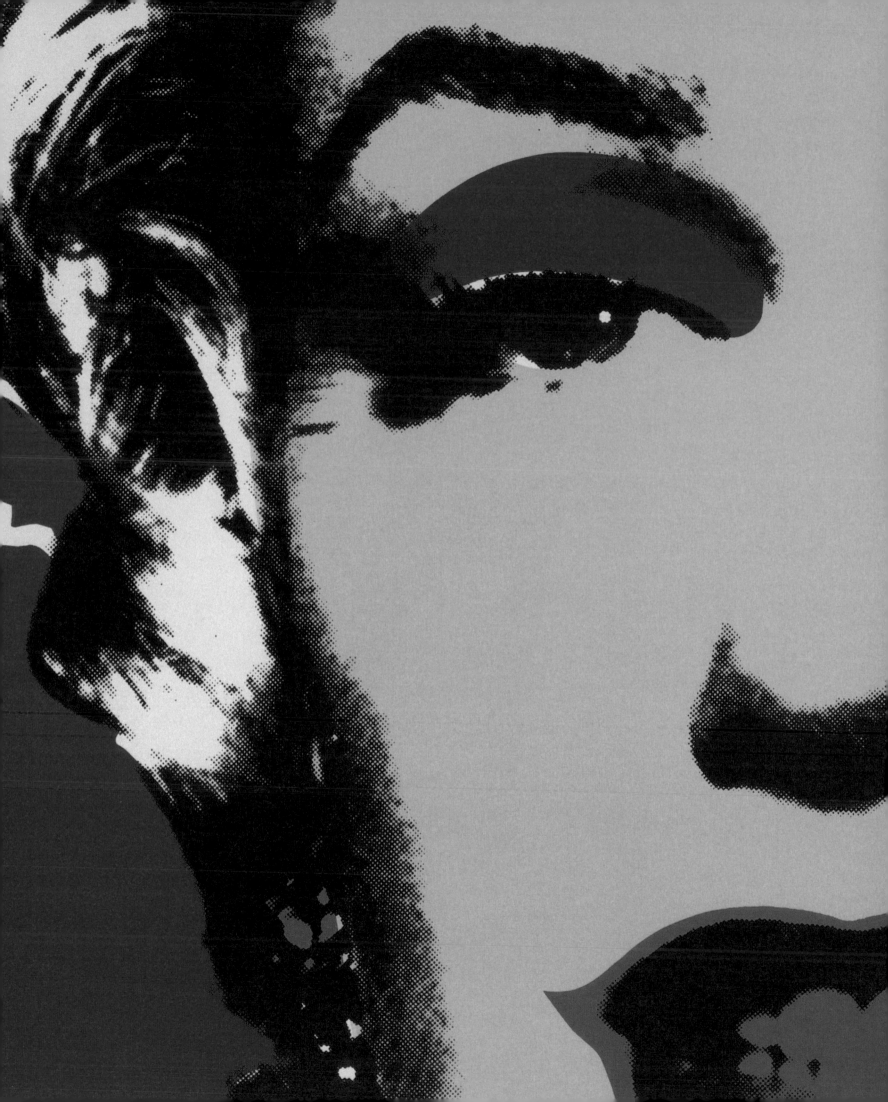

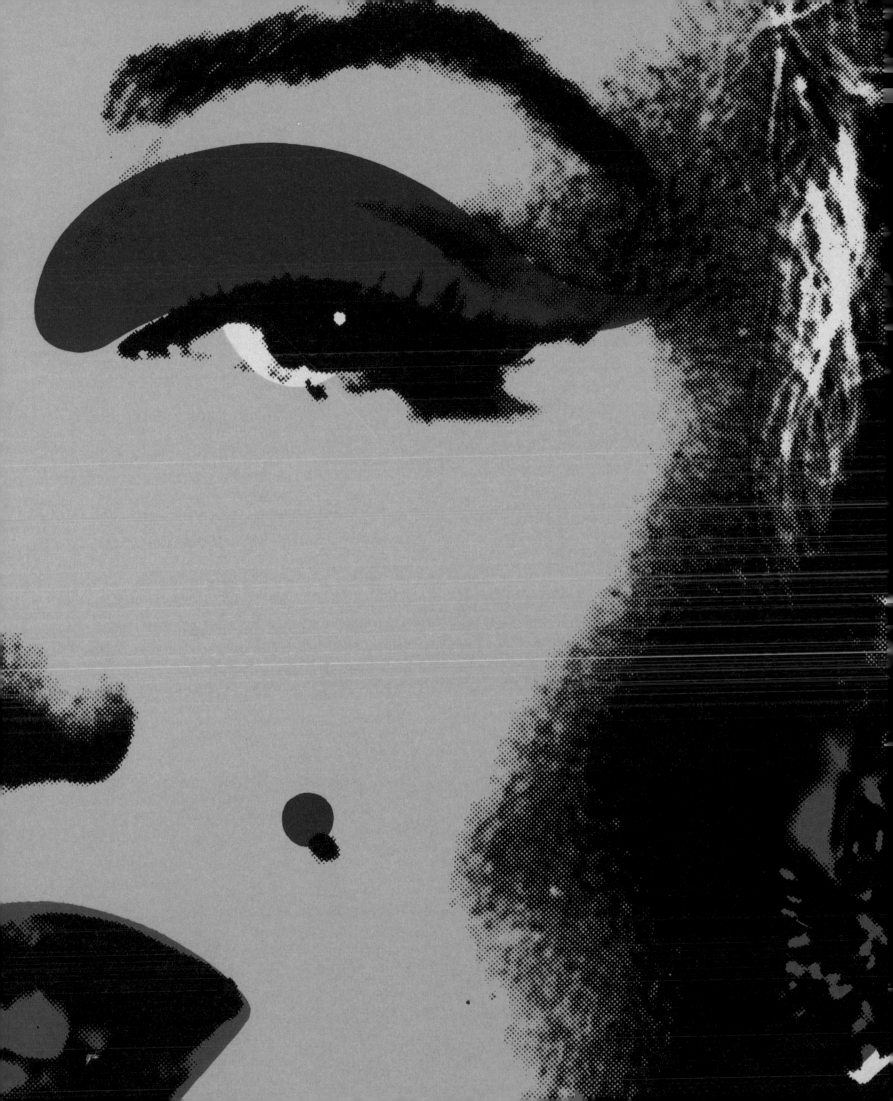

Sifted: Screenprinting and the Art of the 1960s JENNIFER L. ROBERTS

THE SCREENPRINTING MATRIX IS fundamentally different from all other traditional printmaking matrices. Techniques like etching, engraving, lithography, woodcut, and letterpress all produce images by forcing ink from the face of a solid, obdurate matrix onto the face of the paper. The silkscreen, by contrast, is a soft, transparent mesh through which ink is pushed with a rubber squeegee to the paper below.[1] The fine weave of the screen essentially acts as a sieve for the ink. The image is literally *sifted* into being. Although "sifting" is hardly a standard printmaking term, I wish to explore it here as an operation that sits at the literal and metaphorical heart of screenprinting and helps illuminate the appeal of the process for American artists of the 1960s.

The origins of screenprinting lie, surprisingly, in flour milling: silkscreens were originally made from silk bolting cloth, a specialized fine-gauge silk gauze perfected in the eighteenth century for sifting flour in the production of white bread[2] (fig. 1). Although synthetic meshes had largely replaced silk bolting cloth in screenprinting by the 1960s, the logic of the sift continued to define the making, meaning, and impact of screenprints in American art of the later twentieth century.

RUSCHA'S REFINERY. If bolting cloth produces the fine, soft, consistent crumb of white bread, the silkscreen coaxes a similar texture from printing ink. The sifting action of the screen mesh distributes the ink evenly across the support, while also gently aerating it, depositing it in fluffy peaks like so many microscopic dabs of Cool Whip. This produces a uniquely velvety, saturated, unmodulated surface (what Ad Reinhardt called "the ineffable autonomy of the silkscreen deposit"), with overtones of both luxury and industrial anonymity.[3]

Many screenprint artists in the period, wittingly or not, confirmed the ancient links between screenprinting and milling or refinement. Consider the recurrent Wonder Bread iconography in Corita Kent's screenprints of the mid-60s, or Ed Ruscha's productive conflations of screenprinting and food processing. For his 1970 portfolio *News, Mews, Pews, Brews, Stews & Dues,* Ruscha used foodstuffs like chutney and caviar as inks, creating screenprints that are essentially a series of strained stains. His 1970 *Chocolate Room* featured 360 sheets of paper evenly screenprinted with Nestle's chocolate paste.[4]

Although its gas-station iconography might seem unrelated to processed foodstuffs, Ruscha's earlier, iconic *Standard Station* of 1966 (pl. 122) helps us see how screenprinting's processing operations respond to the wider period concern, in pop and related movements, with the standardized refinement of processed foods and other consumer products.[5] Gasoline, of course, is a triumph of industrial refinement (and the fractional distillation process in oil refining involves a series of sieves).[6] Ruscha produced many painted iterations of this composition, but the screenprint versions, with their sifted surfaces, resonate most fully with the values of consistency, precision, and wide distribution that lay behind the refining and marketing of petroleum and other consumer products. Moreover, screenprinting, with its "anonymous, manufactured, smooth, mat deposit of ink" (to borrow a phrase from Richard S. Field), was perfectly suited for interrogating the looming, mystified anonymity of the corporate bodies that controlled those products — a quality that Ruscha explored in his jutting *Standard* sign.[7]

FIG. 1 Illustration showing mesh materials for screenprinting, from *Signs of the Times*, June 1945, reprinted in Guido Lengwiler, *A History of Screenprinting*, 2013.

opaque color on virtually any surface (one of its earliest uses was for printing team names and logos on felt pennants). Since the 1910s when photostencils were developed, screenprinting had also been recognized for its efficient reproduction and transfer of photographic halftones.[10]

Warhol, who had been trained as a commercial artist, chose screenprinting for precisely its commercial associations and mechanistic methods. Seeking an alternative to the heated gestures of abstract expressionism, he found in screenprinting a mark-making technique that "gave more of an assembly line effect."[11] Replacing the frenzied, autographic brushstrokes of abstract expressionism with the pull of the squeegee, rejecting the struggle to invent compositions in favor of the printing of found images through prefabricated photostencils, Warhol used screenprinting to redirect the history of painting and to redefine the meaning of artistic authorship. For Warhol, the mesh of the photostencil and its automatic sifting function replaces the mind and hand of the artist as the site of artistic creation, knowledge, and judgment.

Moreover, as a printing process based on the passage of imagery through a mesh, screenprinting was closely aligned with all of the other screen- or grid-based image mediators, such as television and the halftone, that defined the twentieth century. One of the key traits of Warhol's screenprints is the tension or confrontation they stage between different forms and gauges of image-sifting screen media. *Marilyn* (pl. 123), for example, was pulled with five different screens: the first four carried the print's bright, flat, hard-edged areas of searing pink and yellow. The fifth screen, the last to be printed, laid a coarse halftone photographic image of Marilyn's face in black over the other colors. This halftone

WARHOL'S MESHWORK. Screenprinting first grabbed the full attention of the American art world in 1962 when Andy Warhol began making "paintings" by screening photographic halftones onto canvases.[8] At that time, screenprinting was perceived as a fundamentally commercial process. Although attempts had been made in the previous decades to establish its fine-art credentials, it had never shed its association with advertising and packaging: posters, signs, labels, boxes, cans.[9] Screenprinting, developed in the early twentieth century in the United States, was prized for its ability to reproduce bold,

FIG. 2 Halftone screen detail from Julius Verfasser, *The Half-Tone Process*, Third Edition, Iliffe & Sons Ltd., London, 1904.

FIG. 3 Detail of Andy Warhol's *Marilyn*, 1967, color screenprint, Harvard Art Museums/ Fogg Museum, Gift of Michael F. Marmor, AB '62, MD '66 and Jane B. Marmor, MD '66.

CHAPTER II.

THE SCREEN.

THE screens now universally in use are cross-lined with transparent squares between the intersections of the lines. Fig. 7 shows a portion of a screen of 200 lines to the inch greatly magnified. The edges

Fig. 7.

of good screens are sharp and clear under a magnifying power of 100 diameters. It was formerly the practice to use a single line plate, and to reverse the direction of the ruling by turning the plate a quarter revolution during the exposure, but this method is now obsolete.

Screens formed of circular dots instead of lines have also been tried, but abandoned by all practical workers.

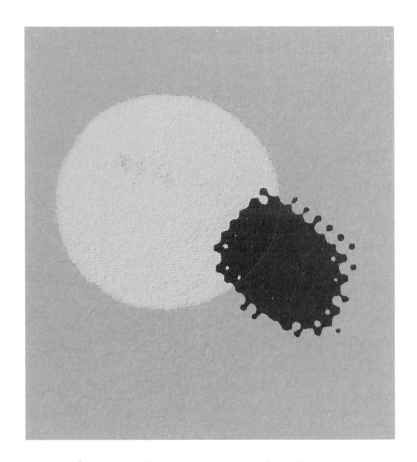

image was itself generated by a kind of mesh-sifting process: halftones are made by photographing a photograph through a sheet of glass ruled in a diagonal net pattern (fig. 2), thereby reconfiguring its continuous tones into a grid of printable dots.

In Warhol's print, then, the photograph of Marilyn is doubly sifted, once through the halftone screen and then again through the silkscreen. This kind of double screening, rarely mentioned in the literature on Warhol's work, has technical implications: for example, one of the rules of screenprinting halftones is that a halftone resolution too fine cannot be "held" by the silkscreen, so the halftone resolution

needs to be at least three times coarser than the screen (Warhol exaggerated this coarsening even further).[12] A good spot for a closer look at these two screen gauges is Marilyn's beauty mark (fig. 3, from a different print in the *Marilyn* portfolio). The fine weave of the silkscreen is evident in the impressions it leaves in the light blue circle. Adjacent to this near-platonic circle is the beauty mark as screened by the halftone. Trailing dots like a disintegrating asteroid, its coarseness is conspicuous in comparison (as is its diagonal screen orientation, a rotation technique used to avoid moiré patterns upon the superimposition of screens). The misregistration of the two screens (a common strategy of Warhol's

work, evoking printing errors and the failure of images to cohere) also bears a misregistration of scales and gauges. The two beauty marks straddle a gap in the continuum of image capture — a fine material sift on the one hand, a coarse optical sift on the other — that contributes profoundly to the elusiveness of the final image. Neither the fine gauge (too perfect, too artificial) nor the coarse gauge (too coarse) quite captures the image of Marilyn. As Tom Crow, Hal Foster, and others have argued, Warhol's *Marilyns* perform the elusiveness of celebrity identity: the compulsive repetitions of the screenprinting process echo the viewer's futile desire to know the real star.[13] But so, too, I would suggest, does the sifting action of the screen: if one of the meanings of "to sift" is epistemological ("to find out, get to know"),[14] Warhol's double sifting fails to yield that knowledge. Marilyn eludes us because she has slipped through the various screens that define her image.

RAUSCHENBERG'S SCRIM. The delicacy, lightness, and transparency of the screen's sifting mesh also had a wide resonance in the art of this period, coming to rhyme with the mobility and ephemerality of images in the age of mass publishing and televisual media. Although all printing processes can be said to mobilize images, most of them paradoxically generate that mobility out of heavy equipment: massive presses, stones, metal plates, etc. Screenprinting, with its delicate meshes and portable tabletop apparatus, asserts the lightness of images even at the heart of the printing process.

There is perhaps no better meditation on the gravities of the reproductive image in this period than Robert Rauschenberg's 1967 *Booster,* a seminal print made at Gemini G.E.L. combining stone lithography and screenprinting

(pl. 125). Rauschenberg had been screenprinting since Warhol introduced him to the process in 1962; it helped inspire his use of layered, found imagery from mixed sources. *Booster* features a composite, life-size X-ray of Rauschenberg's body, surrounded by images of chairs, power drills, athletes, and other miscellany in various states of transfer and clarity. All of those images are printed as lithographs. The red tracery overlaying the lower two-thirds of the print, which is an astronomical chart showing the movements of planets and stars through the 1967 sky over Maryland, is a screenprint.

Booster explores the strange differentiations of gravitational experience that so interested Rauschenberg in the context of early space exploration. On the one hand, there is earthbound gravitation: the incessant pull of the body to the ground and the heavy, ribbed structures (skeleton and chair) or technical or athletic feats ("booster," high jumper, basketball player) required to overcome it. These effortful images mirror the strenuous lithographic activities required to produce them in the print. *Booster* was printed with an unprecedentedly weighty and unwieldy double-stone matrix. Exceeding the size of available lithographic matrices (it remains among the largest hand-pulled lithographs ever made), it had to be printed from two separate stones.[15]

Balancing the massive bones and stones is the screenprinted astronomical chart, whose streaky planetary timelines index a heavenly world where gravity propels rather than immobilizes bodies. The screenprint's bright traceries literally float above the other images (screenprinted ink sits lightly on the surface of the paper). The open network of the chart replicates the structure of the screen used to represent it; like the silkscreen, the chart transmits information. Its

transparent grid captures the images below, pulling them up to the surface. Rauschenberg went to great lengths to produce these effects. He had never combined screenprint and lithography in a single print, nor had the master printers at Gemini G.E.L. Because the Gemini printers were not sufficiently trained in the process to handle the nerve-wracking task of superimposing the screenprint on the paper (which had already received its painstaking lithography work), the job had to be contracted to a nearby commercial printer.[16]

As art critic Lucy Lippard remarked, the netted layering in Rauschenberg's print suggests "the transparency of visual phenomena, their rapidly shifting dispersive space" in the modern world.[17] *Booster*'s star-net, and the silkscreen it thematizes, prefigure the gauzy, scrimlike textiles that Rauschenberg would later explore, as in his *Hoarfrost Editions* of 1974, which feature transferred images on delicate, breezy, plain-weave cloths like cheesecloth, muslin, and silk taffeta (itself a traditional silkscreen material).[18] For Rauschenberg and many other artists of the period, the light, transparent screenprint matrix, with its delicate sifting of images and ideas, was uniquely responsive to the visual culture of the sixties.

1 Throughout this essay, I use "silkscreen" as the generic term for the screenprinting matrix, although silk was gradually replaced with synthetic meshes over the course of the twentieth century.

2 Guido Lengwiler, *A History of Screen Printing* (Cincinnati, 2013), 52–99, 227–228, 301–330.

3 On the qualities of the screenprint surface, including Ad Reinhardt's comment, see Richard S. Field, "Silkscreen: The Media Medium," *Artnews* 70, no. 9 (January 1972): 40–43, 75.

4 Siri Engberg, "Out of Print: The Editions of Edward Ruscha," in *Edward Ruscha: Editions, 1959–1999* (Minneapolis, 1999), 26, 30. On Corita Kent, see Susan Dackerman, ed., *Corita Kent and the Language of Pop* (Cambridge, MA, 2015).

5 For details on this print, see Engberg 1999, 16–19.

6 Encyclopedia Brittanica Online, s.v. "Petroleum Refining," accessed April 9, 2014, http://www.brittanica.com/EBchecked/topic/454440/petroleum-refining.

7 Field 1972, 40.

8 On Warhol's screenprinting methods, see Marco Livingstone, "Do It Yourself: Notes on Warhol's Techniques," in *Andy Warhol: A Retrospective*, ed. Kynaston McShine (New York, 1989), 63–78.

9 On the history of screenprinting see Lengwiler 2013; Reba and Dave Williams, *American Screenprints* (New York, 1987).

10 Lengwiler 2013, 62–99, 247.

11 Andy Warhol and Pat Hackett, *POPism: the Warhol '60s* (New York, 1980), 22.

12 Andrew B. Gardner, *The Artist's Silkscreen Manual* (New York, 1976), 71.

13 Thomas Crow, "Saturday Disasters: Trace and Reference in Early Warhol," in *Andy Warhol*, ed. Annette Michelson (Cambridge, MA, 2001), 49–66; Hal Foster, "Death in America," in Michelson 2001, 69–88.

14 *Oxford English Dictionary Online*, s.v. "sift, v." accessed June 10, 2015, http://www.oed.com.ezp-prod1.hul.harvard.edu/view/Entry/179438?rskey=RxCPFx&result=2#eid.

15 On *Booster* see Sienna Brown, "The Lithographs of Robert Rauschenberg," PhD diss., Emory University, 2010, 90–91; Mary Lynn Kotz, *Rauschenberg: Art and Life* (New York, 2004), 153; Jay Belloli, *Rauschenberg at Gemini* (New York, 2010), 6; Pat Gilmour, *Ken Tyler, Master Printer, and the American Print Renaissance* (New York, 1986), 48–49.

16 Gilmour 1986, 48–49.

17 Lucy Lippard, *Booster and 7 Studies* (Los Angeles, 1967), n.p

18 Ruth Fine, "Writing on Rocks, Rubbing on Silk, Layering on Paper," in Walter Hopps and Susan Davidson, eds., *Robert Rauschenberg: A Retrospective* (New York, 1997), 384.

120 Josef Albers, *White Line Square xii,* 1966, lithograph

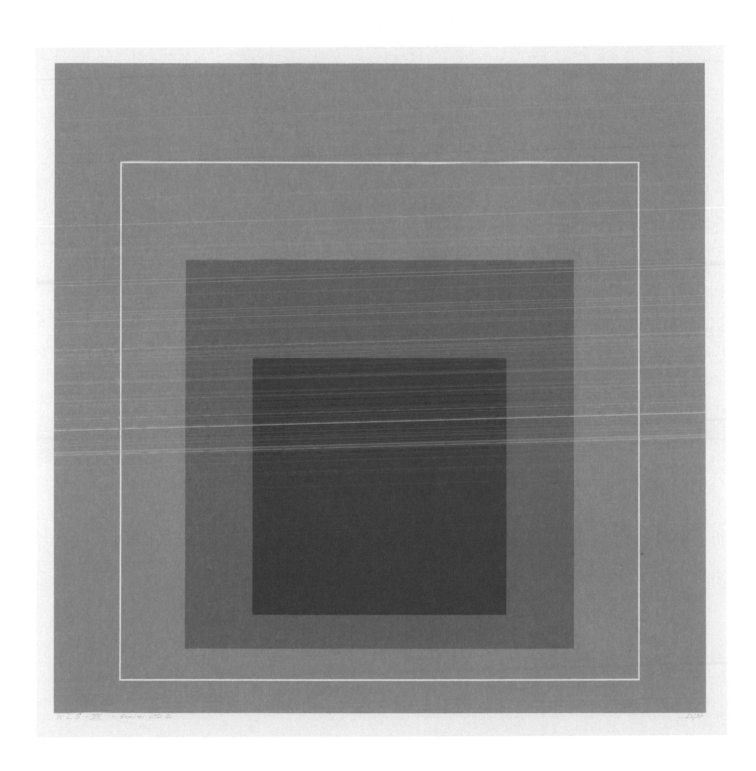

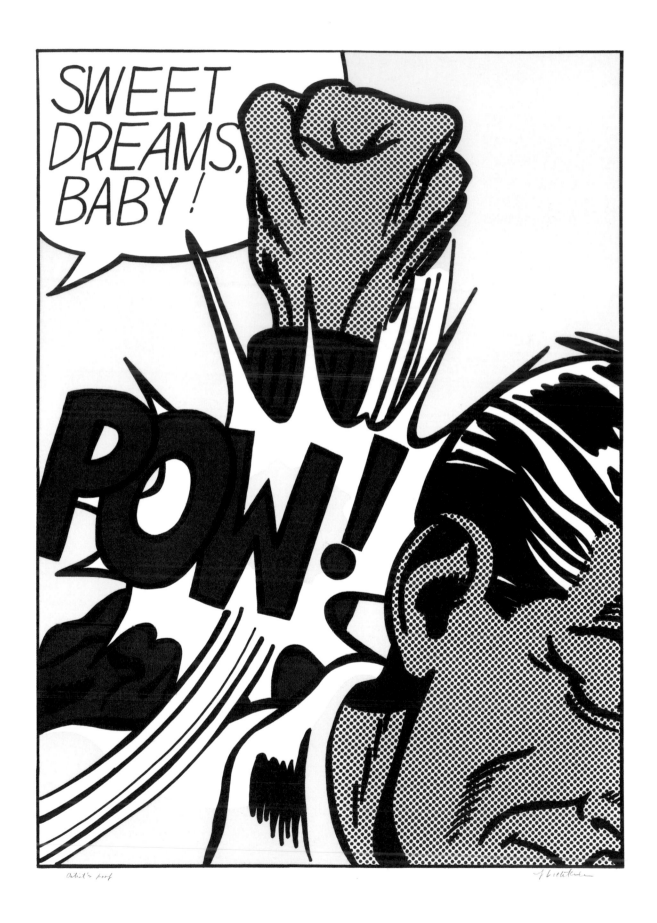

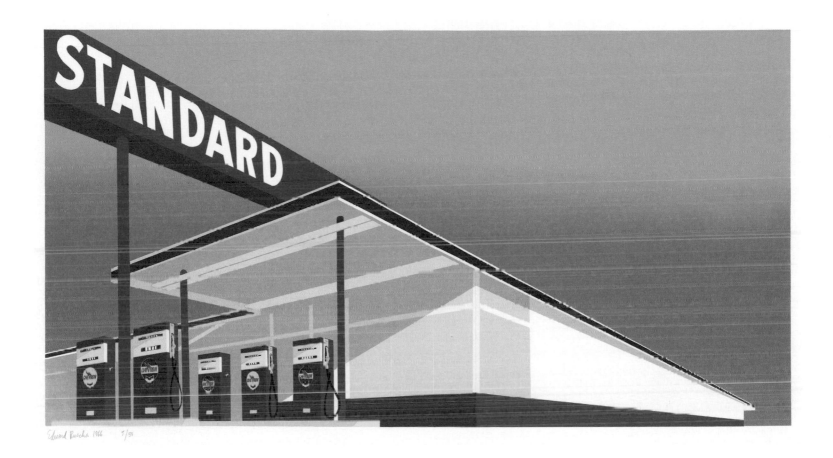

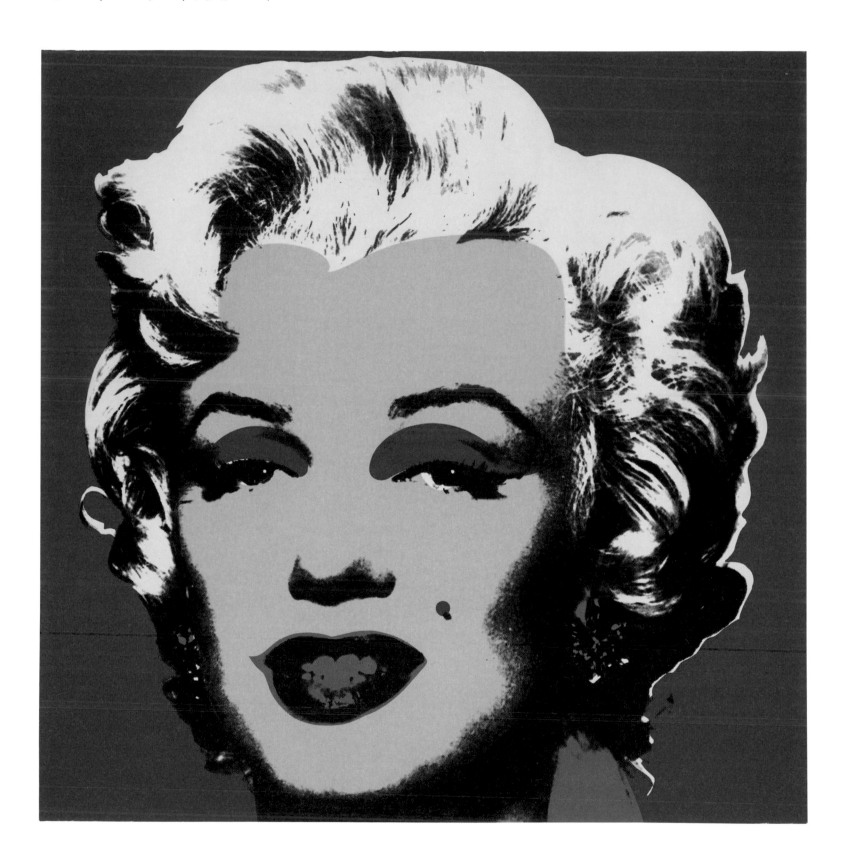

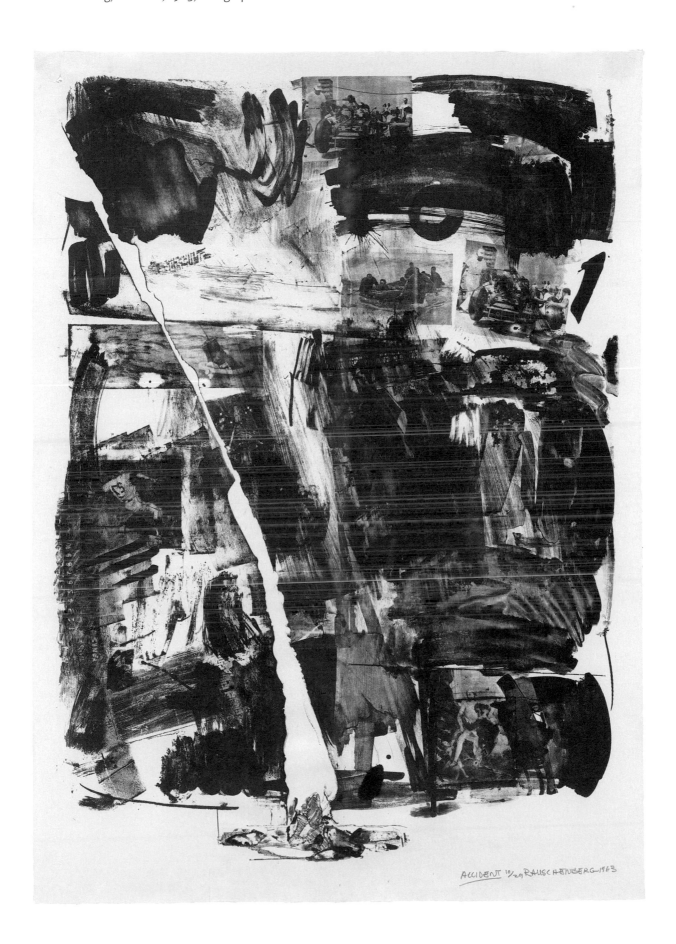

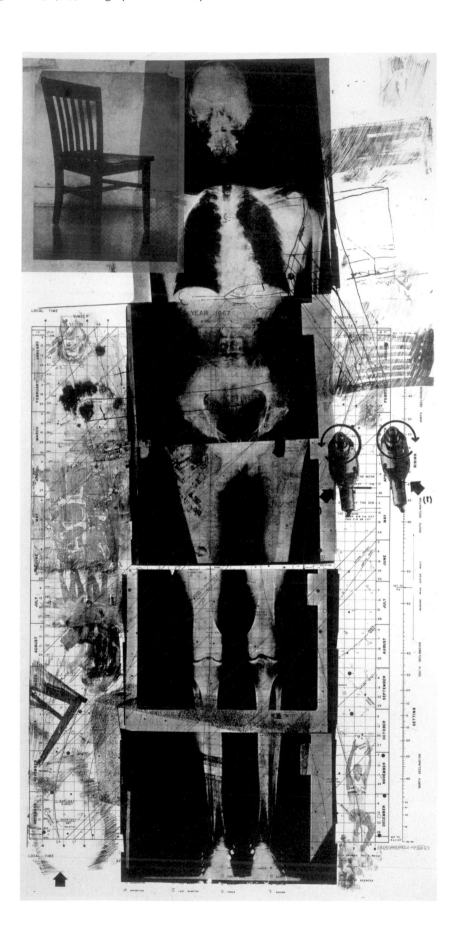

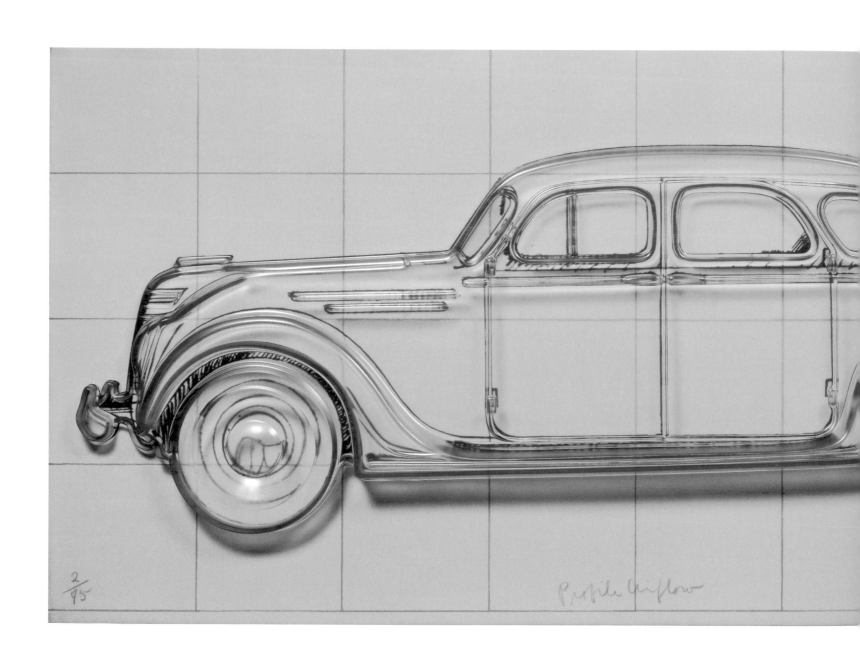

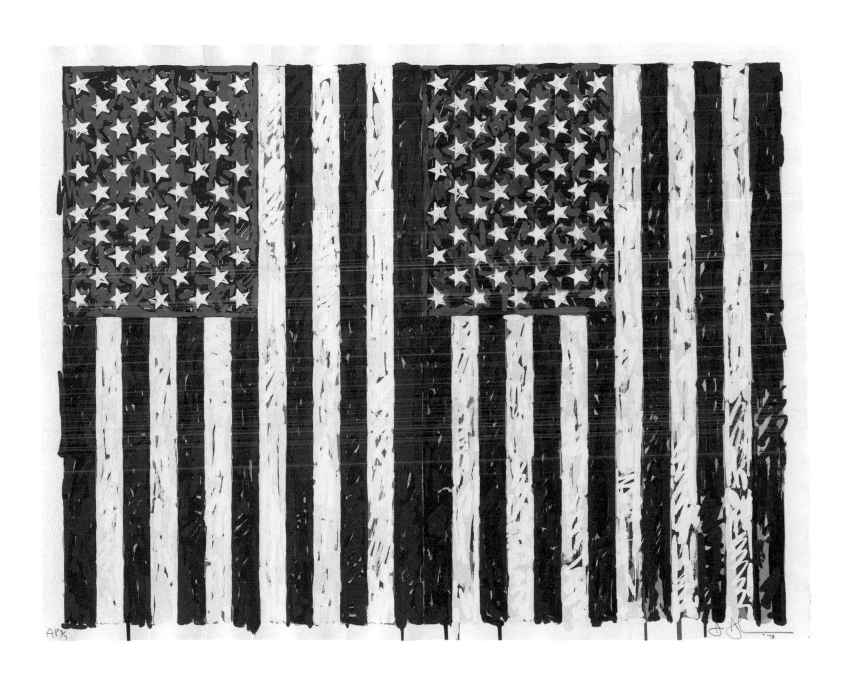

EL MOST C

I AM THRO

A SHARP V

OUND PFE

ED WHEN I

AGAINST A

BACKGROU

ST OUTLINE

LORED WH

N AGAIN

HITE BACK

LMOST COU

AM THROW

HARP WHI

D I FEEL

WHEN

American Printmaking, 1977 to the Present SUSAN TALLMAN

WHEN FRANZ KLINE WAS ASKED in the mid-1950s whether
he had ever thought to explore his painterly gestures through
lithography, his answer was unequivocal: "No.... Print-
making concerns social attitudes, you know — politics and
a public." He concluded, "I can't think about it. I'm involved
with the private image."[1] For Kline and other painters of his
generation, the intimate bond between artist and viewer was
best mediated through a unique object touched by the artist's
hand. In this worldview, the diffusion of printed editions was
a distraction, and the arcane methods required to transform
an artist's mark into a printed image inserted an unwelcome
degree of indirection. The "private image" was sacrosanct
space, a profound alternative to the ruckus of communal life.

In the decades since Kline's statement, the ways we
encounter, produce, and consume images have proliferated
spectacularly. Public and private are now less like distinct,
incompatible domains than mutable, overlapping territories
where border skirmishes are inevitable. Rather than skirt
these conflicts, many contemporary artists have made them
the subject of their work. As a result, prints — which have as
much to do with intimacy and ownership as with politics and
a public — are now more central to the ideas and production
of art than at any other time in history.

Consider Wayne Thiebaud's luminous 1988 drypoint
Eight Lipsticks (pl. 138). Few household objects are as
intimate in their use or as frivolous in their connotations
as lipsticks, but Thiebaud endows them with architectonic
sobriety and military rigor. Scratched into the metal print-
ing plate, his lines carry burrs that catch ink and cause a
slight bleed, softening and enriching the forceful mark with
poignant blushes of pink and gold. Tiny in scale though mon-
umental in attitude, Thiebaud's print is emblematic of the

entanglement of individual identity, social performance, and
sensory experience that has characterized the art of the past
forty years.

In the 1960s, printed editions had flourished as Kline's
ideal of the private image was supplanted by a different goal:
an unpretentious yet meaningful art that could be integrated
into daily life and, as Claes Oldenburg put it, "does some-
thing other than sit on its ass in a museum."[2] The smooth
surfaces and industrial panache of lithography and screen-
print proved critical to the look of pop art in particular, and
a reader glancing through this catalogue can hardly miss the
explosion of color that marks the opening of the sixties —
it's like Dorothy stepping out of the farmhouse door into Oz.
More difficult to perceive in reproduction, however, is the
eruption of *tactility* that followed a decade later.

Large scale and bright color are effective ways to reach
a crowd; tactility demands intimacy. In *Harvest, with Orange
Stripe* (pl. 131), Robert Motherwell exploited the chromatic
intensity of lithography but obstructed its usual flatness
through the palpable complications of collage. In print he
could compose a call and response between found matter
and the autographic gesture at the heart of the private image.
Though lithography may offer a more familiar set of tools for
painters, many found that etching was particularly compel-
ling because of the depth and complexity of its surfaces and
the ability of a metal plate to record a sequence of events
for later playback. From a distance, Richard Diebenkorn's
masterful etchings of the 1980s appear bold and decisive, but
their deftly balanced compositions were achieved through
long and patient fiddling — shifting elements, scraping
down metal, burnishing, redrawing, elaborating, and editing
back down. On close viewing, the surface is revealed as a

palimpsest of doubt and discovery (pl. 137). "I seem to have to do it elaborately wrong," Diebenkorn wrote. "Then maybe...I can arrive at something straight and simple."[3]

The emergence of collaborative, professional print shops in America at the cusp of the sixties changed the landscape of production for contemporary artists in ways that cannot be overestimated. Providing technical virtuosity while encouraging creative experimentation, these organizations enabled artists to stretch toward new ways, means, and materials. The involvement of other people in the execution of the artist's work was problematic for artists like Kline, but younger artists were increasingly disinclined to consider art as an embodiment of personal emotion. Pop had looked to the external world of mechanical reproduction, while minimalist and conceptual artists focused on the logistics and phenomenological workings of art. The objective qualities of the object — rather than the mystique of how they came to be — were now the primary carriers of meaning.

For Richard Serra, whose work operates through direct physical presence, the print's function as an instrument of reproduction is irrelevant. The weight and spatial obstructions of Serra's sculptures can be understood only through bodily proximity, and he considers the color black to be the two-dimensional counterpart of these phenomena. *Muddy Waters*, a looming six-foot-tall accretion of light-sucking pigment, *enacts* rather than depicts the properties of Serra's sculptures, but on a domestic scale (pl. 139). The sculpture of Martin Puryear also hinges on the innate character of the materials but, unlike Serra's, is open to allusion and double-readings. One of the jobs of art, Puryear has said, is to insert "jogs and switchbacks in the historical continuum that people always want to believe in. There

are always convoluted and complicated cul-de-sacs that don't allow things to be read just as a linear evolution."[4] For Puryear, the allure of prints lies in the ambiguity between two and three dimensions: he works primarily in etching, where his line acts to diagram volume and suggest animation even as it asserts its status as a ridge of ink on flat paper (pl. 141).

Chunky, preindustrial print techniques such as woodcut, hand-made paper, and etching assumed new relevance for artists investigating the symbiosis of image and substance. Using stubbornly resistant materials to remake photographic images, Chuck Close and Vija Celmins dissected the mechanics and poetics of representation. Close's fundamental concern has always been the symbiosis between a coherent illusion and the "incremental units" from which it is built.[5] In *Leslie/Fingerprint/Silk Collé* the units are fingerprints and the substrate is silk, a metonym for haptic pleasure (pl. 142). In Celmins's prints the scale is smaller, the subject matter vaster, and the tactility denser. The *Concentric Bearings* prints convene three subjects: an airplane clipped from a newspaper, night skies strewn with stars, and the artist's drawing after a photograph of Marcel Duchamp's *Precision Optics* machine (pl. 136). Each of these subjects nods toward content that a still photograph cannot capture — time, motion, infinite space. John Calvin argued against images with the dictum "finitum non capax infiniti" (the finite cannot circumscribe the infinite). Celmins pictures the act of circumscription itself — the aspiration and failure of representation.

To appreciate the complexities of any of these works the viewer has to be close to the surface. From across the room (or in a thumbnail), the Diebenkorn looks forthright,

the Serra resembles a cutout, and the Celmins might be a collection of magazine clippings. Close up, however, the cogent image comes apart into a collection of small sensory moments. The work's content cannot be fully assessed in either mode; it arises from the process of negotiation between the whole and its parts.

Kline's phrase "politics and a public" alluded to the venerable tradition of prints that shine a light on injustice and instigate action, a role Kline saw as antithetical to the private image. The social upheavals of the sixties, however, gave rise to the conviction — still broadly held — that *everything* is political: every person and every object is embedded in the web of power relationships and nothing can be evaluated in isolation. The swarm of stylistic tendencies and ideological positions dubbed "postmodernism" is unified by the recognition of this complexity and interdependence — the postmodern individual is not a coherent fixed entity but a provisional assemblage shaped by internal and external pressures and linked to the world through myriad exchanges, many of them conducted in print. Politics was implicit in even the most ostensibly private of subjects. There is nothing partisan about Kiki Smith's untitled lithograph of skin and hair (pl. 143). Conceived as an "unfolding" of the human body, however, the print was an extension of Smith's exploration of the body's edge — a border that is fraught psychologically (felt identity versus social roles), physiologically (ingestion and expulsion), and legally (who gets to control what happens within one's body).

The Guerrilla Girls' influential postering campaign of the mid-eighties, on the other hand, was intended as street-corner agitprop. Using humor and occasional public shaming, it called attention to gender inequality within the supposedly progressive art world. While some posters called out specific galleries and museums, others such as *Do Women Have to be Naked to get into the Met. Museum?* (pl. 134) addressed the general imbalance of power between those who control representation and those who are its subjects — the all-important difference between being depicted and being heard that is core to all forms of oppression. For African American artists born in the early twentieth century — Romare Bearden, Elizabeth Catlett, Jacob Lawrence, and others — simply picturing the world they knew constituted an existential assertion of agency. More recent artists have laid claim to history as well, revising familiar events from new vantage points of race and gender. With its pretty schooner held aloft like a toy in the bath, Kara Walker's *no world* (pl. 144) is insidiously innocent in affect, but disaster lurks everywhere: the churning waves, the submerged (drowned?) figure, the jagged pile of clouds — black against white — and the shoreline exchange between the tall figure in a jacket and the small one crowned with leaves. The ship is a slave ship and we are looking at the last moment of the old New World before all things are soiled.

Other artists addressed abstract systems through which power can be encoded and deployed: Barbara Kruger pilloried mass-market graphic design, while Jenny Holzer examined the workings of language. The *Truisms* that Holzer began producing as posters in the late seventies are alphabetically arranged, one-line reductions of sundry philosophical positions, packaged for easy consumption (pl. 133). As in effective advertising and propaganda, their crisp design and punchy syntax exude an authority that masks their moral defects or lapses in logic, inspiring belief in the illusion of sense.

Glenn Ligon also makes language a central subject, but the texts he uses and the manipulations he applies to them tether the personal to the political. Two of his *Four Etchings* quote from Zora Neale Hurston's 1928 essay "How It Feels to Be Colored Me." In black ink on white paper we read, "I do not always feel colored" and "I feel most colored when I am thrown against a sharp white background." The stenciled letters, clearly legible at the top, become increasingly murky as background noise gradually drowns out the signal (pl. 140). The other two etchings are printed on black paper, making it almost impossible to grasp Ralph Ellison's words, which read in part: "…I am invisible, understand, simply because people refuse to see me." This is a physical poem about perception, social and optical. Graphic materials — black ink and white paper — become racial metaphors; the contrast of one against the other is presented in terms of legibility, visibility, personal identity, and power. As in the work of Jasper Johns, a seemingly simple empirical puzzle unexpectedly unravels into a tangle of personal emotion and objective realities, hesitant, controlled, and heartrending.

In works like these, there is no dividing line between the private image, politics, and a public. Each is a reflection of the other — formulated through give and take, self-reflection and acquisition, reproduction and response. Contemporary artists have responded to a world of inescapable replication not by rejecting the spectacle and mediation of printed matter, but by taking its weight and measure. They have given us a complex art to match a complex world.

1 Kline in Thomas B. Hess, "Prints: Where History, Style and Money Meet," *Art News* (January 1972), 29.

2 Claes Oldenburg, "I Am For…," in *Environments, Situations, Spaces* (New York, 1961).

3 Richard Diebenkorn, quoted in Judith Brodie and Adam Greenhalgh, *Yes, No, Maybe: Artists Working at Crown Point Press* (Washington, DC, 2013), 28.

4 Puryear in Dwight V. Gast, "Martin Puryear: Sculpture as an Act of Faith," *Journal of Art* 2, no. 1 (September–October 1989): 7.

5 Close in Terrie Sultan, *Chuck Close: Process and Collaboration* (Munich, London, New York, 2014), 43.

RAISE BOYS AND GIRLS THE SAME WAY

RANDOM MATING IS GOOD FOR DEBUNKING SEX MYTHS

RECHANNELING DESTRUCTIVE IMPULSES IS A SIGN OF MATURITY

RECLUSES ALWAYS GET WEAK

REDISTRIBUTING WEALTH IS IMPERATIVE

RELATIVITY IS NO BOON TO MANKIND

RELIGION CAUSES AS MANY PROBLEMS AS IT SOLVES

REMEMBER YOU ALWAYS HAVE FREEDOM OF CHOICE

REVOLUTION BEGINS WITH CHANGES IN THE INDIVIDUAL

ROMANTIC LOVE WAS INVENTED TO MANIPULATE WOMEN

ROUTINE SMALL EXCESSES ARE WORSE THAN THE OCCASIONAL DEBAUCH

SACRIFICING YOURSELF FOR A BAD CAUSE IS NOT A MORAL ACT

SALVATION CAN'T BE BOUGHT AND SOLD

SELF-AWARENESS CAN BE CRIPPLING

SELF-CONTEMPT CAN DO MORE HARM THAN GOOD

SELFISHNESS IS THE MOST BASIC MOTIVATION

SELFLESSNESS IS THE HIGHEST ACHIEVEMENT

SEX DIFFERENCES ARE HERE TO STAY

SIN IS A MEANS OF SOCIAL CONTROL

SLIPPING INTO MADNESS IS GOOD FOR THE SAKE OF COMPARISON

SLOPPY THINKING GETS WORSE OVER TIME

SOLITUDE IS ENRICHING

SOMETIMES SCIENCE ADVANCES FASTER THAN IT SHOULD

SPENDING TOO MUCH TIME ON SELF-IMPROVEMENT IS ANTISOCIAL

STARVATION IS NATURE'S WAY

STASIS IS A DREAM STATE

STERILIZATION IS A WEAPON OF THE RULERS

STRONG EMOTIONAL ATTACHMENT STEMS FROM BASIC INSECURITY

STUPID PEOPLE SHOULDN'T BREED

SURVIVAL OF THE FITTEST APPLIES TO MEN AND ANIMALS

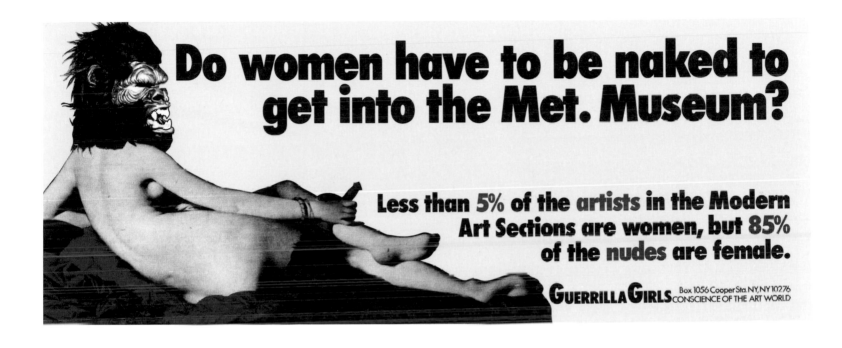

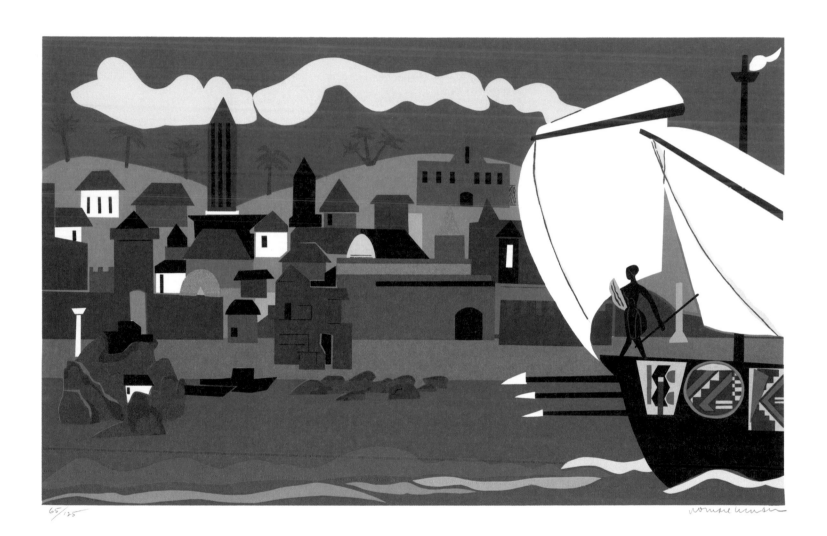

65/125

O C 7 P.

144 Kara Walker, *no world,* 2010, from *An Unpeopled Land in Uncharted Waters*, etching, aquatint, sugarlift aquatint, spitbite aquatint, and drypoint

Whistler. 1860.

American Prints at the National Gallery of Art　JUDITH BRODIE

THE FIRST AMERICAN PRINT TO enter the National Gallery of Art's collection arrived almost as soon as the new building's tall bronze doors were opened to the public. James McNeill Whistler's *The Long Gallery, Louvre* is a lithograph from 1894 showing spectators and a copyist in the immense *Grand Galerie* of one of Europe's great museums (fig. 1).[1] That the subject of the print is the Louvre was perhaps intentional: the donor may have been urging America's new National Gallery to set its sights high. Given by Ellen T. Bullard (1865–1959), the Whistler print was accepted by the trustees the same week that Franklin D. Roosevelt, thirty-second president of the United States, accepted on behalf of the nation the museum's newly completed building along with the artworks it housed. At the opening ceremony on March 17, 1941, Roosevelt bestowed high praise on Andrew W. Mellon (1855–1937) who, in addition to conceiving and funding the National Gallery, adorned its walls with his superb art collection. FDR thanked other supporters as well that day: founding benefactors Samuel Kress (1863–1955), Joseph Widener (1872–1943), and Chester Dale (1883–1962). And he noted that "the gift of Miss Ellen Bullard and of three anonymous donors…mark the beginning of the Gallery's collection of prints."[2] The Bullard gift comprised thirty works: one early nineteenth-century British drawing, twenty-eight European prints dating mostly to the nineteenth century, and the single print by Whistler, an American who left for Europe at age twenty-one and never returned to his homeland. That was indeed the beginning — but only the beginning.

One year later, Elisabeth Achelis (1880–1973), a woman more engaged with reforming the Gregorian calendar than collecting, donated fifty-seven prints,[3] about a quarter of them by Americans and including the Gallery's first prints by Mary Cassatt, Childe Hassam, and Joseph Pennell.[4] (The first painting by Hassam came in 1943, but another twenty years would pass before a painting by Cassatt would enter the collection.) One item in the Achelis gift was a stiffly mannered portrait of George Washington, engraved in 1862 by William Edgar Marshall after a painting by Gilbert Stuart (fig. 2). Being a reproductive print — a print that reproduces a work created in a different medium — it was something of an oddity in the group, most likely added because the Gallery had a painting of George Washington by Stuart (the first of five in the collection today).[5] Another reproductive print, engraved by the American artist Edward Savage after his own painting, *The Washington Family* (1789–1796), was a further oddity. One suspects that it crept through the door almost unnoticed, the single print among three hundred paintings and twenty-nine sculptures that make up the Gallery's Andrew W. Mellon Collection. Mellon must have owned it for the simple reason that he owned the noted painting by Savage, which he had also donated.

The Gallery's first really major gift of prints and drawings — more than 1,600 — was donated as part of the Widener Collection in the fall of 1942. While the gift was enormously important to the Gallery's graphics holdings of European art, raising them to a new level, the Widener Collection did not include a single American work. The American holdings soon got a boost, though. At the close of the year James Watson Webb (1884–1960) and his wife Electra Havemeyer Webb (1888–1960), donated thirty-eight Whistler prints — the first and second *Venice Set* — in memory of Electra's parents, Louisine and Henry Osborne Havemeyer.[6]

282

In March of 1943 Lessing J. Rosenwald (1891–1979), a founding benefactor, made a transformational gift: nearly nine thousand European and American works on paper dating from the fifteenth to the twentieth century, crucial for the holdings of European prints and drawings but also major — indeed the first major comprehensive gift — for the holdings of American graphics. In the context of American collectors and as described in the Gallery's annual report that year, Rosenwald's was "one of the greatest collections of graphic arts ever assembled by a private individual."[7] His donation brought an influx of approximately 1,100 American prints, more than a third of them by Whistler. Rosenwald would go on to donate another seventy-two Whistler prints by the end of the decade.[8] Other outstanding American prints flowed into the collection with the Rosenwald gift, among them Paul Revere's historic *The Bloody Massacre* (1770);[9] thirty-five impressions of prints by Mary Cassatt;[10] 248 prints by Pennell, including *Hail America* (1908) (pl. 61); and the Gallery's first prints by then-living artists Thomas Hart Benton, Edward Hopper, John Sloan, and Benton Spruance.

If Whistler fundamentally launched the Gallery's American print collection, John James Audubon was not far behind. An early edition of his culminating work, *The Birds of America*, donated in 1945 by Mrs. Walter B. James (1860–1946), comprised 435 prints. One of only two known complete sets in its original unbound state, this monumental folio remains one of the treasures of the collection. Another 114 American prints came the following year as part of a bequest of more than 280 prints and drawings from Addie Burr Clark (1868–1946), featuring prints by Hassam, Pennell, and Martin Lewis, including his *Stoops in Snow* (1930)

(pl. 88), wood engravings after Winslow Homer, and the Gallery's first print by then-living artist Reginald Marsh. By 1946 the National Gallery could claim 483 impressions by Whistler, 435 prints by Audubon, 321 prints by Pennell, and 58 impressions by Cassatt. While these numbers suggest that Whistler and Pennell outranked Cassatt, in fact Cassatt simply produced fewer prints: a third the number of Whistler and only a seventh that of Pennell. In proportional terms, her representation was on a par with theirs.

Given the status of these artists today, Pennell seems like the odd man out in the group, but his work was very popular with American print collectors at the time — not just Rosenwald — and his name was often mentioned in the same breath as that of Whistler. Despite Pennell's marked prominence in the Gallery's first decade, relatively few of his prints were acquired between 1950 and 2000. In that same half-century, the stream of Whistler prints also ebbed to a degree.[11] In his 1954 book *Modern Prints and Drawings*, Paul J. Sachs, professor of fine arts at Harvard University and one of the first donors to the Gallery's print collection, explained, "Enthusiasm for Whistler's works, paintings and prints alike, almost universal in my youth, has since been tempered. To many contemporary eyes brought up on 'stronger meat,' he seems thin, too exquisite, too precious."[12]

Stronger meat came in the form of prints by George Bellows — fifteen lithographs, all boxing images acquired from the artist's daughter Jean Bellows Booth in 1956, and including the now iconic *A Stag at Sharkey's* (1917) (pl. 69). This was a milestone acquisition, the Gallery's first-ever purchase of prints.[13] In later years the Gallery would go on to fill gaps and shape its holdings through purchases, but gifts were always (and remain) key to the building of the

American print collection. Gifts, however, follow no historical sequence, tending to arrive at random and without regard for chronology. Thus, for example, Andy Warhol was represented in the collection in 1964, whereas Stuart Davis, born thirty-six years before Warhol, was not represented until 1975. Similarly, the Gallery acquired its first print by Jasper Johns in 1964, four years before it acquired its first by John Marin, born six decades earlier. Such is the chance nature of gifts and the vagaries of taste.

While the Gallery was initially hesitant to acquire paintings and sculptures by living artists, such was not the case when it came to prints and drawings. Rosenwald continued to add to the contemporary holdings, giving the Gallery its first print by Josef Albers in 1951, by Peggy Bacon in 1953, by Leonard Baskin in 1958, and by Sylvia Wald in 1959. He broke significant ground in 1964, donating the Gallery's first prints by a host of important contemporary artists, many of whom made their earliest prints at the pioneering Long Island workshop, Universal Limited Art Editions — Lee Bontecou, Jim Dine, Helen Frankenthaler, Grace Hartigan, Jasper Johns, Robert Motherwell, Larry Rivers, James Rosenquist, Max Weber, and others. Rosenwald, better known for his collecting of rare German wood cuts and prints by Dürer and Rembrandt, was in fact laying the groundwork for a surge of contemporary American prints to follow.[14]

The collection grew by leaps and bounds in the last quarter of the twentieth century. In the early 1970s Emily Hall Tremaine (1908–1987) and Burton G. Tremaine (1901– 1991) donated fifty-nine prints, including Albers's *Tlaloc* (pl. 106) and the Gallery's first prints by Robert Rauschenberg. Stanley Woodward (1899–1992), instrumental in placing contemporary art in United States embassies around the world, contributed through the Woodward Foundation in 1976 about 160 contemporary American prints, including Rauschenberg's daring *Accident* (1963) (pl. 124). Separately and together over the course of more than thirty-five years, Ruth Cole Kainen (1922–2009) and Jacob Kainen (1909–2001) gave approximately 2,300 works to the Gallery: European and American art covering five centuries and encompassing close to 275 American prints, from nineteenth-century prints by Mary Nimmo Moran (pl. 43), and Thomas Moran (pl. 44) to twentieth-century prints by James Lesesne Wells (pl. 74), Louis Lozowick (pls. 75–77), Stuart Davis (pl. 78), and David Smith (pl. 114). Other significant gifts of the period were 156 Lichtenstein prints donated by the artist and his wife; 130 prints plus carved woodblocks and incised metal plates by Milton Avery, donated by the Avery Family (fig. 3); more than 2,000 American prints from Dorothy J. Smith (1912–1986) and Benjamin B. Smith (1907–1989); and nearly 260 American prints from the collection of Robert A. Hauslohner (1923–1990) and Lorna McAlpin Hauslohner (1926–1999), donated by Mrs. Hauslohner.

The establishment of three archives in the 1980s and early 1990s — those of Gemini G.E.L., Crown Point Press, and Graphicstudio — brought to the Gallery thousands of important prints by prominent artists including Vija Celmins, Chuck Close, Richard Diebenkorn, Johns, Sol LeWitt, Lichtenstein, Ellsworth Kelly, Claes Oldenburg, Rauschenberg, Ed Ruscha, Richard Serra, and Wayne Thiebaud. The archives have kept the collection active, dynamic, and current while maintaining a very high standard, recently introducing such leading-edge artists as Trenton

Doyle Hancock, Christian Marclay, Allan McCollum, Julie Mehretu, Shahzia Sikander, and Fred Wilson.

Between 1950 and 2000, the American prints collection grew from just over 1,900 to nearly 12,000 works — more than a sixfold increase. And in the past fifteen years, the collection has almost doubled, now numbering some 22,500 prints. There has been a concurrent increase in the number of works by African American and women artists, and in many ways the collection has taken on a new character, especially with the 2008 acquisition of the Reba and Dave Williams Collection of 5,200 prints. The Williamses collected well-known works by such canonical artists as John Marin (pl. 65) and Charles Sheeler (pl. 73), but they also concentrated on thousands of works by lesser-known artists. Of the 2,070 artists represented in the Williams Collection, more than three-quarters were new to the Gallery's print holdings, including William H. Johnson (pl. 101), Helen

Lundeberg (pl. 79), Bernarda Bryson Shahn (pl. 98), and Grant Wood (pls. 104, 105). The Williams Collection also brought a choice selection of nineteenth-century American prints to the Gallery, most notably Thomas Moran's *The Mountain of the Holy Cross, Colorado* (pl. 51), William Bradford's *Among the Ice Floes* (pl. 52), and two of the most striking prints of the 1960s: Ed Ruscha's *Standard Station* (pl. 122) and Andy Warhol's *Marilyn* (pl. 123). In 2005 Norma B. Marin donated sixty-one prints by John Marin, her father-in-law, following earlier gifts of Marin prints from the family. Funds contributed by Donald and Nancy deLaski have enabled the Gallery since 2006 to fill critical gaps and shape the collection through purchases, ranging from two early nineteenth-century hand-colored prints by John Hill (pls. 17, 18) to Kara Walker's *no world* (2010) (pl. 144). Beginning in 2009 the Gallery acquired Jasper Johns's personal archive of approximately 1,700 proofs for some three

hundred of his prints, a momentous addition to the collection. Today the Gallery has more prints by Johns — some 1,900 in total — than by any other American artist, past or present. Whistler now takes a back seat to Johns.

An unexpected wave of paintings, sculpture, decorative arts, prints, drawings, and photographs came from the Corcoran Gallery of Art in 2015, bringing some 2,000 American prints into the collection. Of special note was an album of more than 830 portrait engravings made and assembled in the late eighteenth and early nineteenth centuries by Charles Balthazar Julien Févret de Saint-Mémin, a French émigré who traveled the United States and created likenesses of sitters ranging from President Thomas Jefferson to members of his own family (pl. 16). Other noteworthy acquisitions include a rare engraving by Paul Revere (pl. 7); a brilliant impression of Cassatt's *The Letter* (c. 1891) (pl. 53); numerous prints by Whistler,[15] Hassam, and Sloan; an extraordinary three-dimensional illustrated book by R. Buckminster Fuller — *Tetrascroll* (1975); and a group of politically charged prints by Rupert García (fig. 4).

Most recently Harry W. Havemeyer made a gift and major pledge of a distinguished collection of 177 eighteenth- and early nineteenth-century prints assembled by him and his father, Horace Havemeyer (1886–1956), in whose memory the pledge was made. Considered among the finest collections of early American prints in private hands, it features numerous important and rare works such as Amos Doolittle's set of four hand-colored engravings from 1775 depicting the battles of Lexington and Concord (pls. 9–12). The Havemeyer family has significant ties to the Gallery. In 1956 Horace Havemeyer donated one of the Gallery's most

beloved paintings, Edouard Manet's *The Railway* (1873), and in 1962 his sons, Harry W. Havemeyer and Horace Havemeyer Jr. (1914–1990), donated Johannes Vermeer's superb *A Lady Writing* (c. 1665). Relevant to the present history, however, it was Horace Havemeyer's sister, Electra Havemeyer Webb, along with her husband, who helped launch the American print collection in 1942 by donating thirty-eight Whistler prints. Thus, in a sense, the Gallery's collection, having grown in depth and quality over seventy-five years, has now come full circle — which is to say, back to one of its most enduring benefactor families.

1 Paintings by Whistler came to the Gallery early on as well, including, in 1942, *Grey and Silver: Chelsea Wharf* and *Mother of Pearl and Silver: The Andalusian,* and in 1943 the celebrated *Symphony in White, No. 1: The White Girl* (1862).

2 The three anonymous donors were W.G. Russell Allen (1882–1955) — who gave the first survey of great old master prints — Phillip Hofer (1898–1984), and Paul J. Sachs (1878–1965). A recording of Roosevelt's March 17, 1941, speech is available at http://www.nga.gov/content/ngaweb/audio-video/audio/west-building-dedication-president-fdr.html (accessed August 15, 2015).

3 Described in the National Gallery's annual report for 1942 as "58 prints." One work was actually a drawing by Muirhead Bone, *Near Siena* (1942.6.13).

4 Elisabeth Achelis was a passionate advocate for calendar reform, petitioning the United States Congress and the League of Nations to adopt a twelve-month perpetual calendar. Her father, Frederick (Fritz) Achelis, a successful German American industrialist, built an important collection of old master prints that his son donated to the Yale University Art Gallery in 1925.

5 Gilbert Stuart, *George Washington (Vaughan-Sinclair portrait)*, 1795, donated by the A.W. Mellon Educational and Charitable Trust in 1940. The West Building opened in 1941, but the Gallery was founded in 1937; Mellon made a donation that year and a bequest of his works of art came in 1940.

6 Electra's mother was in correspondence with Whistler from 1879 until 1881, and both she and her husband bought works from him. Influential tastemakers that they were, the Havemeyers presumably had a part in introducing Whistler to other American collectors. Real credit, though, goes to Charles Lang Freer (1854–1919), who amassed one of the world's most important collections of Whistler's works — including more than 950 of his prints — housing them in the Freer Gallery of Art, which opened to the public in 1923, seventeen years before the National Gallery established itself nearby.

7 *Smithsonian Report for 1943,* "Report on the National Gallery of Art for the year ended June 30, 1943," (United States Government Printing Office, Washington, 1944): 29. The report describes the gift as "some 6,500 items," but the number, once fully catalogued, was considerably higher. The report is available at http://www.nga.gov/content/dam/ngaweb/About/pdf/annual-reports/annual-report-1943.pdf (accessed October 31, 2015)

8 Rosenwald ultimately donated approximately 22,000 old master and modern prints and drawings to the National Gallery of Art. For a detailed understanding of the Rosenwald Collection, see Ruth E. Fine, *Lessing J. Rosenwald: Tribute to a Collector* (National Gallery of Art, Washington, 1982).

9 Rosenwald donated the Gallery's first impression of *The Bloody Massacre* in 1943. Harry W. Havemeyer pledged another impression in 2015. It is the latter that appears in the checklist and is reproduced in this catalog.

10 In years to come Rosenwald would donate an additional forty-six prints by Cassatt, ultimately contributing more of her prints than any other donor.

11 The Gallery acquired fifty-one prints by Pennell between 1950 and 2000, including twenty from one donor in 1995. During the same period, eighty-six impressions of Whistler prints were acquired, hardly insignificant but small relative to the number acquired in the Gallery's first decade.

12 Paul J. Sachs, *Modern Prints and Drawings* (New York, 1954), 202.

13 Ten years later the Gallery made its first-ever purchase of a drawing, Rembrandt's *Saskia Lying in Bed,* c. 1638, Ailsa Mellon Bruce Fund, 1966.21.1.

14 Fine 1982, 216.

15 Today the National Gallery has more than 650 impressions of prints by Whistler.

Artists' Biographies

Compiled by Mollie Berger, Mary Lee Corlett, Lauren Schell Dickens, Davida Fernandez-Barkan, Francesca Kaes, Carlotta Owens, Charles Ritchie, and John Tyson

Josef Albers

Born, Bottrop, Germany, 1888
Died, New Haven, CT, 1976

Josef Albers worked in various media including painting, photography, printmaking, glass, and sculpture. After studying at the Royal School of Art in Berlin (1913–1915) and the Royal Academy of Fine Arts in Munich (1919), Albers enrolled at the newly founded Bauhaus in Weimar in 1920. While Berlin's expressionist art movement informed Albers's early printmaking, it was during his time as a student and later teacher at the Bauhaus that he developed his lifelong interest in form and color.

After the Bauhaus was shut down in 1933, Albers and his wife, Anni — a weaver, textile designer, and printmaker — emigrated to the United States. They were invited to establish an art department at the newly founded Black Mountain College, near Ashville, North Carolina. In 1950 Albers was appointed chair of the Department of Design at Yale University. Albers was famous for his experiential and practical pedagogical approach rather than a focus solely on art theory; his course on color, for example — culminating in the publication of *Interaction of Color* (1963) — was renowned for its experimental methods and hands-on approach.

Albers's exploration of color led most famously to his *Homage to the Square* series, which he first developed in painting during the 1950s and later translated into print. Both his paintings and prints attest to Albers's technical precision and keen interest in exploring different materials and processes. Collaborating with the master printers at Tamarind Lithography Workshops and Gemini G.E.L., Albers strove to enhance the quality of his prints, matching the perfectionism of his paintings. This technical skill is also apparent in the precise, clean lines of the *Graphic Tectonics* and *Structural Constellations* series, which transformed Albers's early interest in abstraction into a more pronounced exploration of linear and geometrical configurations.

REFERENCES

Danilowitz, Brenda. *The Prints of Josef Albers. A Catalogue Raisonné, 1915–1976*. Second revised edition. Manchester and New York, 2010.

Fundación Juan March. *Josef Albers: Minimal Means, Maximum Effect*. Madrid, 2014.

Hanse, Tone, and Milena Hoegsberg. *Josef Albers: No Tricks, No Twinkling of the Eyes*. Oslo, 2014.

John James Audubon

Born, Les Cayes, Saint-Domingue
(today Haiti), 1785
Died, New York, NY, 1851

John James Audubon was a self-taught artist and naturalist. Born in the Caribbean in 1785 and raised in France, young Audubon delighted in exploring the woodlands and marshes near his family home. His parents sent him to America in 1803, both to manage family property near Philadelphia and to avoid conscription in Napoleon's army. In 1808 Audubon married and moved to Kentucky. For the next decade he pursued various businesses — all the while devoting himself to drawing birds in his spare time. At age thirty-five and after a failed business venture that led to bankruptcy, he resolved to dedicate himself to his ambitious dream of publishing *The Birds of America* — a mammoth, four-volume set comprising 435 hand-colored etchings and engravings.

Audubon spent nearly two decades pursuing his dream of portraying every native bird in the United States, life-size and in its natural environment. He traveled through the American wilderness searching for birds, recording their characteristics and behaviors, and shooting them in order to work with fresh specimens. From these he made detailed watercolors that served as models for the beautiful etchings that he ultimately had printed in London. Through frequent correspondence with his printers and by making several trips to Europe, Audubon supervised the printing of *The Birds of America,* an important contribution to the field of ornithology.

Beyond the completion of his publication, Audubon continued to study wildlife, but by 1846 failing eyesight and advancing senility put an end to his career. In 1851 he died at his home in what is now the Washington Heights neighborhood of New York City.

REFERENCES

Olson, Roberta J.M. *Audubon's Aviary: The Original Watercolors for the Birds of America*. New York, 2012.

Rhodes, Richard. *John James Audubon: The Making of an American*. New York, 2004.

Souder, William. *Under a Wild Sky: John James Audubon and the Making of the Birds of America*. New York, 2004.

Peggy Bacon

Born, Ridgefield, CT, 1895
Died, Cape Porpoise, ME, 1987

Margaret Frances (Peggy) Bacon was writing and illustrating her own stories by age ten and began her formal art training at the School of Applied Design for Women in 1913. She went on to study at the New York School of Fine and Applied Arts and the Art Students League where her teachers included Max Weber, George Bellows, and John Sloan.

Bacon's first book (more than a dozen followed), *The True Philosopher and Other Cat Tales* (1919), was illustrated with thirteen drypoints, a technique she favored throughout her career. Her drypoints were published in *World Magazine* in 1919 and for several decades her images appeared in *Vanity Fair, Harper's Bazaar*, and *The New Yorker*. Her print, *Promenade Deck*, was published in 1924 along with prints by Edward Hopper, John Marin, and Sloan in *Six American Etchings: The New Republic Portfolio*. In 1927, working with pastel crayons, she created her first caricatures, a genre for which she became well known.

Bacon married painter Alexander Brook in 1920 (they divorced in 1940) and raised two children. Beginning in the 1930s she taught art for three decades at schools such as the Art Students League, the School of the Corcoran Gallery of Art, Moore College of Art, and Temple University.

By 1920 Bacon's drypoints had been included in several group exhibitions at the Society of Independent Artists and the Painter-Gravers of America. In 1922 the Joseph Brummer Gallery held a major exhibition of her drypoints and drawings. Her work continued to be featured in more than thirty solo exhibitions, including at Stieglitz's Intimate Gallery in 1928 and in a major retrospective at Associated American Artists in 1942. In Washington, DC, the National Collection of Fine Arts (now Smithsonian American Art Museum) honored her with a retrospective in 1975.

BIBLIOGRAPHY

Flint, Janet A. *Peggy Bacon: A Checklist of the Prints.* San Francisco, 2001.

Peggy Bacon papers, 1893–1972 (bulk 1900–1936). Archives of American Art, Smithsonian Institution.

Tarbell, Roberta K. *Peggy Bacon: Personalities and Places.* National Collection of Fine Arts, Smithsonian Institution, Washington, 1975.

F. Bartoli

Born, Eighteenth Century
Died, Date Unknown

Extremely little is known about F. (possibly Frederick or Francesco) Bartoli. He arrived in New York City from London some time before 1796. Bartoli had achieved a certain degree of artistic success prior to coming to the American colonies: he exhibited works at the Royal Academy in London until 1783. Bartoli's portrait of *Ki-On-Twog-Ky* (1796), the Seneca chief who was also known as Cornplanter, is in the collection of the New-York Historical Society. A lithograph made after this work was produced for the *History of the Indian Tribes of North America* (1836). While Bartoli's depiction of Ki-On-Twog-Ky is quite well known, there are scant records of the artist's other works. An engraving after a portrait of George Washington that he executed around 1788 is in the holdings of the National Portrait Gallery, Washington.

REFERENCES

Abler, Thomas. "Governor Blacksnake as a Young Man? Speculation on the Identity of Trumbull's the Young Sachem." *Ethnohistory* 34, no. 4 (Autumn, 1987): 329–351.

Bates, William W. *The Hatchet and the Plow: The Life and Times of Chief Cornplanter.* Bloomington, 2010.

Falk, Peter Hastings. *Who Was Who in American Art, 1564–1975: 400 Years of Artists in America.* Vol. 1. Madison, CT, 1999.

Leonard Baskin

Born, New Brunswick, NJ, 1922
Died, Northampton, MA, 2000

In his mid-teens Leonard Baskin apprenticed with sculptor Maurice Glickman. He began studies at New York University in 1939 before transferring to Yale in 1941. Baskin found Yale's classes less compelling than the library, where he discovered William Blake and the art of the printed book, subjects that would inspire much of his life's work. By 1942 Baskin was crafting limited edition books; the first was a volume of his own poems. He left school in 1943 to serve in the United States Navy during World War II. By the end of the forties he had become deeply absorbed in the processes of relief printmaking, particularly woodcut and linocut.

Most of Baskin's works are figurative. He was convinced that printed representations were supremely equipped for meditation on mortality: he often rendered bodies in states of decay and dissolution. Baskin traveled to France and Italy, 1951–1952, studying late Gothic and early Renaissance art. Upon returning to the United States, he taught sculpture and printmaking at Smith College until 1974.

Baskin worked in etching, lithography, and monotype, yet his woodcuts were probably his greatest contribution. Large works, such as *The Hanged Man*, created in the 1950s, expanded the scale of printmaking, setting the stage for a revolution in the following decade. The artist's late years were dominated by commissioned work: bas-reliefs for the Franklin Delano Roosevelt Memorial in Washington, DC, and a large cast bronze figure for the Ann Arbor Holocaust Memorial at the University of Michigan. In addition, by the end of his life, his Gehenna Press had published more than one hundred illustrated books by a wide range of authors in many genres — from Homer and Shakespeare to children's books and a primer on birds.

REFERENCES

Baskin, Leonard. "Impulsions to Print." *Yale University Library Gazette* 69, no. 3–4, (April 1995): 163–170.

Coppel, Stephen. *The American Scene from Hopper to Pollock.* London, 2008.

Fern, Alan, and Judith O'Sullivan. *The Complete Prints of Leonard Baskin.* Boston, 1984

Romare Bearden

Born, Charlotte, NC, 1911
Died, New York, NY, 1988

Romare Bearden was three when his family moved from North Carolina to Harlem. His mother was active in public service and politics, and her wide social circle brought leading African American intellectuals, writers, and musicians to their home.

Bearden graduated from New York University in 1935 and became a caseworker for New York City Social Services, a position he held for 34 years. He attended night classes at the Art Students League where he studied with German artist George Grosz, and during the 1930s contributed political cartoons to *The Crisis* and the *Baltimore African-American*. His first solo exhibition of paintings and drawings was in 1940. He served in the United States Army during World War II and went to Paris on the G.I. Bill in 1950. Back in New York, he married Nanette Rohan in 1954.

Bearden explored artistic styles from social realism to abstract expressionism. In the 1960s he discovered the power of collage, which became his signature medium. The cornerstone of his printmaking activity was his association with master lithographer Robert Blackburn and the Printmaking Workshop, where Bearden created etchings, collagraphs, and monotypes. He also produced prints at JK Fine Art Editions from about 1978 through 1984.

Bearden helped organize the groundbreaking exhibition *The Evolution of Afro-American Artists, 1800–1950* at the City University of New York (1967), wrote numerous articles and books, was the first art director for the Harlem Cultural Council (1964), and was involved in founding the Studio Museum in Harlem (1968). In 1972 he was elected to the National Institute of Arts and Letters and in 1987 was awarded the National Medal of Arts.

REFERENCES

Corlett, Mary Lee. *From Process to Print: Graphic Works by Romare Bearden.* Petaluma, CA, 2009.

Fine, Ruth E. *The Art of Romare Bearden.* Washington, DC, 2003.

Schwartzman, Myron. *Romare Bearden: His Life and Art.* New York, 1990.

George Bellows

Born, Columbus, OH, 1882
Died, New York, NY, 1925

George Bellows was offered an opportunity to play for the Cincinnati Reds baseball team but turned it down to study art. In 1904 he enrolled at the New York School of Art, becoming a protégé of Robert Henri whose circle of realist artists probed the grittier side of twentieth-century American life. Bellows set up his New York painting studio in 1906, just as his images of impoverished street urchins were garnering attention, and by 1909 his series of violent prize-fighting pictures was gaining notice. Bellows taught at the Art Students League where he met and married his classmate Emma Story. He helped organize the seminal 1913 New York Armory show, where examples of his work were exhibited. That same year he joined the art editorial board for *The Masses*, a leftist magazine for which he

produced illustrations. In 1916 the printer George C. Miller introduced Bellows to lithography. The artist also worked with the printer Bolton Brown, producing a range of lithographs including a series depicting war atrocities in Belgium. In 1919 he taught briefly at the School of the Art Institute of Chicago and the following summer rented a home in Woodstock, New York, eventually building a home there in 1922.

Bellows created more than 190 print editions in his lifetime. His later works often featured domestic scenes, nudes, landscapes, and portraits. At age forty-two a ruptured appendix abruptly ended his life. After his death, Bellows's wife was a vital force in extending his legacy, facilitating exhibitions and helping place his work in important collections.

REFERENCES

Brock, Charles, ed. *George Bellows*. Washington, 2012.

Mason, Lauris. *The Lithographs of George Bellows, a Catalogue Raisonné*. San Francisco, 1992.

Myers, Jane, and Linda Ayers. *The Artist and His Lithographs, 1916–1924*. Fort Worth, 1984.

William James Bennett

Born, England, c. 1787
Died, New York, NY, 1844

Born in England around 1787, William James Bennett is one of many artists who emigrated to America in the early nineteenth century and helped shape the artistic production of the young nation.

Bennett's early life is not well documented, but he likely started his artistic career with the esteemed watercolorist Richard Westall who supported his candidacy for enrollment at the Royal Academy in 1801. While Westall made portraits and history paintings, Bennett's interest lay in landscape painting, a feeling that was deepened while traveling the Mediterranean during his military service in 1803–1807. On his return to London, Bennett was a founding member of the Associated Artists in Water-Colours. In 1812 the association went bankrupt and Bennett was elected a member of the more prestigious Old Water-Colour Society. While he was lauded by critics for his watercolors, Bennett was equally successful at engraving aquatints and produced a number of delicate prints for illustrated travel books.

In 1826 Bennett left England for America where he was elected to the National Academy of Design one year later. Continuing to work as a watercolor painter and printmaker, Bennett engraved a large number of illustrations for topographical albums. Among these, a series of nineteen views of American cities including Washington, Baltimore, and New Orleans stands out. Bennett's American oeuvre also comprises depictions of natural landmarks such as *View of the Natural Bridge,* 1835, and *Niagara Falls from the American Side*, 1840. With his printed views of the American landscape featuring both his own designs and those of other artists, Bennett helped shape a visual culture that inscribed the nation's native scenery with patriotic ideals.

REFERENCES

Deák, Gloria Gilda. *William James Bennett: Master of the Aquatint View*. New York, 1988.

Thomas Hart Benton

Born, Neosho, MO, 1889
Died, Kansas City, MO, 1975

Benton was named after his relative, the well-known senator from Missouri. Living in Washington while his father served in Congress (1896–1904), Benton took art classes at Western High School and studied drawing at the Corcoran School of Art. Back in Missouri in 1906, he worked as a newspaper cartoonist. Anticipating a career in illustration, he enrolled at the Art Institute of Chicago. In 1909 he traveled to France where he briefly studied at the Académie Julian. He moved to New York in 1912 and lived there until 1935, except for a brief stint in the United States Navy (1918).

Benton spent the first years of his career experimenting with various modernist approaches, but in the 1920s he embraced figuration and social commentary. In 1926 he joined the faculty of the Art Students League, where Jackson Pollock was among his students. By the mid-1930s, Benton, Grant Wood, and John Steuart Curry were the key figures of American Regionalism. Benton was also gaining a reputation as a muralist. He experimented with etching and relief printing in the 1920s, but lithography became his preference. George C. Miller printed Benton's first lithograph in 1929. Until his death in 1966, Miller printed most of Benton's lithographs. Beginning in 1934 Associated American Artists distributed more than fifty of Benton's lithographs through department stores and mail order. Benton also produced numerous book illustrations, including several projects for the Limited Editions Club, including *The Grapes of Wrath* (1940). He was a member of the National Academy of Arts and Letters and the recipient of medals from the American Institute of Architects (1960) and the National Arts Club (1974). Having returned to Missouri in 1935, he died in his studio in Kansas City while working on his final mural for the Country Music Hall, Nashville.

REFERENCES

Adams, Henry. *Thomas Hart Benton: Drawing from Life*. Henry Art Gallery, Seattle, 1990.

Fath, Creekmore. *The Lithographs of Thomas Hart Benton*. Austin and London, 1979.

Mazow, Leo G. *Thomas Hart Benton and the American Sound*. University Park, PA, 2012.

Albion Bicknell

Born, Turner, ME, 1837
Died, Malden, MA, 1915

Albion Harris Bicknell was a Boston-based painter and printmaker best known today for his landscape compositions. Originally from Maine, the Bicknell family moved to Boston when Albion was a child. In 1855 he took up art studies at the Boston Athenaeum and the Lowell Institute. He traveled to France in 1860 and enrolled at the École des Beaux-Arts in Paris where he studied under the prominent history painter Thomas Couture.

Returning to Boston in 1864, Bicknell earned recognition for his Venetian cityscapes that he had first painted during a stay in Italy. Because of their great popularity, Bicknell seems to have continued painting views of Venice throughout his career. Stylistically these works were informed by the French Barbizon school and attest to Bicknell's interest in the atmospheric qualities and airy tonalities of light, an interest he skillfully translated into his etchings and monotype prints.

Throughout his career Bicknell was well connected with contemporary art circles, setting up his studio in Boston where he worked next door to William Morris Hunt, Elihu Vedder, and Joseph Alexander Ames. After moving to Malden, Massachusetts, in 1875, Bicknell continued to receive his artist friends and hold annual exhibitions of his work. His paintings and prints were regularly exhibited in Malden, Boston, and New York until around 1900; his etchings featured in William Howe Downes's book on American landscape art, *Arcadian Days* (1891). Although Bicknell produced a large number of portraits of socialites as well as landscape and history paintings, ultimately it was his etchings and monotypes that piqued the curiosity of collectors and art critics.

REFERENCES

Craven, Wayne. "Albion Harris Bicknell, 1837–1915." *Antiques* 106, no. 3 (1974): 443–449.

Downes, William Howe. *Arcadian Days: American Landscapes in Nature and Art*. Illustrated by Albion H. Bicknell, Boston, 1891.

Esposito Hayter, Carla. *The Monotype: The History of a Pictorial Art*. Milan, 2007.

George Caleb Bingham

Born, Augusta County, VA, 1811
Died, Kansas City, MO, 1879

Although portraits constitute the majority of his oeuvre, George Caleb Bingham is known as one of America's first genre painters. Born in Virginia, Bingham grew up in rural Franklin County, Missouri, where his father was an innkeeper and his mother a teacher. From 1828 to 1832 Bingham apprenticed with the cabinetmaker and Methodist

minister Rev. Justinian Williams, with whom he also studied religion and law. In 1834 Bingham became a self-taught draftsman and painter specializing in portraiture.

During the late 1830s Bingham visited Philadelphia and New York before settling in Washington, DC. He exhibited at the National Academy of Design in New York and spent some time studying at the Pennsylvania Academy of Fine Arts in Philadelphia (1843). Upon his return to Missouri, Bingham was celebrated as the state's first genre painter. His depictions of fur traders and boatmen along the Missouri and Mississippi rivers captured and brought to national attention life on the frontier during the time of westward expansion.

Bingham's election to the state legislature of Missouri in 1848 marked the beginning of a lifelong political career that included appointments as Missouri state treasurer (1862–1865), Kansas City board of police commissioner (1874), and adjutant general of Missouri (1875). This concern with local and state politics became increasingly important for his artistic work as well, and is reflected in paintings such as *Country Politician* (1849) and *County Election* (1852, reproduced by the Philadelphia mezzotint engraver John Sartain).

After a brief stint in Europe, 1856–1859, Bingham returned to Missouri to resume both his political career and his artistic work as a portraitist. In 1877 he was appointed the first professor of art at the University of Missouri in Columbia.

REFERENCES

Bloch, Maurice. *George Caleb Bingham.* 2 vols. Berkeley and Los Angeles, 1967.

Rash, Nancy. *The Painting and Politics of George Caleb Bingham.* New Haven and London, 1991.

Shapiro, Michael Edward. *George Caleb Bingham.* New York, 1990.

Isabel Bishop

Born, Cincinnati, OH, 1902
Died, New York, NY, 1988

Born and raised in the Midwest, Isabel Bishop left her home at age sixteen to study illustration at the New York School of Applied Design for Women. After two years she transferred to the Art Students League where she studied with Max Weber, Kenneth Hayes Miller, Guy Pène du Bois, and Robert Henri.

Bishop is best known for her representations of the everyday, unspectacular activities of urban working women, subjects she began to explore after moving to New York's Union Square in 1926. She translated many of her paintings into etchings. A skilled draftsman, she developed a method of naturalistically rendering her subjects and convincingly depicting intimate communication. Bishop was influenced by the work of Peter Paul

Rubens and other Dutch and Flemish painters she saw during trips to Europe. Though her palette is lighter than that of the Baroque masters whose style she updated, Bishop's figures similarly are located in atmospheric grounds. In part reflecting norms of the time, many of her images depict pairs of women in public space. An observer of daily life, she often used her neighbors and those she saw on the streets around her studio as subjects.

Bishop taught at the Art Students League, 1936–1937, as the only fulltime female instructor, and also taught at the Skowhegan School of Painting and Sculpture. In 1943 she won an American Academy of Arts and Letters prize. She was appointed vice president of the National Institute of Arts and Letters in 1946, becoming the first woman to hold an executive position in that organization. In 1979 President Jimmy Carter presented her an award for Outstanding Achievement in the Arts.

REFERENCES

Lunde, Karl. *Isabel Bishop.* New York, 1975.

Reich, Sheldon. *Isabel Bishop.* Tucson, 1974.

Yglesias, Helen. *Isabel Bishop.* New York, 1988.

Karl Bodmer

Born, Zürich, Switzerland, 1809
Died, Paris, France, 1893

Karl Bodmer, born Johann Karl Bodmer, Swiss painter, draftsman, and engraver, is well known today for his depictions of indigenous American tribes. Bodmer studied under the engraver Johann Jakob Meier and quickly received acclaim for his travel albums of the Rhine and Moselle rivers.

In 1832 Bodmer accompanied the naturalist and ethnographer Alexander Philipp Maximilian, prince of Wied-Neuwied on an expedition to study the native people and flora and fauna of northern America. During their two-year-long journey — traveling from Boston to Pittsburgh and continuing west on the Ohio and Missouri Rivers deep into Indian territory at Fort McKenzie in present-day Montana — Bodmer visually recorded the marvels of a land hitherto unknown to European audiences. Although the young artist had set out on the expedition as a landscape painter, his portraits compel with their attention to detail and high verisimilitude.

Returning to Europe in 1834, Bodmer resumed publishing travel books and painting landscapes of the Rhineland before moving to Paris where he exhibited his Native American portraits. He was later hired to oversee the publication of an English and French edition of the prince's travel accounts, engaging printmakers and securing subscriptions. In 1854, after stays in Paris, Cologne, and Barbizon, Bodmer settled in the famous artists' colony in the Fontainebleau forest. Though largely forgotten today, Bodmer's mature work of forest scenes and

animal portraits was well received by his contemporaries. In 1851 he won second prize at the Paris salon and in 1867 he was awarded a Legion of Honor. During his long career, Bodmer regularly contributed illustrations to monthly magazines and books on natural history, including a re-edition of La Fontaine's *Fables*.

REFERENCES

Goetzmann, William H., ed. *Karl Bodmer's America.* Lincoln, NE, 1984.

Isenhagen, Hartwig. *Karl Bodmer: A Swiss Artist in America, 1809–1893.* Zurich, 2009.

Ruud, Brandon K., ed. *Karl Bodmer's North American Prints.* Lincoln, NE, 2004.

Louise Bourgeois

Born, Paris, France, 1911
Died, New York, NY, 2010

Bourgeois entered the Sorbonne in 1932 to study mathematics but soon changed course and took up art. She attended various art academies, including the École des Beaux-Arts, and worked at several artists' studios, among them Fernand Léger's. She married the American art historian Robert Goldwater in 1938 and immediately moved to New York. She experimented with lithography at the Art Students League in 1938, and during the 1940s executed engravings at Atelier 17. She also made woodcuts, drypoints, and etchings at home, where she eventually also did much of her own printing. She made prints through the late 1940s before turning increasingly to sculpture.

With the rise of the feminist art movement, Bourgeois's work received heightened attention, marked by a cover story in *Artforum* (March 1975) and Lucy Lippard's groundbreaking book, *From the Center: Feminist Essays on Women's Art* (1976), which features a Bourgeois drawing on the cover.

Bourgeois's prints exist in numerous states and variants and her oeuvre is heavily populated with unique impressions. She returned to printmaking in the late 1980s and began a significant collaboration with the intaglio printer Felix Harlan. She also produced softground etchings with Wingate Studio, Hinsdale, New York, while Peter Blum Editions and Carolina Nitsch Editions were important publishers of her work. Bourgeois published approximately one hundred of her own prints under the imprint Lison Editions.

Bourgeois represented the United States at the Venice Biennale in 1993; in 1999 she was awarded the Biennale's Golden Lion. Other honors include the Officier de L'Ordre des Arts et des Lettres (1983) and the National Medal of Arts (1997). Major retrospectives were organized by the Museum of Modern Art, New York (1982) and the Tate Modern (2008). MoMA organized her first print retrospective in 1994.

REFERENCES

Morris, Frances, ed. *Louise Bourgeois*. London, 2007.

"Louise Bourgeois: The Complete Prints and Books." *Museum of Modern Art*, New York. http://www.moma.org/explore/collection/lb/ (accessed September 18, 2015).

Smith, Carol. *Louise Bourgeois Prints: 1989–1998*. Lynchburg, VA, 1999.

William Bradford

Born, Fairhaven, MA, 1823
Died, New York, NY, 1892

William Bradford is known primarily for his vivid paintings of ships in turbulent, arctic waters. Born in a Massachusetts whaling town, Bradford worked as a merchant for several years. In 1852 he began painting "portraits" of ships. A self-taught artist, Bradford was initially influenced by etched and lithographic reproductions of drawings in books.

Nineteenth-century Americans were eager for images of awe-inspiring nature. Scenes of the Arctic Circle held special appeal, as it was one of the last uncharted territories then remaining. Bradford made six arctic voyages between 1861 and 1869, during which he created numerous drawings and oil sketches. He wrote extensively about icebergs, remarking on their dazzling colors and exquisite forms. He also hired photographers to capture scenes of the frozen wilderness. The documents yielded by Bradford's explorations provided source material for many of his subsequent artworks. He also published many of the photographs in his 1873 book, *The Arctic Regions*.

From 1871 to 1881 Bradford made several promotional trips to England and California. He won a number of wealthy supporters, including Queen Victoria, who purchased two paintings from him. In addition to offering a new market, California presented new subjects for painting. He was inspired by Yosemite and Mount Hood, in particular. In the 1880s Bradford's artworks were exhibited throughout the United States.

After 1885 Bradford painted less frequently. He increasingly made his own photographs and etchings, presumably driven by a desire to make his work more widely available to consumers. He lectured actively in cities in the Northeast. After a lecture for the Amateur Photographers' Club of New York, Bradford suffered a stroke and died three days later.

REFERENCES

Dearinger, David B. *Paintings and Sculpture in the Collection of the National Academy of Design*. New York, 2004.

Gedeon, Lucinda H., and Daniel Finamore. *Ships and Shorelines: William Bradford and Nineteenth-Century American Marine Painting*. Vero Beach, 2010.

Greenhalgh, Adam. "The Not So Truthful Lens." In *William Bradford: Sailing Ships & Arctic Seas*, ed. Richard C. Kugler. New Bedford, 2003.

George Loring Brown

Born, Boston, MA, 1814
Died, Malden, MA, 1889

Although primarily a painter, George Loring Brown occupies a special place in the history of American printmaking. At age fourteen he apprenticed with the wood engraver Alonzo Hartwell and later studied painting. In 1832 Brown left for Europe and eventually joined the Paris studio of Eugène Isabey to further his training in landscape painting. Returning to America in 1834, Brown traveled the northeastern United States, supporting himself by painting portrait miniatures, landscapes, and illustrations for popular novels.

In 1840 Brown once again set out for Europe. In Italy he successfully copied the landscapes of old masters but soon began composing original designs. Finally in 1858 one of his own landscapes earned him the Grand Prize of the Art-Union in Rome.

Brown returned to the United States in 1859, settling in Boston. His many paintings with American scenery attest to his eagerness to adapt to his new surroundings, but it was his Italian works that gained him recognition and ensured a steady income. However, artists and critics condemned the foreign subject matter and the formal qualities of these paintings — their composition, choice of color, and application of paint — denouncing them as un-American.

Yet Brown proved to be in advance of his American contemporaries. While in Italy he had produced a series of nine etchings that he republished in the United States in 1860. The plates not only paralleled the high degree of originality present in his paintings, but also introduced a painterly mode to the medium of etching. This painterly approach to printmaking was adopted by numerous painter-etchers and came to form the core characteristic of the American etching revival.

REFERENCES

Bruhn, Thomas P. *The American Print: Originality and Experimentation, 1790–1890*. Storrs, CT, 1993.

Golahny, Amy. "George Loring Brown and the Bay of Naples." *Nineteenth Century* 25, no. 1 (2005): 12–17.

Leavitt, Thomas W. *George Loring Brown: Landscapes of Europe and America, 1834–1880*. Burlington, VT, 1973.

Alexander Calder

Born, Lawnton, PA, 1898
Died, New York, NY, 1976

Calder's early creative activity included constructing toys and doll jewelry. Interested in mechanics, he earned an engineering degree from Stevens Institute of Technology, Hoboken (1919). After a series of engineering-related jobs, Calder came to New York in 1922. He studied drawing with Clinton Balmer and attended the Art Students League (1923–1926), where he took classes in etching and lithography and studied with John Sloan and Boardman Robinson.

He traveled to Paris in 1926 and studied drawing at the Académie de la Grande Chaumière. Between 1926 and 1931 Calder created a whimsical circus of more than seventy mechanical figures, his first moving sculptures. He began giving performances of his circus in 1927, sometimes producing linoleum-cut invitations. After 1930 he explored abstraction and motion in his sculpture, which Marcel Duchamp called "mobiles." Jean Arp proposed the term "stabiles" for Calder's stationary constructions.

Calder returned to the United States in 1934. Known for his playful, biomorphic sculpture and inventive utilization of industrial materials, he created costume and set designs for dance and theater, tapestries, jewelry, paintings, drawings, prints, posters, and book and magazine illustration. Calder's earliest prints were woodcuts, linoleum cuts, and etchings; in 1935 his first published etching appeared in *23 Gravures*, a group portfolio that included Wassily Kandinsky, Joan Miró, Pablo Picasso, Max Ernst, and Alberto Giacometti. At Atelier 17 in New York during the 1940s, he made relief prints and etchings. His later prints were primarily lithographs, including two solo portfolios published in the 1970s, printed in Paris by Arte-Adrien Maeght, and Atelier Mourlot, respectively.

Calder was elected to the American Academy of Arts and Letters (1964). The Gold Medal for Sculpture (1971) and the United Nations Peace Medal (1975) are among his numerous awards.

REFERENCES

Bruce Museum, Greenwich, CT. "Alexander Calder: Printmaker October 31, 2009–January 31, 2010." https://brucemuseum.org/files/Calder_PR.pdf (accessed September 1, 2015).

Calder Foundation. http://www.calder.org/ (accessed September 1, 2015).

Giménez, Carmen, and Alexander S. C. Rower, eds. *Calder: Gravity and Grace*. London and New York, 2004.

John Carwitham

Born, England, active 1723–1741

Relatively little is known about the eighteenth-century engraver and etcher John Carwitham. However, a number of Carwitham's artworks survive and their varied subject matter speaks to his versatility as an artist. He worked in various genres, producing numerous portraits after works by other artists, fifteen of which are in the collection of the National Portrait Gallery in London. He also created striking, bold geometric floor designs as well as cartographic views of cities and original representations of landscapes. Carwitham is best known for his eighteenth-century views of New York, Boston, and Philadelphia, known as the "Carwitham views." *A View of Fort George with the City of New York from the SW* (c. 1764) is one of the earliest printed views of the city. He also worked with a range of publishers on illustrations for books, among them images of Laocoön and depictions of biblical scenes.

REFERENCES

Benezit Dictionary of British Graphic Artists and Illustrators. Vol. 1. New York, 2012.

Deák, Gloria Gilda. *Picturing America, 1497–1899: Prints, Maps, and Drawings Bearing on the New World Discoveries and on the Development of the Territory That Is Now the United States.* Princeton, 1988.

Pritchard, Margaret Beck, and Virginia Lascara Sites. *William Byrd II and His Lost History: Engravings of the Americas.* Williamsburg, 1993.

Mary Cassatt

Born, Allegheny City, PA, 1844
Died, Le Mesnil-Théribus, France, 1926

Mary Cassatt, the sole American member of the French Impressionist circle, was one of the few nineteenth-century women artists to achieve professional success and recognition. From 1851 to 1855 Cassatt and her family resided in Europe, during which period she learned French and German.

The 1860s were a time of unprecedented artistic opportunities for American women. Coeducational life-drawing classes began at the Pennsylvania Academy of the Fine Arts, where women constituted nearly 30 percent of the student body. Cassatt was a standout at the Pennsylvania Academy from the time she entered in 1861. Her artistic education continued in Paris, then the center of the art world although Paris was less progressive in terms of women's access to art training. As a result of the limitations, Cassatt copied paintings at the Louvre and studied privately with the academicians Charles Chaplin and Jean-Léon Gérôme. Cassatt's teachers criticized her lack of focus on minute details. However, her comparatively loose style

aligned with the working mode of the impressionists. Edgar Degas asked Cassatt to show with the group in 1877. She contributed artwork to three more impressionist exhibitions.

Inspired by the etchings of fellow impressionists Degas and Camille Pissarro, Cassatt began to experiment with prints. Between 1890 and 1891 she made a series of drypoints with aquatint inspired by Japanese color woodblock prints. Japanese art was fashionable at the time: Western artists admired its line quality, distinct perspectives, and sometimes erotic subject matter. Cassatt imitated aspects of Eastern art in works like *Woman Bathing* (pl. 54). She later produced two other sets of color prints and continued to make prints until around 1910, when her poor eyesight made working on copper plates difficult; at the same time she stopped painting. Cassatt worked almost exclusively in pastel for the remainder of her life.

REFERENCES

Breeskin, Adelyn D. *Mary Cassatt: A Catalogue Raisonné of the Graphic Work.* Washington, 1979.

Mathews, Nancy Mowll, and Barbara Stern Shapiro. *Mary Cassatt: The Color Prints.* New York, 1989.

Mathews, Nancy Mowll. "The Color Prints in the Context of Mary Cassatt's Art." In *Mary Cassatt: The Color Prints.* New York, 1989.

Elizabeth Catlett

Born, Washington, DC, 1915
Died, Cuernavaca, Mexico, 2012

Elizabeth Catlett was an American printmaker and sculptor known for politically charged images. Catlett's artwork takes some inspiration from pre-Columbian sculpture as well as the work of Henry Moore and Diego Rivera. She attended Howard University where she studied design, printmaking, and drawing. At the University of Iowa School of Art and Art History she was the first student to receive an MFA in sculpture. She moved to New York in 1942 to learn lithography at the Art Students League and study with sculptor Ossip Zadkine.

In 1946 she was awarded a Rosenwald Fund Fellowship that allowed her to travel to Mexico. She studied wood carving and ceramics at the Escuela de Pintura y Escultura in Esmeralda. During this trip she fell in love with Mexico, believing the country's politics to be more in line with her own. She married Mexican artist Francisco Mora, made Mexico her permanent home, and eventually became a citizen. She worked with the printmaking group Taller de Gráfica Popular, whose mission was to promote social change through the graphic arts. The collaborative group worked together to design and print posters, books, and prints advocating social justice.

Catlett's artworks were regularly shown in the United States. Throughout her career she continued to demonstrate a concern for United States civil rights issues and the experiences of African Americans. While she did not completely ignore men in her work, she often focused on strong women. She enjoyed a solo show at the Studio Museum in Harlem in 1971. Some of her works were included in the Los Angeles County Museum of Art's important *Two Centuries of Black American Art* (1976).

REFERENCES

Gedeon, Lucinda, ed. *Elizabeth Catlett: Sculpture, a Fifty Year Retrospective.* Purchase, NY, 1998.

Herzog, Melanie. *Elizabeth Catlett: In the Image of the People.* Chicago, 2005.

Lewis, Samella. *The Art of Elizabeth Catlett.* Claremont, 1984.

Vija Celmins

Born, Riga, Latvia, 1938

At the age of five Vija Celmins and her family left her birthplace in Latvia to escape an advancing Russian army. After temporarily settling in Germany, they emigrated to the United States in 1948 and settled in Indianapolis. Celmins earned a BFA at the John Herron Art Institute. A summer session in 1961 at Yale University — where she met Chuck Close, Brice Marden, and David Novros — prompted her to pursue an artistic career.

In 1963 Celmins began making paintings and sculpture from secondhand objects, newspaper clippings, and material from books on World War II. Shortly after her first gallery show at David Stuart Galleries in 1966, she began teaching at the University of California, Irvine. While taking pictures during her freeway commute, she became fascinated with the way a photograph could fix an entire scene onto a flat plane. She began to make pencil drawings, and her 1969 exhibition at Mizuno Gallery was a concentrated presentation of drawings of the ocean and lunar surfaces. In the following years she produced prints with Tamarind Lithography Workshop and Cirrus Editions. It was not until working at the Los Angeles print workshop Gemini G.E.L. in the early 1980s that Celmins became interested in the possibilities of intaglio printmaking. She has created more than fifty editions in lithography, intaglio, and woodcut, laboring on a single print for months, sometimes years.

In 1981, following the first major exhibition of her work at the Newport Harbor Art Museum, she moved to New York City. The ICA Philadelphia organized a traveling retrospective of her work in 1992. An exhibition of her prints was held at the Metropolitan Museum of Art in 2002, and a retrospective traveled to the Centre Pompidou, Paris, in 2006.

REFERENCES

Relyea, Lane, et al. *Vija Celmins*. New York, 2004.

Rippner, Samantha. *The Prints of Vija Celmins*. New York, 2002.

Tannenbaum, Judith. *Vija Celmins*. Philadelphia, 1992.

Jean Charlot

Born, Paris, France, 1898
Died, Honolulu, HI, 1979

Jean Charlot's multicultural heritage included French, Jewish, Russian, Spanish, and Aztec ancestry, informing his artistic exploration of religious and historical themes, indigenous culture, and folk art. His maternal Mexican ancestry fueled a lifelong interest in Mexican art, which he wrote about and collected. While the versatile artist considered himself a natural mural painter, he was also a printmaker, book illustrator, scholar, author, teacher, and prolific easel painter.

Born and raised in France, Charlot was intrigued as a child by the color separations and progressive proofs brought home by his neighbor, a commercial printer. His art education included study at the École des Beaux-Arts, Paris. Charlot's first print was a woodcut, executed in 1916. While serving in the army at the end of World War I, he began the drawings for his first woodcut series, *Chemin de Croix*. The blocks were cut in Germany and printed in France in 1920.

Charlot was apprenticed to Diego Rivera in Mexico from 1921 to 1928. Working in true fresco, he established his place as a Mexican muralist. Furthermore, Charlot made a significant contribution to the history of Mexican printmaking by bringing renewed attention to the work of satirist printmaker José Guadalupe Posada.

Although he eventually executed prints in every major medium, in 1923 Charlot began exploring lithography, which would become his preferred mode of creating images. He was drawn to the collaborative aspects of printmaking and worked closely with several master lithographers, including George C. Miller, Emilio Amero, and in particular, Lynton Kistler, with whom he developed his method of creating color lithographs and explored the creative possibilities of offset lithography. Charlot lived in the continental United States from 1928 until 1949 when he moved to Hawaii, where he resided until his death.

REFERENCES

Morse, Peter. "The Lithographic Inventions of Jean Charlot." *The Tamarind Papers* 3, no. 1 (1979): 6–9, 31.

Morse, Peter. *Jean Charlot's Prints: A Catalogue Raisonné*. Honolulu, 1976.

Charlot, Jean. *Jean Charlot: A Retrospective*. The University of Hawai'i Art Gallery, Honolulu, 1990.

Frederic Edwin Church

Born, Hartford, CT, 1826
Died, New York, NY, 1900

Frederic Edwin Church was one of the central painters of the Hudson River School. He was born into a privileged Hartford family. Church's father managed to get his son accepted as a pupil of Thomas Cole from 1844 to 1846. Church's training consisted primarily of sketching in the Berkshires and the Catskills. Cole proclaimed his student the best draftsman of the era.

After his term with Cole, Church established a New York studio. The painter rapidly rose to national prominence, distinguishing himself by creating striking large-scale depictions of both North and South American landscapes. Church believed that the sublime beauty of nature indicated the presence of God. He was also influenced by the theories of Alexander von Humboldt, the German naturalist who explored the relationship between landscape painting and modern science. Humboldt's accounts of his voyages inspired the artist to travel widely. Church visited South America, Europe, the Arctic, the Caribbean, and the Middle East. Though some of his works contain invented elements, the artist's landscape paintings were usually a synthesis of various sketches made on his trips.

The National Gallery of Art's *Niagara* (1857) and the Metropolitan Museum of Art's *The Heart of the Andes* (1859) are perhaps Church's greatest achievements. When *The Heart of the Andes* spectacularly debuted in New York, the work attracted 12,000 viewers in the first three weeks: it was the most popular American painting of the mid-eighteenth century. Prints made after the work were sold as souvenirs at exhibitions in New York and London. By the turn of the century, Church's popularity had waned. After years of relative obscurity, a major exhibition of his work at the Met in 1960 helped rebuild his reputation as an American master.

REFERENCES

Avery, Kevin. "Frederic Edwin Church (1826–1900)." In *Heilbrunn Timeline of Art History*. The Metropolitan Museum of Art, August 2009. http://www.metmuseum.org/toah/hd/chur/hd_chur.htm (accessed September 3, 2015).

Kelly, Franklin. *Frederic Edwin Church*, Washington, 1989.

Rogers, David. "Church, Frederic Edwin." In *The Oxford Companion to Western Art. Oxford Art Online*, http://www.oxfordartonline.com/subscriber/article/grove/art/T017654 (accessed September 3, 2015).

Chuck Close

Born, Monroe, WA, 1940

Charles Thomas (Chuck) Close's first paint set came from a Sears catalog when he was six. He went on to earn a BA in art from the University of Washington and an MFA at Yale (1964), where he studied the history of prints and was an assistant to printmaker Gabor Peterdi.

In 1964–1965 Close traveled in Europe on a Fulbright scholarship, studying at Vienna's Akademie der Bildenen Künste. Returning to the United States, he taught painting at the University of Massachusetts. Close's art progressively shifted toward figuration; by the late 1960s he was painting the large-scale, photography-based portraits for which he is known.

Close made his first professional print in 1972: *Keith/Mezzotint*, a groundbreaking, large-scale mezzotint in which Close exposed for the first time the underlying organizational scaffolding of the grid. Complex conceptual strategies revealed through modular structure, from uniform grids to organic fingerprints, remain the hallmark of Close's work in all media, and printmaking continues to be a dynamic force in his overall artistic practice.

Close has worked with numerous master printers in the United States, Europe, and Japan, including Robert Blanton, Kathan Brown, Aldo Crommelynck, Jack Lemon, Deli Sacilotto, Yasu Shibata, Tadashi Toda, and Joe Wilfer. His experimentation with techniques and processes includes etching, lithography, pulp paper, woodcut (Japanese ukiyo-e and European), screenprint, reduction linoleum cut, Woodburytype, and tapestry.

Close confronted a grave medical crisis in 1988 when his spinal artery collapsed, leaving him mostly paralyzed. This event changed his life but did not define it as he devised strategies to continue working. The landmark exhibition, *Chuck Close Prints: Process and Collaboration*, opened in Houston in 2003 and continues to tour with new work added at successive venues.

REFERENCES

Finch, Christopher. *Chuck Close: Life*. Munich, 2010.

Storr, Robert. *Chuck Close*. Museum of Modern Art, New York, 1998.

Sultan, Terrie. *Chuck Close Prints: Process and Collaboration*. Munich, 2014.

George Cooke

Born, St. Mary's County, MD, 1793
Died, New Orleans, LA, 1849

George Cooke was an itinerant painter active in the southeastern United States but resident for extended periods in Washington, DC. He trained with the painter Charles Bird King and produced numerous portraits, which sustained him

economically. He resided in Europe for five years (1826–1831), making copies after classical sculpture as well as engravings. He spent considerable time studying the holdings of the Uffizi Gallery in Florence as well as collections in Rome and Paris.

An admirer of Raphael, Cooke aspired to continue the tradition of art begun by European artists in the Renaissance and baroque eras. In 1830 Cooke produced a massive, four-by-six-foot version of Théodore Géricault's even larger original, *The Raft of the Medusa* (1818–1819), which demonstrates Cooke's desire to impress the importance of the Grand Manner style on US audiences. Coooke's equally large *The Interior of St. Peter's* (1847) is perhaps his best-known work.

In addition to creating commissioned likenesses, Cooke completed approximately twenty-four history paintings and thirty-two landscapes. His views of the natural world seem to be accurate depictions of historically important sites. He also painted portraits of notable political figures such as George Washington and Daniel Webster. Many of Cooke's works have not survived; however, four aquatints made by his friend William Bennett after works by Cooke have helped maintain his legacy.

Cooke held the post of director of the American Academy of Fine Arts until resigning in 1835. He briefly opened an institution in New Orleans that he called the National Gallery of Paintings. He also ran a gallery there housed in a building owned by his major patron, the industrialist Daniel Pratt.

REFERENCES

Deák, Gloria Gilda. *Picturing America, 1497–1899: Prints, Maps, and Drawings Bearing on the New World Discoveries and on the Development of the Territory That Is Now the United States.* Princeton, 1988

Keyes, Donald D. "George Cooke: History and Landscape Paintings." In *George Cooke 1793–1849.* Athens, GA, 1991.

Stuart Davis

Born, Philadelphia, PA, 1892
Died, New York, NY, 1964

Stuart Davis's mother was a sculptor and his father was the art editor of the *Philadelphia Press*. From 1909 to 1912 Davis studied at the Robert Henri School of Art where he was one of Henri's outstanding students. He moved to Greenwich Village, then the epicenter of bohemian life, and earned a living as an illustrator for *The Masses*. In 1913 he showed five watercolors in the Armory Show.

The Armory Show introduced Davis to European avant-garde art. Increasingly he created flat, planar compositions that owe a debt to cubism. Around 1920 he made spare compositions representing consumer goods and their packaging, which anticipate pop art. In 1928 Davis traveled to Paris, depicting the city's buildings as textured planes of bright color. It was during this trip that he began to produce lithographs.

Davis was a committed socialist whose political focus was better working conditions for artists. In 1934 he joined the Artists' Union and later became the group's president. In 1936 he edited *Art Front,* the organization's official publication. In the same year he became national secretary of the American Artists' Congress and, two years later, national chairman. Davis was concerned with creating abstract art that would reflect Marxist politics and the industrial age. Beginning in the late 1930s his works demonstrate an interest in modern vernacular music. While the cubist avant-garde artistic language he used was arguably European, Davis infused it with brassy American color and jazz rhythms. He created murals in this mode for the Works Progress Administration's Federal Arts Project.

Davis's rank as a preeminent figure in American modernism is due in great part to the works he created during the period 1939–1964, when he blurred the distinctions between text and image, high and low culture, and abstraction and figuration.

REFERENCES

Hills, Patricia. *Stuart Davis.* New York, 1996.

Cole Jr., Sylvan, and Jane Myers. *Stuart Davis: Graphic Work and Related Paintings with a Catalogue Raisonné of the Prints.* Fort Worth, 1986.

Whiting, Cécile. "Davis, Stuart." In *Grove Art Online.* Oxford Art Online, http://www.oxfordartonline.com/subscriber/article/grove/art/T021615 (accessed October 5, 2015).

Dorothy Dehner

Born, Cleveland, OH, 1901
Died, New York, NY, 1994

Dehner traded theatrical aspirations for art studies, enrolling in the Art Students League in New York City, where she studied with Jan Matulka. In 1927 she encouraged sculptor David Smith to attend classes there, Smith and Dehner married later that year. The couple acquired a property in Bolton Landing, New York, in 1929. In 1931–1932 they lived in the Virgin Islands and Dehner began to make images based on natural forms. In Paris in 1935 they met surrealist André Breton and visited printmaker Stanley William Hayter at his Atelier 17.

Moving to Bolton Landing in 1940, Dehner employed a highly imaginative and detailed figurative style in a series of paintings entitled *Life on the Farm.* After encountering Ernst Haeckel's 1904 book, *Art Forms in Nature,* she began to base her images on microscopic forms. These evolved into a darker, surrealist biomorphism in the later 1940s.

Dehner left Bolton Landing in 1950, divorcing Smith two years later. She earned a degree from Skidmore College and started making prints at Atelier 17's New York space. In 1957 Dehner began casting wax constructions in bronze. The scale and complexity of her sculpture grew over the years to include monumental works. By the late

1960s Dehner had distilled her work to geometric essences and branched out into a variety of projects. Notable ones included wood constructions in the 1970s, and lithographs done at Tamarind Institute in Albuquerque, New Mexico, in 1970 and 1971. She was awarded numerous public commissions for her sculpture and continued to create new work until her death at the age of ninety-three.

REFERENCES

Acton, David. *The Stamp of Impulse: Abstract Expressionist Prints.* Worcester, MA, 2001.

Teller, Susan. *Dorothy Dehner: A Retrospective of Prints, April 7 through May 2, 1987.* Associated American Artists, New York, 1987. Brochure

Glaubinger, Jane. *Dorothy Dehner: Drawings, Prints, Sculpture.* Cleveland, 1995.

Willem de Kooning

Born, Rotterdam, Netherlands, 1904
Died, East Hampton, NY, 1997

A precocious artistic talent in his youth, Willem de Kooning completed a degree in fine and applied art at Rotterdam Academy before stowing away on a ship in 1926 to New York City, where he settled. While supporting himself variously as a house painter, window display designer, carpenter, and commercial artist, he befriended the artists Stuart Davis, Arshile Gorky, and John Graham. During the Depression, de Kooning was hired to create murals for the Works Project Administration; he then committed to painting fulltime.

De Kooning's first solo exhibition at the Charles Egan Gallery in 1948 was acclaimed by critics. By 1950 he had emerged as one of the key figures of abstract expressionism. De Kooning shifted his working mode and in 1953 exhibited his *Women* series. These canvases, which the artist reworked extensively, appeared to contradict the beliefs of his abstract expressionist colleagues because they reintroduced the figure. A move to Long Island in 1963 prompted the artist to change stylistically again; his work of the period shows a new luminosity and atmosphere in addition to a softer palette and more simplified brushwork.

De Kooning made his first etching, *Revenge,* in 1957 to accompany a poem by the critic Harold Rosenberg (pl. 118). His first lithograph was produced in 1960 by creating an image on the lithographic stone using a conventional mop. After a visit to Japan in 1970 de Kooning explored highly textured lithographs inspired by sumi-e ink painting. Many of these works also suggest surrealist automatism. By the 1980s his calligraphic forms grew sparer and he tended to preserve and feature more of the white of the ground. His last artwork dates to 1991.

REFERENCES

Elderfield , John, ed. *Willem de Kooning: A Retrospective.* New York, 2011.

Graham, Lanier. *The Prints of Willem de Kooning, a Catalogue Raisonné 1957–1971.* Paris, 1991.

Graham, Lanier, Barry Walker, and Dan Budnik. *Willem de Kooning, the Printer's Proofs.* New York, 1991.

Richard Diebenkorn

Born, Portland, OR, 1922
Died, Berkeley, CA, 1993

Richard Diebenkorn and his family relocated to San Francisco when he was two; he would be identified as a California artist for the entirety of his career. Diebenkorn attended Stanford University for two years before enlisting in the Marines. He enrolled at the California School of Fine Arts on the GI Bill. After returning to the Bay Area in 1947, he joined the faculty at the California School of Fine Arts and met fellow instructor Clyfford Still. At age twenty-six, his first solo exhibition at the California Palace of the Legion of Honor established his reputation as an abstract painter. His style shifted dramatically toward figuration in 1957, and again to nonrepresentation a decade later.

In 1950 he began an MFA at the University of New Mexico, Albuquerque, where he experimented with making monotypes. Diebenkorn made his first drypoints in 1949. He did not experiment further until 1962, when he sought out the newly established Crown Point Press, where he would return frequently. In 1966 Diebenkorn accepted a teaching position at the University of California, Los Angeles, and took up residence in the Ocean Park neighborhood. In 1971, he had his first exhibition at Marlborough Gallery in New York, in which his Ocean Park series debuted to great acclaim. In 1976 the Frederick S. Wight Gallery at UCLA mounted the first exhibition of his monotypes.

Major retrospectives of Diebenkorn's work were organized by the Pasadena Art Museum (1960), Albright-Knox Gallery (1976), San Francisco Museum of Modern Art (1983), and the Whitney Museum of American Art (1997). A 1981 retrospective of his intaglio prints traveled extensively and a major exhibition of his works on paper was organized by the Museum of Modern Art in 1988. In 1978 he represented the United States at the Venice Biennale.

REFERENCES

Elderfield, John. *The Drawings of Richard Diebenkorn.* New York, 1988.

Livingston, Jane. *The Art of Richard Diebenkorn.* New York, 1997.

Stevens, Mark. *Richard Diebenkorn: Etchings and Drypoints, 1949–1980.* Houston, 1981.

Jim Dine

Born, Cincinnati, OH, 1935

It was in his grandfather's hardware store in Cincinnati that Jim Dine became familiar with the tools that later — along with hearts, bathrobes, and more — were among the signature motifs that identified him with pop art. Dine's work is both tactile and personal, however, devoid of the cool detachment that informed that movement. His subjects include classical themes, nature, portraiture, the figure, and recently, nonobjective imagery.

Dine took art classes at the Cincinnati Art Academy while in high school, and later at the School of the Museum of Fine Arts, Boston. At Ohio University (BFA, 1957), he explored printmaking and experimented with etching, drypoint, woodcut, and lithography. In 1958 he moved to New York City, engaged in Happenings and produced painting and sculptural assemblages incorporating found objects. His artistic practice includes painting, sculpture, stage design, illustrated books, photography, and poetry, with printmaking and drawing at its center. His prodigious output of prints, characterized by a bold, inventive approach to every technique, spans more than five decades. He developed lasting collaborative relationships with such master printers as Aldo Crommelynck, Julia D'Amario, Donald Saff, and Kurt Zein, working on presses and at workshops around the world, publishing editions with Universal Limited Art Editions, Petersburg Press, Atelier Crommelynck, Graphicstudio, Pace Editions, and more.

Dine's prints have been widely exhibited since the 1960s. In 2005 the Jim Dine Print Archive, currently approaching one thousand works, was created at the Museum of Fine Arts, Boston, and celebrated with a major retrospective in Nagoya, Japan (2011).

REFERENCES

Ackley, Clifford S., and Patrick Murphy. *Jim Dine Printmaker: Leaving My Tracks.* Boston, 2012.

Carpenter, Elizabeth. *Jim Dine Prints, 1985–2000: A Catalogue Raisonné.* Minneapolis, 2002.

Dine, Jim. *Jim Dine: A Printmaker's Document.* Göttingen, Germany, 2013.

Amos Doolittle

Born, Cheshire, CT, 1754
Died, New Haven, CT, 1832

Amos Doolittle was among the earliest American copperplate engravers. Often dubbed the Paul Revere of Connecticut, he was a versatile print maker as well as an astute businessman. His output includes maps, songbooks, bank notes, certificates and diplomas, illustrations for moralizing and religious texts in books and magazines, as well as political cartoons, portraits, and prints documenting historic events.

Doolittle apprenticed with the silversmith Eliakim Hitchcock and presumably taught himself how to engrave copperplates. In 1774 Doolittle moved to New Haven where he established himself as a printmaker. In his house on College Street he ran a printing and engraving shop and a bookstore. From 1801 to 1826 he rented out a room in his house to a Freemason lodge, of which he had become an active member in 1792.

Doolittle created about three hundred plates and an additional one hundred works with his own designs, many of which he printed and published himself. Among these separately issued prints, his depictions of the historic battles at Lexington and Concord stand out. This series of four hand-colored copperplate engravings made in 1775 constitutes both Doolittle's first known engravings and his earliest known depiction of historic events (pls. 9–12). Although naïve in style, the images impress with their minute details that serve to emphasize the accuracy of the depiction. Although not objective, Doolittle's prints are the only visual documentation of these two Revolutionary battles and thus give invaluable insight into the beginnings of the American War of Independence. Other important historical moments documented by Doolittle include the presidential inaugurations of George Washington in 1789, John Adams in 1797, and Thomas Jefferson in 1801.

REFERENCES

O'Brien, Donald C. *Amos Doolittle, Engraver of the New Republic.* New Castle, 2008.

Quimby, Ian M. G. "The Doolittle Engravings of the Battle of Lexington and Concord." *Winterthur Portfolio* 4 (1968): 83–108.

Mabel Dwight

Born, Cincinnati, OH, 1875
Died, Sellersville, PA, 1955

While best known for her satirical observations of everyday life, Mabel Dwight's images encompass many genres: urban and rural landscape, architecture, portraits, and politically charged commentary on World War II and the rise of fascism. Born Mabel Jacque Williamson, her earliest years were spent in New Orleans; in her mid-teens she moved to San Francisco where she began her art studies. In her twenties she traveled extensively to such destinations as Egypt, Ceylon, India, and Java, returning to settle in New York City in 1903. She met and married artist Eugene Higgins in 1906, postponing her artistic ambitions for a domestic life until she separated from Higgins in 1917.

the Guerrilla Girls wear gorilla masks, which conceal the members' true identities, allowing them to express critical ideas with relative impunity. By donning the beastly costume elements as they strive for justice, the women become masked vigilantes of sorts, a role typically considered masculine.

The Guerrilla Girls are still active today. There are presently three subsections of the group: Guerrilla Girls, Inc., Guerrilla Girls BroadBand, and Guerrilla Girls On Tour!

REFERENCES

Boucher, Melanie. *Guerrilla Girls: Disturbing the Peace.* Montreal, 2010.

Chadwick, Whitney, and the Guerrilla Girls. *Confessions of the Guerrilla Girls.* New York, 1995.

Schechter, Joel. *Satiric Impersonations: From Aristophanes to the Guerrilla Girls.* Carbondale, 1994.

Robert Gwathmey

Born, Manchester, VA, 1903
Died, Southampton, NY, 1988

Robert Gwathmey initially studied business at North Carolina State College in Raleigh. He left school and worked on cargo ships before enrolling at the Pennsylvania Academy of Fine Arts in Philadelphia. In 1929 and 1930 Gwathmey won travel scholarships, allowing him to visit the European art centers and study the works of Pablo Picasso, Henri Matisse, Vincent Van Gogh, and Jean-François Millet.

Gwathmey was radicalized while in Philadelphia; he read texts by Karl Marx and protested in favor of loyalists in Spain. The FBI kept him under surveillance even in the last decades of his life. Upon returning to the South in 1938–1939, he was shocked by the racial inequality that was now clear to him. He believed that ethics and aesthetics were intertwined and that artists should be "social commentators," treating all aspects of American life — especially the everyday, overlooked elements. His social realist artwork often depicts sharecroppers or migrant workers, rendering them in bright colors and with strong, broken outlines — characteristics that prompt his works to evoke then-contemporary, mass-produced imagery made for popular audiences. His artworks generally elevate their subjects. They take on a calm, monumental grandeur when silhouetted in Gwathmey's spare landscapes. He also created caricatures of pompous Southern politicians in a related style.

Gwathmey relocated to New York in 1940, where he was represented by the ACA Gallery and Terry Dintenfass Gallery. He taught at Beaver College in Glenside, Pennsylvania, Carnegie Institute of Technology in Pittsburgh, and Manhattan's Cooper Union School of Art. In 1973 Gwathmey was elected into the National Academy of Design.

REFERENCES

Eldredge, Charles, et al. *Tales from the Easel: American Narrative Paintings from Southeastern Museums, circa 1800–1950.* Athens, GA, 2004.

Kammen, Michael. *Robert Gwathmey: The Life and Art of a Passionate Observer.* Chapel Hill, 1999.

Searl, Marjorie B., ed. *Painting and Sculpture from the Collection of the Memorial Art Gallery of the University of Rochester.* Rochester, 1996.

John Hall

Born, Wivenhoe, Essex, England, 1739
Died, London, England, 1797

Among the large number of printmakers active in eighteenth-century London, John Hall stands out. While his work is noted for its accurate and careful translation of painting into print, it also attests to the role of prints in making oil-painted works accessible to a larger audience. At this historical moment, art appreciation shifted from being a princely pursuit to forming part of a culture of consumption that welcomed the availability of affordable printed images.

Hall apprenticed with the engraver William Wynne Ryland and later became a pupil of the French printmaker Simon François Ravenet. In 1756, at the age of eighteen, he won a prize from the Society for the Encouragement of Arts, Manufacture, and Commerce. In 1761 the same group awarded him a prize for his reproduction of a painting by Guido Reni. Four years later Hall became a fellow of the Incorporated Society of Artists; he was elected director of the society in 1768, 1769, and 1771.

It was around 1770 that Hall first engraved a painting from the king's collection and formed valuable connections with court painters such as Benjamin West. Hall repeatedly collaborated with West, reproducing his paintings for the growing print market in England and its overseas colonies. Thus the two artists not only ensured the wide dissemination of West's works, but generated profits neither of the two artists would have earned on their own.

In 1785, at the height of his career, Hall was appointed history engraver to the king. While his focus then clearly was on the reproduction of history paintings, Hall also engraved a number of portraits, theater stage designs, and book illustrations, such as James Cook's *A Voyage towards the South Pole and round the World* (1777).

REFERENCES

Clayton, Timothy. *The English Print 1688–1802.* New Haven, 1997.

Clifton, James. "Reverberated Enjoyment. Prints, Printmakers, and Publishers in Late-Eighteenth Century London." In *American Adversaries: West and Copley in a Transatlantic World,* ed. Emily Ballew Neff. Houston, 2013.

Childe Hassam

Born, Dorchester, MA, 1859
Died, East Hampton, NY, 1935

Briefly apprenticed to a wood engraver in 1876, Childe Hassam turned to freelance illustration and built a reputation in Boston. In the summer of 1883 he traveled in Europe, studying the masters, painting in watercolor, and making his first etchings. He married Kathleen Maud Doane in 1884 after returning to Boston and in 1886 headed to Paris, where he studied at the Académie Julian and showed his work in the Paris Salons of 1887, 1888, and 1889. The couple settled in New York City in 1889 and acquired a home in East Hampton, Long Island, in 1919.

Perhaps the foremost American impressionist, Hassam played a pivotal role in bringing the French-based movement to the United States. His images of urban life at century's end were progressive in their use of broken brushwork to investigate light and color. His images of landscapes and gardens — executed while he summered in coastal New England and other locales — made him a celebrated chronicler of rural and suburban settings. In 1898 he became a founding member of The Ten, a group of artists who opposed the entrenched conservatism of the American Academy of Arts and Letters. By 1913 (and the Armory Show), however, Hassam appeared to be the conservative, vocally rejecting the aesthetics of cubists and other avant-garde movements. From 1916 to 1919, he produced a vibrant series of flag paintings depicting Fifth Avenue and its environs decorated for a parade.

Hassam's first extended campaign in etching began in the summer of 1915 with the assistance of the young printmaker Kerr Eby; two years later he explored lithography with the printer George C. Miller. Over the next twenty years, Hassam created more than four hundred prints; many of his late works record Long Island and the surrounding countryside.

REFERENCES

Adelson, Warren, Jay Cantor, and William H. Gerdts. *Childe Hassam, Impressionist.* New York and London, 1999.

Cortissoz, Royal, and the Leonard Clayton Gallery. *Catalogue of the Etchings and Dry Points of Childe Hassam, N.A.,* rev. ed. San Francisco, 1989.

Weinberg, H. Barbara. *Childe Hassam, American Impressionist.* New York, 2004.

Robert Havell Jr.

Born, Reading, England, 1793
Died, Tarrytown, NY, 1878

Born into an artistic family, Robert Havell Jr. learned printmaking as a child from his father, Robert Havell Sr., an esteemed printmaker and painter. Havell Jr. officially joined his father's

workshop in 1818. They published sets of aquatints depicting notable buildings and picturesque views. Havell Jr. later ceased working with his father and pursued watercolor painting, undertaking an extensive sketching tour in southeast Wales. Upon his return to London he rapidly won acclaim and found work painting and etching landscapes in the picturesque style for large publishing firms such as the famous print gallery Colnaghi.

When John James Audubon commissioned the elder Havell to print the color plates for his famous *Birds of America* (1827–1838), Havell Jr. returned to his father's firm. Havell took over the business and Audubon's book project a year later. He skillfully translated the tonal qualities of Audubon's watercolor paintings into print and carefully captured every minute detail, yielding an interplay of artistic mastery and scientific accuracy.

After the death of their two infant sons in 1829 and 1838, Robert Havell and his wife Amelia Jane Edington emigrated to America with their daughter. Initially they lived with Audubon before moving to Ossining, New York, in 1842. Havell successfully established himself once more as a printmaker renowned for his outstanding technique in aquatint etching. In 1857 the family settled in Tarrytown, New York. Havell painted canvases in oil with views of the Hudson River and valley, which were exhibited during his lifetime at the National Academy of Design, the American Art-Union, and the American Academy of Fine Art.

REFERENCES

Fries, Waldemar H. *The Double Elephant Folio. The Story of Audubon's Birds of America.* Amherst, 2006.

Goddu, Joseph. *John James Audubon & Robert Havell, Jr. Artist's Proofs for* The Birds of America. New York, 2002.

Low, Susanne M. *A Guide to Audubon's Birds of America.* New Haven, 2002.

Stanley William Hayter

Born, London, England, 1901
Died, Paris, France, 1988

Stanley William Hayter was raised in a family of artists. He earned a degree in chemistry and geology at King's College, London. After graduation he worked in Iran for an oil company, drawing and painting in his spare time. In 1925 he returned to England, where his company sponsored an exhibition of his paintings at their London offices. Its success was impetus for Hayter's move to Paris in 1926 to pursue an art career.

He briefly attended the Académie Julian but otherwise studied independently. Hayter made his first engravings with Joseph Hecht in 1926. In 1927 he bought a press and organized a print workshop in his studio, moving to a larger space by year's end. In 1933, he relocated to 17, rue Campagne-Première, where he founded his Atelier 17.

Hayter explored surrealist automatic drawing processes during the 1930s and automatism played an important role in his approach to printmaking. At Atelier 17, Hayter's informal teaching methods and the workshop's communal nature attracted many artists including Joan Miró, Max Ernst, and Alberto Giacometti. With the onset of World War II, Hayter left Paris, temporarily reestablishing Atelier 17 at the New School for Social Research in New York in 1940. Atelier 17 moved to its own space in Greenwich Village in 1945.

The workshop was a meeting place for European émigrés and American artists. Hayter's technical innovations in color intaglio printing and his emphasis on the expressive power of the graphic medium were critically important to the development of American printmaking. In 1950 Hayter returned to Paris to reopen his workshop there.

Among Hayter's many awards are the Légion d'Honneur (1951), O.B.E (1959), C.B.E. (1968), and Commandeur des Arts et Lettres (1986). The British Museum acquired Hayter's print archive in 1988.

REFERENCES:

Black, Peter, and Désirée Moorhead. *The Prints of Stanley William Hayter: A Complete Catalogue.* New York, 1992.

Hayter, Stanley William. *New Ways of Gravure*, New York and London, 1949. Revised ed. London, 1966.

Moser, Joann. *Atelier 17: A 50th Anniversary Retrospective Exhibition.* Elvehjem Art Center, Madison, WI, 1977.

John Hill

Born, London, England, 1770
Died, Clarksville (today West Nyack), NY, 1850

John Hill's early life is largely undocumented. He produced numerous artworks; his aquatints were particularly successful. His detailed notebooks reveal much about his career in London — then a thriving center for aquatint printmaking — and in the United States, where the technique was relatively new.

Hill was apprenticed to a London printmaker but apparently taught himself the aquatint process. His early work comprises reproductions after landscape paintings and watercolors. He also illustrated books focusing on a diverse range of subjects: for example, Henry Angelo's treatise *Hungarian & Highland Broadsword* (1799), William Henry Pyne's *The Costume of Great Britain* (1806–1807), and Rudolph Ackermann's *Microcosm of London*, 3 vols. (1808–1811).

In 1816 Hill moved to Philadelphia before settling in New York six years later. Although both American cities were publishing centers with thriving print markets, few artists worked in aquatint. Being a master of the process, Hill filled a niche in the market and quickly gained recognition. His prints did not merely introduce a relatively new technique to the American public, they also promoted the tradition of picturesque landscape painting, which was firmly rooted in eighteenth-century English aesthetics. While landscapes had been depicted in magazines and travel books prior to Hill's arrival, his prints for illustrated books such as the *Hudson River Portfolio* (1821–1825) presented a new level of skill and artistry and helped the landscape genre gain wide popularity in the United States.

Until the late 1830s when Hill retired to Clarksville, he continued to engrave and publish book illustrations as well as large-scale landscape prints, such as views of Niagara Falls after watercolors by his fellow Englishman William James Bennett.

REFERENCES

Diebold, William. "Four Great Sequences of Hudson River Prints." *Imprint* 21, no. 1 (Autumn 1995): 2–18.

Koke, Richard J. "John Hill, Master of Aquatint." *The New-York Historical Society Quarterly* 43, no. 1 (January 1959): 51–117.

Carl Hoeckner

Born, Munich, Germany, 1883
Died, Berkeley, CA, 1972

Carl Hoeckner received lessons from his father, an etcher, before formally training at art academies in Germany and Belgium. In 1910, spurred by his father's enthusiasm for the United States and the opportunities the country offered for commercial artists, Hoeckner emigrated to Chicago. He worked as an illustrator for the Armour Meat Packing Company and for Marshall Field's department store until the conclusion of World War I.

The Great War radicalized Hoeckner. Many of his paintings and prints made after 1918 are forceful indictments of war. The artist was interested in depicting everyday aspects of modern life, too. His works of the twenties and thirties represent jazz music and industrial manufacturing. Others caricature distinct social types, critiquing inequality, consumerism, and the exploitation of women. The artist considered his prints to be documents that transmitted difficult truths about his subjects.

Influenced by Mexican muralism — both compositionally and thematically — Hoeckner often depicted rows of layered, contorted bodies with pained expressions of suffering, and his figures typically inhabit spaces that suggest subterranean caves.

From 1913 to the mid-1930s Hoeckner regularly showed work at the Art Institute of Chicago. Although the artist was based in Chicago, his artwork appeared in major exhibitions elsewhere: the Pennsylvania Academy of Fine Arts (1921), the Society of Independent Artists (1918, 1928–1929), and the National Academy of Design (1942–1943). In the 1930s the artist directed the graphics division

of the Illinois Art Project of the Works Progress Administration. An influential educator, Hoeckner taught at the School of the Art Institute of Chicago from 1929 to 1943, as well as at Chicago's Hull House, an organization that worked to educate and assist recent immigrants.

REFERENCES

Galpin, Amy, and Susan Weininger. "Carl Hoeckner." In *Chicago Modern 1893–1945: Pursuit of the New*, ed. Elizabeth Kennedy. Chicago, 2004.

Smith Scanlan, Patricia. "Carl Hoeckner." In *Modernism in the New City: Chicago Artists 1920–1950*. http://www.chicagomodern.org/artists/carl_hoeckner/ (accessed September 1, 2015).

Jenny Holzer

Born, Gallipolis, Ohio, 1950

Jenny Holzer completed her undergraduate degree in painting and printmaking at Ohio University in Athens. While earning her MFA at the Rhode Island School of Design, her abstract painting gave way to a more conceptual interest in the relationship between image and text. After graduation she moved to New York and participated in the Whitney Independent Study Program in 1977. Inspired by readings discussed in the program's seminars, Holzer created *Truisms*, pithy axioms printed as posters, which she plastered around Manhattan. Since then her installations and public art interventions have focused on the power of language.

In the late 1970s and early 1980s Holzer worked as a typesetter. In 1978 she created work for P.S. 1; her *Truisms* were presented as photostats and audiotape at New York's Franklin Furnace. She organized *Manifesto Show* with Coleen Fitzgibbon, marking the beginning of her involvement with the artist collective Collaborative Projects (Colab). In 1982 the Public Art Fund invited Holzer to show the *Truisms* on the Spectacolor sign in Times Square. Following this project, she began to use electronic signs extensively in her work.

Since the mid-1980s Holzer has made granite benches carved with text, sarcophagi, architectural elements paired with LED texts, and paintings. In the past decades her writing has taken on a more subjective voice when addressing themes of violence, sex, power, and money. In 1990 she became the first woman to represent the United States at the Venice Biennale. Her installation won the prize for best pavilion. In addition to public light projects, Holzer has produced web projects and videos for MTV.

Major exhibitions of Holzer's work have been organized by the Guggenheim Museum, New York (1989); Dia Art Foundation (1989); Contemporary Arts Museum, Houston (1997); Neue Nationalgalerie, Berlin (2001); and Museum of Contemporary Art, Chicago (2008).

REFERENCES

Breslin, David, ed. *Jenny Holzer: Protect Protect*. Chicago, 2008.

Joselit, David, Joan Simon, and Renata Salecl. *Jenny Holzer*. London, 1998.

Waldman, Diane. *Jenny Holzer*. New York, 1997.

Winslow Homer

Born, Boston, MA, 1836
Died, Prout's Neck, Scarborough, ME, 1910

Winslow Homer grew up in Cambridge, Massachusetts. At nineteen he became an apprentice at John H. Bufford's lithographic firm in Boston. Homer left the firm and began to take orders for illustrations independently, becoming a contributing illustrator to *Harper's Weekly*. In 1859 he moved to New York and took classes at the National Academy of Design.

Harper's sent Homer to the front in Virginia to sketch scenes of the Civil War, which were often subsequently turned into prints. His depictions of soldiers and camp activities are unsentimental and generally unbiased. Homer also completed a series of wartime lithographs for publisher Louis Prang in 1863. A few of his wartime sketches became substantial oil paintings that he exhibited at the National Academy of Design.

Homer's peacetime subject matter tends to be depictions of the natural world and people engaging in rustic labor or leisure. Other works capture the sublime power of nature. He enjoyed spending time outdoors, and took repeated trips to the Adirondacks throughout his life. In 1883 he moved to Prout's Neck, Maine, where — despite having no formal training — he created eight etchings based on paintings of maritime scenes that he produced during the same period.

Homer died in 1910. He spent his final days in the studio in Prout's Neck that had been his home for almost three decades. The following year, the Metropolitan Museum of Art held a memorial exhibition for Homer, setting a precedent of reverence and respect for this American artist.

REFERENCES

Cikovsky, Nicolai, and Franklin Kelly. *Winslow Homer*. Washington, 1995.

Goodrich, Lloyd, and Abigail Booth Gerdts. *Record of Works by Winslow Homer*. New York, 2005–2014.

Tatham, David. *Winslow Homer in the 1880s: Watercolors, Drawings, and Etchings*. Syracuse, 1983.

Edward Hopper

Born, Nyack, NY, 1882
Died, New York, NY, 1967

Edward Hopper enrolled in the New York Institute of Art and Design at the age of eighteen to study with William Merritt Chase and Robert Henri. Three European sojourns allowed Hopper to absorb the art of the impressionists and cultivate a lifelong interest in France. Returning from his final trip in 1910, Hopper supported himself as an illustrator while continuing to paint.

In 1915 printmaker Martin Lewis offered him guidance on etching, and Hopper began to make prints that earned him awards and sold well. A highly successful show of watercolors at the Frank Rehn Gallery in New York City in 1924 freed the artist from the illustration work he considered drudgery. At the same time, Hopper put aside etching, while acknowledging that printmaking had helped him crystallize his vision in painting.

Hopper married Josephine "Jo" Nivison, whom he met in Henri's class. Nivison became his lifelong partner, model, and studio manager. Over the years they traveled and painted together, crossing the United States and visiting Canada and Mexico. The couple began summering in Truro, Massachusetts, in 1930, building a cottage there that would be a seasonal destination for the rest their lives.

The Museum of Modern Art mounted Hopper's first large-scale retrospective in 1933, but with the mid-century ascendance of abstraction, some deemed his work outdated. Nevertheless, in 1952 he represented the United States at the Venice Biennale. The Hoppers lived modestly in their New York apartment on Washington Square, splurging only on books and the theater. Hopper died in his studio and Jo followed less than a year later. Their collection of more than three thousand works went to the Whitney Museum of American Art.

REFERENCES

Haskell, Barbara. *Modern Life: Edward Hopper and His Time*. Hamburg, 2009.

Levin, Gail. *Edward Hopper: The Complete Prints*. New York and London, 1979.

Levin, Gail. *Edward Hopper: An Intimate Biography*. New York, 1995.

Jasper Johns

Born, Augusta, GA, 1930

Jasper Johns grew up in South Carolina. After three semesters at the University of South Carolina, he moved to New York City and briefly studied at Parsons School of Design. In the early fifties he met Robert Rauschenberg. Their synergistic relationship fueled both their oeuvres: they had adjacent studios and shared a concern for translating

everyday materials into art and mixing media. Gallerist Leo Castelli first encountered Johns's artwork while visiting Rauschenberg. In 1958 Castelli mounted Johns's first solo show. The Museum of Modern Art's founding director, Alfred Barr, purchased four of the exhibition's works for his museum's collection. Through Rauschenberg, Johns also met the composer John Cage, who introduced him to the dancer Merce Cunningham. Johns and Cage would later create the Foundation for Contemporary Arts in New York. Johns designed outfits and a stage set for Cunningham's dance company.

Johns's artworks of the fifties and early sixties provide the basis for many of his numerous prints of subsequent decades. His works can be understood as parodies of abstract expressionism, which was once known as "American-type" painting. Unlike artists of the prior generation who created psychologically charged, nonfigurative compositions, Johns coolly and literally presents recognizable American content such as flags, maps, or beer cans. He typically renders these iconic, everyday forms using expressive marks, yielding a poetic tension between legible figures and texture. Johns blends painting with sculpture, drawing, or printmaking — a move that was anathema to mid-century modernists who strove for medium purity.

In 1990 Johns was awarded the National Medal of Arts. He was given the Presidential Medal of Freedom in 2011, becoming the first painter or sculptor since Alexander Calder to receive the award.

REFERENCES

Johnson, Jill. *Jasper Johns: Privileged Information.* New York, 1996.

Orton, Fred. *Figuring Jasper Johns.* Cambridge, 1996.

Yau, John. *A Thing Among Things: The Art of Jasper Johns.* New York, 2008.

William H. Johnson

Born, Florence, SC, 1901
Died, Islip, Long Island, NY, 1970

Raised in poverty in the rural South, Johnson's love of drawing began in childhood. As a teenager he saved up money to move to New York City and pursue a career in art. He studied at the National Academy of Design, where Charles Hawthorne became his teacher and mentor. In the summers (1923–1926) he attended Cape Cod School of Art, Provincetown, founded by Hawthorne.

Johnson worked briefly for the Ashcan School artist George Luks. Hawthorne raised funds to send Johnson to live in France for three years (1926–1929). He resided in Whistler's Paris studio, met Henry O. Tanner, and found inspiration in the work of Chaim Soutine. He also met his future wife, the Danish artist Holcha Krake, in the spring of

1929. They traveled in Europe before he returned to New York where, with the support of Luks, he was awarded the Harmon Foundation Gold Medal (1929). In 1930 he moved to Denmark and married Krake. The couple settled in Kerteminde but traveled in Germany, France, Scandinavia, and North Africa, with extended stays in Tunisia and Norway. Meeting Edvard Munch in Norway had a powerful impact on Johnson's art. He and his wife moved to New York in 1938 and soon thereafter Johnson's self-described "primitive" modernism blossomed in compelling images reflecting African American life and culture.

Johnson made his first woodcuts in Denmark, evoking the prints of the German expressionists. He exhibited these at the Artists' Gallery in New York in 1939. Johnson also made linoleum cuts, and began making screenprints while teaching at the Harlem Community Art Center in 1939.

Johnson's health deteriorated soon after his wife died in 1944. In 1947 he was diagnosed with paresis and was institutionalized in Long Island for the remainder of his life.

REFERENCES

Breeskin, Adelyn D. *William H. Johnson: 1901–1970.* Washington, 1971.

Powell, Richard J. *Homecoming: The Art and Life of William H. Johnson.* Washington, 1991.

Turner, Steve, and Victoria Dailey. *William H. Johnson: Truth Be Told.* Los Angeles, 1998.

Alfred Jones

Born, Liverpool, England, 1819
Died, New York, NY, 1900

Alfred Jones and his family emigrated to the United States when he was an infant. In 1834 he became an apprentice engraver at a firm that specialized in banknotes. For a number of years Jones worked solely in the commercial printmaking industry. Although he would continue to create commercial images throughout his career, Jones began making fine art prints and was quickly successful at this endeavor. Various American publishers contracted him to produce artistic prints.

In 1839 one of his drawings won the top prize in a competition held by the National Academy of Design in New York. In 1846 Jones traveled to Europe to further his artistic training. Upon his return to the United States he continued to work as an engraver but also began to paint small genre scenes. In 1851 the artist was elected to the National Academy. He served as secretary and treasurer of the organization for many years. By 1854 he had established a studio in Boston. Jones made numerous engravings after paintings by American artists, many of which were distributed to members of the American Art-Union.

Jones also developed a precursor to the halftone printing process. The invention of this technique helped assure his success, especially as a commercial printmaker. He created a number of important stamp designs in the 1890s for the American Bank Note Company, among them portraits of Thomas Jefferson and Abraham Lincoln. Jones created engravings for a stamp depicting Christopher Columbus as well as another with a scene from the Genoan explorer's life. Both stamps were issued in conjunction with the Columbian Exhibition of 1893.

REFERENCES

"30-Cent Jefferson." In *Arago. Smithsonian National Postal Museum.* http://arago.si.edu/category_2032680.html (accessed September 3, 2015).

"Alfred Jones." In *Paintings and Sculpture in the Collection of the National Academy of Design,* ed. David Dearinger. New York, 2004.

Bryant, William Cullen. *The Letters of William Cullen Bryant.* Vol. 3. New York, 1981.

Charles Bird King

Born, Newport, RI, 1785
Died, Washington, DC, 1862

Initially receiving drawing lessons in his native Newport, King moved to New York in 1800 and trained with the portraitist Edward Savage. In 1806 King continued his studies under Benjamin West at the Royal Academy in London.

Returning to the United States in 1812, King did not permanently settle for another six years. Finally in 1818 King arrived in Washington, DC, where he soon gained recognition for his portraits of the city's social elite. Many of these portraits reflect the self-confidence of a burgeoning ruling class as well as the pride of the capital's citizens. Throughout his career King was well established in Washington, receiving commissions from his close friends, the former presidents James Monroe and John Quincy Adams.

Today King is best known for his portraits of Native American leaders who visited Washington to pursue their rights to their ancestral lands. While depictions of American Indians were by then not a novelty, no artist had attempted a systematic production of Native American paintings on such a scale. Between 1822 and 1842 King produced at least 143 canvases, commissioned by Thomas McKenney for the War Department's Indian Gallery. Driven largely by an ethnographic interest, the portraits served as pictorial records of the various native tribes, which were believed to be going extinct. In 1865 most of the paintings were destroyed in a fire; many of King's designs, however, survive as painted copies and lithographic reproductions, and a number of original paintings are in international collections.

Beyond portraiture, King painted a number of lesser-known genre scenes, still lifes, and trompe-l'œil paintings with vanitas motifs. These rather unusual subjects — for example *Poor Artist's Cupboard* (c. 1815) and *Landscape with Catalogue* (1828) — attest to King's artistic versatility and wit.

REFERENCES

Cosentino, Andrew J. "Charles Bird King: An Appreciation." *American Art Journal* 6, no. 1 (May, 1974): 54–71.

Cosentino, Andrew J. *The Paintings of Charles Bird King (1785–1862)*. Washington, 1977.

Moore, Robert J. *Native Americans. A Portrait. The Art and Travels of Charles Bird King, George Catlin, and Karl Bodmer*. New York, 1997.

Elbridge Kingsley

Born, Carthage, OH, 1842
Died, New York, NY, 1918

Elbridge Kingsley grew up in rural western Massachusetts. Before he moved to New York in 1863 he was an apprentice printer at the *Hampshire Gazette* in Northampton. In Manhattan he studied at the Cooper Union and worked as a typesetter at the *New York Tribune*. Kingsley then worked as an engraver at J.W. Orr publishing house where he created illustrations for *Scribner's Magazine* and *Century Magazine*.

In the 1870s Kingsley turned his energies to wood engraving. He wanted the medium, which until then had been designated a commercial craft, to be appreciated as a fine art. He achieved a high degree of realistic detail by photographically transferring images onto his blocks. However, the printmaker did not slavishly follow photography; he also worked directly from nature.

Capitalizing on the expressive possibilities of wood engraving, Kingsley created original artworks, including numerous landscapes. He synthesized traditions from both sides of the Atlantic: like other American artists such as Thomas Cole or George Inness, he depicted the pastoral landscape of New England. Kingsley's forested scenes also evoke those of French Barbizon school artists, and his atmospheric effects owe a debt to Albert Pinkham Ryder and the British painter J.M.W. Turner. Because of the range of textures and subtle tonalities possible in wood engraving, it was a particularly apt medium for reproducing paintings. Kingsley excelled in the technique and was commissioned to interpret works by Inness and Ryder.

Kingsley's works were featured in numerous traveling exhibitions organized by the Grolier Club. In 1889 he received a gold medal at the Paris Exposition Universelle. He also won gold medals for engraving at the Columbian Exposition in Chicago in 1893 and at the Mid-Winter Exposition in California in 1894.

REFERENCES

Catalogue of the Works of Elbridge Kingsley. Mount Holyoke College, Hadley, MA, 1901.

"Elbridge Kingsley." In *Search Collections, Smithsonian American Art Museum and the Renwick Gallery*. http://americanart.si.edu/collections/search/artist/?id=2530 (accessed September 6, 2015).

Siercks, Elizabeth. "Elevating the Wood Engraved Landscape: The Work of Elbridge Kingsley." MA thesis, University of Wisconsin–Milwaukee, 2013.

Mauricio Lasansky

Born, Buenos Aires, Argentina, 1914
Died, Iowa City, IA, 2012

Mauricio Lasansky was a printmaker and art professor. He trained in sculpture, painting, and printmaking at the Superior School of Fine Arts in Buenos Aires. After 1935 Lasansky primarily focused on printmaking, regularly employing a wide variety of techniques. Because he ran his prints through the press multiple times, Lasansky required and developed a paper that was especially durable. Oscillating between figuration and abstraction, his works are characterized by their large scale and broad range of expressive marks.

In 1936 Lasansky assumed the directorship of the Free Fine Arts School in Villa María, Argentina. In 1943 he received a Guggenheim grant to travel to the United States where he studied both contemporary and old master prints in the collection of the Metropolitan Museum of Art in New York. A renewal of the grant enabled him to work at Stanley William Hayter's printmaking workshop, Atelier 17, which had temporarily relocated to the city during World War II. Lasansky then joined the faculty at the University of Iowa (1945–1970) where he established a renowned printmaking program and trained many others who started college-level programs elsewhere.

Like Jackson Pollock and Adolph Gottlieb, artists who also passed through Hayter's workshop, Lasansky looked to European surrealism. He also recognized the creative potential of printmaking, countering its reputation of being merely a reproductive medium. Inspired by Picasso's methods, Lasansky often worked directly on the plates rather than from preparatory designs.

In the mid-1960s he turned from making prints to drawing, producing the series *Hitler Drawings*. These chilling life-size works were shown at the Whitney Museum of American Art in 1967. A retrospective exhibition of Lasansky's prints was held in Washington at the Smithsonian American Art Museum in 1977.

REFERENCES

Fox, Margalit. "Mauricio Lasansky, Master Printmaker, Dies at 97." *New York Times*, April 7, 2012. http://www.nytimes.com/2012/04/08/arts/design/mauricio-lasansky-master-printmaker-dies-at-97.html?_r=0 (accessed September 4, 2015).

Perazzo, Nelly. "Lasansky, Mauricio." In *Grove Art Online. Oxford Art Online*, http://www.oxfordartonline.com/subscriber/article/grove/art/T049426 (accessed September 4, 2015).

Thein, John, and Phillip Lasansky. *Lasansky, Printmaker*. Iowa City, IA, 1975

Martin Lewis

Born, Castlemaine, Australia, 1881
Died, New York, NY, 1962

Martin Lewis arrived in San Francisco from Australia in 1900 and made his way to New York to earn a living as a commercial illustrator. While on a brief trip to England in 1910 the artist encountered the etchings of James McNeill Whistler. By 1915 Lewis was accomplished enough in the etching medium to mentor his friend, Edward Hopper. Moving to Japan for eighteen months in 1920, Lewis returned to the United States inspired by ukiyo-e prints, which led to a series based on Japanese subjects.

His signature works, mostly created between 1925 and 1935, depict New York City with striking lighting and atmospheric effects, and emphasize nocturnal settings. Lewis also masterfully integrated a range of drypoint, etching, and aquatint techniques. The artist's first solo show at Kennedy & Company in New York City in 1929 was a great success and Lewis quit commercial art to focus on printmaking. The Great Depression soon dried up the market, and in 1932 Lewis left the city to live more frugally in the small town of Sandy Hook, Connecticut. This new environment gave him the opportunity to pursue a series of rural subjects. Lewis returned to New York in 1936 and continued to produce prints; however, his work sold rather poorly and financial stability eluded him.

Lewis became an instructor of graphic arts at the Art Students League in 1944, teaching until declining health forced him to retire in 1952. Giving away his press and other equipment around 1960, the artist's reputation was in eclipse at the time of his death. However, his star has risen steadily since. His prints are in major collections and frequently exhibited. Lewis is now considered a major printmaker of the twentieth century.

REFERENCES

Blackwell, Barbara, and John Brady. *Emerging from the Shadows. The Art of Martin Lewis, 1881–1962*. Ithaca, 1983.

McCarron, Paul. *The Prints of Martin Lewis, a Catalogue Raisonné*. Bronxville, 1995.

Swenson, Christine. *An American Master. Prints by Martin Lewis*. Detroit, 1991.

Roy Lichtenstein

Born, New York, NY, 1923
Died, New York, NY, 1997

Roy Lichtenstein was a central figure of American pop art. He was born into an upper-middle class Jewish family in New York City. An avid jazz fan, he frequented the Apollo Theater in Harlem, where he drew portraits of the musicians. In his final year of high school he took summer classes with Reginald Marsh at the Art Students League of New York. He studied fine arts at Ohio State University, then left college for a three-year stint in the army. Returning to Ohio State in 1946, he finished his MFA degree in 1949.

Eight years later Lichtenstein moved to upstate New York and taught at the State University of New York at Oswego. At this time he began incorporating images of cartoon characters such as Mickey Mouse and Bugs Bunny into his abstract expressionist works. In 1960 he started teaching at Rutgers University where fellow professor Allan Kaprow encouraged him to make art with everyday content. Lichtenstein began producing works that translated the language of comics into painting. Often using stencils, he incorporated the appearance of Ben-Day dots into his depictions in order to evoke commercial, ephemeral printed matter. Although many of his works contain comic book imagery — usually with some modifications — Lichtenstein also mines the history of art: confounding categories of culture, he satirically renders "high-brow" masterpieces, such as works by Claude Monet or Paul Cézanne, in a "low-brow" visual language.

Lichtenstein's work is in numerous museum collections around the world, including the Tate Modern in London, the Museum of Modern Art in New York, the Art Institute of Chicago, and the National Gallery of Art.

REFERENCES

Bader, Graham. *Hall of Mirrors: Roy Lichtenstein and the Face of Painting in the 1960s.* Cambridge, MA, 2010.

Coplans, John. *Roy Lichtenstein.* New York, 1972.

Rondeau, James, and Sheena Wagstaff. *Roy Lichtenstein: A Retrospective.* Chicago, 2012.

Glenn Ligon

Born, Bronx, NY, 1960

Glenn Ligon attended Manhattan's prestigious Walden School on scholarship before enrolling at the Rhode Island School of Design and finishing at Wesleyan University in 1982. In 1984–1985 he participated in the Whitney Independent Study Program and was exposed to more conceptual modes of making art. Ligon gained recognition for his 1988 canvas *Untitled (I Am a Man)*, which represents the language and format of signs carried by striking African American workers in Memphis in 1968. Quotation of both words and images is central to Ligon's work; he has appropriated texts from Walt Whitman, Zora Neal Hurston, Gertrude Stein, James Baldwin, Ralph Ellison, Ice Cube, and Richard Pryor. Transferred into oil crayon pressed through letter stencils, their words become material body in his paintings. While Ligon threads his own identity as a black gay man into his artwork, his projects also address collective experience and examine broader cultural norms.

In 1992 Ligon created *Four Etchings* with Burnet Editions. Since then he has made additional works with Dieu Donné Papermill, Poligrafa Obra Gráfica, and others. As an artist concerned with the form of language and its circulation, Ligon is interested in the medium of print. In the early 2000s he adopted printmaking to revisit his earlier paintings. His translations of prior works into new media are conceptually charged: he is concerned with issues of conservation, chemical change, and degradation.

Ligon has had solo exhibitions at the Hirshhorn Museum and Sculpture Garden (1993), Brooklyn Museum of Art (1996), Saint Louis Art Museum (2000), Walker Art Center (2000), the Studio Museum in Harlem (2001), and the ICA Philadelphia (1998). His work has appeared in the Whitney Biennial (1991, 1993) and Venice Biennale (1997, 2015), and Documenta (2002). His mid-career retrospective opened at the Whitney Museum of American Art in 2011.

REFERENCES

Golden, Thelma, et al. *Glenn Ligon: Unbecoming.* Philadelphia, 1997.

Kirk Hanley, Sarah. "Ink Working Proof: Glenn Ligon's Editions." *Art 21 Magazine,* May 4 2012. http://www.blog.art21.org/2012/05/04/ink-working-proof-glenn-ligons-editions/#.VSWDpKIpCJA (accessed April 14, 2015).

Rothkopf, Scott. *Glenn Ligon: AMERICA.* New York, 2011.

William Home Lizars

Born, Edinburgh, Scotland, 1788
Died, Jedburgh, Scotland, 1859

Edinburgh was one of the leading centers of printing and book publishing in the nineteenth century and William Home Lizars was one of its most sought-after printmakers. He was highly regarded for his decorative and ornamental prints, typographical etchings, book plates, banknotes, and other letterpress printing techniques, but he was best known for his prints of natural history subjects.

Lizars first apprenticed to his father Daniel Lizars, who had an engraving and publishing firm. But the artist preferred painting and spent several years studying at the Trustees Academy of Edinburgh under the portrait painter John Graham. His portraits and domestic genre paintings were frequently exhibited, but his promising painting career began to falter after his father's death in 1812 when Lizars was compelled to take over the family business.

Due to the growing British and American fascination with natural history beginning around 1820, Lizars began to focus almost exclusively on illustrating natural history subjects. In 1826 he met the American artist-naturalist John James Audubon who hired him to etch the plates for Audubon's mammoth publication, *Birds of America* (1827–1838). Lizars etched the first ten prints in the 435-plate publication. However, their collaboration came to an abrupt end after Lizars had labor problems with his colorists, forcing Audubon to hire an engraver in London. Lizars continued to be a prolific printmaker and publisher, completing a long list of popular natural history publications, including the extremely successful forty-volume publication *The Naturalist's Library* (1833–1843) with the Scottish naturalist Sir William Jardine. Lizars's passion "to enable all classes to procure information regarding the Great Works of Creation" made him without question one of the finest engravers of natural history subjects.

REFERENCES

"Guy, John C. "Edinburgh Engravers." *Book of the Old Edinburgh Club,* vol. IX. Edinburgh, 1916.

William Home Lizars." Edinburgh University Library. Accessed September 18, 2105. http://www.walterscott.lib.ed.ac.uk/portraits/engravers/lizars.html .

Louis Lozowick

Born, Ludvinovka, Ukraine, 1892
Died, South Orange, NJ, 1973

Louis Lozowick entered the Kiev Art School in 1903 and emigrated to the United States in 1906. He took classes at the National Academy of Design in New York and later at Ohio State University, earning a degree in 1918. He volunteered for the US Army and served in the Medical Corps until 1919. He went abroad in the early 1920s, first to Paris to continue his studies in art, then Berlin, where he created his first city studies and machine ornament drawings. He also traveled to Moscow, the first of several visits to the Soviet Union.

Lozowick wrote articles for *Broom* and contributed to publications such as the *Little Review* and *The Nation*. He became a board member of the *New Masses* (1926), to which he also contributed illustrations. He designed posters, window displays, and theater sets. As a member of the artists committee of the *Little Review*'s 1927 *Machine-Age Exposition*, he contributed an essay that defined his views on the aesthetics of the industrial age and the role of art in society.

Lozowick produced his first lithographs in Berlin in 1923, but after his return to the United States in 1925, he began to explore the medium more fully. Between 1928 and 1930 Lozowick produced more than seventy lithographs; his first one-man show was held at the Weyhe Gallery in 1929. In the late 1930s Lozowick was employed by the Graphic Arts Division of the Works Progress Administration.

The Whitney Museum of American Art organized a major retrospective of Lozowick's prints in 1972. That same year he was elected to the National Academy of Design.

REFERENCES

Flint, Janet. *The Prints of Louis Lozowick: A Catalogue Raisonné.* New York, 1982.

Lozowick, Louis. *Survivor from a Dead Age: The Memoirs of Louis Lozowick.* Virginia Hagelstein Marquardt, ed. Washington, 1997.

Marquardt, Virginia Hagelstein. "Louis Lozowick: Development from Machine Aesthetic to Social Realism, 1922–1936." PhD diss., University of Maryland, 1983.

Helen Lundeberg

Born, Chicago, IL, 1908
Died, Los Angeles, CA, 1999

Lundeberg moved to Pasadena, California, with her family at age four. A gifted child, she developed an interest in writing, but shifted her focus to painting after studying with Lorser Feitelson in 1930. The two were artistic and intellectual partners and married in 1934.

Both Feitelson and Lundeberg admired the rationality and clarity of Italian Renaissance painting. They sought to introduce these qualities to surrealism, offering an alternative to the random, dream-based imagery of the European movement. In 1934 Lundeberg penned a manifesto advocating an American-style surrealism, calling for carefully chosen content that could lead the viewer through levels of meaning while preserving mystery. As a central force within this movement, her works became prominent in exhibitions. In 1936 she was asked by Alfred Barr to participate in the exhibition *Fantastic Art, Dada, Surrealism* at the Museum of Modern Art in New York.

Lundeberg participated in the Works Progress Administration from 1936 to 1942, and created four transfer lithographs, one of which was *Planets* (pl. 79). She made several murals including one 240-feet long, *The History of Transportation,* for the City of Inglewood, California. By the 1950s Lundeberg had begun to distill her programmatic imagery, nesting her subjects in arrangements of geometric planes. Her later work grew even more abstract and hard-edged. In 1965 she shifted from oil paint to acrylic, which she used to emphasize flat, unmodulated surfaces in her paintings. While eliminating the rendering of objects, rarely did her work lose its associative qualities, often evoking landscape, architecture, aerial views, or astronomical references. Lundeberg's subtly nuanced color, allegiance to the curve, evocative shadows, and perspectival invention made her the most lyrical of the Los Angeles hard-edge painters.

REFERENCES

Chambers, Marie. *Infinite Distances: Architectural Compositions by Helen Lundeberg.* West Hollywood, 2007.

Fort, Ilene Susan. *80th: A Birthday Salute to Helen Lundeberg.* Los Angeles, 1988.

Muchnic, Suzanne. *Helen Lundeberg: Poetry Space Silence.* West Hollywood and Los Angeles, 2014.

Brice Marden

Born, Bronxville, NY, 1938

Combining reductive geometric forms and calligraphic gesture, Brice Marden has employed printmaking, drawing, and painting to explore diverse avenues of expression. Marden earned a BFA from Boston University School of Fine and Applied Arts where his study included making woodcuts and etchings. He subsequently earned a MFA at Yale University School of Art and Architecture and moved to New York in 1963.

An exhibition of the work of Jasper Johns at the Jewish Museum in 1964 stimulated Marden's interest in grid-based compositions. He began also to work in encaustic. In 1965 Marden returned to printmaking: he worked first in a screenprinting shop, then as Robert Rauschenberg's studio assistant for four years. Marden's first New York City solo exhibition comprised muted, monochromatic panels in oil and wax that celebrate the idiosyncrasies of paint application and personal color associations.

Marden began to take holidays on the Greek island of Hydra in the summer of 1971, and the luminous tones and rhythms of the landscape and architecture became a major influence on his art. Working with the printer Kathan Brown in 1971, Marden produced an outstanding portfolio of eight intaglio prints, collectively titled *Ten Days,* published by Parasol Press (pl. 129).

As early as 1972 Marden applied ink to twigs he found near his New York studio, drawing with them to cultivate accidental markmaking, eventually trying a range of sticks of various lengths. His interest in Japanese calligraphy led to many improvisational works composed in organic linear networks. In the later 1980s Marden discovered the ninth-century Chinese poet Han Shan and developed weblike compositions based on his poetry. Marden continues to find inspiration in the literature and visual culture of non-Western countries.

REFERENCES

Codognato, Mario, ed. *Brice Marden: Works on Paper 1964–2001.* London, 2002.

Kertess, Klaus. *Brice Marden: Paintings and Drawings.* New York, 1992.

Lewison, Jeremy. *Brice Marden Prints 1961–1991: A Catalogue Raisonné.* London, 1992.

John Marin

Born, Rutherford, NJ, 1870
Died, Addison, ME, 1953

John Marin worked as an architectural draftsman and practiced architecture before taking art classes at the Pennsylvania Academy of the Fine Arts in 1899. He then studied at the Art Students League in New York from 1901 to 1903. In 1905 Marin relocated to Paris, where his first known prints were executed. He probably learned from Maxime Lalanne's *Treatise on Etching.* Marin mastered the medium quickly, creating works that show the influence of James McNeill Whistler.

Marin participated in the Salon des Indépendents and the Salon d'Automne, where his work was seen by Edward Steichen, a friend of the photographer and influential gallerist Alfred Stieglitz. Stieglitz mounted Marin's first monographic exhibition in 1910. By 1913 Marin was considered a leading American modernist, and he was selected to participate in the historic Armory Show in New York City. He was fascinated by the rapidly modernizing urban landscape, in particular the Brooklyn Bridge and skyscrapers such as the Woolworth Building. As his career progressed, Marin concentrated more on people, vehicles, and other elements of urban existence. Maine also captured Marin's imagination. He first visited the state in 1914, and soon after purchased an island there, where he returned to work almost every summer.

Marin was the first American artist to have a retrospective at the Museum of Modern Art. In the 1940s the art critic Clement Greenberg recognized Marin as one of the greatest American painters of the twentieth century. At age eighty Marin represented the United States at the Venice Biennale. After his death, memorial exhibitions at the American Academy of Arts and Letters and National Institute of Arts and Letters honored his legacy.

REFERENCES

Fine, Ruth E. *John Marin.* Washington, 1990.

Fine, Ruth E. *The John Marin Collection at the Colby College Museum of Art.* Waterville, ME, 2003.

Rose, Barbara. *John Marin: The 291 Years.* New York, 1998.

Reginald Marsh

Born, Paris, France, 1898
Died, Dorset, VT, 1954

Reginald Marsh was born in France, the child of expatriate American artists. He graduated from Yale University in 1920. While an undergraduate, he created illustrations for the *Yale Record*. After college he worked as an artist on the staffs of *Vanity Fair* and the *New Yorker*.

In 1924 he showed watercolors of New York street scenes in a solo exhibition at the Whitney Studio Club. The next year he traveled to Europe with his wife, the sculptor Betty Burroughs. Marsh was struck by the works of Peter Paul Rubens, Rembrandt, and Michelangelo, particularly their arrangements of figures. In 1927–1928 he began classes with Kenneth Hayes Miller at the Art Students League. Miller encouraged him to continue to explore the energy of the modern metropolis. Basing his paintings on photographs and sketches that he made, Marsh often depicted working-class subjects, capturing the vitality of dance marathons, Coney Island beaches, and the rush of the daily commute on the elevated train.

Marsh was also interested in historic painting techniques. The painter Thomas Hart Benton taught him how to work with egg tempera, a medium used in Renaissance Italy. A significant number of his images of urban life are in tempera. In the 1940s Marsh utilized "Maroger medium," an oil paint similar to that used by Flemish artists in the Renaissance and baroque periods. The line quality of many of his prints also betrays a historicizing tendency. Although he employed old-fashioned methods, Marsh nearly always focused on the representation of modern life. The Whitney Museum of American Art organized a 1955–1956 traveling exhibition of Marsh's works; the museum held another in 1983 focusing on his artworks from the thirties.

REFERENCES

Goodrich, Lloyd. *Reginald Marsh.* New York, 1955.

Kendall, M. Sue. "Reginald Marsh." In *Grove Art Online. Oxford Art Online,* http://www.oxfordartonline.com/subscriber/article/grove/art/T054580 (accessed October 6, 2015).

Sasowsky, Norman. *The Prints of Reginald Marsh: an essay and definitive catalog of his linoleum cuts, etchings, engravings, and lithographs.* New York, 1976.

Charles Mielatz

Born, Bredding, Germany, 1864
Died, New York, NY, 1919

Charles Mielatz emigrated to the United States with his family in 1866. He attended Chicago's public schools and the Chicago Institute of Design, where he studied painting with Frederick Rondel. He spent several years drawing maps and plans for the US Army Corps of Engineers in Newport, Rhode Island. Mielatz began making etchings after meeting artist James J. Calahan in Newport in 1883.

Mielatz moved to New York City in the 1880s to pursue a career in art. Etchings comprised the majority of his output, though he was respected for his watercolors as well. After being invited by the Iconophiles Society of New York to create a print of Wall Street in 1889, he became fascinated by the urban scenery and devoted his greatest efforts to making prints of New York City. The emerging forms of architecture and growing ethnic neighborhoods that made up the metropolis's landscape at the turn of the century were of particular interest to Mielatz.

Mielatz continually revised his plates and often created several variations on the same work. He applied innovative combinations of techniques, using, for instance, aquatint, softground, and roulette work in a single print. Mielatz was also among the first Americans to practice multiplate color etching.

Mielatz was an instructor at the National Academy, secretary of the New York Etching Club, and a member of the Brooklyn Society of Etchers, the National Arts Club, and the American Watercolor Society.

REFERENCES

Kraeft, June, and Norman Kraeft. *Charles Frederick William Mielatz: An Early Etcher of Old New York.* June 1 Gallery, Bethlehem, CN, 1979.

"Mr. Charles F.W. Mielatz, Noted Etcher and Water Color Artist Dies at 59." *New York Herald,* June 4, 1919.

Weitenkampf, Frank. "Charles Frederick William Mielatz." In *Biography Resource Center,* 2002. http://galenet.com/servlet/BioRC (accessed July 17, 2015).

Mary Nimmo Moran

Born, Strathaven, Scotland, 1842
Died, East Hampton, NY, 1899

Mary Nimmo came to the United States with her father and brother in 1852 and settled in Crescentville, Pennsylvania. At age eighteen, Nimmo studied painting at the Pennsylvania Academy of Fine Arts under the tutelage of Thomas Moran and became his wife two years later. The couple spent many years traveling throughout Europe and the American frontier together, depicting the varied landscapes they encountered.

Nimmo Moran began etching in 1879, following her husband's experimentation with the medium during the previous year. She submitted four plates to the Society of Painter-Etchers of New York, and was elected to its membership. Because she was then an unknown artist and signed her pieces simply "M. Nimmo Moran," the society assumed that she was a man. In 1881 both Nimmo Moran and her husband exhibited works in the Museum of Fine Arts, Boston's exhibition of four hundred printmakers. They were among twelve artists selected for membership in the nascent Society of Painter-Etchers in London; Nimmo Moran was the only woman chosen. The supposedly masculine character of her work garnered much critical praise. Morris T. Everett of *Brush and Pencil* declared that her prints disproved the notion that an artist's gender always determined the style and content of a work of art.

Nimmo Moran's etchings are atmospheric compositions that tend to incorporate solitary farmhouses or groups of trees. In addition to original prints, Nimmo Moran often created etchings of her husband's paintings for catalogs. Indeed, publishers paid more for those etchings than they did for her original prints. In 1887 she exhibited fifty-four prints in an exhibition of women printmakers at the Museum of Fine Arts, Boston. She received a medal and diploma from the Chicago Columbian exposition of 1893.

REFERENCES

Everett, Morris T. "The Etchings of Mary Nimmo Moran." *Brush and Pencil* 8, no. 1 (April 1901): 2–16.

Friese, Nancy. *Prints of Nature: Poetic Etchings of Mary Nimmo Moran.* Tulsa, OK, 1984.

Klackner, Christian. *A Catalogue of the Complete Etched Works of Thomas Moran, N.A., and M. Nimmo Moran, S.P.E.* New York, 1889.

Thomas Moran

Born, Lancashire, England, 1837
Died, Santa Barbara, CA, 1926

Thomas Moran became involved with printmaking at an early age. He was apprenticed to the woodengraving firm of Scattergood and Telfer, which created illustrations for periodicals and books. In 1856 Moran left his apprenticeship to concentrate on becoming an artist. To supplement his income, he created illustrations on commission. His work appeared in a variety of books as well as publications such as *Harper's Weekly* or the *Illustrated London News*.

Moran became known for grand canvases of sunsets, forests, and other natural phenomena. He was invited to join Professor Ferdinand Vandeveer Hayden and the United States Exploring Expedition to the Yellowstone River in 1871. He also accompanied Major John Wesley Powell's expedition along the Colorado River. Two of Moran's most acclaimed paintings, *The Grand Canyon of the Yellowstone* and *The Chasm of the Colorado,* are based on sketches from these trips. The United States Congress bought the paintings for $10,000 each, making Moran something of a celebrity. In addition to his trips throughout the American frontier, he also

journeyed to Europe several times, chiefly to study the work of J.M.W. Turner. Mary Nimmo Moran, the artist's wife and a successful artist in her own right, often accompanied him.

Moran began to devote substantial attention to etching around 1877. He was a founding member of the New York Etching Club. Moran's interest in etching was concurrent with a renewed enthusiasm for etchings among the general population in the United States.

Moran's etchings show a significant amount of experimentation; he often used unconventional tools. In addition to his own works, Moran created a number of reproductions of paintings. In 1881 Moran and his wife were two of twelve Americans to be honored with selection to the Society of Painter-Etchers in London.

REFERENCES

Anderson, Nancy K. *Thomas Moran*. Washington, 1997.

Hansen, T. Victoria. "Thomas Moran and Nineteenth-Century Printmaking." In *The Prints of Thomas Moran in the Thomas Gilcrease Institute of American History and Art*, ed. Anne Morand and Nancy Friese. Tulsa, OK, 1986.

Klackner, Christian. *A Catalogue of the Complete Etched Works of Thomas Moran, N.A., and M. Nimmo Moran, S.P.E.* New York, 1889.

Eugene Morley

Born, Scranton, PA, 1909
Died, New York, NY, 1953

Eugene Morley studied under Thomas Hart Benton at the Art Students League where he befriended the painter Jackson Pollock and other American abstract artists such as Lee Krasner, Ashile Gorky, and Ad Reinhardt. Morley was active as a painter and printmaker in the 1930s, but in the late 1940s he devoted himself increasingly to commercial art and design.

A committed Marxist, Morley was a founding member of the American Artists' Congress (AAC), which was tied to the US Communist Party. He taught at the AAC's American Artists School, where the artist Jacob Lawrence was one of his students. From 1935 to 1941 Morley belonged to the silkscreen unit of the Graphic Arts Division of the Works Progress Administration's Federal Arts Project.

Morley's political beliefs led him to be a socially conscious artist. He produced scenes of American life during the Depression. His lithographs appeared in the leftist publications *New Masses* and *Art Front*. Many of his prints of the late 1930s render cityscapes in a style that reflects the dual influences of cubism and surrealism, especially the work of Joan Miró. The poet Hilda Morley Wolpe, the artist's wife from 1945 to 1949, stated that Morley drew inspiration from the rectilinear compositions of Piet

Mondrian. He was also influenced by his American peers: his *Jersey Landscape* (pl. 100), with its boldly colored geometric forms, recalls depictions of urban space by Charles Sheeler or fellow AAC member Stuart Davis.

A study for a mural by Morley was in *Subway Art* (1938) at the Museum of Modern Art. The Metropolitan Museum of Art exhibited some of his prints in 1941.

REFERENCES

Acton, David. *Color in American Printmaking, 1890–1960*. New York, 1990.

Watrous, James. *A Century of American Printmaking, 1880–1980*. Madison, WI, 1984.

Robert Motherwell

Born, Aberdeen, WA, 1915
Died, Provincetown, MA, 1991

In 1932 Robert Motherwell enrolled at Stanford to study art but ultimately majored in philosophy. He did graduate work in philosophy at Harvard and traveled through Europe, studying in Paris. He moved to New York in 1940 to study art history at Columbia University with Meyer Schapiro. Schapiro introduced him to artist Kurt Seligmann, in whose studio Motherwell probably made his first etching. Through Seligmann, Motherwell met Chilean artist Roberto Matta, an important early influence, who introduced him to surrealist automatism.

Steeped in literature and poetry, Motherwell's approach to abstraction was both humanist and personal. The youngest of the first-generation abstract expressionists, Motherwell explored themes and variations, a method that fit comfortably within printmaking's natural accommodation of variants, suites, and series. Although he experimented with etching and engraving at Stanley William Hayter's New York Atelier 17 during the early forties, his first lithograph, printed with Robert Blackburn at Tatyana Grosman's Universal Limited Art Editions (ULAE) in 1961, marked the true beginning of his engagement with printmaking. Motherwell also worked at the Hollander Workshop, Gemini G.E.L., Tyler Graphics Ltd., and later at Trestle Editions. Although he favored etching and lithography, his oeuvre includes illustrated books, screenprints, and monotypes. In the seventies he purchased his own presses and hired master printers to work with him.

Motherwell's prints have been exhibited in many solo and group exhibitions, including a traveling graphics retrospective organized by the American Federation of Arts in 1980. Also a writer, editor, and critic, Motherwell was founding director and editor of the groundbreaking series *Documents of Modern Art* (later *Documents of Twentieth-Century Art*) (1944). His many awards include the National Medal of Arts (1989).

REFERENCES

Engberg, Siri, and Joan Banach. *Robert Motherwell: The Complete Prints 1940–1991. Catalogue Raisonné*. Minneapolis, 2003.

Motherwell, Robert, Robert Bigelow, and John E. Scofield. *Reconciliation Elegy*. New York, 1980.

Terenzio, Stephanie, and Dorothy C. Belknap. *The Painter and the Printer: Robert Motherwell's Graphics 1943–1980*. New York, 1980.

Thomas Nast

Born, Landau, Kingdom of Bavaria (today Germany), 1840
Died, Guayaquil, Ecuador, 1902

Thomas Nast was a pioneering political cartoonist. Covering a wide range of topics, his oeuvre not only gives insight into the prevailing debates of its time, but it also attests to the rapidly growing importance of the press as a political force during the latter half of the nineteenth century.

In 1846 Nast and his family moved to New York. After studying with the German painter Theodor Kaufmann for six months, Nast took lessons at the Academy of Design. In 1855 he secured a position as staff artist at *Frank Leslie's Illustrated Newspaper*, where he first drew cartoons illustrating current sociopolitical and economic affairs. In 1860 Nast was sent to Europe; he covered Giuseppe Garibaldi's military campaign for Italian unification, an experience that prepared him for reporting on the American Civil War.

During his twenty-four years as a staff artist at *Harper's Weekly* (1862–1886), Nast created biting commentaries on politics, economics, corruption, minorities' civil rights, immigration, and the separation of church and state. Among his more than three thousand published images, his campaign against William M "Boss" Tweed and his circle of corrupt New York City officials exposed the illicit entanglements of politics and private businesses interests. Nast's influence on public opinion was particularly manifest in presidential elections. A fervent supporter of the Republican Party, Nast created cartoons that contrasted the strengths of Republican candidates with the weaknesses and transgressions of Democratic candidates. Significantly, candidates supported by Nast proved successful in their campaigns.

Nast's contribution to American visual culture includes the iconic depiction of Santa Claus (1862) as well as the donkey (1870) and elephant (1874) representing the Democratic and Republican Parties, respectively. Although not the originator of those images, it was Nast's designs that made them famous.

REFERENCES

Halloran, Fiona Deans. *Thomas Nast. The Father of Modern Political Cartoons.* Chapel Hill, 2012.

Reaves, Wendy Wick. "Thomas Nast and the President." *American Art Journal* 19, no. 1 (1987): 60–71.

St. Hill, Thomas Nast. *Thomas Nast. Cartoons and Illustrations.* New York, 1974.

Louise Nevelson

Born, Pereyaslav, near Kiev, Russia, 1899
Died, New York, NY, 1988

Louise Berliawsky emigrated from Russia to the United States with her family in 1905. Growing up in Rockland, Maine, she pursued music and visual arts in high school. She married successful business owner Charles Nevelson in 1920 (divorced 1941) and moved to New York.

Nevelson enrolled at the Art Students League in the late 1920s. In 1931 she went to Europe, studying with Hans Hofmann in Munich. She returned to New York in 1932, again studying with Hofmann and also briefly assisting Mexican muralist Diego Rivera. In 1934 she enrolled in Chaim Gross's sculpture class at the Educational Alliance; thereafter sculpture became her major focus. From 1935 to 1939 she worked for the Works Progress Administration as a teacher, painter, and sculptor.

In the late 1950s she created her first large-scale, black wood assemblages and environments, composed of found objects organized within stacked compartments, unified by monochromatic color, creating monumentality out of the familiar. Nevelson made her first prints in 1953 at Atelier 17 in New York. The imagery reflected her interest in pre-Columbian art. In 1963 she worked at the Tamarind Lithography Workshop in Los Angeles, producing an amazing twenty-six editions of lithographs in six weeks. The *Facade* portfolio (1966), twelve prints accompanying poems by Edith Sitwell, was Nevelson's first screenprint project. In 1967 she returned to Tamarind, producing *Double Imagery*, a group of sixteen lithographic editions. During the 1970s and 1980s Nevelson continued to make prints periodically.

Nevelson was a member of Artists Equity, director of the New York chapter (1957–1959), and national president in 1963. The Whitney Museum of American Art honored her with a retrospective in 1967. Her numerous awards include the Edward MacDowell Medal (1969), the Skowhegan Medal for Sculpture (1971), and the National Medal of Arts (1985).

REFERENCES

Baro, Gene. *Nevelson: The Prints.* New York, 1974.

Indiana, Robert. *Louise Nevelson: The Way I Think Is Collage.* Zurich, 2013.

Johnson, Una E. *Louise Nevelson: Prints and Drawings, 1953–1966.* New York, 1967.

Albert Newsam

Born, Steubenville, OH, 1809
Died, near Wilmington, DE, 1864

Albert Newsam excelled in creating portrait likenesses. He produced depictions of major figures of his day including Andrew Jackson and Davy Crockett. Newsam faced adversity early in life: he was orphaned and also deaf. In 1820 he was taken to Philadelphia and enrolled in the Pennsylvania Institution for the Deaf and Dumb. He demonstrated talent in the visual arts from a young age.

In 1827 Newsam was apprenticed to the Philadelphia lithographer Col. Cephas G. Childs of the firm Childs & Inman. Following this formative experience, Newsam began working as the primary artist in the studio of Peter S. Duval, a pioneer of color lithography and publisher of the *Parlour Review*. Duval's publication featured sheet music and portraits of noted composers by Newsam. In addition to possessing great abilities as a portraitist, the artist, like his employer, was respected for his deft manipulation of color.

Like many printers of the time, Newsam created prints based on artworks by others. He made work after such renowned American painters as Henry Inman, Charles Bird King, John Neagle, Gilbert Stuart, and Thomas Sully. Newsam was an avid reader and as an adult developed a fairly deep knowledge of American and European history as well as the history of painting. He traveled to London, Paris, and Rome to study the work of European masters. He also possessed a considerable print collection and thus kept abreast of developments in printmaking in Britain and Continental Europe.

At the height of his career, a series of ailments slowed his artistic production. Declining eyesight followed by a stroke left him institutionalized until his death.

REFERENCES

"Albert Newsam Papers." *Library Company of Philadelphia.* March 2005. http://www.librarycompany.org/mcallister/pdf/newsam.pdf (accessed October 16, 2015).

Bewley, John. "Philadelphia Lithographers: Albert Newsam (1809–1864)." *University of Pennsylvania, Rare Book and Manuscript Library.* http://www.library.upenn.edu/collections/rbm/keffer/newsam.html (accessed October 16, 2015).

Pyatt, Joseph O. *Memoir of Albert Newsam.* Philadelphia, 1868.

Claes Oldenburg

Born, Stockholm, Sweden, 1929

Swedish American sculptor, draftsman, printmaker, and performance artist Claes Oldenburg arrived in the United States as an infant and grew up in Chicago. Oldenburg studied literature and art history at Yale University (1946–1950). Returning to Chicago, he worked as a newspaper reporter and studied art with Paul Wieghardt at the Art Institute of Chicago. In 1956 he moved to New York and became renowned for his performances and Happenings. His early work featured sculptural objects, which foreshadowed his later interest in the materiality of things. He introduced consumer goods into his artistic vocabulary, aligning his projects with pop art.

In the early 1960s Oldenburg developed his soft sculptures, translating everyday objects such as food, washstands, toilets, typewriters, or light switches into soft materials. As they seemed to collapse and sprawl on the gallery floor, the soft sculptures played with the viewer's expectations of familiar things, which were rendered strange in the sphere of art. Oldenburg's interest in shifting objects into new contexts and formats is also apparent in his monumental outdoor sculptures. With his wife, Coosje van Bruggen, Oldenburg produced over forty large-scale, site-specific works.

While drawing has always played an important role in Oldenburg's oeuvre, it was not until 1968 that he first worked making prints at Gemini G.E.L. Over his career Oldenburg grew more confident with the medium and worked in a variety of techniques including etching, lithography, woodcut, offset, and screenprinting. Transferring the logic of prints to three-dimensional artwork, he also made sculptural editions with Gemini. For Oldenburg, exploring different artistic modes reveals new but complementary ideas about the subject.

REFERENCES

Axsom, Richard H. *Printed Stuff: Prints, Poster, and Ephemera by Claes Oldenburg. A Catalogue Raisonné 1958–1996.* New York, 1997.

Rottner, Nadja, ed. *Claes Oldenburg.* Cambridge, MA, and London, 2012.

Solomon R. Guggenheim Foundation. *Claes Oldenburg: An Anthology.* New York and Washington, 1995.

Frances Flora Palmer

Born, Leicester, England, 1812
Died, Brooklyn, NY, 1876

An artist of exceptional skill, Frances Flora Palmer (née Bond), known as Fanny, succeeded in a field dominated by men. Women normally were employed only for menial work such as hand-coloring prints. Instead Palmer drew designs and worked up the lithographic stone, tasks commonly performed by men. She quickly gained recognition for her work and today is regarded as one of the foremost lithographers of nineteenth-century America.

Palmer received drawing lessons as a young girl. In 1842 she married Edmund Seymour Palmer, with whom she opened a lithography firm the same year. Although the Palmers received high praise for their work, financial difficulties forced them to leave England and emigrate to the United States, presumably in late 1843. The couple quickly resumed their business in New York. Frances's designs attracted the attention of Nathaniel Currier, owner of the renowned printmaking firm Currier and Ives. In 1851 the Palmers' business had once again proven unviable, and Currier hired Frances as a fulltime staff artist. During the twenty years that she worked at the firm, she produced at least 170 prints copyrighted in her name.

The key to Palmer's success lay in her ability to cover a wide range of subject matter and genres. Palmer was most revered for her depictions of the American landscape, both rural and urban. More than her other prints, these addressed contemporary concerns such as the impact of industrialization on country life or westward expansion. Ultimately Palmer's designs not only gained her high recognition in a male-dominated business, but they also shaped the visual culture of her time and provided a pictorial form for the manifold ideas, values, and sentiments that constitute America's cultural identity.

REFERENCES

Gale Research Co. *Currier & Ives: A Catalogue Raisonné. A Comprehensive Catalogue of the Lithographs of Nathaniel Currier, James Merritt Ives and Charles Currier, including ephemera associated with the firm, 1834–1907.* Detroit, 1984.

Le Beau, Bryan F. *Currier and Ives. America Imagined.* Washington and London, 2001.

Rubinstein, Charlotte Streifer. "The Early Career of Frances Flora Bond Palmer (1812–1876)." *American Art Journal* 17, no. 4 (Autumn 1985): 71–88.

Peter Pelham

Born, London, England, c. 1697
Died, Boston, MA, 1751

Peter Pelham was among a number of British artists who emigrated to the colonies during the first half of the eighteenth century, taking with them their knowledge and skills of new techniques and styles. They shaped the field of artistic production in their new home.

A successful mezzotint engraver before coming to America, Pelham apprenticed with the London printmaker John Simon, who specialized in prints made after paintings. It is unclear why Pelham decided to leave London for America; one source suggests he had fallen out with his father. Whatever the reason, in 1727 he settled in Boston with his family. Once there he launched his career by making a commemorative print after a painting of Rev. Cotton Mather. Pelham had painted Mather shortly before the minister's death, and produced a mezzotint version shortly after Mather died. This was the first image in this technique ever made in America.

During his American period, Pelham produced six portrait paintings, a plan of the fortress of Louisbourg, and fourteen mezzotints. His works — the mezzotints particularly — attest to the changes the Boston art market had undergone since Pelham's arrival in America twenty-five years earlier. While initially access to prints had been very limited, collecting prints grew to become a more widespread activity. Nevertheless, despite the expanding market Pelham undertook other commercial activities. He opened a school teaching dancing, reading, and writing, as well as drawing on glass, and needlework. In 1734 Pelham married his third wife, Mary Copley. Pelham provided art instruction to two successful artists of the next generation: his son Henry Pelham and his stepson, John Singleton Copley.

REFERENCES

Oliver, Andrew "Peter Pelham (c. 1697–1751). Sometime Printmaker of Boston." In *Boston Prints and Printmakers, 1670–1775.* Charlottesville, 1973.

Saunders, Richard H., and Ellen G. Miles, eds. *American Colonial Portraits, 1700–1776.* Washington, 1987.

Joseph Pennell

Born, Philadelphia, PA, 1857
Died, Brooklyn, NY, 1926

Joseph Pennell was a painter and printmaker who began his artistic formation at the Pennsylvania Museum and School of Industrial Art in Philadelphia and later at the Pennsylvania Academy of Fine Arts. Independent and outspoken, the artist clashed with instructors and did not graduate from either institution.

Pennell achieved great success with his illustrations. In 1880 the artist opened his own commercial illustration studio. His work was published in *Scribner's Monthly* in 1881. Pennell was particularly recognized for his ability to depict cityscapes. Juxtaposing dramatic clouds with monumental structures, he deftly combined natural and manmade forms. His images of American cities appeared in various publications. In 1883 Pennell received a commission from *Century* magazine to illustrate a series of articles on Tuscan cities.

In 1884 he moved to London with his wife, the writer Elizabeth Robins Pennell. Some of the artist's most notable works are collaborations on travel books with his wife. They also coauthored *Lithography and Lithographers* (1898), a text that discusses art history and technique. Pennell was active in London's artistic and literary scene. He befriended James McNeill Whistler, Robert Louis Stevenson, and George Bernard Shaw. Whistler was an especially important influence on Pennell. Both the artist and his wife enjoyed extended conversations with Whistler, whose artistic philosophy and work they admired. Based on these discussions, Pennell composed a posthumous biography of his friend.

Pennell was a founding member of the Society of Engravers of Philadelphia and belonged to artists' organizations on both sides of the Atlantic. He received a gold medal for engraving at Paris's Exposition Universelle of 1900. He and his wife traveled extensively between 1913 and 1917 before settling in New York. Manhattan's burgeoning skyline provided Pennell with rich material for his artworks.

REFERENCES

Fern, Alan. "Pennell, Joseph." In *Grove Art Online. Oxford Art Online.* http://www.oxfordartonline.com/subscriber/article/grove/art/T066188 (accessed September 4, 2015).

Wuerth, Louis A. *Catalogue of the Etchings of Joseph Pennell.* Boston, 1928.

Jackson Pollock

Born, Cody, WY, 1912
Died, East Hampton, NY, 1956

Moving to New York City in 1930, Jackson Pollock began studies with Thomas Hart Benton at the Art Students League. Although initially exploring traditional techniques, Pollock became intrigued with surrealism as well as the possibilities inherent in new methods of painting. Working with Mexican muralist David Alfaro Siqueiros in 1936, Pollock was exposed to radical techniques such as the application of liquid paint by pouring. In 1939 and 1940 he underwent Jungian psychoanalysis, contemplating subconscious motivations through automatic drawing, a strategy that encourages the hand to wander across the page without rational control.

The artist's first printmaking investigations were lithographs made between 1938 and 1942, contemporaneous with his work for the Federal Arts Project of the Works Progress Administration. During 1944 and 1945 the artist made drypoints and engravings while working at Stanley William Hayter's printmaking studio, Atelier 17. Pollock printed only a few impressions of these plates, which were subsequently editioned after his death.

In 1945 Pollock married painter Lee Krasner and the couple moved to East Hampton, Long Island. Between 1947 and 1950, in a converted barn on their property, a convergence of ideas coalesced into a highly innovative method of dripping, pouring, and spattering paint onto canvas spread on the floor. Eliminating nearly all representational elements, Pollock's work became increasingly abstract. A high-profile *Life* magazine article in August 1949 sensationalized the artist's persona. Controversy continued, particularly among artistic circles, when Pollock reintroduced figuration to his work in 1951. That same year he authorized six of his paintings to be translated into a portfolio of screenprints. Pollock experienced a creative crisis in the 1950s that manifested in extended periods of inactivity and meager artistic output. He died in an automobile accident at age forty-four.

REFERENCES

Harrison, Helen A. *Jackson Pollock*. London and New York, 2014.

Landau, Ellen G. *Jackson Pollock*. New York, 1989.

O'Connor, Francis V. *Jackson Pollock*. New York, 1967.

Maurice Brazil Prendergast

Born, St. John's, Newfoundland, 1858
Died, New York, NY, 1924

Maurice Prendergast moved to Boston with his family in 1861. Although his parents were not well off, they did what they could to encourage their son's interest in art and eventually apprenticed him to a commercial artist. In 1886 Prendergast took the first of six trips to Europe, sketching the British countryside. He lived in Paris from 1891 to 1894, where he studied at the Académies Colarossi and Julian. Through a fellow student, James Wilson Morrice, Prendergast became affiliated with a group of expatriate artists, authors, and intellectuals who gathered at the Chat Blanc café. In 1892 Prendergast began creating monotypes, which he would continue to do for the next decade, creating some two hundred prints in this period.

His years in France lent Prendergast artistic credibility when he returned to the United States. He was given an exhibition at the Chase Gallery in 1899. In 1900 he had a solo exhibition at New York's Macbeth Galleries. In 1901 he was awarded a bronze medal at the Pan-American Exposition in Buffalo and was given retrospective exhibitions at art museums in Cincinnati and Detroit. He met William Glackens, and with six other artists, formed The Eight; the group's eponymous exhibition in 1908 brought Prendergast widespread attention. Some critics were shocked by his use of color.

Prendergast was also a member of the Association of American Painters and Sculptors, and exhibited works in the 1913 Armory Show. He sold work to prominent collectors such as Lillie P. Bliss, Albert C. Barnes, and Duncan Phillips. He was awarded the William A. Clark Memorial Prize and a bronze medal at the Corcoran Gallery of Art's biennial in 1923.

REFERENCES

Brown, Milton W. "Maurice B. Prendergast." In *Maurice Brazil Prendergast, Charles Prendergast: A Catalogue Raisonné*, ed. Carol Clark et al. Williamstown, MA, and Munich, 1990.

Mathews, Nancy Mowll. "Postscript: The Monotypes." In *Maurice Prendergast*, 41–43. Williamstown, MA, 1990.

Rhyse, Hedley Howell. *Maurice Prendergast, 1859–1924*. Cambridge, MA, 1960.

Martin Puryear

Born, Washington, DC, 1941

While growing up, Martin Puryear frequented the Smithsonian museums, cultivating an interest in multiculturalism and natural history. He attended Catholic University, switching from biology to art (painting) in his junior year. Following graduation, Puryear joined the Peace Corps, teaching for two years in Sierra Leone, where he made his earliest prints.

In 1966 Puryear studied etching at the Swedish Royal Academy of Arts, Stockholm, where an abiding interest in woodcraft led him to independent work in the sculpture studio. Puryear earned his MFA from Yale in 1969, studying sculpture with Robert Morris and Richard Serra, among others. His first solo museum exhibition was at the Corcoran Gallery of Art in 1977. That same year he completed his first large-scale commission for Artpark in Lewiston, New York.

Puryear's first major print project was a series of woodcuts (2000) for Jean Toomer's 1923 literary masterpiece *Cane*. In 2001 Puryear began producing etchings at Paulson Press. In his prints, Puryear seeks to explore ideas embodied in his sculpture, such as the blurring of art and craft or the fluidity of signs. He favors the woodcut and intaglio processes, both characterized by a sculptural working of the printing matrix — the carving, incising, and scoring of a block or plate.

Puryear has taught at Fisk University, University of Maryland, and the University of Illinois, Chicago. He has twice been a visiting artist at the American Academy in Rome (1986, 1997) and received numerous awards and grants, including a Guggenheim Fellowship (1982) and a MacArthur Foundation Fellowship (1989). In 1989 Puryear represented the United States at the São Paulo Biennial, Brazil, the first African American artist to do so, receiving the Grand Prize. In 2011 he was awarded the National Medal of Arts and Humanities.

REFERENCES

Benezra, Neal, and Robert Storr. *Martin Puryear*. Chicago, 1991.

Elderfield, John, Michael Auping, Elizabeth Reede, Richard J. Powell, and Jennifer Field. *Martin Puryear*. New York, 2007.

Tallman, Susan. "Martin Puryear." *Art in Print* 3, no. 3 (2013). http://artinprint.org/review/martin-puryear (accessed September 18, 2015).

Robert Rauschenberg

Born, Port Arthur, TX, 1925
Died, Captiva Island, FL, 2008

Robert Rauschenberg studied pharmacology before being drafted into the US Navy during World War II. He later enrolled at Black Mountain College where he studied with German abstract artist Josef Albers. Rauschenberg's artworks diverged radically from those of his teacher. The majority of his works question and blur categories. He remarked that his multimedia projects were intended to occupy a position between art and life.

Following his studies, Rauschenberg moved to New York. He formed part of an artistic circle that included composer John Cage and dancer Merce Cunningham. Linked by common interests in chance and the exploration of artistic boundaries, the three men collaborated frequently. In 1953 Rauschenberg met the artist Jasper Johns. Their interaction led to a potent exchange of artistic ideas. Always open to innovation, Rauschenberg cofounded the group Experiments in Art and Technology (EAT) in 1966.

While some of his works reprise Dada tactics in their juxtaposition of found materials, Rauschenberg developed unique ways of integrating images. Beginning in the late fifties he used a novel solvent transfer process to embed newspaper photographs into the picture plane. This technique can be observed in *Booster* (1967), a work that combines lithography and screenprinting (pl. 125). The print epitomizes Rauschenberg's tendency to mine uncommon material: an astrological chart overlays x-rays of his own body. *Booster* pushed the frontiers of printmaking in terms of its ambition and size: it remains one of the largest lithographs ever handpulled. In his later years Rauschenberg continued to confound categorization and play with scale. One of his final artworks, *The 1/4 Mile or 2 Furlong Piece* (1981–2008), mixes a range of media and spans approximately one thousand feet.

REFERENCES

Brown, Sienna. "The Lithographs of Robert Rauschenberg." PhD diss. Emory University, 2010.

Kotz, Mary Lynn. *Rauschenberg: Art and Life.* New York, 2004.

Tomkins, Calvin. *Off the Wall: A Portrait of Robert Rauschenberg.* New York, 1980.

Paul Revere

Born, Boston, MA, 1735
Died, Boston, MA, 1818

Paul Revere is known primarily for the ride he took the night of April 18, 1775, to warn colonists in Lexington and Concord about approaching British troops. While this ride became legendary only during the late nineteenth century after Henry Wadsworth Longfellow published his poem *Paul Revere's Ride* (1860), Longfellow's ode ignores Revere's accomplishments as a silversmith, printmaker, and copper miner, three pursuits that were valuable to the revolutionary cause.

Apprenticed to his father, a French Huguenot silversmith, Paul Revere took over the family's shop in 1756. He soon expanded the business, engraving copper plates and making woodcuts for magazines and books as well as single-leaf woodcuts. His prints depicting the Boston Massacre (1770) (pl. 8) and his *Landing of the Troops* (1770), in addition to anti-British satirical prints, stand out. Revere also engraved and printed paper currency for the Massachusetts Provincial Congress.

In 1788 Revere opened an iron foundry, producing iron, brass, and copper bells for civilian purposes as well as canons, ordnance, and gunpowder for the military. Although the United States was rich in natural resources, knowledge about the extraction and processing of metals was scarce. Copper mining was highly desirable not only to capitalize on native copper resources, but also to gain independence from overseas imports, especially from Britain, and thus strengthen the national economy.

While Revere's prints offer an insight into the Boston print market and demonstrate how images were used for political ends, his business activity in processing metals presents a more complete picture of commercial activity in Boston during a time of fundamental change.

REFERENCES

Brigham, Clarence. *Paul Revere's Engravings.* Worcester, 1969.

Fairbanks, Jonathan. *Paul Revere's Boston, 1735–1818.* Boston, 1975.

York, Neil Longley. *The Boston Massacre: A History with Documents.* New York, 2010.

Diego Rivera

Born, Guanajuato, Mexico, 1886
Died, Mexico City, Mexico, 1957

Diego Rivera was born into an upper-class Mexican family. From age ten he studied art at the Academy of San Carlos in Mexico City. In 1907 he traveled to Europe, first living in Madrid and eventually moving to Paris where he was exposed to a variety of artistic influences. He befriended Amedeo Modigliani and witnessed the beginnings of cubism — even creating vibrantly colored, Mexican-themed works in the artistic idiom.

When Rivera returned to Mexico in 1921, the revolutionary socialist government commissioned him, along with muralists José Clemente Orozco and David Alfaro Siqueiros, to create a new national art form for civic buildings. Rivera and his contemporaries considered murals an apt form because they were public, could not easily be commodified, and had been used by indigenous peoples of the region. Rivera's murals and prints foment nationalist sentiments and critique historic injustices: many depict strife in the region, such as the effects of Spanish colonialism and the tumult of the Mexican Revolution and its aftermath.

Rivera was a communist and explored politically committed imagery for much of his career. In 1929 he married Mexican artist Frida Kahlo who shared many of his political beliefs. During a visit to Moscow he met Alfred H. Barr Jr., the Museum of Modern Art's first director. Barr became Rivera's friend and champion, introducing him to Abby Aldrich Rockefeller, one of the founders of MoMA, and her husband John. A retrospective of Rivera's work was held at MoMA in 1931. That same year he finished important murals in San Francisco. In 1932 he created a mural cycle in Detroit. His relationship with the Rockefellers soured in 1933 when he refused to eliminate a portrait of Lenin from a now-destroyed mural at Rockefeller Center.

REFERENCES

Helms, Cynthia Newman. *Diego Rivera: A Retrospective.* Detroit, 1986.

Reyero, Manuel. *Diego Rivera.* Mexico, 1983.

Wolfe, Bertram David. *Diego Rivera: His Life and Times.* New York, 1939.

Ed Ruscha

Born, Omaha, NE, 1937

Edward Ruscha grew up in Nebraska and Oklahoma, eventually moving to Los Angeles in 1956. He studied at the Chouinard Art Institute, now the California Institute of the Arts. After leaving Chouinard in 1960 his career took off as he became firmly associated with the Ferus Gallery in Los Angeles. The versatile artist's oeuvre spans conceptual art and pop. He often combines texts and images in novel ways.

Working in many different media, Ruscha mines everyday life for inspiration. He creates deadpan depictions of Americana. The centrality of automobiles in American life is a motif that runs through many of his projects. Representing gas stations, elements of urban Los Angeles, iconic logos, or commonplace words, Ruscha's art explores the signs and built environment of the United States. Not unlike that of the dadaists, his work often explores the materiality of words, not solely their meaning.

The artist is equally famous for his photo books, such as *Twentysix Gasoline Stations* (1963), which typically consist of serial documentation of a single theme. Ruscha is a highly innovative printmaker and skilled draftsman. He has experimented with unusual materials such as gunpowder, axle grease, and Pepto-Bismol, as well as a range of different foods. His print series *News, Mews, Pews, Brews, Stews, & Dues* consists of a variety of stains produced by organic matter.

Ruscha represented the United States at the Venice Biennale in 2005. His works are in the collections of major museums including the Museum of Modern Art, the Los Angeles County Museum of Art, the Hirshhorn Museum, and the National Gallery of Art.

REFERENCES

Auping, Michael, and Richard Prince. *Ed Ruscha: Road Tested.* Berlin, 2011.

Crow, Thomas, and Paul Schimmel. *Ed Ruscha: Industrial Strength.* Philadelphia, 2008.

Schwartz, Alexander. *Ed Ruscha's Los Angeles.* Cambridge, MA, 2010.

Charles Balthazar Julien Févret de Saint-Mémin

Born, Dijon, France, 1770
Died, Dijon, France, 1852

Charles Saint-Mémin was a self-taught printmaker and one of the most accomplished portraitists of early federal America. Born into a French noble family, he was educated at the École Royale Militaire in Paris and in 1788 became a cadet in the Gardes-Française, the palace guard of Louis XVI. Following the Revolution, his family was dispossessed and fled to Switzerland. In 1793 Saint-Mémin and his father left for the French colony of Saint-Domingue (today Haiti). However, during their journey riots had broken out on the island, prompting the Saint-Mémins to head to the United States.

In New York Saint-Mémin found employment engraving architectural designs and plans. Although he had never received artistic training, he proved a prolific engraver and in 1796 formed a business partnership with Thomas Bluget de Valdenuit. The two French émigrés offered profile portraits produced with a physiognotrace, a mechanical device

that allowed for a remarkably accurate tracing of a sitter's profile. The tracings would be worked into finished watercolors or chalk drawings and reproduced in print.

When Valdenuit returned to France in 1797, Saint-Mémin took over the business. After relocating to Burlington, New Jersey, with the arrival of his mother and sister in 1798, Saint-Mémin worked as an itinerant artist making portraits of sitters in Philadelphia, Baltimore, Washington, Richmond, and Charleston. Depicting the profiles of military officers, politicians, and other well-to-do citizens, Saint-Mémin left behind a unique visual record of the social elites of his time. He gave up engraving in 1810, possibly because of eyestrain, and moved to New York. In 1814, following the restoration of the Bourbon monarchy, the family returned to France. In 1817 Saint-Mémin was appointed director of the Dijon Museum, a post he held for the remainder of his life.

REFERENCES

Dexter, Elias. *The St.-Mémin Collection of Portraits Consisting of Seven Hundred and Sixty Medallion Portraits, Principally of Distinguished Americans.* New York, 1862.

Miles, Ellen. *Saint-Mémin and the Neoclassical Profile Portrait in America.* Washington, 1994.

Norfleet, Fillmore. *Saint-Mémin in Virginia: Portraits and Biographies.* Richmond, 1942.

John Singer Sargent

Born, Florence, Italy, 1856
Died, London, England, 1925

John Singer Sargent was born in Italy to American parents who nurtured his artistic talent. Sargent passed the difficult entrance exam for the École des Beaux-Arts in Paris on his first attempt. From 1874 to 1878 he studied with Carolus-Duran, a master who painted directly on canvas without preliminary drawing. Throughout his career Sargent traveled extensively, recording foreign landmarks and producing images of foreign subjects. Among his many journeys was a trip to the United States in 1876 where he saw the Centennial Exhibition in Philadelphia and visited Niagara Falls. He also traveled to Spain in 1879, Belgium and Holland in 1880, Venice in 1881, and the Holy Land in 1905 and 1906. As his career progressed, Sargent moved away from landscape and genre scenes to commissioned portraits, at which he excelled.

First exhibiting in the Paris salons in 1877, his entries were generally well received until *Madame X*, his sensuous portrait of Virginie Gautreau, created a scandal in 1884, precipitating a move to London the following year. Sargent executed several grand mural designs including one done between 1890 and 1919 at the Boston Public Library. During his career Sargent produced only a handful of prints, all of them lithographs. He was introduced to the

process by the master printer Frederic Goulding. All of Sargent's prints relate to the human figure and some have characteristics akin to the draped figures in his contemporaneous Boston Public Library murals. By 1907 the artist essentially gave up painting portraits, as he was able to support himself by painting subjects of his own choosing. In 1918 as a war artist, Sargent witnessed atrocities on the French front that inspired his monumental painting, *Gassed*.

REFERENCES

Fairbrother, Trevor. *John Singer Sargent.* New York, 1994.

Fairbrother, Trevor. *John Singer Sargent, the Sensualist.* New Haven and London, 2000.

Ratcliff, Carter. *John Singer Sargent.* New York, 1982.

John Sartain

Born, 1808, London, England
Died, 1897, Philadelphia, PA

John Sartain was one of nineteenth-century America's best mezzotint engravers. Born in England, Sartain apprenticed with the London engraver John Swaine in 1822, and later studied oil and watercolor painting as well as mezzotint engraving with Henry Richter and John Varley. Although his English printmaking studio was very successful, Sartain and his wife, Susannah Longmate Swaine Sartain, emigrated to the United States in 1830.

Sartain entered Philadelphia's quickly expanding print market with reproductions of portraits after such revered painters as Thomas Sully and John Neagle. Sartain's mastery of various printmaking techniques — particularly mezzotint, a technique not widely used in America — ensured him steady commissions throughout his career. He was awarded a silver medal from the Franklin Institute in Philadelphia in 1838. His success, however, can be attributed not only to his exceptional skill but also to his adaptability. His illustrations of everyday American life published in periodicals and gift books during the 1840s and 1850s were for a broad middle-class audience. Accordingly, they employed a more popular and realistic style than the comparatively expensive mezzotint prints Sartain produced at the same time.

Sartain served in a number of local and national institutions, such as the Pennsylvania Academy of Fine Arts, the Art-Union of Philadelphia, the National Art Association, as well as the American Art-Union. He facilitated public discourse on art through his own magazine, *Sartain's Union Magazine of Literature and Art* (1849–1852), in which he published art criticism and exhibition reviews as well as the work of writers such as Henry Wadsworth Longfellow and Edgar Allan Poe. His writings on art also include an anthology of American artists — *The American Gallery of Art* (1848) — as well as his *Brief Sketch of the History and Practice of Engraving* (1880).

REFERENCES

Martinez, Katharine. "John Sartain (1808–1897): His Contribution to American Printmaking." *Imprint. Journal of the American Historical Print Collectors Society* 8, no. 1 (1983): 1–12.

Martinez, Katharine, and Page Talbott, eds. *Philadelphia's Cultural Landscape. The Sartain Family Legacy.* Philadelphia, 2000.

Sartain, John. *The Reminiscences of a Very Old Man.* New York, 1900.

Edward Savage

Born, Princeton, MA, 1761
Died, Princeton, MA, 1817

Edward Savage was a self-taught artist and proprietor of a paintings gallery and natural history museum. He began his career making portraits after John Singleton Copley in the mid-1780s. Savage painted *The Washington Family* (1789–1796), in the National Gallery's collection. In 1791 Savage traveled to London where he published prints after his portraits of Henry Knox, the first US secretary of war, and President George Washington. Although his painting and engraving technique improved during his stay abroad, his talent never quite matched his ambition.

In 1794 Savage moved to Philadelphia where he worked as a painter, engraver, and print publisher until 1801. He employed two assistants — John Wesley Jarvis and David Edwin — who contributed greatly to the quality of Savage's work during that period. In 1796 he opened his Columbian Gallery where he showed and sold his own paintings and prints, as well as copies and reproductions of works by his contemporaries and forerunners. His gallery, which he reopened in New York City in 1801, was inspired by the ideals of the English physician and scientist Sir Hans Sloane, who upon his death in 1753 bequeathed his collection of sculpture, prints, drawings, and natural history specimens to the English nation, which prompted the creation of the British Museum.

Remaining in New York until 1810, Savage employed as apprentices Charles Bird King and Ethan Allen Greenwood. After a brief stay in Baltimore, he moved to Boston. In 1812 he reopened his gallery, then called the New-York Museum.

REFERENCES

Dresser, Louisa. "Edward Savage, 1761–1817." *Art in America* 40, no. 4 (Autumn 1952): 157–212.

Miles, Ellen G. *American Paintings of the Eighteenth Century.* Washington, 1995.

Richard Serra

Born, San Francisco, CA, 1939

Richard Serra worked in steel mills as a teenager, eventually financing his college education at the University of California, Berkeley and Santa Barbara. He subsequently earned an MFA from Yale University, studying with Josef Albers and winning a Yale Traveling Fellowship and a Fulbright, which allowed him to live in Paris and Florence.

In 1966 Serra moved to New York's Greenwich Village where he made process-based art and explored nontraditional materials like rubber and fiberglass. He began making "prop" pieces — physically imposing steel constructions predicated on balance and equilibrium. Serra's work is characterized by industrial scale and materials as well as a minimalist sensibility. His first solo exhibition was held at the Leo Castelli Warehouse in New York in 1969. The following year he built his first site-specific sculpture in the Bronx, a giant steel semicircle embedded into a street.

Although Serra is known as a sculptor, drawing and printmaking are central to his practice. His first lithographs were published by Gemini G.E.L. in 1972. Since then he has explored materiality, weight, and bodily presence in his prints. After pushing lithography to an extreme size, he turned to silkscreen in the 1980s for a greater density and structuring of black color, and to etching in the 1990s. Serra has worked with Gemini to publish more than 260 editions to date, repeatedly challenging and expanding the formal possibilities of the medium.

Major retrospectives of his work have been organized by the Centre Georges Pompidou, Paris (1983), and the Museum of Modern Art, New York (1986 and 2007). Exhibitions of his prints and drawings have been held at the National Museum of Art, Osaka (1994), the Drawing Center, New York (1994), and the Menil Collection, Houston (2011).

REFERENCES

Berswordt-Wallrabe, Silke von, and Susanne Breidenbach. *Richard Serra: Druckgrafik: Werkverzeichnis 1972–1999.* Düsseldorf, 1999.

McShine, Kynaston, and Lynne Cooke. *Richard Serra Sculpture: Forty Years.* New York, 2007.

Rose, Bernice, Michelle White, and Gary Garrels. *Richard Serra, Drawing: A Retrospective.* Houston, 2011.

Bernarda Bryson Shahn

Born, Athens, OH, 1903
Died, Roosevelt, NJ, 2004

Bernarda Bryson Shahn majored in philosophy, art, and aesthetics at Ohio State University. She later studied printmaking at the Cleveland Institute of Arts and went on to teach etching and lithography at the Columbus Gallery of Fine Arts School. She also wrote art criticism and in 1933 traveled to New York to interview Diego Rivera. There she met and subsequently married the artist Ben Shahn, Rivera's assistant at the time.

Bryson Shahn was committed to the progressive ideals of Franklin Delano Roosevelt's New Deal. She made lithographs for the Public Works of Art Project. In 1935 she and her husband moved to Washington to participate in the Resettlement Administration. They toured the South, creating images of the poor people and desiccated land, as in Bryson Shahn's *Arkansas Sharecroppers* (pl. 98). The figures in her print are based on photographs her husband made. In 1937–1938 Bryson Shahn assisted her husband on a fifty-foot fresco in a public school in Roosevelt, NJ. The following year the couple co-created murals for the Bronx New York Post Office.

Although the couple prioritized Shahn's career, Bryson Shahn's illustrations appeared in *Harper's*, *Fortune*, and *Scientific American*. In the 1960s she wrote and illustrated *The Twenty Miracles of Saint Nicolas* (1960), *The Zoo of Zeus* (1964), and *Gilgamesh: Man's First Story* (1967). After her husband's death she authored a large monograph on his oeuvre, published in 1972. From the 1970s onward Bryson Shahn painted steadily. Her first solo show was held at the Midtown Gallery in New York in 1983. She received the Outstanding Achievement in the Visual Arts Award from the Women's Caucus for Art in 1989.

REFERENCES

Fox, Margalit. "Bernarda Bryson Shahn, Painter, Dies at 101." *New York Times*, December 16, 2004. http://www.nytimes.com/2004/12/16/arts/bernarda-bryson-shahn-painter-dies-at-101.html (accessed September 2, 2015).

Seaton, Elizabeth. *Paths to the Press: Printmaking and American Women Artists, 1910–1960.* Manhattan, KS, 2006.

Wien, Jake Milgram. *The Vanishing American Frontier: Bernarda Bryson Shahn and Her Historical Lithographs Created for the Resettlement Administration of FDR.* New York, 1995.

Charles Sheeler

Born, Philadelphia, PA, 1883
Died, Dobbs Ferry, NY, 1965

Charles Sheeler studied at the School of Industrial Art in Philadelphia and later under William Merritt Chase at the Pennsylvania Academy of the Fine Arts. He moved to Doylestown, Pennsylvania, in 1910, where he developed his skills as a photographer by recording local architecture and the elemental forms of his own studio.

Although he continued to paint, exhibiting work in the 1913 Armory Show, Sheeler supported himself as a commercial photographer, eventually relocating to New York City in 1919. The following year he collaborated with photographer Paul Strand on a film project, *Manhatta,* which distilled dynamic abstraction from images of skyscrapers and city environs. In 1927–1928 he documented the innovative Ford Motor Company plant in River Rouge, Michigan, a project that stimulated new work in a variety of media.

The artist's collection of traditional American design also stirred his creative vision. Sheeler found a modernist aesthetic in the simplicity and functionality of forms. When precisely rendered in Sheeler's compositions, the geometric planes of Shaker furniture, textiles, or architecture suggest cubism. His work came to be associated with precisionism, an emphasis on simple shapes and underlying geometric structures. With representation by Edith Halpert at the Downtown Gallery in 1931, Sheeler's career gained momentum; he had a solo exhibition at the Museum of Modern Art in 1939. Between 1942 and 1945 he worked as a senior research fellow in photography for the Metropolitan Museum of Art, recording objects in the museum's collection. Not a prolific printmaker, the artist created only six lithographs and one screenprint over the course of his career. A stroke ended his art-making in 1959 and another stroke took his life in 1965.

REFERENCES

Brock, Charles. *Charles Sheeler: Across Media.* Washington, 2006.

Bryce, Kristy, and Carol Troyen. *Charles Sheeler Prints: A Catalogue Raisonné.* New York, 2008.

Troyen, Carol, and Erica E. Hirshler. *Charles Sheeler: Paintings and Drawings.* Boston, 1987.

John Simon

Born, Normandy, France, 1675
Died, London, England, 1751

Born into a family of artists, John Simon was trained as an engraver in Paris. After completing his formal training, Simon moved to London. While there is no evidence as to why he left France, he seems to have been one of many Huguenots who faced persecution for their Calvinist beliefs.

Arriving in London around 1700 Simon learned how to make mezzotints. The large number he produced during the first decade of the eighteenth century suggests that he mastered this new technique quickly. Among these early works were prints after paintings by Sir Godfrey Kneller. The collaboration with Kneller, a leading portraitist of the time, doubtless gained Simon broad recognition.

Simon's *Four Indian Kings*, a group of four mezzotints after paintings by the portraitist John Verelst (pls. 1–4), circulated widely. The work depicts four Native Americans who came to London in 1710 as part of an envoy of colonists seeking

Queen Anne's support for a military campaign against the French and their allies. While the original paintings were hung in Kensington Palace, Simon's prints were disseminated throughout Great Britain and the North American colonies.

His partnership with Verelst and his association with Kneller indicate that by the end of the 1710s Simon was a successful printmaker. Until around 1720 Simon worked for print publishers such as Edward Cooper, engraving mezzotint plates after paintings by the most prominent portraitists in London. After 1720 Simon designed original compositions including portraits and religious and mythological subjects, publishing them as mezzotint prints. Notable examples are portraits on six plates of *The Poets and Philosophers of England* (c. 1727) and a depiction of *The Judgment of Paris*.

REFERENCES

Muller, Kevin. "From Palace to Longhouse: Portraits of the Four Indian Kings in a Transatlantic Context." *American Art* 22, no. 3 (Fall 2008): 26–49.

Smith, John Chaloner. *British Mezzotint Portraits.* Vol. II. London, 1884.

David Alfaro Siqueiros

Born, Chihuahua, Mexico, 1896
Died, Cuernavaca, Mexico, 1974

Mexican muralist David Alfaro Siqueiros's career was characterized by his activism, artistically and politically. Born into an educated family, Siqueiros enrolled at the Academia de San Carlos to study architecture, painting, and drawing. At age eighteen he joined the revolutionary army opposed to Mexican President Huerta and later became a member of the communist party. He was sent to Paris as both a military attaché and an artist on scholarship in 1919. Returning to Mexico in 1922, he worked with other artists to establish an official national mural program to present Mexican history. He was editor of the artist's union newspaper, *El Machete*, dedicated to art as an agent of social change. His manifesto declaring the irrelevance of easel painting appeared in its pages.

A high-profile communist party leader, Siqueiros's art reflected his Marxist ideology for which he would be jailed and exiled from Mexico. As a result, his painting and printmaking was intermittent. During the early 1930s he made several trips to New York where he was encouraged by Carl Zigrosser of Weyhe Gallery to make lithographs for the North American market. He produced an offset photolithograph while in exile and teaching at Chouinard Art Institute in Los Angeles. When he returned to Mexico from Chile and Cuba in the mid-1940s, he produced a group of lithographs at Taller de Gráfica Popular.

In 1935 he established the Siqueiros Experimental Workshop in New York, attracting young artists (mostly employed by the Works Progress Administration) to explore the use of synthetic paints and new techniques in the creation of politically charged paintings. During the years following World War II and throughout the 1950s, Siqueiros painted several of his best known murals, which are in the Palacio de Bellas Artes in Mexico City.

REFERENCES

Ittmann, John. "David Alfaro Siqueiros." In *Mexico and Modern Printmaking: A Revolution in the Graphic Arts, 1920 to 1950.* Philadelphia, 2006.

Siqueiros, David Alfaro. *Portrait of a Decade: 1930–1940.* Mexico City, 1997.

John Sloan

Born, Lock Haven, PA, 1871
Died, Hanover, NH, 1951

John Sloan left high school at sixteen in order to support his family. He taught himself to etch while working at a bookstore that sold fine prints. In 1892 he became a sketch artist for *The Philadelphia Inquirer*. For brief periods he took classes at the Pennsylvania Academy of Fine Arts. In 1904 he moved to New York where he made contact with artists such as William Glackens, Robert Henri, George Luks, and Everett Shinn. They would later exhibit together as The Eight. Seeking to capture the grit of urban life in a realistic style, they eschewed modernist abstraction and aestheticism. Some members of this group (along with other artists) became known as the Ashcan School.

Sloan continued to support himself as a newspaper and book illustrator. He simultaneously participated in and helped organize many groundbreaking exhibitions, including the 1913 Armory Show. A passion for social reform led him to join the Socialist Party. In 1912 he became an art editor for the leftist magazine *The Masses*, creating illustrations and commissioning work from colleagues. However, he came to doubt the course of the party, leaving both the organization and the magazine in 1916. That same year he began a teaching career at the Art Students League that would last until 1938.

Sloan spent summers away from Manhattan, generating new color palettes and subjects including landscapes and nudes. From 1914 to 1918 he summered in Gloucester, Massachusetts, and from 1919 to 1950, with only one exception, he summered in Santa Fe, New Mexico. Etching remained Sloan's essential printmaking medium: he created over three hundred editions in his lifetime. In 1936 the Whitney Museum showed one hundred of his etchings, and in 1952 held a major retrospective of his work.

REFERENCES

Brooks, Van Wyck. *John Sloan: A Painter's Life.* New York, 1955.

Morse, Peter. *John Sloan's Prints: A Catalogue Raisonné of the Etchings, Lithographs and Posters.* New Haven and London, 1969.

Scott, David W., and E. John Bullard. *John Sloan 1871–1951: His Life and Paintings His Graphics.* Washington, 1971.

David Smith

Born, Decatur, IL, 1906
Died, South Shaftsbury, VT, 1965

David Smith grew up in the Midwest, attending Ohio University for one year before taking a job in 1925 assembling automobile frames at a plant in South Bend, Indiana, where he acquired industrial metalworking experience. After brief stints at the University of Notre Dame and George Washington University, Smith moved to New York in 1926 where he met his future wife, Dorothy Dehner, who encouraged him to enroll at the Art Students League. There Smith focused on drawing and painting, and also executed his first prints: woodcuts and linocuts.

In 1930 he encountered images of metal sculptures by Pablo Picasso and Julio González and realized the potential for applying his metalworking skills to art. In 1933 he made his first welded steel sculptures, possibly the first in America. Smith and Dehner relocated fulltime to their summer studio, Terminal Iron Works, at Bolton Landing in upstate New York in 1940. In his early work Smith combined abstraction with surrealist figuration. His etchings produced between 1933 and 1946 extended this inquiry.

As sculpture came to dominate the artist's oeuvre, his compositions generally grew more abstract. His drawings followed suit, becoming vitally concerned with the physical movements of their making. Smith's lithographs from 1952 to 1954 echoed the painterly fluidity of his brush-and-ink drawings of the period. Among his late career highlights were a retrospective at the Museum of Modern Art in 1957 and representation at the Venice Biennale in 1958. At a 1962 festival in Spoleto, Italy, Smith appropriated materials found in abandoned factories to produce twenty-seven large sculptures in thirty days. At age fifty-nine Smith died in an automobile accident.

REFERENCES

Acton, David. *The Stamp of Impulse: Abstract Expressionist Prints.* Worcester, MA, 2001.

Cummings, Paul. *David Smith, the Drawings.* New York, 1987.

Merkert, Jorn. *David Smith, Sculpture and Drawings.* Munich, 1986.

Kiki Smith

Born, Nuremberg, Germany, 1954

As a young girl in New Jersey, Chiara Lanier Smith, known as Kiki, grew up helping her father, sculptor Tony Smith, make cardboard models. After briefly studying at Hartford Art School, she moved to New York in 1976 and began working with the artists group Collaborative Projects, Inc. (Colab). Smith renders the human body in materials such as glass, fabric, ceramic, and paper, exploring the physiology and psychology of corporeal forms.

Smith's experimentation with printmaking began early in her career: she made monotypes on a friend's press, screenprinted t-shirts and scarves for Colab, produced political posters, and made exhibition announcements for her first solo exhibition at The Kitchen in 1982. To make up for the lack of formal art training, she took etching courses at the Lower East Side Printshop and Robert Blackburn's Printmaking Workshop in the late 1970s and mid-1980s. Her first solo exhibition in Europe, presented at Centre d'Art Contemporain in Geneva, included printed artworks. Smith has worked with many publishers, beginning with Universal Limited Art Editions in 1989. In 1997 she established her own imprint, Thirteen Moons. Drawn to experimental and collaborative processes, Smith has had many university residencies and intermittent teaching positions. She has completed more than 150 published prints and books in diverse formats, including screenprinted tattoos and rubber stamps.

Smith had major solo exhibitions at the Louisiana Museum of Modern Art in Denmark (1994), Whitechapel Art Gallery in London (1995), Montreal Museum of Fine Arts (1996), and the Walker Art Center (2006). A retrospective of her prints and multiples was presented at the Museum of Modern Art, New York (2003). She received the 2012 National Medal of Arts.

REFERENCES

Engberg, Siri. *Kiki Smith: A Gathering, 1980–2005.* Minneapolis, 2005.

Posner, Helaine. *Kiki Smith.* New York, 2005.

Weitman, Wendy. *Kiki Smith: Prints, Books & Things.* New York, 2003.

Benton Murdoch Spruance

Born, Philadelphia, PA, 1904
Died, Philadelphia, PA, 1967

Encouraged by his stepfather to pursue a practical profession, Spruance studied architecture at the University of Pennsylvania in 1923. He took evening drawing and etching courses at the Graphic Sketch Club and by 1925 was set on an art career, enrolling at the Pennsylvania Academy of the Fine Arts (PAFA) on a partial scholarship. Spruance earned two Cresson Traveling Scholarships at PAFA,

enabling him in 1928 and 1930 to travel to Paris where he studied painting with André Lhote and was introduced to lithography at Edmond Desjobert's atelier.

Beginning in the late 1930s Spruance executed several mural commissions. His art often featured literary, religious, and mythological themes. He experimented with woodcut and monotype but remains best known for his lithographs, having produced over five hundred editions. Spruance advanced his technical knowledge with master lithographer Theodore Cuno, who printed Spruance's lithographs for two decades.

Spruance began teaching at Beaver College in 1926, becoming head of the art department in 1933. In 1934 he took a second teaching position at the Philadelphia Museum School. In 1951 Spruance began printing his own lithographs, first at the Philadelphia Museum School and then on the press he purchased in 1953. Through his influential teaching career and his innovations in color lithographic printing — including a reduction method he devised for printing multiple colors from a single stone — Spruance contributed to the medium's revival in the 1950s and 1960s.

In 1948 he was elected to the National Academy of Design. His numerous awards and honors include two Guggenheim fellowships (1950, 1962) and the Philadelphia Art Alliance Medal of Achievement (1965). He was an influential figure in the Philadelphia arts community, taking leadership roles in many organizations, including the Philadelphia Print Club and the Philadelphia Art Commission.

REFERENCES:

Abernethy, Lloyd M. *Benton Spruance: The Artist and the Man.* Philadelphia, London, and Toronto, 1988.

Fine, Ruth E., and Robert F. Looney. *The Prints of Benton Murdoch Spruance: a Catalogue Raisonné.* Philadelphia, 1986.

Philadelphia College of Art. *Benton Spruance: Lithographs 1932–1967.* Philadelphia, 1967.

Wayne Thiebaud

Born, Mesa, AZ, 1920

Thiebaud began drawing in high school, creating movie house posters and signs. During the summers of 1936 and 1937 he was an animator at Disney Studios and took commercial art classes. After high school he worked as a cartoonist and an illustrator before serving as an artist in the US military (1942–1945). Thiebaud earned his BA (1951) and MA (1953) at California State College, Sacramento. He taught at Sacramento Junior College where he became chair of the art department in 1954, developing courses in film and television production and commercial art. In 1960 he began teaching at the University of California, Davis, where he is now professor emeritus.

In the 1950s Thiebaud's painting combined the tactile surfaces of abstract expressionism with the figuration that was popular among Bay Area artists. He is often associated with pop art, but Thiebaud's selection of everyday subjects — cakes, lipsticks, shoes, and more — was not driven by a concern for slick mass-media representations.

Thiebaud explored screenprinting and lithography in the 1950s. His interest in printmaking and film production came together in 1954 when he founded Patrician Films and produced *Color on a Stone* (1955), a documentary on lithography. In 1963 Kathan Brown invited him to Crown Point Press, beginning an extended collaborative relationship. He later made prints at Gemini G.E.L., Los Angeles, and the Shi-un-do Print Shop, Kyoto, Japan, among other workshops. His subjects range from gumball machines to the streets of San Francisco.

Thiebaud's prints have been exhibited since the 1950s, with solo exhibitions organized by the Whitney Museum of American Art (1971) and the Fine Arts Museums of San Francisco (1991). His paintings have been the subject of several major retrospectives, and his many honors include the National Medal of Arts in 1994.

REFERENCES

Berkson, Bill, and Robert Flynn Johnson. *Vision and Revision: Hand-Colored Prints by Wayne Thiebaud.* San Francisco, 1991.

Thiebaud, Wayne. *Wayne Thiebaud: Graphics, 1964–1971.* New York, 1971.

Sylvia Wald

Born, Philadelphia, PA, 1915
Died, New York, NY, 2011

Sylvia Wald was a versatile artist best known for her experimental prints. She also worked in painting and sculpture. Her first solo exhibition was held in 1939 and her initial screenprints appeared one year later. In 1941 Wald joined the Silk Screen Group, which included progressive artist Ben Shahn among its members. She was also a member of the National Association of Women Artists. Wald's early prints are figurative; they often depict Americans whose lives were affected by the Depression.

In 1942 Wald married and later moved to Manhattan. Like many artists working in New York at the time, she was influenced by surrealism and began to experiment with biomorphic abstraction. The artist always attempted to avoid the appearance of mechanical reproduction in her works. In *Between Dimensions* (pl. 111) she deftly combined colors and capitalized on the range of textures and levels of transparency available in screenprinting. Wald enjoyed particular success in the 1950s. Her prints were acquired by the Museum of Modern Art, the Whitney Museum of Art, and the Metropolitan Museum of Art.

Following her husband's death in 1963 Wald traveled abroad for the first time. After returning to the United States she increasingly devoted herself to sculpture. An exhibition of her sculptural works was held at New York's Aaron Berman Gallery in 1981. In 1993 Hirschl and Adler Galleries organized an exhibition of her prints. From 2005 until her death Wald ran the Sylvia Wald and Po Kim Art Gallery in New York with the artist Po Kim, her second husband. A retrospective exhibition of her work, *Sylvia Wald: Seven Decades,* was held at Fairfield University's Thomas J. Walsh Gallery in 2012.

REFERENCES

Acton, David. *Sylvia Wald: Abstract Expressionist Works on Paper.* New York, 1993.

Jessup, Sally. "Sylvia Wald." *Arts* 55, no. 7 (March 1981): 19.

Yi, Hyewon. "A Gentle Giant: Po Kim (1917–2014)." *Art Critical.* February 21, 2014. http://www.artcritical.com/2014/02/21/a-gentle-giant-po-kim-1917–2014/ (accessed August 31, 2015).

Charles A. Walker

Born, Loudon, NH, 1848
Died, Brookline, MA, 1920

Charles Alvah Walker was a painter, engraver, and etcher, as well as an art collector and dealer. He worked for a time at the Peabody Academy of Science (now the Peabody Essex Museum). In the late 1870s he set up a studio in Chelsea, Massachusetts, reproducing portraits and landscape paintings in print. Beginning in 1880 he regularly showed prints and oil paintings at the Spring Exhibition of the Boston Art Club, serving as the club's vice president for two years. Stylistically Walker's paintings and prints were informed by the atmospheric landscapes of the Barbizon school: for example by Charles-François Daubigny, whose work Walker reproduced in print early in his career and for which he received an honorable mention at the Paris Salon.

In 1881 Walker presented an exhibition of one hundred prints in a technique he called monotype and which he claimed, falsely, to have invented. He is credited, however, with coining its name, which encapsulates the inherent paradox of a medium that is both a print and a unique work of art. Coinciding with the etching revival in America, the monotype thus marks a transition in the late nineteenth century from printmaking as a largely interpretative medium to an artistic creation in its own right.

Having exhibited his works nationally and internationally, Walker became a collector and art dealer during the latter half of his career, advising collectors such as the famous actor and amateur artist Joseph Jefferson. Walker's own collection comprised paintings by European and American masters including Jean-François Millet, Sir Godfrey Kneller, Eugène Delacroix, William Morris Hunt, and John Singer Sargent.

REFERENCES

Esposito Hayter, Carla. *The Monotype. The History of a Pictorial Art.* Milan, 2007.

The Metropolitan Museum of Art. *The Painterly Print. Monotypes from the Seventeenth to the Twentieth Century.* New York, 1980.

Moser, Joann. *Singular Impressions. The Monotype in America.* Washington and London, 1997.

Kara Walker

Born, Stockton, CA, 1969

Kara Walker moved to Stone Mountain, Georgia, at the age of thirteen when her father, a painter, took a teaching position at Georgia State University. Walker earned her BFA at Atlanta College of Art (1991) and her MFA in painting and printmaking at the Rhode Island School of Design (1994), where her art increasingly confronted issues of race and gender. Invoking taboos and stereotypes, her art is provocative and controversial while also staying attuned to line, form, negative and positive space, pacing, and balance.

Paper is central to Walker's artistic practice. Her oeuvre is dominated by drawings, watercolors, and her signature cut-paper silhouettes, first shown in a fifty-foot installation at the Drawing Center in New York in 1995. She has also produced text-based works, sculpture, film, video, and light projections.

Walker executed her first print edition, an etching, with master printer Jack Lemon at Landfall Press in 1995. She later returned to Landfall to make etchings and linoleum cuts. In 2000 she worked with printer Maurice Sanchez at Derrière L'Etoile Studio, New York, to produce a linoleum cut commissioned by Parkett, the Zurich-based contemporary art publication. She has since worked in photogravure, lithography, and screenprint.

Walker became one of the youngest conferees of the John D. and Catherine T. MacArthur Foundation award in 1997. She represented the United States at the São Paulo Biennial in 2002. The Walker Art Center, Minneapolis, organized the first major survey of her work in 2007. In 2012 she was elected to the American Academy of Arts and Letters. Walker lives and works in New York.

REFERENCES

DiTillio, Jessi. "Emancipating the Past: Kara Walker's Tales of Slavery and Power." University of Oregon, Jordon Schnitzer Museum of Art. January 25, 2014. http://jsma.uoregon.edu/sites/jsma1.uoregon.edu/files/Emancipating the Past.pdf (accessed April 14, 2015).

Shaw, Gwendolyn Dubois. *Seeing the Unspeakable: The Art of Kara Walker.* Durham and London, 2004.

Vergne, Philippe. *Kara Walker: My Complement, My Enemy, My Oppressor, My Love.* Minneapolis, 2007.

William Guy Wall

Born, Dublin, Ireland, 1792
Died, Dublin, Ireland, 1864 or after

William Guy Wall was an Irish artist who trained in Britain before emigrating to New York City in 1818. Wall was among a number of artists from the British Isles who worked in the mode of the American Hudson River School. Indeed, he depicted some of the same locations as the American artist Thomas Cole. In addition to specializing in landscape, Wall created background designs for silhouettes by William James Hubard.

When working in watercolor Wall used a series of washes to build up his views of the natural world. He then added darker sections and details. Wall often painted initial sketches and studies *en plein air*. Between 1820 and 1825 he produced a series of watercolors depicting views of the Hudson River Valley, for which he gained particular recognition. A portfolio of aquatints after Wall's paintings was issued in 1821. A second set of prints made after his watercolors was published in 1825; it was so popular that it was reissued in 1828. Beginning in 1826 he regularly showed his work in the exhibitions of the National Academy of Design. Recognizing Wall's prowess in depicting the American landscape, Thomas Jefferson invited the artist to become an instructor at his college in Charlottesville (now the University of Virginia). Wall declined and continued working in New York. In 1827 he created one of his most significant paintings, *Cauterskill Falls on the Catskill Mountains, taken from under the Cavern,* which received great critical acclaim.

Wall remained in the United States until 1836. His landscape paintings of the late twenties and thirties commanded high prices. He returned to North America in 1856 and spent an additional six years in this country before finally returning to his native Ireland.

REFERENCES

Howat, John K. "A Picturesque Site in the Catskills: The Kaaterskill Falls as Painted by William Guy Wall." *Honolulu Academy of Arts Journal* 1 (1974): 16–29.

Shelley, Donald. "William Guy Wall and His Watercolors for the Historic *Hudson River Portfolio.*" *The New-York Historical Society Quarterly* 31, no. 1 (January 1947): 25–45.

Andy Warhol

Born, Pittsburgh, PA, 1928
Died, New York, NY, 1987

Andy Warhol (born Andrew Warhola), the child of immigrants from present-day Slovakia, grew up in Pittsburgh. Often ill, he spent bedridden days listening to the radio and reading comics. From 1945 to 1949 he studied commercial art at the Carnegie Institute of Technology. After graduating he moved

to New York City where he designed window displays and worked as an illustrator, winning prizes for his faux-naïf advertisement drawings.

In the early sixties Warhol transitioned to fine art, quickly becoming one of pop art's leading figures. His 1962 exhibition of *Campbell's Soup Cans* at the Sidney Janis Gallery launched his career. Merging "high" and "low" culture as well as painting and printmaking, he created thirty-two silkscreened canvases, each depicting a can of a different flavor of soup. Warhol repeatedly worked with screenprinting throughout his career. The medium, which had been used primarily for commercial purposes until the mid-twentieth century, allowed him to achieve machine-like repetition and remove clear traces of the artist's hand from the work. The name of Warhol's studio, The Factory, further underscores his interest in approaching automation.

Warhol made numerous films and took an immense number of photographs. In many ways he was a modern-day court painter, creating portraits of celebrities and wealthy socialites. He documented and maintained his high-profile social circle that included the designer Halston, the model Nico, and film icons like Liza Minnelli and Natalie Wood. Warhol could regularly be found at Manhattan's trendiest locales such as Max's Kansas City and Studio 54. His sudden death in 1987 due to postoperative complications shocked the world. His obsession with stardom, his concern with the everyday, and his creative prowess helped convert Warhol into a celebrity and a kind of artistic brand.

REFERENCES

Bockris, Victor. *Warhol: The Biography*. London, 1989.

Danto, Arthur C. *Andy Warhol (Icons of America)*. New Haven, 2009.

Warhol, Andy. *The Andy Warhol Diaries*. New York, 1989.

Max Weber

Born, Bialystok, Russia (now Poland), 1881
Died, Great Neck, NY, 1961

At age ten, Max Weber emigrated with his family from Russia to the United States. He studied with Arthur Wesley Dow at the Pratt Institute in Brooklyn and later taught art in Lynchburg, Virginia, and Duluth, Minnesota. In 1905 Weber traveled to Europe where he met Pablo Picasso, attended Gertrude Stein's salon, befriended Henri Rousseau, and studied with Henri Matisse. After seeing the bold inventive color of the fauves and the multiple, simultaneous viewpoints of the cubists, Weber returned home in 1909 to forge these and other influences into a personal vision. In doing so, he became one of the first to carry the tenets of modernism to the United States.

Weber exhibited briefly with Alfred Stieglitz at his 291 gallery. In 1913 the Newark Museum hosted a show of Weber's work, considered to be the first solo exhibition by a modernist artist in an American museum. That same year the artist refused to participate in the landmark Armory Show, disagreeing with its organizers about how many of his works would be included. From 1914 to 1918 Weber taught at the Clarence H. White School of Photography and during the 1920s at the Art Students League. Small relief prints that Weber produced in the winter of 1919–1920 highlight figures strongly influenced by African art. The designs were often cut into panels from disassembled basswood boxes, then uniquely inked and hand-printed with touches of color. Alfred H. Barr Jr., the first director of the Museum of Modern Art, New York, promoted Weber's work, giving him a retrospective at the museum in 1930. By the 1940s Weber was considered among America's most prominent artists, celebrated in shows at major institutions, his works featured in key collections. Weber's later work leaned toward lyrical figuration rather than modernist revolt.

REFERENCES

Rubenstein, Daryl R. *Max Weber, a Catalogue Raisonné of His Graphic Work*. Chicago, 1980.

Weber, Max. 1881–1961, Memorial Exhibition: Paintings, Drawings, Sculpture. New York, 1962.

Whitney, Catherine, and Percy North. *Models & Muses: Max Weber and the Figure*. Tulsa, 2012.

James Lesesne Wells

Born, Atlanta, GA, 1902
Died, Washington, DC, 1993

Wells was a printmaker known particularly for wood engravings and linocuts. His work explores African American life and working-class experience, encompassing biblical and social themes. After high school Wells moved to New York City where he studied with George Laurence Nelson at the National Academy of Design. In 1922 he was awarded a scholarship at Lincoln University in Oxford, Pennsylvania, but returned to Manhattan to complete his undergraduate education at Columbia University, later earning his graduate degree there.

With his first printmaking course at Columbia, Wells became committed to the medium. His encounter with African art in a 1923 exhibition at the Brooklyn Museum shaped his artistic sensibility. His earliest professional work included block-print illustrations for periodicals such as *The Dial, New Masses,* and *Opportunity*, and Willis Richardson's anthology *Plays and Pageants from the Life of the Negro* (1930). His prints exhibited in New York received positive reviews.

In 1929 Wells accepted a position at Howard University where he established the graphic arts department and was an influential teacher for over

30 years. While on sabbatical Wells advanced his etching, lithography, and copper-engraving skills, working in New York with political cartoonist Frank A. Nankivell (1936–1937) and at Atelier 17 (1947–1948). After Wells retired in 1968, his travel to West Africa inspired him to produce color linoleum cuts.

The Smithsonian Institution organized a solo exhibition of Wells's prints in 1961. In 1986 the Washington Project for the Arts mounted a major exhibition of his work that traveled to the Studio Museum in Harlem. Wells won numerous awards including the 1930 Harmon Foundation award in fine arts. He was honored by President Carter at the White House in 1980.

REFERENCES

Bearden, Romare, and Harry Henderson. *A History of African-American Artists from 1792 to the Present*. New York, 1993.

Powell, Richard, and Jock Reynolds. *James Lesesne Wells: Sixty Years in Art*. Washington, 1986.

Powell, Richard J. "Talking to James Lesesne Wells." *Print Review* 9 (1979): 65–75.

Benjamin West

Born, Springfield, PA, 1738
Died, London, England, 1820

Benjamin West was arguably the most important American painter of the late eighteenth century. Born to a Quaker family, West received only limited schooling as a child. In 1757 he moved to Philadelphia where he received a classical education from his patron, Rev. William Smith, and quickly established himself as a portrait painter.

In 1760 West departed for Italy to complete his artistic training, studying antiquities and Old Master paintings. En route back to America in 1763, he visited London where he was celebrated as the "American Raphael." After a successful debut at the Society of Artists he decided to stay in England. He quickly emerged as one of the leading figures of the art world, receiving both private and royal commissions. Although West's oeuvre comprised a wide variety of subject matter — history, portrait, genre, and landscape — it was paintings such as *The Death of General Wolfe* (1770) and *Penn's Treaty with the Indians* (1771–1772) that cemented his reputation as a virtuoso history painter. In 1772 West was appointed history painter to the king, and in 1791 took the post of surveyor of the king's pictures. At the height of his career in 1792 West was elected president of the Royal Academy, an institution he had helped found in 1768.

Although he spent his professional life exclusively in England, West wielded major influence over the development of American painting. Because he trained many of America's most revered

painters — Charles Willson Peale, Gilbert Stuart, and John Trumbull, among others — his style and choice of subject matter helped shape the young nation's artistic production.

REFERENCES

Ballew Neff, Emily, and Kaylin H. Weber, eds. *American Adversaries: West and Copley in a Transatlantic World.* Houston, 2013.

Peters Corbett, David, and Sarah Monks, eds. *Anglo-American: Artistic Exchange between Britain and the USA.* Chichester, UK, and Malden, MA, 2012.

Tobin, Beth Fowkes. *Picturing Imperial Power: Colonial Subjects in Eighteenth-Century British Painting.* Durham, 1999.

James McNeill Whistler

Born, Lowell, MA, 1834
Died, London, England, 1903

James McNeill Whistler spent his childhood in St. Petersburg, Russia, and as an adult moved between London and Paris. His aesthetic influences were diverse, and his work resists categorization by national school or dominant style.

Whistler's mature practice is now described as "aestheticism," characterized by a reduced importance of subject matter in favor of a focus on form and beauty. Aesthetes looked to music as an example of an art form that was minimally concerned with subject matter. The titles of many of Whistler's works from the period allude to music, containing words such as "nocturne," "arrangement," "harmony," and "symphony."

Although the general public is perhaps most familiar with Whistler's paintings, particularly his depiction of his mother, *Arrangement in Grey and Black, No. 1* (1871), he was also a revered printmaker. Whistler first developed his skills as an etcher while a student at West Point and when creating topographical etchings for the United States Coast Survey. He began seriously to pursue the technique in the late 1870s. Indeed, his etchings were accepted by the Paris Salon before any of his paintings. Critics even compared Whistler to Rembrandt for his skill and creativity in the medium.

Whistler was enormously influential as a printmaker, and for half a century his etchings and lithographs set the standard for what an artistic print should be. For an American who departed for Europe at age twenty-one never to return to his homeland, his prints were considered *de rigeur* for American print collectors well into the twentieth century. Over the course of his life, he created 450 etchings and around 170 lithographs. Printmaking is an integral part of Whistler's legacy as one of the major artists of the nineteenth century.

REFERENCES

Dorment, Richard, and Margaret Macdonald, eds. *Whistler.* London, 1994.

Levy, Mervyn. *Whistler: Lithographs.* London, 1975.

MacDonald, Margaret F., et al. *James McNeill Whistler: The Etchings, a catalogue raisonné.* Glasgow, 2012. http://etchings.arts.gla.ac.uk/catalogue/ (accessed November 19, 2015).

Charles White

Born, Chicago, IL, 1918
Died, Los Angeles, CA, 1979

Raised on Chicago's South Side, Charles White developed an interest in art at an early age. He joined the Arts and Crafts Guild where he met the writers Richard Wright and Gwendolyn Brooks. He made his first lithographs while attending the School at the Art Institute of Chicago on scholarship, graduating in 1938. Determined to use art to uplift African Americans, he joined the Works Progress Administration, completing his first public mural in 1940.

In 1941 three of his works were included in *Exhibition of American Negro Art* at the Library of Congress. That same year White married Elizabeth Catlett; they moved briefly to New Orleans, experiencing the Jim Crow-era South firsthand. Consecutive Rosenwald Fellowships allowed White to travel throughout the South making sketches for his mural *The Contribution of the Negro to American Democracy* at Hampton University in Virginia and to study at the Art Students League in New York with Harry Sternberg, a leading printmaking instructor. The Whites moved to New York where they were part of an intellectual circle that included Langston Hughes, Duke Ellington, and W.E.B. Du Bois. By the mid-1940s White's drawings were appearing in progressive publications such as the *Daily Worker* and *Masses & Mainstream.*

In 1946 White was invited to work at the Taller de Gráfica Popular in Mexico. There he met muralists Diego Rivera and David Alfaro Siqueiros. White and Catlett divorced and he returned to New York with a renewed drive to make his work accessible to the masses. The New York Graphic Workshop published a portfolio of his prints, and American Contemporary Art Gallery in New York gave White his first solo exhibition (1947). White taught at Otis Art Institute from 1965 until his death, inspiring a generation of young black artists.

REFERENCES

Barnwell, Andrea. *Charles White.* San Francisco, 2002.

Belafonte, Harry, James A. Porter, and Benjamin Horowitz. *Images of Dignity: the Drawings of Charles White.* Los Angles, 1967.

Clothier, Peter. *Images of Dignity: A Retrospective of the Work of Charles White.* New York, 1982.

Henry Wolf

Born, Eckwersheim, Alsace, France, 1852
Died, New York, NY, 1916

As a youth Henry Wolf was interested in drawing and mechanical engineering. At age fourteen he moved to Strasbourg, entering an apprenticeship in a machine builder's shop. He met Strasbourg's distinguished wood engraver, Jacques Levy, and became his student. He also studied drawing with Émile Schweitzer. Disillusioned following the Franco-Prussian War, Wolf moved to America in 1871. He first went to Albany, then to New York City where he attended art classes at Cooper Union. He found employment with engraver Frederick Juengling, a founder of the Society of American Wood Engravers. Within a few years Wolf had established his own reputation as a master wood engraver, even as the technique was gradually being replaced with newly developed photomechanical processes for art reproduction and illustration.

Wolf's engravings were first published in *Scribner's Monthly* in 1877. His wood engravings were included in numerous publications over four decades, but appeared regularly in *Scribner's, Harper's,* and *The Century* magazines. He went on to carve nearly 800 blocks. He was particularly admired for his extraordinarily accomplished reproductions of works by a remarkable list of American painters and illustrators. He also translated the work of European Old Masters. In 1896 Wolf began to engrave original images, with a focus on landscape. At the same time he began to publish limited editions of his prints.

Wolf was a member of the Society of American Wood Engravers, the National Academy of Design, the International Society of Sculptors, Painters, and Gravers (London), and the American Federation of Arts. He was the recipient of numerous honors and awards, including his last, great honor, the Grand Prize in graphics at the Panama-Pacific International Exposition, San Francisco (1915).

REFERENCES

Smith, Ralph Clifton. *Life and Works of Henry Wolf.* Champlain, NY, 1927.

Whittle, George Howes. "Monographs on American Wood Engravers: Henry Wolf." *The Printing Art* 32, no. 2 (October 1918): 93–99.

Wolf, Henry. "Concerning Wood-Engraving." *The Print Collector's Quarterly* 1 (July 1911): 348–359.

Grant Wood

Born, near Anamosa, IA, 1891
Died, Iowa City, IA, 1942

Grant Wood was a key figure in the American regionalist movement that countered European modernism by advancing traditional realism to represent American daily life. Born in rural Iowa, Wood

and his family left the farm when his father died, moving to Cedar Rapids. In 1910 he began art school in Minneapolis where he studied metalsmithing and design. By 1913 he was enrolled at the School of the Art Institute of Chicago. Wood enlisted in the army and designed camouflage between 1917 and 1918. He later taught high school art in Cedar Rapids until 1925. Through the late 1920s he worked on easel paintings, but also embarked on other commissions such as murals for the Montrose Hotel's Iowa Corn Room, a stained glass window for the city of Cedar Rapids, and interior schemes for private residences.

Voyages to Europe in the 1920s greatly influenced Wood. He was particularly taken with Flemish art and impressionism. Like the Flemish paintings he admired, which typically contain meticulous renderings of human subjects, many of Wood's artworks are detailed, witty depictions of the inhabitants of small-town America. Others consist of curving representations of idealized pastoral landscapes. By 1930 his paintings were featured in exhibitions such as the Art Institute of Chicago's Annual, where his now-renowned *American Gothic* (1930) won a bronze medal and was purchased by the museum.

Many other exhibitions and commissions followed. Wood established the Stone City Art Colony in 1932, joined the faculty of University of Iowa in 1934, and was described by *Time* magazine as one of America's leading artists. In 1937 he began making lithographs for Associated American Artists, exploring subjects similar to those of his paintings. He spent his last years in Iowa City where he died of pancreatic cancer at age fifty.

REFERENCES

Corn, Wanda M. *Grant Wood: The Regionalist Vision.* New Haven and London, 1983.

Milosch, Jane C., ed. *Grant Wood's Studio: Birthplace of American Gothic.* Munich, 2005.

Cole Jr., Sylvan. *Grant Wood: The Lithographs. a Catalogue Raisonné,* ed. Susan Teller. New York, 1984.

Richard Caton Woodville

Born, Baltimore, MD, 1825
Died, London, England, 1855

American genre painter Richard Caton Woodville's mature artistic production spanned only about ten years, spent primarily in Europe. His known oeuvre includes about a dozen finished oil paintings.

Woodville's earliest known work is a watercolor, painted when he was eleven. He attended school at St. Mary's College, Baltimore, where he received drawing instruction, but otherwise the specifics of his early art training remain uncertain. While there is no record of other formal training in Baltimore, he likely had the opportunity to study Dutch and Flemish painting in the collection of art patron Robert Gilmore. Woodville briefly studied medicine at the University of Maryland, and sketches made during this period survive in the scrapbook of his friend, Dr. Stedman R. Tilghman.

Woodville's first professional success came in 1845 when one of his oil paintings was included in the annual exhibition at the National Academy of Design and was subsequently purchased. Later that year Woodville traveled to Germany to study at the Düsseldorf Academy. After a year he left the Academy to continue his studies privately with Carl Ferdinand Sohn. Woodville's second wife, Antoinette Schnitzler, was a fellow Sohn student.

Woodville's paintings became well known in the United States due to the patronage of the American Art-Union, a relationship initiated by Woodville's father in 1847 when he brokered the sale of *The Card Players* (1846). This was the first of Woodville's paintings to be purchased for the Union's distribution program. It was also among the Woodville paintings later reproduced as engravings for the Union's popular subscription program.

Woodville died of an accidental morphine overdose in London a few months after his thirtieth birthday.

REFERENCES

Grubar, Francis S. *Richard Caton Woodville: An Early American Genre Painter.* Washington, 1967.

Heyrman, Joy Peterson, ed. *New Eyes on America: The Genius of Richard Caton Woodville.* Baltimore, 2013.

Wolff, Justin. *Richard Caton Woodville: American Painter, Artful Dodger.* New Jersey, 2002.

Glossary

Compiled by Judith Brodie

Prints and print processes fall into four main categories: (1) relief, (2) intaglio, (3) planographic, and (4) stencil. Generally speaking:

(1) Relief prints are printed from the raised surface of a woodblock or linoleum block.

(2) Intaglio prints are printed from the recessed areas of a metal plate.

(3) Planographic prints are printed from the flat surface of a limestone block or aluminum plate.

(4) Stencil prints are printed by forcing ink through a fine mesh onto a substrate below.

AQUATINT: An intaglio process used to produce tonal effects. A metal plate is dusted with powdered rosin and then heated, causing the rosin to melt and adhere to the plate. Areas meant to print without tone are "stopped out," or blocked, with an acid-resistant varnish. When the plate is immersed in a solution of acid, the acid etches the small spaces between the rosin particles. Modern variants of the process include **SOAPGROUND AQUATINT**, **SPITBITE AQUATINT**, and **SUGARLIFT AQUATINT**.

BURIN: A tool used to engrave, or incise, V-shaped furrows into a metal plate (typically copper).

CHINE COLLÉ: A French term meaning "rice paper, glued." Chine collé is a method in which a thin sheet of paper (often Asian) is bonded to a second, heavier sheet. The thin sheet is laid over an inked plate and then brushed with a water-soluble paste. A heavier (and typically larger) sheet is positioned on top. Together the plate and the papers are run through the press. The thinner sheet picks up the printed image, and at the same time, becomes mounted to the thicker one.

CHROMOLITHOGRAPH: A term used to describe abundantly colored lithographs of the mid- to late nineteenth-century, sometimes printed from as many as twenty lithographic stones. A chromolithograph is typically a **REPRODUCTIVE PRINT**.

DIRECT GRAVURE: An intaglio process similar to **PHOTOGRAVURE** but involving the transfer of an image that, instead of being photographically developed, is typically drawn or digitally printed on Mylar. A direct gravure is etched and printed in the same manner as a photogravure.

DRYPOINT: An intaglio process not requiring an acid solution — hence a "dry" process. Lines are drawn or scratched on a metal plate with an etching needle or other sharp-pointed implement. The metal is displaced and raises a "burr" — a rough ridge that captures ink erratically and tends to print as a velvety film shadowing the printed lines. The burr is fragile and tends to wear down quickly under the pressure of printing.

ENGRAVING: An intaglio process, not requiring acid, in which a **BURIN** is used to incise lines in a metal plate (usually copper). The sharpness of the burin's faceted point creates a V-shaped furrow tapering at both ends.

ETCHING: An intaglio process in which an image is etched into a metal plate (usually copper or zinc) using a solution of acid. The plate is typically covered with an acid-resistant ground through which lines or marks are drawn using an etching needle or other implement — exposing the metal beneath. The exposed areas are etched when the plate is immersed in a solution of acid.

HAND-COLORING: A method of manually adding color, often watercolor, to a print after it has been pulled.

IMPRESSION: A single printing from a lithographic stone, metal plate, woodblock, or other material being printed.

INTAGLIO: The term derives from the Italian word *intagliare*, "to incise." Intaglio printmaking is a broad category covering a wide variety of processes: **AQUATINT**, **DRYPOINT**, **ENGRAVING**, **ETCHING**, **MEZZOTINT**, **PHOTOGRAVURE**, **STIPPLE**, among others. In all of these an image is incised or etched in a metal plate (usually copper or zinc), whether by using a pointed tool or by biting the metal with acid. In the intaglio printing process, the plate is inked and its surface is wiped, allowing ink deposits to remain in the incised areas and usually leaving a film, called plate tone, on the surface. Since the ink lies in the recesses, it stands up in relief upon printing.

LINOCUT: Also called linoleum cut. A relief process, essentially the same as that of a **WOODCUT**, in which the image is cut into or carved away from linoleum rather than from wood. A linocut is printed in the same manner as a woodcut.

LITHOGRAPHY: A planographic process based on the fact that grease and water repel each other. An image is executed using a greasy crayon or ink — historically done on a block of Bavarian limestone, later on a zinc plate, and now regularly on an aluminum plate. The stone or plate is kept wet during printing so the greasy ink, applied with a roller, adheres only to those areas previously drawn or painted with the crayon or ink. The inked image is then transferred to paper using a press.

MEZZOTINT: An intaglio process in which a toothed metal instrument, known as a rocker, is used to roughen the surface of a metal plate (usually copper). Areas of the roughened surface are then smoothed using a burnishing tool. Depending on the plate's degree of roughness or burnished smoothness, when inked and printed (traditionally in black), the plate yields tones ranging from white to velvety black.

MONOTYPE: A single print taken from an image created in oil paint or printing ink on a surface of glass or metal. Whatever the surface, the image carries no etched, engraved, or otherwise incised design. A second print can sometimes be taken, although it will be weaker in intensity.

OFFSET LITHOGRAPHY: The process differs from conventional **LITHOGRAPHY** in that the image is first picked up from the surface of an aluminum plate by a rubber roller, which then offsets, or reprints it, onto paper. Offset lithography not only provides speed of production but also prints the image in the left-to-right alignment in which it was drawn, rather than in reverse, as in most printmaking processes (an exception being screenprinting).

PHOTOGRAVURE: An intaglio process in which a photographic image is chemically etched into a metal plate. A photogravure, which reproduces the detail and continuous tones of a photograph, is etched and printed in the same manner as an **ETCHING**.

PLATE: Refers to a metal plate (copper, zinc, or steel) used for **INTAGLIO** printmaking; also called a printing plate.

PHOTOLITHOGRAPHY: A planographic process in which an image is photographically transferred to a plate (usually aluminum) and then printed in the same manner as a conventional lithograph.

PROOF: Preliminary impressions taken before a final edition.

REMARQUE: A sketch etched in the margin of a metal plate, often unrelated to the main composition. The practice began as a means of testing the strength of an acid solution, but in the nineteenth century became a sort of marketing tool — a means of creating a special limited edition bearing the remarque.

REPRODUCTIVE PRINT: A print that reproduces a work created in a different medium.

ROULETTE: A tool with a revolving textured wheel designed to create rows of small dots, lines, or some irregular pattern, traditionally used to imitate chalk or crayon lines. A roulette tool essentially produces texture that will hold ink.

SANDGROUND: Related to **MEZZOTINT**, an intaglio process in which a plate is roughened with sandpaper. The sandpaper is placed face down on a plate. Together the plate and the sandpaper are repeatedly run through a press.

SCREENPRINT: Also called silkscreen or serigraph. A stencil process involving a fine mesh fabric fixed tautly to a rectangular frame. An impermeable stencil design is adhered to the mesh fabric. Once ready for printing, the frame is laid directly on top of a sheet of paper. Ink is spread over the mesh then forced through it with a rubber blade, called a squeegee, onto the paper. The mesh was traditionally made of silk but is now more commonly nylon.

SILK COLLÉ: The same process as **CHINE COLLÉ** but employing a piece of translucent silk instead of Asian paper.

SOAPGROUND AQUATINT: Also called whiteground aquatint. An intaglio process in which an image is brushed onto a metal plate, then processed as an aquatint. When the plate is immersed in acid, the soap holds up imperfectly — the thicker areas tending to resist the acid while the thinner areas break down gradually. The image prints light against a dark background.

SOFTGROUND ETCHING: An intaglio process in which marks of varying texture and weight are created. A metal plate is coated with a soft, acid-resistant wax. A sheet of paper or other textured material is placed on the wax and then drawn on with a pencil or other hard instrument. The pressure of the drawing tool pulls the wax onto the back of the paper, exposing the metal plate. The harder the pressure, the more wax is removed and the darker the mark after etching. Likewise any flat, textured substance — nylon hosiery or a leaf, for example — can be pressed into the wax and lifted away. The plate is immersed in a solution of acid, allowing the areas of exposed metal to be etched into the plate.

SPITBITE AQUATINT: An intaglio process in which an acid solution is hand-applied to a metal plate prepared for aquatint. The process is similar to conventional aquatint, but the plate is not immersed in a solution of acid; instead acid is brushed or dripped onto the metal plate. Spitbite aquatint creates tones of subtle variation. The term refers to the fact that saliva, a weak acid, was used originally to "bite" into the plate.

STEEL ENGRAVING: An engraving done on a steel plate. Because steel is a very hard metal, the engraved lines are relatively shallow and tend to print as a pale, shimmering gray.

STIPPLE: An intaglio process used to produce tone. Innumerable dots are either etched into the metal plate or incised directly using a tool.

STONE: Refers to a lithographic stone, specifically a type of limestone quarried in Bavaria.

SUGARLIFT AQUATINT: An intaglio process in which an image is brushed onto a metal plate using syrup made of sugar and water. The plate is coated with an acid-resistant varnish and then immersed in water. This causes the sugar under the varnish to swell and lift, exposing parts of the metal plate, which then receive an aquatint ground. The plate is etched in the normal manner. The image prints dark against a light background.

TINTED LITHOGRAPH: Refers to a type of nineteenth-century lithograph meant to resemble a wash drawing. A line drawing is printed from a stone while a background tone is printed from one or two stones.

TRANSFER LITHOGRAPH: Instead of creating an image directly on a stone or aluminum plate, the image is done on special soluble paper, which allows for the image's transfer onto the stone or aluminum plate.

WOODCUT: A relief process that involves the cutting of an image into a piece of wood, or woodblock. Areas meant to print negative (blank) are cut away using a knife, chisel, or gouge. Areas meant to print positive are left standing in relief. Ink is daubed or rolled onto the uppermost surface of the woodblock. A sheet of paper is then laid down on the inked block and either rubbed from the back with a smooth surface such as a spoon, or printed using a mechanical press.

WOOD ENGRAVING: A relief process similar to **WOODCUT**, but one involving the incising of an image into the end grain of a piece of wood, usually a hard variety such as boxwood. A wood engraving is printed in relief in the same manner as a woodcut.

REFERENCES

Ash, Nancy, Scott Homolka, and Stephanie Lussier. *Guidelines for Descriptive Terminology for Works of Art on Paper.* Philadelphia, 2014.

Brown, Kathan. *Ink, Paper, Metal, Wood: Painters and Sculptors at Crown Point Press.* San Francisco, 1996.

Gascoigne, Bamber. *How to Identify Prints: A Complete Guide to Manual and Mechanical Processes from Woodcut to Inkjet.* New York, 2004.

Griffiths, Antony. *Prints and Printmaking: An Introduction to the History and Techniques.* London, 1996.

Checklist of Works in the Exhibition

All works in the exhibition are from the collection of the National Gallery of Art, Washington.

Dimensions are listed height by width. Where only one dimension is given, the image and sheet are the same dimension. Catalogue raisonné number and state are listed after the medium, when available.

Colonial Era to the Civil War

John Simon (British, 1675–1751), after John Verelst (British, born Netherlands, c. 1675–1734)

1 *Ho Nee Yeath Taw No Row, King of the Generethgarick*, after 1710
mezzotint
sheet: 40.9 × 25.4 cm (16 ⅛ × 10 in.)
Paul Mellon Fund, 2001.118.41

John Simon (British, 1675–1751), after John Verelst (British, born Netherlands, c. 1675–1734)

2 *Etow Oh Koam, King of the River Nation*, after 1710
mezzotint
sheet: 41.2 × 25.4 cm (16 ¼ × 10 in.)
Paul Mellon Fund, 2001.118.42

John Simon (British, 1675–1751), after John Verelst (British, born Netherlands, c. 1675–1734)

3 *Sa Ga Yeath Qua Pieth Tow, King of the Maquas*, after 1710
mezzotint
sheet: 41 × 25.4 cm (16 ⅛ × 10 in.)
Paul Mellon Fund, 2001.118.43

John Simon (British, 1675–1751), after John Verelst (British, born Netherlands, c. 1675–1734)

4 *Tee Yee Neen Ho Ga Row, Emperour of the Six Nations*, after 1710
mezzotint
sheet: 41.5 × 25.5 cm (16 ⁵⁄₁₆ × 10 ¹⁄₁₆ in.)
Paul Mellon Fund, 2001.118.44

Peter Pelham (American, born England, c. 1697–1751)

5 *Cotton Mather*, 1727 (early 19th-century impression from the original plate)
mezzotint
image: 30.2 × 24.8 cm (11 ⅞ × 9 ¾ in.)
sheet: 34.1 × 24.8 cm (13 ⁷⁄₁₆ × 9 ¾ in.)
Reba and Dave Williams Collection, Gift of Reba and Dave Williams, 2008.115.3872

John Hall (British, 1739–1797), after Benjamin West (American, 1738–1820)

6 *William Penn's Treaty with the Indians*, 1775
etching and engraving
image: 42.6 × 58.7 cm (16 ¾ × 23 ⅛ in.)
sheet: 48.9 × 62.4 cm (19 ¼ × 24 ⁹⁄₁₆ in.)
Rosenwald Collection, 1943.3.8377

Paul Revere (American, 1735–1818)

7 *Buried with Him by Baptism*, c. 1760–1780
engraving
Brigham 1969, plate 49
image: 15.9 × 10.6 cm (6 ¼ × 4 ³⁄₁₆ in.)
sheet: 17.8 × 12.7 cm (7 × 5 in.)
Corcoran Collection (Museum Purchase, Mary E. Maxwell Fund), 2015.19.608

Paul Revere (American, 1735–1818), after Henry Pelham (American, 1749–1806)

8 *The Bloody Massacre*, 1770
hand-colored engraving
Brigham 1969, plate 14
image: 20 × 21.6 cm (7 ⅞ × 8 ½ in.)
sheet: 26.0 × 22.9 cm (10 ¼ × 9 in.)
Promised Gift of Harry W. Havemeyer in memory of his father, Horace Havemeyer
(WASHINGTON ONLY)

Amos Doolittle (American, 1754–1832), after Ralph Earl (American, 1751–1801)

9 *Plate I: The Battle of Lexington, April 19th, 1775*, 1775
hand-colored engraving
image: 29.9 × 44.8 cm (11 ¾ × 17 ⅝ in.)
sheet: 36.4 × 47.5 cm (14 ⁵⁄₁₆ × 18 ¾ in.)
Promised Gift of Harry W. Havemeyer in memory of his father, Horace Havemeyer
(WASHINGTON ONLY)

Amos Doolittle (American, 1754–1832), after Ralph Earl (American, 1751–1801)

10 *Plate II: A View of the Town of Concord*, 1775
hand-colored engraving
image: 30.3 × 44.6 cm (11 ¹⁵⁄₁₆ × 17 ⁹⁄₁₆ in.)
sheet: 36.2 × 47.8 cm (14 ¼ × 18 ¹³⁄₁₆ in.)
Promised Gift of Harry W. Havemeyer in memory of his father, Horace Havemeyer
(WASHINGTON ONLY)

Amos Doolittle (American, 1754–1832), after Ralph Earl (American, 1751–1801)

11 *Plate III: The Engagement at the North Bridge in Concord*, 1775
hand-colored engraving
image: 30.2 × 44.5 cm (11 ⅞ × 17 ½ in.)
sheet: 36.4 × 47.6 cm (14 ⁵⁄₁₆ × 18 ¾ in.)
Promised Gift of Harry W. Havemeyer in memory of his father, Horace Havemeyer
(WASHINGTON ONLY)

Amos Doolittle (American, 1754–1832),
after Ralph Earl (American, 1751–1801)

12 *Plate IV: A View of the South Part of
 Lexington*, 1775
 hand-colored engraving
 image: 29.9 × 44.5 cm (11¾ × 17½ in.)
 sheet: 36.2 × 47.6 cm (14¼ × 18¾ in.)
 Promised Gift of Harry W. Havemeyer in
 memory of his father, Horace Havemeyer
 (WASHINGTON ONLY)

Valentine Green (British, 1739–1813),
after Thomas Stothard (British,
1755–1834), after Charles Willson Peale
(American, 1741–1827)

13 *General Washington*, 1785
 mezzotint
 Whitman 1902, no. 129
 image: 50.2 × 35.2 cm (19¾ × 13⅞ in.)
 sheet: 54.3 × 36.5 cm (21⅜ × 14⅜ in.)
 Rosenwald Collection, 1943.3.4674

Edward Savage (American, 1761–1817),
after Robert Edge Pine (American,
c. 1730–1788)

14 *Congress Voting Independence*, c. 1803
 stipple and line engraving
 image: 48.1 × 65.4 cm (18¹⁵⁄₁₆ × 25¾ in.)
 sheet: 59.1 × 74.6 cm (23¼ × 29⅜ in.)
 Corcoran Collection (Museum Purchase,
 Mary E. Maxwell Fund), 2015.19.598

John Carwitham (British,
active c. 1723–1741)

15 *A View of Fort George with the City of New York
 from the SW*, c. 1764
 hand-colored engraving (state ii or later)
 sheet: 29.2 × 44.3 cm (11½ × 17⁷⁄₁₆ in.)
 overall with added border strips.
 29.5 × 44.8 cm (11⅝ × 17⅝ in.)
 Promised Gift of Harry W. Havemeyer in
 memory of his father, Horace Havemeyer
 (WASHINGTON ONLY)

Charles Balthazar Julien Févret de
Saint-Mémin (French, 1770–1852)

16 *Saint-Mémin Album*, 1796–1810
 unbound volume of fifty-eight pages con-
 taining 833 engravings mounted on brown
 paper and annotated in ink (apparently
 under Saint-Mémin's direction)
 each page (including modern mount): 29.2 ×
 40.6 cm (11½ × 16 in.)
 Corcoran Collection (Gift of William Wilson
 Corcoran), 2015.19.1584–2406

John Hill (American, born England,
1770–1850), after William Guy Wall
(Irish, 1792–1864 or after)

17 *View from Fishkill Looking to West Point*,
 1821–1825
 from *The Hudson River Portfolio*
 hand-colored aquatint and engraving
 Koke 1961, no. 92
 image: 35.7 × 53.7 cm (14¹⁄₁₆ × 21⅛ in.)
 sheet: 47.3 × 65.7 cm (18⅝ × 25⅞ in.)
 Donald and Nancy deLaski Fund, 2013.3.1

John Hill (American, born England,
1770–1850), after William Guy Wall
(Irish, 1792–1864 or after)

18 *New York from Weehawk*, 1823
 hand-colored aquatint and etching
 Koke 1961, no. 95 (state i/iii)
 image: 40 × 62.4 cm (15¾ × 24⁹⁄₁₆ in.)
 sheet: 54.1 × 74.3 cm (21⁵⁄₁₆ × 29¼ in.)
 Donald and Nancy deLaski Fund, 2006.166.1

William Home Lizars (Scottish, 1788–1859),
after John James Audubon (American,
1785–1851)

19 *Great American Cock Male (Wild Turkey)*, 1827
 from *The Birds of America*
 hand-colored etching
 sheet: 99 × 64.5 cm (39 × 25⅜ in.)
 Gift of Mrs. Walter B. James, 1945.8.1

Robert Havell Jr. (American, born England,
1793–1878), after John James Audubon
(American, 1785–1851)

20 *American White Pelican*, 1836
 from *The Birds of America*
 hand-colored etching and aquatint
 image: 89.5 × 60.0 cm (35¼ × 23⅝ in.)
 sheet: 100.4 × 67.6 cm (39½ × 26⅝ in.)
 Gift of Mrs. Walter B. James, 1945.8.311

Robert Havell Jr. (American, born England,
1793–1878), after John James Audubon
(American, 1785–1851)

21 *American Flamingo*, 1838
 from *The Birds of America*
 hand-colored etching, aquatint, and
 engraving
 image: 87.6 × 58.6 cm (34½ × 23¹⁄₁₆ in.)
 sheet: 101.3 × 68.3 cm (39⅞ × 26⅞ in.)
 Gift of Mrs. Walter B. James, 1945.8.431

William James Bennett (American,
born England, c. 1787–1844), after
Jacob C. Ward (American, 1809–1891)

22 *View of the Natural Bridge, Virginia*, 1835
 hand-colored aquatint
 Deák 1988, no. 28
 image: 49.9 × 65.1 cm (19⅝ × 25⅝ in.)
 sheet: 58.4 × 70.8 cm (23 × 27⅞ in.)
 Collection of Mr. and Mrs. Paul Mellon,
 1985.64.134

William James Bennett (American,
born England, c. 1787–1844), after
George Cooke (American, 1793–1849)

23 *City of Charleston S. Carolina looking across
 Cooper's River*, 1838
 hand-colored aquatint and engraving
 Deák 1988, no. 35
 image: 40.5 × 62.7 cm (15¹⁵⁄₁₆ × 24¹¹⁄₁₆ in.)
 sheet: 54 × 73.2 cm (21¼ × 28¹³⁄₁₆ in.)
 Promised Gift of Harry W. Havemeyer in
 memory of his father, Horace Havemeyer

William James Bennett (American,
born England, c. 1787–1844)

24 *Boston, From City Point near
 Sea Street*, 1833
 hand-colored aquatint
 Deák 1988, no. 22 (state i/ii)
 image: 40.5 × 61.3 cm (15¹⁵⁄₁₆ × 24⅛ in.)
 sheet: 53.7 × 69.9 cm (21⅛ × 27½ in.)
 Promised Gift of Harry W. Havemeyer in
 memory of his father, Horace Havemeyer
 (WASHINGTON ONLY)

Johann Hürlimann (Swiss, 1793–1850),
after Karl Bodmer (Swiss, 1809–1893)

25 *Sih-Chida and Mähchsi-Karéhde*, 1841
 hand-colored engraving and aquatint
 Ruud 2004, no. 20 (state ii/ii)
 plate: 50.2 × 42 cm (19¾ × 16⁹⁄₁₆ in.)
 sheet: 63.1 × 45 cm (24¹³⁄₁₆ × 17¹¹⁄₁₆ in.)
 Donald and Nancy deLaski Fund, 2012.77.1

After F. Bartoli (active New York
and London, 1783–1796), misattributed to
Charles Bird King

26 *Ki-On-Twog-Ky or Cornplanter*, 1837
 from *History of the Indian Tribes of
 North America*
 hand-colored lithograph
 sheet: 52.1 × 35.9 cm (20½ × 14⅛ in.)
 Donald and Nancy deLaski Fund, 2012.141.2

Albert Newsam (American, 1809–1864), after Charles Bird King (American, 1785–1862)

27 *Ne-Sou-A Quoit, A Fox Chief*, 1837
from *History of the Indian Tribes of North America*
hand-colored lithograph
sheet: 50.8 × 35.6 cm (20 × 14 in.)
Donald and Nancy deLaski Fund, 2014.168.1

John Sartain (American, born England, 1808–1897), after George Caleb Bingham (American, 1811–1879)

28 *The County Election*, 1854
hand-colored etching, stipple, line engraving, and mezzotint
image: 56.5 × 76 cm (22 ¼ × 29 ¹⁵⁄₁₆ in.)
sheet: 60.3 × 81 cm (23 ¾ × 31 ⅞ in.)
Gift of Gaillard F. Ravenel and Frances P. Smyth-Ravenel, 2000.7.36

Michele Fanoli (Italian, 1807–1876), after Richard Caton Woodville (American, 1825–1855)

29 *Politics in an Oyster-House*, 1851
hand-colored lithograph
image: 37.2 × 30.2 cm (14 ⅝ × 11 ⅞ in.)
sheet: 38.3 × 31.1 cm (15 ¹⁄₁₆ × 12 ¼ in.)
Corcoran Collection (Gift of the Estate of William Woodville, VIII), 2015.19.3019

Alfred Jones (American, born England, 1819–1900), after Richard Caton Woodville (American, 1825–1855)

30 *Mexican News*, 1851
engraving
image: 52.4 × 47 cm (20 ⅝ × 18 ½ in.)
sheet: 63.8 × 54 cm (25 ⅛ × 21 ¼ in.)
Corcoran Collection (Gift of Donald Webster), 2015.19.1049

Frances Flora Palmer (American, born England, 1812–1876)

31 *A Midnight Race on the Mississippi*, 1860
color lithograph with hand-coloring
image: 46 × 71.1 cm (18 ⅛ × 28 in.)
sheet: 55.9 × 81.3 cm (22 × 32 in.)
Donald and Nancy deLaski Fund, 2012.16.1

Frances Flora Palmer (American, born England, 1812–1876)

32 *"Wooding Up" on the Mississippi*, 1863
color lithograph with hand-coloring
image: 45.7 × 70.5 cm (18 × 27 ¾ in.)
sheet: 53.3 × 76.2 cm (21 × 30 in.)
Donald and Nancy deLaski Fund, 2011.30.1

After Thomas Nast (American, born Germany, 1840–1902)

33 *Why He Cannot Sleep*, 1866
wood engraving on newsprint
image: 35.2 × 23.5 cm (13 ⅞ × 9 ¼ in.)
sheet: 40.6 × 28.6 cm (16 × 11 ¼ in.)
Donald and Nancy deLaski Fund, 2013.3.3

After Winslow Homer (American, 1836–1910)

34 *The Army of the Potomac — A Sharp-Shooter on Picket Duty*, 1862
wood engraving on newsprint
Foster 1936, no. 62
image: 23.2 × 35 cm (9 ⅛ × 13 ¾ in.)
sheet: 28.7 × 41.9 cm (11 ⁵⁄₁₆ × 16 ½ in.)
Avalon Fund, 1986.31.75

Reconstruction to World War II

George Loring Brown (American, 1814–1889)

35 *A View near Rome*, 1854
etching on Japanese paper
image: 13.2 × 20 cm (5 ³⁄₁₆ × 7 ⅞ in.)
sheet: 18.7 × 27 cm (7 ⅜ × 10 ⅝ in.)
Corcoran Collection, 2015.19.2847

James McNeill Whistler (American, 1834–1903)

36 *Rotherhithe*, 1860
etching on Japanese paper
MacDonald 2012, no. 70 (state vi/vi)
plate: 27.6 × 20.2 cm (10 ⅞ × 7 ¹⁵⁄₁₆ in.)
sheet: 34.6 × 24.8 cm (13 ⅝ × 9 ¾ in.)
Rosenwald Collection, 1943.3.8442

James McNeill Whistler (American, 1834–1903)

37 *Florence Leyland*, c. 1873
drypoint on Japanese paper
MacDonald 2012, no. 136 (state v/xi)
plate: 21.6 × 13.3 cm (8 ½ × 5 ¼ in.)
sheet: 30.5 × 20.6 cm (12 × 8 ⅛ in.)
Rosenwald Collection, 1943.3.1729

James McNeill Whistler (American, 1834–1903)

38 *Nocturne*, 1879/1880
etching and drypoint
MacDonald 2012, no. 222 (state vi/ix)
plate: 20.3 × 29.2 cm (8 × 11 ½ in.)
sheet: 21 × 29.5 cm (8 ¼ × 11 ⅝ in.)
Gift of Mr. and Mrs. J. Watson Webb in memory of Mr. and Mrs. H.O. Havemeyer, 1942.15.2

James McNeill Whistler (American, 1834–1903)

39 *Nocturne*, 1879/1880
etching and drypoint
MacDonald 2012, no. 222 (state ix/ix)
sheet: 20.2 × 29.5 cm (7 ¹⁵⁄₁₆ × 11 ⅝ in.)
Rosenwald Collection, 1943.3.8518

Mary Cassatt (American, 1844–1926)

40 *The Visitor*, c. 1881
softground etching, aquatint, etching, and drypoint
Breeskin 1979, no. 34 (state v/vi)
plate: 39.7 × 31.1 cm (15 ⅝ × 12 ¼ in.)
sheet: 52.1 × 39.7 cm (20 ½ × 15 ⅝ in.)
Rosenwald Collection, 1946.21.94

John Singer Sargent (American, 1856–1925)

41 *Study of a Seated Man*, 1895
transfer lithograph
Dodgson 1926, no. 1
image: 29.5 × 21.9 cm (11 ⅝ × 8 ⅝ in.)
sheet: 41.6 × 26.7 cm (16 ⅜ × 10 ½ in.)
Ailsa Mellon Bruce Fund, 1971.30.3

William Forrest (Scottish, 1805–1889), after Frederic Edwin Church (American, 1826–1900)

42 *The Heart of the Andes*, 1862
hand-colored engraving
image: 34.3 × 62.9 cm (13 ½ × 24 ¾ in.)
sheet: 51.3 × 77.5 cm (20 ³⁄₁₆ × 30 ½ in.)
Corcoran Collection (Museum Purchase), 2014.136.220

Mary Nimmo Moran
(American, 1842–1899)

43 *Tween the Gloamin' and the Mirk When the Kye Come Hame*, 1883
etching and roulette on Japanese paper
Klackner 1889, no. 29
plate: 18.8 × 28.5 cm (7 3/8 × 11 1/4 in.)
sheet: 35.1 × 47.9 cm (13 13/16 × 18 7/8 in.)
Gift of Jacob Kainen, 2002.98.160

Thomas Moran (American, 1837–1926)

44 *The Much Resounding Sea*, 1886
etching, drypoint, and roulette on Japanese paper
Klackner 1889, no. 45
image: 37.5 × 82.5 cm (14 3/4 × 32 1/2 in.)
sheet: 56.4 × 94.7 cm (22 3/16 × 37 5/16 in.)
Gift of Jacob Kainen, 2002.98.166

Winslow Homer (American, 1836–1910)

45 *Eight Bells*, 1887
etching
Goodrich/Gerdts 2012, vol. 4.2, no. 1398
sheet: 48.3 × 61.3 cm (19 × 24 1/8 in.)
Gift of John W. Beatty, Jr., 1964.4.7

Winslow Homer (American, 1836–1910)

46 *Saved*, 1889
etching on imitation parchment
Goodrich/Gerdts 2012, vol. 4.2, no. 1403
image: 42.2 × 70.2 cm (16 5/8 × 27 5/8 in.)
sheet: 59 × 86.7 cm (23 1/4 × 34 1/8 in.)
Gift of John W. Beatty, Jr., 1964.4.10

Elbridge Kingsley (American, 1842–1918)

47 *New England Elms*, c. 1889–1890
wood engraving on Japanese paper
Mt. Holyoke 1901, no. 310
image: 22.5 × 35.9 cm (8 7/8 × 14 1/8 in.)
sheet: 31.4 × 44.3 cm (12 3/8 × 17 7/16 in.)
Reba and Dave Williams Collection, Gift of Reba and Dave Williams, 2008.115.2881

Henry Wolf (American, born France, 1852–1916), after Alexander Harrison (American, 1853–1930)

48 *Le Crépuscule*, 1891
wood engraving on Japanese paper
image: 9.4 × 20 cm (3 11/16 × 7 7/8 in.)
sheet: 23.2 × 27.6 cm (9 1/8 × 10 7/8 in.)
Reba and Dave Williams Collection, Gift of Reba and Dave Williams, 2008.115.5112

Charles A. Walker (American, 1848–1920)

49 *Evening on a River with a Boatman*, 1885
monotype
plate: 25.1 × 54 cm (9 7/8 × 21 1/4 in.)
sheet: 31.3 × 60 cm (12 5/16 × 23 5/8 in.)
Donald and Nancy deLaski Fund, 2008.4.3

Albion Bicknell (American, 1837–1915)

50 *A Sun-dappled Meadow by a River*, c. 1890
monotype on Japanese paper
plate: 25.2 × 43.2 cm (9 15/16 × 17 in.)
sheet: 32.9 × 50.5 cm (12 15/16 × 19 7/8 in.)
Donald and Nancy deLaski Fund, 2008.4.1

Thomas Moran (American, 1837–1926)

51 *Mountain of the Holy Cross, Colorado*, 1888
etching, roulette, and aquatint
Klackner 1889, no. 62
image (not including remarque):
67.3 × 47.3 cm (26 1/2 × 18 5/8 in.)
sheet: 84.8 × 63.6 cm (33 3/8 × 25 1/16 in.)
Reba and Dave Williams Collection, Gift of Reba and Dave Williams, 2008.115.3589

William Bradford (American, 1823–1892)

52 *Among the Ice Floes*, 1890
etching
image (not including remarque):
37.8 × 64.1 cm (14 7/8 × 25 1/4 in.)
sheet: 46.2 × 70.8 cm (18 3/16 × 27 7/8 in.)
Reba and Dave Williams Collection, Gift of Reba and Dave Williams, 2008.115.1024

Mary Cassatt (American, 1844–1926)

53 *The Letter*, 1890–1891
drypoint, softground etching, and aquatint
Mathews and Shapiro 1989, no. 8
(state iv/iv)
image: 34.9 × 22.9 cm (13 3/4 × 9 in.)
sheet: 41.9 × 30.2 cm (16 1/2 × 11 7/8 in.)
Corcoran Collection (Museum Purchase through a gift of Josephine Boardman Crane), 2014.136.198

Mary Cassatt (American, 1844–1926)

54 *Woman Bathing*, 1890–1891
drypoint and aquatint
Mathews and Shapiro 1989, no. 10
(state iv/iv)
plate: 36.5 × 26.6 cm (14 3/8 × 10 1/2 in.)
sheet: 47.9 × 31.2 cm (18 7/8 × 12 5/16 in.)
Gift of Mrs. Lessing J. Rosenwald, 1989.28.5

Mary Cassatt (American, 1844–1926)

55 *The Coiffure*, 1890–1891
drypoint and aquatint
Mathews and Shapiro 1989, no. 14
(state v/v)
plate: 36.5 × 26.7 cm (14 3/8 × 10 1/2 in.)
sheet: 43.2 × 30.7 cm (17 × 12 1/16 in.)
Chester Dale Collection, 1963.10.257

Mary Cassatt (American, 1844–1926)

56 *The Banjo Lesson*, c. 1893
drypoint and aquatint with monotype inking
Mathews and Shapiro 1989, no. 16
(state iv/iv)
plate: 29.9 × 23.8 cm (11 3/4 × 9 3/8 in.)
sheet: 41.9 × 29.2 cm (16 1/2 × 11 1/2 in.)
Gift of Mrs. Jane C. Carey as an addition to the Addie Burr Clark Memorial Collection, 1959.12.6

Maurice Brazil Prendergast
(American, 1858–1924)

57 *Six Ladies in Elegant Dress*, 1891/1894
monotype with graphite on Japanese paper
Clark et al. 1990, no. 1583
sheet (sight): 39.5 × 28.3 cm (15 9/16 × 11 1/8 in.)
Promised Gift of Max and Heidi Berry

Maurice Brazil Prendergast
(American, 1858–1924)

58 *Central Park*, c. 1901
monotype on Japanese paper with mica
Clark et al. 1990, no. 1760
image: 20 × 25.5 cm (7 7/8 × 10 1/16 in.)
sheet: 25.4 × 32.4 cm (10 × 12 3/4 in.)
Gift of An Anonymous Donor, 2006.75.1

John Sloan (American, 1871–1951)

59 *Turning Out the Light*, 1905
etching
Morse 1969, no. 134 (state iii/iii)
plate: 12.4 × 17.5 cm (4 7/8 × 6 7/8 in.)
sheet: 21.9 × 26 cm (8 5/8 × 10 1/4 in.)
Rosenwald Collection, 1964.8.1884

Charles Mielatz (American, 1864–1919)

60 *A Rainy Night, Madison Square*, 1890
etching, aquatint, and roulette on Japanese paper
image: 31.8 × 22.9 cm (12 1/2 × 9 in.)
sheet: 41.9 × 28.6 cm (16 1/2 × 11 1/4 in.)
Reba and Dave Williams Collection, Gift of Reba and Dave Williams, 2008.115.3513

Joseph Pennell (American, 1857–1926)

61 *Hail America*, 1908
mezzotint
Wuerth 1928, no. 503
plate: 21.3 × 38.1 cm (8 3/8 × 15 in.)
sheet: 27.9 × 43.2 cm (11 × 17 in.)
Rosenwald Collection, 1943.3.6943

John Sloan (American, 1871–1951)

62 *Anshutz on Anatomy*, 1912
etching
Morse 1969, no. 155 (state viii/viii)
plate: 18.7 × 22.8 cm (7 3/8 × 9 in.)
sheet: 29.8 × 39.4 cm (11 3/4 × 15 1/2 in.)
Rosenwald Collection, 1964.8.1874

John Sloan (American, 1871–1951)

63 *McSorley's*, c. 1915
monotype
image: 20.2 × 25.1 cm (7 15/16 × 9 7/8 in.)
sheet: 21.4 × 27.7 cm (8 7/16 × 10 7/8 in.)
Gift of Frank and Jeannette Eyerly, 1984.95.1

Lyonel Feininger (American, 1871–1956)

64 *The Gate*, 1912
etching and drypoint
Prasse 1972, no. E52
image: 27 × 20 cm (10 5/8 × 7 7/8 in.)
sheet: 42.2 × 32.1 cm (16 5/8 × 12 5/8 in.)
Ailsa Mellon Bruce Fund, 1974.80.1

John Marin (American, 1870–1953)

65 *Brooklyn Bridge, No. 6 (Swaying)*, 1913
etching
Zigrosser 1969, no. 112
image: 27.6 × 22.5 cm (10 7/8 × 8 7/8 in.)
sheet: 36.2 × 28.6 cm (14 1/4 × 11 1/4 in.)
Reba and Dave Williams Collection,
Florian Carr Fund and Gift of the Print
Research Foundation, 2008.115.212

John Marin (American, 1870–1953)

66 *Woolworth Building, No. 1*, 1913
etching with monotype inking on Japanese
paper
Zigrosser 1969, no. 113
plate: 30.1 × 25.2 cm (11 7/8 × 9 15/16 in.)
sheet: 36.6 × 29.4 cm (14 7/16 × 11 9/16 in.)
Avalon Fund, 1981.11.1

John Marin (American, 1870–1953)

67 *Woolworth Building (The Dance)*, 1913
etching and drypoint
Zigrosser 1969, no. 116 (state ii/ii)
image: 27.3 × 21.3 cm (10 3/4 × 8 3/8 in.)
sheet: 38.4 × 31.4 cm (15 1/8 × 12 3/8 in.)
Reba and Dave Williams Collection,
Florian Carr Fund and Gift of the Print
Research Foundation, 2008.115.210

George Bellows (American, 1882–1925)

68 *Splinter Beach*, 1916
lithograph
Mason 1992, no. 28 (unrecorded state)
image: 38.1 × 50.2 cm (15 × 19 3/4 in.)
sheet: 56.2 × 71.1 cm (22 1/8 × 28 in.)
Purchased as the Gift of Max Berry, 2014.21.1

George Bellows (American, 1882–1925)

69 *A Stag at Sharkey's*, 1917
lithograph
Mason 1992, no. 46
image: 47.6 × 60.6 cm (18 3/4 × 23 7/8 in.)
sheet: 55.6 × 70.2 cm (21 7/8 × 27 5/8 in.)
Andrew W. Mellon Fund, 1956.6.13

Childe Hassam (American, 1859–1935)

70 *The Lion Gardiner House, Easthampton*, 1920
etching
Cortissoz/Clayton 1989, no. 159
plate: 25.4 × 36.2 cm (10 × 14 1/4 in.)
sheet: 32.2 × 44.2 cm (12 11/16 × 17 3/8 in.)
Reba and Dave Williams Collection,
Florian Carr Fund and Gift of the Print
Research Foundation, 2008.115.96

John Sloan (American, 1871–1951)

71 *Mosaic*, 1917
etching and aquatint
Morse 1969, no. 185
plate: 18.4 × 23.5 cm (7 1/4 × 9 1/4 in.)
sheet: 30.2 × 35.2 cm (11 7/8 × 13 7/8 in.)
Reba and Dave Williams Collection, Gift of
Reba and Dave Williams, 2008.115.4459

Max Weber (American, 1881–1961)

72 *Prayer*, 1920
linocut on Japanese paper
Rubenstein 1980, no. 32
image: 22.9 × 7 cm (9 × 2 3/4 in.)
sheet: 23.8 × 16.5 cm (9 3/8 × 6 1/2 in.)
Gift of Jack and Margrit Vanderryn,
2015.114.19

Charles Sheeler (American, 1883–1965)

73 *Delmonico Building*, 1926
lithograph
Bryce 2008, no. 4
image: 24.8 × 17.5 cm (9 3/4 × 6 7/8 in.)
sheet: 40.3 × 28.9 cm (15 7/8 × 11 3/8 in.)
Reba and Dave Williams Collection,
Florian Carr Fund and Gift of the Print
Research Foundation, 2008.115.262

James Lesesne Wells
(American, 1902–1993)

74 *Looking Upward*, 1928
woodcut
image: 35.2 × 23.2 cm (13 7/8 × 9 1/8 in.)
sheet: 55.9 × 43.2 cm (22 × 17 in.)
Ruth and Jacob Kainen Collection, 1994.87.9

Louis Lozowick (American, 1892–1973)

75 *New York*, 1923
lithograph
Flint 1982, no. 6
image: 29.2 × 22.8 cm (11 1/2 × 9 in.)
sheet: 40.1 × 28.9 cm (15 13/16 × 11 3/8 in.)
Gift of Jacob Kainen, 2002.98.145

Louis Lozowick (American, 1892–1973)

76 *Still Life #2*, 1929
lithograph
Flint 1982, no. 36
image: 26.3 × 33.7 cm (10 3/8 × 13 1/4 in.)
sheet: 36 × 51.2 cm (14 3/16 × 20 3/16 in.)
Ruth and Jacob Kainen Collection,
1989.80.12

Louis Lozowick (American, 1892–1973)

77 *Subway Construction*, 1931
lithograph
Flint 1982, no. 86
image: 17 × 33.1 cm (6 11/16 × 13 1/16 in.)
sheet: 29 × 40.4 cm (11 7/16 × 15 7/8 in.)
Gift of Jacob Kainen, 2002.98.149

Stuart Davis (American, 1892–1964)

78 *Barber Shop Chord*, 1931
lithograph
Cole/Myers 1986, no. 14
image: 35.3 × 48.4 cm (13 7/8 × 19 1/16 in.)
sheet: 45.2 × 55.8 cm (17 13/16 × 21 15/16 in.)
Gift of Ruth Cole Kainen, 2005.99.10

Helen Lundeberg (American, 1908–1999)

79 *Planets*, c. 1937
lithograph
image: 30.4 × 22.7 cm (11 15/16 × 8 15/16 in.)
sheet: 40.5 × 32.3 cm (15 15/16 × 12 11/16 in.)
Reba and Dave Williams Collection, Gift of
Reba and Dave Williams, 2008.115.3263

Carl Hoeckner (American,
born Germany 1883–1972)
80 *Cold Steel*, 1934
lithograph
image: 26.4 × 40.6 cm (10 ⅜ × 16 in.)
sheet: 29.2 × 43.3 cm (11 ½ × 17 1/16 in.)
Reba and Dave Williams Collection, Gift of
Reba and Dave Williams, 2008.115.2527

Jolán Gross-Bettelheim
(American, 1900–1972)
81 *Home Front*, 1942
lithograph
image: 40.3 × 30.5 cm (15 ⅞ × 12 in.)
sheet: 50.2 × 39.4 cm (19 ¾ × 15 ½ in.)
Reba and Dave Williams Collection,
Florian Carr Fund and Gift of the Print
Research Foundation, 2008.115.75

Benton Murdoch Spruance
(American, 1904–1967)
82 *Riders of the Apocalypse*, 1943
lithograph
Fine/Looney 1986, no. 222
image: 32.2 × 41.8 cm (12 11/16 × 16 7/16 in.)
sheet: 39.8 × 48.7 cm (15 11/16 × 19 3/16 in.)
Reba and Dave Williams Collection,
Florian Carr Fund and Gift of the Print
Research Foundation, 2008.115.267

Edward Hopper (American, 1882–1967)
83 *The Locomotive*, 1923
etching and drypoint
Levin 1979, no. 100
plate: 20 × 25 cm (7 ⅞ × 9 13/16 in.)
sheet: 20.7 × 34.3 cm (11 5/16 × 13 ½ in.)
Amon G. Carter Foundation Fund, 2006.129.1

Peggy Bacon (American, 1895–1987)
84 *Frenzied Effort*, 1925
drypoint
Flint 2001, no. 57
image: 14.9 × 22.7 cm (5 ⅞ × 8 15/16 in.)
sheet: 24.1 × 30.5 cm (9 ½ × 12 in.)
Reba and Dave Williams Collection, Gift of
Reba and Dave Williams, 2008.115.727

Mabel Dwight (American, 1875–1955)
85 *Stick 'Em Up*, 1928
lithograph
Robinson/Pirog 1997, no. 33
image: 26.4 × 26 cm (10 ⅜ × 10 ¼ in.)
sheet: 29.4 × 32.4 cm (11 9/16 × 12 ¾ in.)
Reba and Dave Williams Collection, Gift of
the Print Research Foundation, 2008.115.374

Mabel Dwight (American, 1875–1955)
86 *Queer Fish*, 1936
lithograph
Robinson/Pirog 1997, no. 80
image: 27 × 33 cm (10 ⅝ × 13 in.)
sheet: 31.1 × 45.4 cm (12 ¼ × 17 ⅞ in.)
Reba and Dave Williams Collection, Gift of
Reba and Dave Williams, 2008.115.1562

Isabel Bishop (American, 1902–1988)
87 *Noon Hour*, 1935
etching
plate: 17.5 × 12.2 cm (6 ⅞ × 4 13/16 in.)
sheet: 25.1 × 20.3 cm (9 ⅞ × 8 in.)
Gift of Mrs. Virginia M. Gray, 1985.19.4

Martin Lewis (American, 1881–1962)
88 *Stoops in Snow*, 1930
drypoint and sandground
McCarron 1995, no. 89 (state II/II)
plate: 25.4 × 38.1 cm (10 × 15 in.)
sheet: 34.3 × 47 cm (13 ½ × 18 ½ in.)
Gift of Addie Burr Clark, 1946.9.108

Martin Lewis (American, 1881–1962)
89 *Arc Welders at Night*, 1937
drypoint and sandground
McCarron 1995, no. 124
plate: 25.4 × 20.2 cm (10 × 7 15/16 in.)
sheet: 36 × 27.5 cm (14 3/16 × 10 13/16 in.)
Reba and Dave Williams Collection,
Florian Carr Fund and Gift of the Print
Research Foundation, 2008.115.190

Reginald Marsh (American, 1898–1954)
90 *Tattoo-Shave-Haircut*, 1932
etching and engraving
Sasowsky 1976, no. 140 (state x/x)
plate: 25.4 × 25.4 cm (10 × 10 in.)
sheet: 29.5 × 27.9 cm (11 ⅝ × 11 in.)
Reba and Dave Williams Collection,
Florian Carr Fund and Gift of the Print
Research Foundation, 2008.115.213

Reginald Marsh (American, 1898–1954)
91 *Eltinge Follies*, 1940
hand-colored engraving
Sasowsky 1976, no. 211 (state vii/vii)
image: 29.5 × 24.3 cm (11 ⅝ × 9 9/16 in.)
sheet: 33.7 × 27.3 cm (13 ¼ × 10 ¾ in.)
Donald and Nancy deLaski Fund, 2014.90.1

David Alfaro Siqueiros
(Mexican, 1896–1974)
92 *Reclining Nude*, 1931
lithograph
image: 41.3 × 57.8 cm (16 ¼ × 22 ¾ in.)
sheet: 52.9 × 69.9 cm (20 13/16 × 27 ½ in.)
Rosenwald Collection, 1944.2.73

David Alfaro Siqueiros
(Mexican, 1896–1974)
93 *Black Woman*, 1931
lithograph
image: 50.5 × 35.2 cm (19 ⅞ × 13 ⅞ in.)
sheet: 58.6 × 40.5 cm (23 1/16 × 15 15/16 in.)
Rosenwald Collection, 1944.8.41

Diego Rivera (Mexican, 1886–1957)
94 *Viva Zapata*, 1932
lithograph
image: 41.4 × 33.3 cm (16 5/16 × 13 ⅛ in.)
sheet: 58.2 × 40.7 cm (22 15/16 × 16 in.)
Gift of Mrs. Robert A. Hauslohner,
1990.106.51

Jean Charlot (American,
born France, 1898–1979)
95 *Tortilla Maker*, 1937
lithograph
Morse 1976, no. 391
image: 34.6 × 22.2 cm (13 ⅝ × 8 ¾ in.)
sheet: 44.1 × 31.6 cm (17 ⅜ × 12 7/16 in.)
Reba and Dave Williams Collection, Gift of
Reba and Dave Williams, 2008.115.1209

Charles White (American, 1918–1979)
96 *We Have Been Believers*, 1949
lithograph
Gedeon 1981, no. Ea8
image: 29.2 × 27.9 cm (11 ½ × 11 in.)
sheet: 45.4 × 33 cm (17 ⅞ × 13 in.)
Reba and Dave Williams Collection,
Florian Carr Fund and Gift of the Print
Research Foundation, 2008.115.289

Elizabeth Catlett (American, 1915–2012)

97 *Untitled (Harriet Tubman)*, 1953
linocut
image: 32.4 × 25.7 cm (12 ¾ × 10 ⅛ in.)
sheet: 41 × 32.7 cm (16 ⅛ × 12 ⅞ in.)
Reba and Dave Williams Collection,
Florian Carr Fund and Gift of the Print
Research Foundation, 2008.115.37

Bernarda Bryson Shahn
(American, 1903–2004)

98 *Arkansas Sharecroppers*, 1935–1936
lithograph
image: 23.2 × 31.8 cm (9 ⅛ × 12 ½ in.)
sheet: 29.2 × 40 cm (11 ½ × 15 ¾ in.)
Reba and Dave Williams Collection, Gift of
Reba and Dave Williams, 2008.115.4357

Robert Gwathmey
(American, 1903–1988)

99 *The Hitchhiker*, 1937–1943
screenprint
Williams 1994, no. 1
image: 42.6 × 33.3 cm (16 ¾ × 13 ⅛ in.)
sheet: 44.8 × 35.2 cm (17 ⅝ × 13 ⅞ in.)
Reba and Dave Williams Collection, Gift of
Reba and Dave Williams, 2008.115.2283

Eugene Morley (American, 1909–1953)

100 *Jersey Landscape*, 1939
screenprint
image: 28.6 × 37.5 cm (11 ¼ × 14 ¾ in.)
sheet: 33.8 × 42.2 cm (13 ⁵⁄₁₆ × 16 ⅝ in.)
Reba and Dave Williams Collection, Gift of
Reba and Dave Williams, 2008.115.3601

William H. Johnson
(American, 1901–1970)

101 *Blind Singer*, c. 1940
color screenprint with tempera additions
image: 42.5 × 28 cm (16 ¾ × 11 in.)
sheet: 44.4 × 29.2 cm (17 ½ × 11 ½ in.)
Reba and Dave Williams Collection,
Florian Carr Fund and Gift of the Print
Research Foundation, 2008.115.122

Edward Hopper (American, 1882–1967)

102 *American Landscape*, 1920
etching
Levin 1979, no. 102
plate: 18.5 × 31.3 cm (7 ⁵⁄₁₆ × 12 ⁵⁄₁₆ in.)
sheet: 34.1 × 45.4 cm (13 ⁷⁄₁₆ × 17 ⅞ in.)
Print Purchase Fund (Rosenwald Collection)
and Ailsa Mellon Bruce Fund, 1979.64.1

Thomas Hart Benton
(American, 1889–1975)

103 *Departure of the Joads*, 1939
lithograph
Fath 1979, no. 34
image: 32.5 × 47 cm (12 ¹³⁄₁₆ × 18 ½ in.)
sheet: 37 × 50.8 cm (14 ⁹⁄₁₆ × 20 in.)
Reba and Dave Williams Collection,
Florian Carr Fund and Gift of the Print
Research Foundation, 2008.115.14

Grant Wood (American, 1891–1942)

104 *Fertility*, 1939
lithograph
Cole 1984, no. 15
image: 22.9 × 30.3 cm (9 × 11 ¹⁵⁄₁₆ in.)
sheet: 32.2 × 45.7 cm (12 ¹¹⁄₁₆ × 18 in.)
Reba and Dave Williams Collection,
Florian Carr Fund and Gift of the Print
Research Foundation, 2008.115.293

Grant Wood (American, 1891–1942)

105 *Shrine Quartet*, 1939
lithograph
Cole 1984, no. 11
image: 20.3 × 30.2 cm (8 × 11 ⅞ in.)
sheet: 30.5 × 40.6 cm (12 × 16 in.)
Reba and Dave Williams Collection,
Florian Carr Fund and Gift of the Print
Research Foundation, 2008.115.290

Post-World War II to the Present

Josef Albers (American,
born Germany, 1888–1976)

106 *Tlaloc*, 1944
woodcut on Japanese paper
Danilowitz 2010, no. 118
plate: 31.6 × 30.5 cm (12 ⁷⁄₁₆ × 12 in.)
sheet: 36.8 × 38.1 cm (14 ½ × 15 in.)
Gift of Mr. and Mrs. Burton Tremaine,
1971.86.2

Stanley William Hayter
(British, 1901–1988)

107 *Danse du Soleil*, 1951
engraving, softground etching, and
woodblock offset
Black 1992, no. 197 (state v/v)
plate: 39.4 × 24.1 cm (15 ½ × 9 ½ in.)
sheet: 56.5 × 37.8 cm (22 ¼ × 14 ⅞ in.)
Andrew W. Mellon Fund, 1977.31.1

Mauricio Lasansky (American,
born Argentina, 1914–2012)

108 *Sol y Luna*, 1945
engraving, etching, softground etching,
aquatint, with scraping and burnishing
Thein/Lasansky 1975, no. 65
plate: 40.2 × 51.8 cm (15 ¹³⁄₁₆ × 20 ⅜ in.)
sheet: 46.1 × 62.2 cm (18 ⅛ × 24 ½ in.)
Rosenwald Collection, 1945.5.83

Alexander Calder (American, 1898–1976)

109 *The Big I*, 1944
engraving, softground etching, and aquatint
plate: 11.6 × 17.3 cm (4 ⁹⁄₁₆ × 6 ¹³⁄₁₆ in.)
sheet: 24.6 × 32.6 cm (9 ¹¹⁄₁₆ × 12 ¹³⁄₁₆ in.)
Reba and Dave Williams Collection, Gift of
Reba and Dave Williams, 2008.115.1147

Louise Bourgeois (American,
born France, 1911–2010)

110 *He Disappeared into Complete Silence*, 1947
unbound volume of nine engravings (plate
seven illustrated)
Wye/Smith 1994, nos. 29–37
each sheet: 25.4 × 35.6 cm (10 × 14 in.)
Purchased as the Gift of Dian Woodner,
2010.132.1–9
(WASHINGTON ONLY)

Sylvia Wald (American, 1915–2011)

111 *Between Dimensions*, 1950
screenprint
Acton 1993, no. 29
image: 52.1 × 37.5 cm (20 ½ × 14 ¾ in.)
sheet: 66 × 51.4 cm (26 × 20 ¼ in.)
Reba and Dave Williams Collection, Gift of
Reba and Dave Williams, 2008.115.4915

Jackson Pollock (American, 1912–1956)

112 *Untitled*, 1944/1945 (printed 1967)
engraving and drypoint on Japanese paper
O'Connor/Thaw 1978, vol. 4, no. 1078 (P16)
plate: 37.3 × 45.4 cm (14 ¹¹⁄₁₆ × 17 ⅞ in.)
sheet: 50.2 × 69.2 cm (19 ¾ × 27 ¼ in.)
The William Stamps Farish Fund, 2009.3.2

Jackson Pollock (American, 1912–1956)

113 *Untitled*, 1951
screenprint
O'Connor/Thaw 1978, vol. 4, no. 1094,
State (P30)
image: 48.6 × 41.9 cm (19 ⅛ × 16 ½ in.)
sheet: 73.7 × 58.5 cm (29 × 23 ⅛ in.)
Patrons' Permanent Fund, 2001.24.4

David Smith (American, 1906–1965)

114 *A Letter*, 1952
lithograph
sheet: 51 × 66 cm (20 1/16 × 26 in.)
Gift of Ruth Cole Kainen, 2006.57.33

Dorothy Dehner (American, 1901–1994)

115 *Figures in Landscape*, 1956
engraving
Teller 1987, no. 25
image: 22.5 × 30.3 cm (8 7/8 × 11 15/16 in.)
sheet: 31.9 × 46.4 cm (12 9/16 × 18 1/4 in.)
Reba and Dave Williams Collection, Gift of
Reba and Dave Williams, 2008.115.1456

Louise Nevelson (American,
born Russia, 1899–1988)

116 *Magic Garden*, 1953/1955
hand-colored etching, engraving, aquatint,
and softground etching
Baro 1974, no. 12 (proof)
plate: 14.6 × 22.5 cm (5 3/4 × 8 7/8 in.)
sheet: 22 × 29.4 cm (8 11/16 × 11 9/16 in.)
Gift of the Collectors Committee, 1990.88.1

Louise Nevelson (American,
born Russia, 1899–1988)

117 *Magic Garden*, 1953/1955
hand-colored etching, engraving, aquatint,
and softground etching
Baro 1974, no. 12 (proof)
plate: 14.5 × 22.5 cm (5 11/16 × 8 7/8 in.)
sheet: 22.5 × 29.3 cm (8 7/8 × 11 9/16 in.)
Gift of the Collectors Committee, 1990.91.1

Willem de Kooning (American,
born Netherlands, 1904–1997)
and Harold Rosenberg (author)
(American, 1906–1978)

118 *Revenge*, 1957, published 1960
etching
plate: 30 × 34.3 cm (11 13/16 × 13 1/2 in.)
sheet: 42.9 × 50.2 cm (16 7/8 × 19 3/4 in.)
Prospero Foundation Fund, 1997.6.5

Leonard Baskin (American, 1922–2000)

119 *The Hydrogen Man*, 1954
woodcut on Japanese paper
Fern/O'Sullivan 1984, no. 249
sheet: 223.5 × 101.6 cm (88 × 40 in.)
Ailsa Mellon Bruce Fund, 1981.20.1

Josef Albers (American,
born Germany, 1888–1976)

120 *White Line Square XII*, 1966
lithograph
Danilowitz 2010, no. 172.4
image: 40 × 40 cm (15 3/4 × 15 3/4 in.)
sheet: 52.7 × 52.7 cm (20 3/4 × 20 3/4 in.)
Gift of Gemini G.E.L. and the Artist,
1981.5.125

Roy Lichtenstein (American, 1923–1997)

121 *Sweet Dreams, Baby!*, 1965
screenprint
Corlett 2002, no. 39
image: 90.5 × 64.9 cm (35 5/8 × 25 9/16 in.)
sheet: 95.6 × 70.1 cm (37 5/8 × 27 5/8 in.)
Gift of Roy and Dorothy Lichtenstein,
1996.56.30

Ed Ruscha (American, born 1937)

122 *Standard Station*, 1966
screenprint
Engberg/Phillpot 1999, no. 5
image: 49.5 × 93.2 cm (19 1/2 × 36 11/16 in.)
sheet: 65.1 × 101.5 cm (25 5/8 × 39 15/16 in.)
Reba and Dave Williams Collection,
Florian Carr Fund and Gift of the Print
Research Foundation, 2008.115.257

Andy Warhol (American, 1928–1987)

123 *Marilyn*, 1967
screenprint
Feldman/Schellmann 2003, no. II.31
sheet: 91.5 × 91.5 cm (36 × 36 in.)
Reba and Dave Williams Collection,
Florian Carr Fund and Gift of the Print
Research Foundation, 2008.115.285

Robert Rauschenberg
(American, 1925–2008)

124 *Accident*, 1963
lithograph
sheet: 104.4 × 74.9 cm (41 1/8 × 29 1/2 in.)
Gift of the Woodward Foundation,
Washington, DC, 1976.56.129

Robert Rauschenberg
(American, 1925–2008)

125 *Booster*, 1967
lithograph and screenprint
sheet: 183 × 90.3 cm (72 1/16 × 35 9/16 in.)
Gift of Dr. and Mrs. Maclyn E. Wade,
1978.92.11

Robert Rauschenberg
(American, 1925–2008)

126 *Cardbird II*, 1971
corrugated cardboard, tape, staples, offset
lithography, and screenprint
overall: 137.2 × 83.8 cm (54 × 33 in.)
Gift of Gemini G.E.L. and the Artist,
1981.5.76

Claes Oldenburg (American,
born Sweden, 1929)

127 *Profile Airflow*, 1969
molded polyurethane over lithograph
overall: 85.1 × 166.4 cm (33 1/2 × 65 1/2 in.)
Gift of Gemini G.E.L. and the Artist,
1981.5.70

Jasper Johns (American, born 1930)

128 *Flags I*, 1973
screenprint
Field 1994, no. 128 (AP)
sheet: 69.9 × 90 cm (27 1/2 × 35 7/16 in.)
Robert and Jane Meyerhoff Collection,
1994.82.8

Brice Marden (American, born 1938)

129 *Ten Days (1)*, 1971
etching and aquatint
Lewison 1992, no. 20 (state a)
plate: 40 × 52.5 cm (15 3/4 × 20 11/16 in.)
sheet: 56.5 × 76 cm (22 1/4 × 29 15/16 in.)
The Nancy Lee and Perry Bass Fund,
2003.92.1

Jim Dine (American, born 1935)

130 *Five Paintbrushes* (third state), 1973
etching and drypoint
Krens 1977, no. 137 (state iii/v)
plate: 52.1 × 69.5 cm (20 1/2 × 27 3/8 in.)
sheet: 74.6 × 90.2 cm (29 3/8 × 35 1/2 in.)
Gift of the Artist, 2014.11.18

Robert Motherwell (American, 1915–1991)

131 *Harvest, with Orange Stripe*, 1973
lithograph with collage
Engberg 2003, no. 146
(Gemini impression 1)
image: 76.2 × 31.3 cm (30 × 12 5/16 in.)
sheet: 91.2 × 47 cm (35 7/8 × 18 1/2 in.)
Gift of Gemini G.E.L. and the Artist,
1991.74.166

Helen Frankenthaler
(American, 1928–2011)

132 *Savage Breeze*, 1974
woodcut on handmade laminated
Nepalese paper
Harrison/Boorsch 1996, no. 47
sheet: 80 × 68.6 cm (31½ × 27 in.)
Andrew W. Mellon Fund and Ailsa Mellon
Bruce Fund, 1975.38.1

Jenny Holzer (American, born 1950)

133 *Truisms*, 1977
offset lithograph
sheet: 88.3 × 58.1 cm (34¾ × 22⅞ in.)
Gift of the Artist, 2008.111.9

Guerrilla Girls (founded 1985)

134 *Do women have to be naked to get into
the Met. Museum?*, 1989
offset lithograph on illustration board
sheet: 27.9 × 71.1 cm (11 × 28 in.)
Gift of the Gallery Girls in support of the
Guerrilla Girls, 2007.101.7

Romare Bearden (American, 1911–1988)

135 *Home to Ithaca*, 1979
screenprint
image: 38.1 × 61 cm (15 × 24 in.)
sheet: 55.9 × 75.3 cm (22 × 29⅝ in.)
Purchased as the Gift of Richard
A. Simms, 2013.142.6

Vija Celmins (American,
born Latvia, 1938)

136 *Concentric Bearings, D*, 1984
mezzotint, aquatint, drypoint, and
photogravure
Rippner 2002, fig. 19
image (overall): 24.1 × 41.6 cm
(9½ × 16⅜ in.)
sheet: 45.7 x 57 cm (18 x 22⁷⁄₁₆ in.)
Gift of Edward R. Broida, 2005.142.46

Richard Diebenkorn
(American, 1922–1993)

137 *Green*, 1986
spitbite aquatint, soapground aquatint,
and drypoint
plate: 114.3 × 89.5 cm (45 × 35¼ in.)
sheet: 135.9 × 103.5 cm (53½ × 40¾ in.)
Eugene L. and Marie-Louise Garbáty Fund
and Patrons' Permanent Fund, 1996.77.77

Wayne Thiebaud (American, born 1920)

138 *Eight Lipsticks*, 1988
drypoint
image: 17.8 × 15.2 cm (7 × 6 in.)
sheet: 35.6 × 30.5 cm (14 × 12 in.)
Gift of Kathan Brown, 1996.93.99

Richard Serra (American, born 1939)

139 *Muddy Waters*, 1987
Paintstik screenprint on coated paper
sheet: 188 × 153 cm (74 × 60¼ in.)
Gift of Gemini G.E.L. and the Artist, in
Honor of the 50th Anniversary of the
National Gallery of Art, 1990.71.13

Glenn Ligon (American, born 1960)

140 *Untitled: Four Etchings [B]*, 1992
softground etching, aquatint, spitbite
aquatint, and sugarlift aquatint
plate: 59.7 × 40 cm (23½ × 15¾ in.)
sheet: 63.8 × 44.1 cm (25⅛ × 17⅜ in.)
Gift of Werner H. and Sarah-Ann Kramarsky
and the Collectors Committee Fund,
2004.65.1.2

Martin Puryear (American, born 1941)

141 *Untitled*, 2001
etching, softground etching, and drypoint
with chine collé
plate: 60.1 × 45 cm (23¹¹⁄₁₆ × 17¹¹⁄₁₆ in.)
sheet: 88.1 × 70.5 cm (34¹¹⁄₁₆ × 27¾ in.)
Gift of the Collectors Committee, 2006.148.1

Chuck Close (American, born 1940)

142 *Leslie/Fingerprint/Silk Collé*, 1986
direct gravure with silk collé
plate: 114.6 × 93.4 cm (45⅛ × 36¾ in.)
sheet: 137.8 × 102.3 cm (54¼ × 40¼ in.)
Gift of Graphicstudio/University of South
Florida and the Artist, 1987.77.8

Kiki Smith (American,
born Germany, 1954)

143 *Untitled [Hair]*, 1990
lithograph on Japanese paper
sheet: 90.8 × 91.5 cm (35¾ × 36 in.)
Gift of the Collectors Committee, 2007.33.1

Kara Walker (American, born 1969)

144 *no world*, 2010
from *An Unpeopled Land in Uncharted
Waters*
etching, aquatint, sugarlift aquatint, spitbite
aquatint, and drypoint
plate: 60.7 × 90.2 cm (23⅞ × 35½ in.)
sheet: 76.8 × 100.5 cm (30¼ × 39⁹⁄₁₆ in.)
Donald and Nancy deLaski Fund, 2015.42.1

Bibliography

Acton, David. *Color in American Printmaking, 1890–1960*. New York, 1990.

Acton, David. *Sylvia Wald: Abstract Expressionist Works on Paper*. New York, 1993.

Acton, David. *The Stamp of Impulse: Abstract Expressionist Prints*. Worcester, MA, 2001.

Adams, Henry. *The Degradation of the Democratic Dogma*. New York, 1920.

Adès, Dawn. "The Mexican Printmaking Tradition, c. 1900–1930." In *Revolution on Paper: Mexican Prints 1910–1960*, edited by Mark McDonald, 11–25. London, 2009.

"American Prints in Boston." *The Collector* 4, no. 16 (July 1, 1893): 252.

"Annual Meeting of the American Art-Union." *New York Evening Post*. December 19, 1846: 7.

Archer, Richard. *As If an Enemy's Country: The British Occupation of Boston and the Origins of Revolution*. New York, 2010.

Axsom, Richard H. *Printed Stuff: Prints, Poster, and Ephemera by Claes Oldenburg, A Catalogue Raisonné 1958–1996*. New York, 1997.

Barnwell, Andrea D. "Sojourner Truth or Harriet Tubman? Charles White's Depiction of an American Heroine." In *The Walter O. Evans Collection of American Art*, edited by Andrea D. Barnwell, 55–66. Seattle, 1999.

Baro, Gene. *Nevelson: The Prints*. New York, 1974.

Beard, Charles A. and William Beard. *The American Leviathan*. New York, 1930.

"A Beautiful Picture." *Masonic Review*, 14, no. 4 (January, 1856): 256.

Bedini, Silvio A. *At the Sign of the Compass and Quadrant: The Life and Times of Anthony Lamb*. Philadelphia, 1984.

Belleroche, Albert. "The Lithographs of Sargent." *Print Collector's Quarterly* 13, no. 1 (February 1926): 30–45.

Belloli, Jay. *Rauschenberg at Gemini*. New York, 2010.

Benton, Thomas Hart. *An Artist in America*, 3rd ed. Columbia, MO, 1968.

Berlo, Janet Catherine, and Ruth B. Phillips. *Native North American Art*. 2nd ed. Oxford, 2015.

Berswordt-Wallrabe, Silke von and Susanne Breidenbach. *Richard Serra: Druckgrafik: Werkverzeichnis 1972–1999*. Düsseldorf, 1999.

Black, Peter and Désirée Moorhead. *The Prints of Stanley William Hayter: A Complete Catalogue*. New York, 1992.

Bloch, Maurice. *George Caleb Bingham*, 2 vols. Berkeley, Los Angeles, 1967.

Boswell. Review in *New York Herald*. Reprinted in *Camera Work* 42–43 (April–July): 25.

Bourne, Russell. *Cradle of Violence: How Boston's Waterfront Mobs Ignited the American Revolution*. Hoboken, NJ, 2006.

Breeskin, Adelyn D. *Mary Cassatt: A Catalogue Raisonné of the Graphic Work*. Washington, DC, 1979.

Brigham, Clarence. *Paul Revere's Engravings*. Worcester, MA, 1969.

Brodie, Judith and Adam Greenhalgh. *Yes, No, Maybe: Artists Working at Crown Point Press*. Washington, DC, 2013.

Brown, Sienna. "The Lithographs of Robert Rauschenberg." Ph.D. diss., Emory University, 2010.

Bruce, David K. E. *National Gallery of Art Annual Report, June 30, 1942*. United States Government Printing Office, Washington, DC, 1943.

Bruhn, Thomas P. *The American Print: Originality and Experimentation 1790–1890*. William Benton Museum of Art, Storrs, CT, 1993.

Bryce, Kristy, and Carol Troyen. *Charles Sheeler Prints: A Catalogue Raisonné*. New York, 2008.

Burg, B. R. *Richard Mather*. Boston, 1982.

Burns, Sarah, and John Davis. *American Art to 1900: A Documentary History*. Berkeley, 2009.

Caffin, Charles H. Review in *New York American*. Reprinted in *Camera Work* 42–43 (April–July): 42.

Campbell, Helen, Thomas W. Knox, and Thomas Byrnes. *Darkness and Daylight; or, Lights and Shadows of New York Life*. Hartford, CT, 1899.

Carr, Gerald L. "American Art in Great Britain: The National Gallery Watercolor of *The Heart of the Andes*." *Studies in the History of Art* 12 (1982): 81–100.

Catalogue of the Works of Elbridge Kingsley. Mount Holyoke College, Hadley, MA, 1901. http://babel.hathitrust.org/cgi/pt?id=-chi.80803494;view=1up;seq=1(accessed 27 August 2015).

Chamberlin, J. Edgar. Review in *New York Mail*. Reprinted in *Camera Work* 42–43 (April–July): 23.

Clark, Carol, et al. *Maurice Brazil Prendergast, Charles Prendergast: A Catalogue Raisonné*. Williamstown, MA and Munich, 1990.

Clayton, Timothy. *The English Print 1688–1802*. New Haven, 1997.

Cole, Jr., Sylvan. *Grant Wood: The Lithographs: A Catalogue Raisonné*, edited by Susan Teller. New York, 1984.

Cole Jr., Sylvan, and Jane Myers. *Stuart Davis: Graphic Work and Related Paintings with a Catalogue Raisonné of the Prints.* Fort Worth, 1986.

Conrad, Peter. *The Art of the City: Views and Versions of New York.* New York, 1984.

Conrads, Margaret C. "The *Grapes of Wrath* in Pictures." In *American Epics: Thomas Hart Benton and Hollywood,* edited by Austen Barron Bailly, 68–79. Salem, MA, 2015.

Conway, Robert. *The Powerful Hand of George Bellows, Drawings from the Boston Public Library.* Washington, DC, and Boston, 2006.

Cooperman, Emily T., and Lea Carson Sherk. *William Birch: Picturing the American Scene.* Philadelphia, 2010.

Coppel, Stephen. *The American Scene from Hopper to Pollock.* London, 2008.

Corlett, Mary Lee. *The Prints of Roy Lichtenstein: a catalogue raisonné, 1948–1997.* 2nd rev. ed. New York, 2002.

Cortissoz, Royal, and the Leonard Clayton Gallery. *Catalogue of the Etchings and Dry-Points of Childe Hassam, N.A.* rev. ed. San Francisco, 1989.

Cox, Kenyon. "Sargent." In *Old Masters and New,* 255–265. New York, 1905.

"The Craft in Philadelphia." *Masonic Review,* 14, no. 4 (January, 1856): 240–245.

Crane, Stephen. "Maggie: A Girl of the Streets" (1893). In *The Portable Stephen Crane,* edited by Joseph Katz, 3–74. New York, 1969.

Craven, Wayne. "Albion Harris Bicknell, 1837–1915." *Antiques* 106, 1974: 443–449.

Crow, Thomas. "Saturday Disasters: Trace and Reference in Early Warhol." In *Andy Warhol,* Annette Michelson, ed, 49–66. Cambridge, MA, 2001.

Cummings, Abbott Lowell. "A Recently Discovered Engraving of the Old State House in Boston." In *Boston Prints and Printmakers, 1670–1775,* edited by Walter Muir Whitehall, 174–184. Boston, 1973.

"The Curious and Beautiful Prospect of the City and Harbour of Philadelphia." *Pennsylvania Gazette,* November 8, 1753: 5.

Dackerman, Susan, ed. *Corita Kent and the Language of Pop.* Cambridge, MA, 2015.

Danilowitz, Brenda. *The Prints of Josef Albers. A Catalogue Raisonné, 1915–1976.* 2nd rev. ed. Manchester and New York, 2010.

Deák, Gloria Gilda. *Picturing America, 1497–1899: Prints, Maps, and Drawings Bearing on the New World Discoveries and on the Development of the Territory that is now the United States.* Princeton, 1988.

Deák, Gloria Gilda. *William James Bennett, Master of the Aquatint View.* New York, 1988.

Dennison, Mariea Caudill. "John Sloan's Saloon Etchings." *Print Quarterly* 22, no. 3 (September 2005): 302–307.

Dodgson, Campbell. "Catalogue of the Lithographs of J.S. Sargent, R.A." *Print Collector's Quarterly* 13 (1926): 44–45.

Doezema, Marianne. *George Bellows and Urban America.* New Haven, 1992.

Doss, Erika. "Catering to Consumerism: Associated American Artists and the Marketing of Modern Art." *Winterthur Portfolio* 26, nos. 2–3 (1991): 143–167.

Dunlap, William. *History of the Rise and Progress of the Arts of Design in the United States,* vol. 1. New York, 1834.

DuVal, Kathleen. *The Native Ground: Indians and Colonists in the Heart of the Continent.* Philadelphia, 2006.

Engberg, Siri. "Out of Print: The Editions of Edward Ruscha." In *Edward Ruscha: Editions, 1959–1999: Catalogue Raisonné,* edited by Siri Engberg and Clive Phillpot. Minneapolis, 1999.

Engberg, Siri, and Joan Banach. *Robert Motherwell: The Complete Prints 1940–1991, Catalogue Raisonné.* Minneapolis, 2003.

Esposito Hayter, Carla. *The Monotype: The History of a Pictorial Art.* Milan, 2007.

Ewers, John C. "An Appreciation of Karl Bodmer's Pictures of Indians." In *Views of a Vanishing Frontier,* edited by John C. Ewers et al, 51–93. Omaha, NE, 1984.

Fagg, John. "Chamber Pots and Gibson Girls: Clutter and Matter in John Sloan's Graphic Art." *American Art,* 29, no. 3, 28–57.

Fath, Creekmore. *The Lithographs of Thomas Hart Benton.* Austin, TX, and London, 1979.

Feldman, Frayda, and Jörg Schellmann. *Andy Warhol Prints, A Catalogue Raisonné, 1962–1987.* 4th rev. ed., New York, 2003.

Fern, Alan, and Judith O'Sullivan. *The Complete Prints of Leonard Baskin.* Boston, 1984.

Field, Richard S. "Silkscreen: The Media Medium." *Artnews* 70, no. 9 (January 1972): 40–44, 75.

Field, Richard S. *The Prints of Jasper Johns, 1960–1993: A Catalogue Raisonné.* West Islip, NY, 1994.

Fine, Ruth E. *Lessing J. Rosenwald: Tribute to a Collector.* Washington, DC, 1982.

Fine, Ruth E. "Writing on Rocks, Rubbing on Silk, Layering on Paper." In *Robert Rauschenberg: A Retrospective,* Walter Hopps and Susan Davidson, ed., 376–389. New York, 1997.

Fine, Ruth E. and Robert F. Looney. *The Prints of Benton Murdoch Spruance: A Catalogue Raisonné.* Philadelphia, 1986.

Fischer, David Hackett. *Albion's Seed: Four British Folkways in America.* New York, 1989.

Flint, Janet A. *The Prints of Louis Lozowick: A Catalogue Raisonné.* New York, 1982.

Flint, Janet A. and Roberta K. Tarbill. *Peggy Bacon: A Checklist of the Prints.* San Francisco, 2001.

Foster, Allen Evarts. *A Check List of Illustrations by Winslow Homer in Harper's Weekly and Other Periodicals.* New York, 1936.

Foster, Hal. "Death in America." In *Andy Warhol,* Annette Michelson, ed., 69–88. Cambridge, MA, 2001.

Foster, Kathleen. *Shipwreck! Winslow Homer and The Life Line.* Philadelphia, 2012.

Fowble, E. McSherry. *Two Centuries of Prints in America, 1680–1880.* Charlottesville, VA, 1987.

Gale Research Co. *Currier & Ives: A Catalogue Raisonné. A Comprehensive Catalogue of the Lithographs of Nathaniel Currier, James Merritt Ives and Charles Currier, including ephemera associated with the firm, 1834–1907.* Detroit, 1984.

Gardner, Andrew B. *The Artist's Silkscreen Manual.* New York, 1976.

Gast, Dwight V. "Martin Puryear: Sculpture as an Act of Faith." *Journal of Art* 2, no. 1 (September–October 1989): 6–7.

Gedeon, Lucinda. "Introduction to the Work of Charles W. White: with a catalogue raisonné." MA thesis, University of California, Los Angeles, 1981.

Gilmour, Pat. *Ken Tyler, Master Printer, and the American Print Renaissance.* New York, 1986.

Goodrich, Lloyd. *The Graphic Art of Winslow Homer.* New York, 1968.

Goodrich, Lloyd, and Abigail Booth Gerdts. *Record of Works by Winslow Homer.* New York, 2005–2014.

Graham, Lanier. *The Prints of Willem de Kooning, A Catalogue Raisonné 1957–1971.* Paris, 1991.

Greenberg, Clement. *The Collected Essays and Criticism.* John O'Brian, ed. Chicago, 1993.

Gretton, Tom. "Difference and Competition: The Imitation and Reproduction of Fine Art in a Nineteenth-Century Illustrated Weekly News Magazine." *Oxford Art Journal* 23, no. 2 (2000): 145–162.

Griffin, Gillett. *John Foster's Woodcut of Richard Mather.* Lunenberg, VT, 1959.

Hafertepe, Kenneth. "*The Country Builders Assistant*: Text and Context." *American Architects and their Books Before 1848*, edited by Kenneth Hafertepe and James F. O'Gorman, 129–148. Amherst, MA, 2001.

Hamerton, Philip Gilbert. "The Philosophy of Etching." *Philadelphia Evening Telegraph* (May 26, 1869): 7.

Harrison, Pegram and Suzanne Boorsch. *Frankenthaler: A Catalogue Raisonné: Prints, 1961–1994.* New York, 1996.

Hartmann, Sadakichi. "Studio-Talk." *International Studio* 30 (December 1906): 182–183.

Hawthorne, Nathaniel. "*The Marble Faun* (1860)". In *Nathaniel Hawthorne: Collected Novels*, edited by Millicent Bell. New York, 1983.

Heckscher, Morrison H. and Leslie Greene Bowman. *American Rococo, 1750–1775: Elegance in Ornament.* New Haven, 1992.

Hegyi, Lóránd. "Introduction to the Exhibition of Jolán Gross-Bettelheim." In *Gross-Bettelheim Jolán Retrospektív Kiállítása*, n.p. Kiállítóterem, Budapest, 1988.

Helsinger, Elizabeth et al. *The "Writing" of Modern Life: The Etching Revival in France, Britain, and the U.S., 1850–1940.* Chicago, 2008.

Hess, Thomas B. "Prints: Where History, Style and Money Meet." *Art News* 70, no. 9 (January 1972): 29–30.

Higgonet, Anne. *Berthe Morisot's Images of Women.* Cambridge, MA, 1992.

Higgonet, Anne. *Pictures of Innocence: The History and Crisis of Ideal Childhood.* London, 1998.

Howard, Hugh. *The Painter's Chair: George Washington and the Making of American Art.* New York, 2009.

Howells, William Dean. "A Sennight of the Centennial." *Atlantic Monthly* 38 (July 1876): 92–107.

Hunt, David C. and Marsha V. Gallagher. *Karl Bodmer's America.* Omaha, NE, 1984.

Hutchinon, Elizabeth. "From Pantheon to Indian Gallery: Art and Sovereignty on the Early Nineteenth-Century Cultural Frontier." *Journal of American Studies* 47, no. 2 (May 2013): 313–337.

Isernhagen, Hartwig. "Bodmer — Wied — America: A Journey of Exploration." In *Karl Bodmer: A Swiss Artist in America, 1809 –1893.* Zürich, 2009.

Ittman, John. "David Alfaro Siqueiros." In *Mexico and Modern Printmaking: A Revolution in the Graphic Arts, 1920 to 1950*, John Ittman, ed., 158–171. Philadelphia, 2006.

Ives, Colta Feller. *The Great Wave: The Influence of Japanese Woodcuts on French Prints.* New York, 1974.

Jackson, Kenneth T., ed. *The Encyclopedia of New York City.* New Haven, 1995.

Jacobowitz, Ellen S. "Henry Dawkins." In *Philadelphia: Three Centuries of American Art*, edited by Darrel Sewell, 77–78. Philadelphia, 1976.

Johnson, Una. *American Prints and Printmakers.* Garden City, NY, 1980.

Kelly, Franklin. *Frederick Edwin Church.* Washington, DC, 1989.

Kingsley, Elbridge. "Wood-Engraving Direct from Nature." *The Century* 25 (1882): 48–50.

Kinsey, Joni L. "Sacred and Profane: Thomas Moran's *Mountain of the Holy Cross*." *Gateway Heritage* 11 (1990): 4–23.

Kitch, Carolyn L. *The Girl on the Magazine Cover: The Origins of Visual Stereotypes in American Mass Media.* Chapel Hill, NC, 2001.

Klackner, Christian. *A Catalogue of the Complete Etched Works of Thomas Moran, N.A., and M. Nimmo Moran, S.P.E.* New York, 1889.

Koehler, S. R. "The Works of the American Etchers: XXVI — George Loring Brown." *American Art Review* 2, pt. 2 (1881): 192.

Koehler, S. R. *American Etchings: A Collection of Twenty Original Etchings.* Boston, 1885.

Koehler, S. R. *Etching: An Outline of Its Technical Process and Its History.* New York, 1885.

Koehler, S. R. *American Art.* New York, 1886.

Koke, Richard J. *A Checklist of the American Engravings of John Hill (1770–1850).* New York Historical Society, New York, 1961.

Kotz, Mary Lynn. *Rauschenberg: Art and Life.* rev. ed. New York, 2004.

Kraut, Alan. *Silent Travelers: Germs, Genes, and the "Immigrant Menace."* New York, 1994.

Krens, Thomas. *Jim Dine Prints, 1970–1977.* New York, 1977.

Kugler, Richard C. *William Bradford: Sailing Ships and Arctic Seas.* New Bedford, MA, 2003.

Landau, Ellen G. *Artists for Victory.* Washington, DC, 1983.

Leavitt, Thomas W. "The Life, Work, and Significance of George Loring Brown, American Landscape Painter." PhD diss., Harvard University, 1957.

Leavitt, Thomas W. *George Loring Brown: Landscapes of Europe and America, 1834–1880.* Burlington, VT, 1973.

Lengwiler, Guido. *A History of Screen Printing.* Cincinnati, 2013.

Levin, Gail. *Edward Hopper: The Complete Prints.* New York and London, 1979.

Lewison, Jeremy. *Brice Marden Prints 1961–1991: A Catalogue Raisonné.* London, 1992.

Lippard, Lucy. *Booster and 7 Studies.* Los Angeles, 1967.

Livingstone, Marco. "Do It Yourself: Notes on Warhol's Techniques." In *Andy Warhol: A Retrospective*, edited by Kynaston McShine, 63–78. New York, 1989.

Livingstone, Margaret. *Vision and Art, the Biology of Seeing.* New York, 2002.

Lloyd, James T. *Lloyd's Steamboat Directory and Disasters on Western Waters.* Cincinnati, 1856.

Lobel, Michael. *John Sloan: Drawing on Illustration.* New Haven, 2014.

London, Jack. "A Piece of Steak." In *To Build a Fire and Other Stories by Jack London*, edited by Donald Pizer, 270–289. New York, 1986.

"Louise Bourgeois: The Complete Prints and Books." *Museum of Modern Art*, New York. http://www.moma.org/explore/collection/lb/ (accessed September 18, 2015). See also Wye, Deborah.

MacDonald, Margaret F., et al. *James McNeill Whistler: The Etchings, a catalogue raisonné.* Glasgow, 2012. http://etchings.arts.gla.ac.uk/catalogue/ (accessed November 19, 2015).

"Malden's Artist Recluse," *New York Times*, June 7, 1885.

Mancini, J. M. *Pre-Modernism: Art-World Change and American Culture from the Civil War to the Armory Show*. Princeton, 2005.

Marin, John. Untitled statement, in *An Exhibition of Water-Colors — New York, Berkshire and Adirondack Series — and Oils by John Marin, of New York*, Gallery of the Photo-Secession. Reprinted in *Camera Work* 42–43 (April–July): 18.

Mason, Lauris. *The Lithographs of George Bellows, A Catalogue Raisonné*. rev. ed. San Francisco, 1992.

Mather, Increase. *The Life and Death of that Reverend Man of God, Mr. Richard Mather*. Cambridge, MA, 1670.

Mathews, Nancy Mowll, ed. *Mary Cassatt and Her Circle: Selected Letters*. New York, 1984.

Mathews, Nancy Mowll. *Mary Cassatt: A Life*. New Haven, 1994.

Mathews, Nancy Mowll, and Barbara Stern Shapiro. *Mary Cassatt: The Color Prints*. New York, 1989.

Maximilian, Prince of Wied. *Travels in the Interior of North America*, translated by H. Evans Lloyd. London, 1843.

McCarron, Paul. *The Prints of Martin Lewis, A Catalogue Raisonné*. Bronxville, NY, 1995.

McCormick, W.B. Review in *New York Press*. Reprinted in *Camera Work* 42–43 (April–July): 24–25.

McGerr, Michael E. *The Decline of Popular Politics. The American North, 1865–1928*. New York and Oxford, 1986.

McQueen, Alison. *The Rise of the Cult of Rembrandt: Reinventing an Old Master in Nineteenth-Century France*. Amsterdam, 2003.

Melcher, David, and Patrick Cavanagh. "Pictorial Cues in Art and in Visual Perception." In *Art and the Senses*, edited by Francesca Bacci and David Melcher, 359–394. Oxford, 2011.

Merkert, Jörn. *David Smith, Sculpture and Drawings*. Munich, 1986.

Moore, Robert J. *Native Americans: A Portrait; The Art and Travels of Charles Bird King, George Caitlin, and Karl Bodmer*. New York, 1997.

Morse, Peter. *John Sloan's Prints, A Catalogue Raisonné of the Etchings, Lithographs, and Posters*. New Haven and London, 1969.

Morse, Peter. *Jean Charlot's Prints: A Catalogue Raisonné*. Honolulu, 1976.

Moser, Joann. *Singular Impressions: The Monotype in America*. Washington and London, 1997.

"Mr. Whistler's Etchings." *British Architect* 14 (December 10, 1880): 247.

Mumford, Lewis. "Opening Address" (1936). In *Artists against War and Fascism*, 62–64. New Brunswick, NJ, 1985.

Munsing, Stefanie A. *Made in America, Printmaking 1760–1860*. Philadelphia, 1973.

Munsing, Stefanie A. "Max Rosenthal." In *Philadelphia: Three Centuries of American Art*, edited by Darrel Sewell, 348–350. Philadelphia, 1976.

Myer, Jane and Linda Ayres. *George Bellows, The Artist and his Lithographs, 1916–1924*. Fort Worth, TX, 1988.

Nussbaum, Martha C. "Objectification." *Philosophy and Public Affairs* 24, no. 4 (1995): 249–291.

O'Brien, Donald C. *Amos Doolittle: Engraver of the New Republic*. New Castle, DE, 2008.

O'Connor, Francis V., and Eugene Victor Thaw. *Jackson Pollock: a catalogue raisonné of paintings, drawings, and other works*. New Haven, 1978.

Ohmann, Richard. *Selling Culture: Magazines, Markets, and Class at the Turn of the Century*. London, 1996.

Oldenburg, Claes. "I Am For…" In *Environments, Situations, Spaces*. New York, 1961.

Patterson, Cynthia Lee. *Art for the Middle Classes: America's Illustrated Magazines of the 1840s*. Jackson, MS, 2010.

Pegler, Martin. *Sniper. A History of the US Marksman*. Oxford, 2009.

Peixotto, Benjamin F. "Julius Bien." *The Menorah* 8, no. 6 (June 1890): 285–295.

Pemberton, Murdock. *Object: Every American an Art Patron*. New York, 1945.

Pennell, Elizabeth Robins. *The Art of Whistler*. New York, 1928.

Perlman, Bennard. *Painters of the Ashcan School: The Immortal Eight*. Mineola, NY, 1988.

Pfitzer, Gregory M. *Picturing the Past: Illustrated Histories and the American Imagination, 1840–1900*. Washington, DC, 2002.

Pfitzer, Gregory M. *Popular History and the Literary Marketplace, 1840–1920*. Amherst, MA, 2008.

Pilcher, Jeffrey M. *Planet Taco: A Global History of Mexican Food*. New York, 2012.

Piola, Erika. *Philadelphia on Stone: Commercial Lithography in Philadelphia, 1828–1878*. State College, PA, 2012.

Porter, Joseph C. "The Eyes of Strangers: 'Fact' and Art on the Ethnographic Frontier, 1832–34." In *Karl Bodmer's Studio Art: The Newberry Library Bodmer Collection*, Wood, W. Raymond, Joseph C. Porter, and David C. Hunt, 23–98. Urbana, IL, 2002.

Potter, David M. *The Impending Crisis. America Before the Civil War, 1848–1861*, completed and edited by Don E. Fehrenbacher. New York, 2011.

Prasse, Leona E. *Lyonel Feininger: A Definitive Catalogue of His Graphic Work, Etchings, Lithographs, Woodcuts*. Cleveland, 1972.

"Prints for the People." *Brooklyn Daily Eagle* (Jan. 3, 1937): 8C.

"Prints, Pictures, and Prices." *Harper's New Monthly Magazine*, 35, no. CCX (November, 1867): 798–801.

"Proposals by John Trumbull." *Pennsylvania Packet*. May 7, 1790: 4.

"Proposals for Printing by Subscription." *Pennsylvania Packet*. December 5, 1774: 1.

"A Prospective View of the Pennsylvania Hospital." *Pennsylvania Gazette*. October 29, 1761: 4.

Prown, Jules David. "John Trumbull as History Painter." In *Art as Evidence: Writings on Art and Material Culture*, 159–187. New Haven, 2001.

"Punches Which Would Run Factories," *New York American*, 3 April 1910, magazine section, 6.

Quimby, Ian M. G. "The Doolittle Engravings of the Battle of Lexington and Concord." *Winterthur Portfolio* 4 (1968): 83–108.

Reinhardt, Ad. *Art-as-Art: The Selected Writings of Ad Reinhardt*. New York, 1975.

"Rembrandt's Etchings." *The Art-Journal* 6 (August 1, 1867): 193.

Rensselaer, Marianna Griswold van. "American Etchers." *Century Magazine* 25, no. 4 (February 1883): 483–499.

Rensselaer, Marianna Griswold van. "American Painters in Pastel." *Century Magazine* 29, no. 2 (December 1884): 204–210.

Report on the National Gallery of Art for the Year Ended June 30, 1943. United States Government Printing Office, Washington, DC, 1944.

Richardson, Edgar P. *Painting in America: The Story of 450 Years*. New York, 1956.

Riis, Jacob A. *How the Other Half Lives: Studies Among the Tenements of New York*. New York, 1890.

Rippner, Samantha. *The Prints of Vija Celmins*. New York, 2002.

Roark, Elisabeth L. *Artists of Colonial America*. Westport, CT, 2003.

Roberts, Jennifer L. *Transporting Visions: The Movement of Images in Early America*. Berkeley, 2014.

Robinson, Susan Barnes, and John Pirog. *Mabel Dwight: A Catalogue Raisonné of the Lithographs*. Smithsonian Institution, Washington, DC, 1997.

Recording of Franklin Delano Roosevelt's dedication speech March 17, 1941. http://www.nga.gov/content/ngaweb/audio-video/audio/west-building-dedication-president-fdr.html (accessed August 15, 2015).

Rubenstein, Daryl R. *Max Weber, A Catalogue Raisonné of His Graphic Work*. Chicago, 1980.

Ruud, Brandon K., ed. *Karl Bodmer's North American Prints*. Lincoln, NE, 2004.

Sachs, Paul J. *Modern Prints and Drawings*. New York, 1954.

Sartain, John. *The Reminiscences of a Very Old Man, 1808–1897*. New York, 1899.

Sasowsky, Norman. *The Prints of Reginald Marsh: an essay and definitive catalog of his linoleum cuts, etchings, engravings, and lithographs*. New York, 1976.

Scott, Kenneth. *Counterfeiting in Colonial America*. Philadelphia, 2000.

Seaton, Elizabeth. *Paths to the Press: Printmaking and American Women Artists, 1910–1960*. Manhattan, KS, 2006.

Seltzer, Mark. *Bodies and Machines*. New York, 1992.

Shadwell, Wendy. *American Printmaking, The First 150 Years*. Washington, DC, 1969.

Sloan, John. "Major Influences." In *John Sloan*, Whitney Museum Library Artists Files Miscellaneous.

Sloan, John. *John Sloan's Diaries (1906–13)*, April 3, 1912. Transcribed and annotated by Judith O'Toole and based on originals in Delaware Art Museum's John Sloan Manuscript Collection.

Sloan, John. *Gist of Art*. American Artists Group, New York, 1939.

Sloan, John. "Autobiographic Notes on Etching." In *John Sloan's Prints*, edited by Peter Morse, 382–392. New Haven, 1969.

Staiti, Paul. "Winslow Homer and the Drama of Thermodynamics." *American Art* 15, no. 1 (Spring, 2001): 10–33.

Stauffer, David McNeely. *American Engravers Upon Copper and Steel*, pt. 1. New York, 1907.

Sterling, Christopher H. *Encyclopedia of Journalism*, vol. 3. Thousand Oaks, CA, 2009.

Strahan, Edward [Earl Shinn]. "The National Academy of Design." *Art Amateur* 1, no. 2 (July 1879): 27–29.

Sultan, Terrie. *Chuck Close Prints: Process and Collaboration*. Munich, London, New York, 2014.

Sweet, Frederick A. *Miss Mary Cassatt: Impressionist from Pennsylvania*. Norman, OK, 1967.

Swift, Samuel. Review in the *New York Sun*. Reprinted in *Camera Work* 42–43 (April–July): 23.

Taylor, George Rodgers. *The Transportation Revolution, 1815–1860*. New York and Toronto, 1957.

Teller, Susan. *Dorothy Dehner: A Retrospective of Prints, April 7 through May 2, 1987*. Associated American Artists, New York, 1987. Brochure.

Tiersten, Lisa. *Marianne in the Market: Envisioning Consumer Society in Fin-de-Siècle France*. Berkeley, 2001.

Thein, John and Phillip Lasansky. *Lasansky, Printmaker*. Iowa City, IA, 1975.

Trumbull, John. *Autobiography, Reminiscences and Letters of John Trumbull*. New Haven and London, 1841.

Vivian, Thomas J., and Grena J. Bennett. "The Tilting Island." *Everybody's Magazine* 21 (September 1909): 380–389.

Wainwright, Nicholas B. *Philadelphia in the Romantic Age of Lithography: An Illustrated History of Early Lithography in Philadelphia*. Philadelphia, 1958.

Walker, Margaret. "We Have Been Believers." In *For My People*, edited by Stephen Vincent Benét, 16–17. New Haven, 1942.

Warhol, Andy, and Pat Hackett. *POPism: the Warhol '60s*. New York, 1980.

Watrous, James. *A Century of American Printmaking*. Madison, WI, 1984.

Weber, Max. "The Artist, His Audience, and Outlook." In *Artists against War and Fascism*, 121–129. New Brunswick, NJ, 1985.

Weber, Wilhelm. *Aloys Senefelder, Erfinder der Lithographie*. Frankfurt am Main, 1981.

Whitman, Alfred. *British Mezzotinters: Valentine Green*. London, 1902.

Wien, Jake Milgram. *The Vanishing American Frontier: Bernarda Bryson Shahn and Her Historical Lithographs Created for the Resettlement Administration of FDR*. New York, 1995.

Wilentz, Sean. "Nassau Hall, Princeton, New Jersey." In *American Places: Encounters with History*, edited by William E. Leuchtenburg, 311–324. New York, 2000.

Wilkinson, W. T. *Photo-Engraving, Photo-Etching, and Photo-Lithography in Line and Half Tone*, 3rd ed. New York, 1888.

Williams, Reba White. "The Prints of Robert Gwathmey." In *Hot off the Press: Prints and Politics*, edited by Linda Tyler and Barry Walker, 33–56. Albuquerque, 1994.

Williams, Reba White. "The Weyhe Gallery Between the Wars, 1919–1940." PhD diss., The City University of New York, 1996.

Williams, Reba White and Dave Williams. *American Screenprints*. New York, 1987.

Wilmerding, John. "William Bradford: Artist of the Arctic." In *American Views: Essays on American Art*, edited by John Wilmerding. Princeton, 1991.

Wilson, Edmund. *Patriotic Gore. Studies in the Literature of the Civil War*. New York, 1962.

Wilson, James Grant, and John Fiske. "Rosenthal, Max." In *Appletons' Cyclopaedia of American Biography*, vol. 5, 326. New York, 1898.

Witte, Stephen S., and Marsha V. Gallagher, eds. *The North American Journals of Prince Maximilian of Wied, Volume 3: September 1822–August 1834*, translated by Dieter Karch. Norman, OK, 2012.

Wood, W. Raymond, and Robert M. Lindholm. *Karl Bodmer's America Revisited: Landscape Views Across Time*. Norman, OK, 2013.

"Work of an American Etcher." *New York Times*, July 6, 1919, magazine section, 67.

"Works on Art: The American Art Review for September." *New York Times*, October 16, 1881.

Wuerth, Louis A. *Catalogue of the Etchings of Joseph Pennell*. Boston, 1928.

Wye, Deborah, and Carol H. Smith. *The Prints of Louise Bourgeois*. New York, 1994. See also "Louise Bourgeois."

Yablon, Nick. *Untimely Ruins: An Archaeology of American Urban Modernity, 1819–1919*. Chicago, 2009.

York, Neil. *The Boston Massacre: A History with Documents*. New York and London, 2010.

Zigrosser, Carl. *The Complete Etchings of John Marin*. Philadelphia, 1969.

Zobel, Hiller B. *The Boston Massacre*. New York, 1970.

Index

Photography Credits and Illustration Details

All plates in this catalog (pls. 1–144) are courtesy of the Board of Trustees of the National Gallery of Art, Washington.

Photographs of the works in this catalog, except where otherwise noted, are by Ricardo Blanc, Dennis Doorly, Lee Ewing, Christina Moore, Greg Williams, and Tricia Zigmund, all of the National Gallery of Art, and by Erica Abbey, Adam Davies, and Lea Ingold.

AMERICAN PRINTS, THEIR MAKERS, AND THEIR PUBLIC
Fig. 1 © Princeton University Library; fig. 3 www.metmuseum.org; figs. 5, 7, 12, 13, 14 courtesy of the Board of Trustees of the National Gallery of Art, Washington; fig. 8 © Davis Museum and Cultural Center, Wellesley College, Wellesley, MA; fig. 15 © Tim Nighswander

PAUL REVERE'S CAFFEINE: *THE BLOODY MASSACRE*
Fig. 1 © 2015 Museum of Fine Arts, Boston; fig. 2 courtesy of the Board of Trustees of the National Gallery of Art, Washington.

LINES DEFINING LAND AND SEA
Fig. 1 www.metmuseum.org.

BUILDING BODIES, BODY BUILDINGS: NEW YORK CITY AROUND 1900
Fig. 2 © Yale University Art Gallery.

"JUST LOOKING": PRINTS, 1925–1940
Fig. 1 digital image © The Museum of Modern Art/ Licensed by SCALA / Art Resource, NY.

SIFTED: SCREENPRINTING AND THE ART OF THE 1960S
Fig. 1 courtesy Guido Lengwiler; fig. 3 © President and Fellows of Harvard College.

ILLUSTRATION DETAILS

pp. ii–iii Robert Havell Jr. after John James Audubon, *American White Pelican,* pl. 20

pp. xii–1 Kara Walker, *no world,* pl. 144

pp. 32–33 Paul Revere after Henry Pelham, *The Bloody Massacre,* pl. 8

pp. 54–55 Johann Hürlimann after Karl Bodmer, *Síh-Chidä and Máhchsi-Karéhde,* pl. 25

pp. 74–75 After Winslow Homer, *The Army of the Potomac – A Sharp-Shooter on Picket Duty,* pl. 34

pp. 90–91 James McNeill Whistler, *Nocturne,* pl. 38

pp. 104–105 William Bradford, *Among the Ice Floes,* pl. 52

pp. 124–125 Mary Cassatt, *Woman Bathing,* pl. 54

pp. 140–141 John Sloan, *Anshutz on Anatomy,* pl. 62

pp. 160–161 Louis Lozowick, *New York,* pl. 75

pp. 180–181 Mabel Dwight, *Queer Fish,* pl. 86

pp. 196–197 Elizabeth Catlett, *Untitled ('Harriet Tubman),* pl. 97

pp. 218–219 Sylvia Wald, *Between Dimensions,* pl. 111

pp. 238–239 Andy Warhol, *Marilyn,* pl. 123

pp. 260–261 Glenn Ligon, *Untitled: Four Etchings [B],* pl. 140

pp. 280–281 James McNeill Whistler, *Rotherhithe,* pl. 36

pp. 290–291 Edward Hopper, *The Locomotive,* pl. 83

pp. 326–327 Peggy Bacon, *Frenzied Effort,* pl. 84.

The exhibition is organized by the National Gallery of Art, Washington.

The exhibition is made possible by Altria Group in celebration of the 75th Anniversary of the National Gallery of Art.

The international tour of the exhibition is sponsored by the Terra Foundation for American Art.

Additional support is provided by The Exhibition Circle of the National Gallery of Art.

The Terra Foundation for American Art also provided funding for foreign-language translations of the exhibition catalog.

EXHIBITION DATES
National Gallery of Art, Washington
April 3 – July 24, 2016

Národní galerie v Praze, Prague, Czech Republic
October 4, 2016 – January 5, 2017

10 9 8 7 6 5 4 3 2 1

Produced by the Publishing Office, National Gallery of Art, Washington
www.nga.gov

Judy Metro, *editor in chief*
Wendy Schleicher, *design manager*

Designed by Chris Vogel
Edited by John Strand

Sara Sanders-Buell, *permissions manager;*
John Long, *print and digital production associate;*
Mariah Shay, *production assistant;* and Katie Adkins, *program assistant*

Typeset in Sentinel and Ideal Sans. Separations by Prographics, Rockford, IL. Printed on Kiara by Elcograf, Verona, Italy.

First published in hardcover in the United States of America in 2016 by Thames & Hudson Inc., 500 Fifth Avenue, New York, New York 10110
www.thamesandhudsonusa.com

First published in the United Kingdom in 2016 by Thames & Hudson Ltd, 181A High Holborn, London WC1V 7QX
www.thamesandhudson.com

LIBRARY OF CONGRESS CATALOGING-IN-PUBLICATION DATA

Names: National Gallery of Art (U.S.), author, organizer, host institution. / Brodie, Judith. American prints at the National Gallery of Art. / Národní galerie v Praze, host institution.
Title: Three centuries of American prints from the National Gallery of Art / Judith Brodie, Amy Johnston, Michael J. Lewis ; With contributions by John Fagg, Adam Greenhalgh, Franklin Kelly, David M. Lubin, Leo G. Mazow, Alexander Nemerov, Jennifer Raab, Jennifer L. Roberts, Marc Simpson, Susan Tallman, Joyce Tsai, David C. Ward.
Description: 1st edition. / Washington : National Gallery of Art, 2016. / Includes bibliographical references and index.
Identifiers: LCCN 2015045313 /
ISBN 978-0-500-23952-0 (hardcover : alk. paper)
ISBN 978-0-894-68400-5 (softcover : alk. paper)
Subjects: LCSH: Prints, American — Exhibitions. / Prints — Washington (D.C.) — Exhibitions. / National Gallery of Art (U.S.) — Exhibitions.
Classification: LCCN E505 .N38 2016 /
DDC 769.973 — dc23
LC record available at
http://lccn.loc.gov/2015045313

A catalogue record for this book is available from the British Library.